WITNESS
TO OUR TIME

ALFRED EISENSTAEDT

Foreword by Henry R. Luce

Revised Edition

WITNESS TO OUR TIME

A Studio Book The Viking Press New York

To Kathy

The text for *Witness to Our Time* was prepared by
Milton Orshefsky and edited by Joseph Kastner.

ACKNOWLEDGMENTS

I owe deep thanks to *Life* magazine as a whole and to many individuals on its staff for their help in producing this book. Richard O. Pollard, Director of Photography, made available his own time and the services of many departments at *Life*. Special thanks go to Ruth Lester for her devotion and patience in collecting and organizing quantities of my photographs, which seemed to me hopelessly disorganized. I am grateful to the members of *Life's* photographic laboratory, especially Mauro Rubino, who supervised the making of prints. In the preparation of the text, invaluable research was done by Nancy Haskell. The text, based in part on material that has appeared in *Life*, is, by design, a blend of straight reporting about the times and of my own memories and comments.

Finally, I am in debt to the staff of The Viking Press for all their work in putting this volume together, to Bryan Holme, who designed the book, and to Nicolas Ducrot, his able assistant. They had to wade through literally thousands of my pictures of the last four decades to choose those that finally appear.

ALFRED EISENSTAEDT

This edition of *Witness to Our Time* differs slightly from the original. Escalating production costs have made it necessary to reduce the trim size from 9⅝″ × 12⅝″ to 9⅛″ × 12″; to convert the color photographs to black-and-white (pages 13–16, 161–162, 195–196, 205–206, 223–224, 241–242, 260–261, 264–265, 268–269, 272–273, 276–277, 280–281, 284–285, 288–289, 307–308, 317–324, and 333–339); and to print the book by offset. The photograph that originally appeared on pages 336-337 has been replaced by a similar photograph on page 336 and the captions that originally appeared on page 341 now appear on page 337. The photograph that appeared on pages 338-339 has been dropped. Otherwise, and except for the addition of eight pages at the end of the book, the material remains the same.

Published simultaneously in Canada by
Penguin Books Canada Limited

Library of Congress Cataloging in Publication Data
Eisenstaedt, Alfred.
 Witness to our time.
 Includes index.
 1. Photography—Portraits.
2. Photography, Journalistic. 3. Twentieth
century—Pictorial works. I. Title.
TR681.F3E55 1980 779'.990982 80-16970
ISBN 0-670-77702-1

Printed in the United States of America

Contents

Foreword

Alfred Eisenstaedt came to the United States in 1935 and joined the small pre-publication staff of *Life*. When he showed me the results of his first assignment—sharecroppers in Mississippi—I was convinced that our ideas for the picture magazine would work. For Eisie showed that the camera could do more than take a striking picture here and there. It could do more than record "the instant moment." Eisie showed that the camera could deal with an entire subject—whether the subject was a man, a maker of history, or whether it was a social phenomenon. That is what is meant by photojournalism. And that is why Eisenstaedt is called the "father" of photojournalism—a title which I am sure he would insist upon sharing with a few others, notably his friend and colleague Margaret Bourke-White.

Not only was Eisenstaedt a founding father of this modern form of significant journalism; he has been undoubtedly its most prolific and ubiquitous practitioner. As this book went to press, Eisenstaedt had done 1728 picture stories for *Life*. The range of his themes is approximately equal to the range of human experience in our time.

It has often been remarked that Eisenstaedt takes little interest in the techniques of photography—or at any rate he doesn't seem to. He started long years ago with a Leica, and recently he was presented with the 1,000,001st copy of that famous instrument. When I visualize Eisie on an assignment, I do not see a man with a camera; I simply see a man looking, a man unobtrusively, quietly, but intently looking. When he comes into the office or home of a famous person, Eisie begins with a line of chatter. Only after a quarter of an hour will he begin to do some arranging of the scene. He will then take a dozen or twenty shots—but the really important pictures will already have been taken before the formal proceedings began.

But do not think of Eisie as an indoor man. Only 5 feet 3 inches in height, he has an amazing physique. He is as strong as an ox and as agile as a mountain goat. He does not like danger and does quite a lot of squawking about it, but that doesn't stop him from walking into a Mau Mau massacre or shooting from the top ledge of a skyscraper. Some years ago he was on an assignment in the rain forests of South America. To get to the treetops he had to climb up a 150-foot-long rope ladder; he had to live with snakes and giant mosquitoes and flies that buried their eggs under his skin. To all this catalogue of hazards Eisenstaedt added a characteristic remark: "That was where the pictures were."

Essentially, Eisenstaedt is a man looking, with a camera as a magical adjunct more or less automatically recording what he sees. He is a man who lives in a world of sight, of endless sights, of sight and light. Except when he is asleep—perhaps. But Eisenstaedt's looking and seeing are far more than a reflex of undifferentiated curiosity; Eisenstaedt is a

man who sees intensely with a point of view. What is that point of view? It is not, I think, what we would call political or even sociological. It is, of course, partly artistic, for Eisenstaedt is an amateur of beauty. But my guess is that Eisenstaedt's essential point of view is one of seriousness—what, in another age, Matthew Arnold called high seriousness. For Eisenstaedt, the world, and especially the world of people, is a serious proposition. It is also amusing, wondrous, shocking, and infinitely various, but it is always real and in that sense serious. I think he would have a hard time with nihilism, for nihilism literally refers to nothingness, and for Eisenstaedt everything is something—really something! As for the modern disease of alienation, Eisenstaedt's sympathy would be engaged, but he would be hard pressed to understand. There are few people of whom it could be more truly said that nothing human is alien to him. And so he has done his 1728 stories, in the course of which he has come close (closer than they know) to many of the great figures of contemporary history. He has also seen, with the unique intensity of his concern, all manner of "ordinary people" of all races.

This extraordinary man was born in Dirschau in West Prussia, the son of a merchant who removed his family to Berlin when he retired from active business in 1906. Eisie remembers his early home life as a period when strong emphasis was placed on learning the values and concepts of honor, duty, and responsibility. Remembering his mother as a woman of quiet dignity who had never heard of a cocktail glass and on whom a daub of nail polish would look incongruous, he still winces whenever he passes bars where young mothers drop in to have a drink while their babies wait outside in their carriages.

Eisenstaedt spent his own teen-age years in the strictly disciplined Hohenzollern Gymnasium in Berlin until he was drafted into the German Army when he was seventeen—one of the German *Kindersoldaten* grabbed up as replacements after the slaughter on the Western Front. He survived, but with shrapnel in both knees. For months back home he hobbled about on crutches, then graduated to two canes. His right leg healed to some extent, but his left knee remained stiff, and the doctors tried to convince him that it should be broken again. He refused and, after months of treatments, got his legs back into shape again. By that time the November revolution had struck Berlin and at one point, as he hobbled along the street with his two canes, the revolutionists cornered him and stripped off his Iron Cross and uniform markings.

Revolution, inflation, and despair gripped all Germany in those postwar days. The Eisenstaedt family's money disappeared, and Alfred had to get a job. He studied fabrics; when a job as a salesman for buttons and belts came along, he took it. He was not a good salesman, and he already had a strong interest in photography. An uncle had given him an Eastman folding Kodak when he was fourteen, and he now joined the swarms of Germans who in the 1920s fanned out all over the countryside on Sundays and holidays, taking snapshots of swans on the river and beams of light in the forests. He was so devoted to his hobby that he never appeared in the beer halls and coffee houses because he never had enough extra money left over after buying photographic equipment.

On December 3, 1929, his hobby became a full-time profession. He began working as a reporter–news photographer for the Associated Press, operating out of Berlin. His first assignment was the award of Nobel prizes at Stockholm in 1929. Then came the Hague conference, the Lausanne conference, other conferences and League of Nations meetings, all attempting to keep Europe from falling apart. He went on tour with the Swedish royal

family, invaded Mussolini's "mile-long" office, and attended the wedding of King Boris of Bulgaria to an Italian princess (where he became so intrigued with photographing the pageantry that he forgot to take a picture of the bride and groom). He photographed Chancellor Dollfuss of Austria and was fascinated to find that the Chancellor was almost a midget and had to carry a child-sized desk with him wherever he went.

A man with no political pretensions, Eisenstaedt nevertheless put a sting into some of his pictures, particularly those of the international set at Saint Moritz and the pre-Munich appeasers. As his pictures began to speak more clearly, his reputation increased and his activities expanded even more. He flew in a special plane from Berlin to Venice for the first meeting of Hitler and Mussolini. He had to argue until four in the morning to get himself allowed within arm's length of the two men, to take a rare picture of the two dictators shaking hands.

For Eisenstaedt, as for so many others, the successes of Fascism marked the end of a Europe in which he wanted to live and work. So in the late autumn of 1935 he came to the United States—and what he has done in the three decades since comprises the pictures that make up most of this book.

The dedicated photojournalist is constantly aware that he must make awesome judgments on good and evil. Eisie knows and accepts his responsibility. As an adopted American, he has shown the joy, the glory, the shame, and the excitement of what he has seen in the United States—and what Americans may see better through his eyes than through their own. History and photojournalism can both thank the circumstances that lost the button business a salesman but gave us such an inspired witness to our time.

—HENRY R. LUCE

WITNESS
TO OUR TIME

Echoes of World War I: Verdun

A rusty tangle of barbed wire etched against the sky; a stone figure paying mute tribute to a ruined village; row on row of crosses in a cemetery gently lit by a waning sun; a bronze statue of the Prince of Peace grotesquely shattered by an errant shell-burst—this is Verdun today. There, half a century ago, millions of French and German soldiers hammered and slashed at each other for ten months—the longest single battle in history. When it was over, the front line had moved less than four miles but almost a million men had been killed, wounded, gassed, shell-shocked—a senseless carnage that forever after symbolized the horror and futility of World War I.

Like millions of my generation, I fought on the Western Front. In 1916, at seventeen, I was drafted into the German Army and shipped six months later to the bloody Flanders sector to fight as an artilleryman at Arras and Passchendaele, 125 miles from Verdun. On April 12, 1918, my unit was racing to set up positions against an Allied offensive near the village of Nieppe. Never will I forget the scene. Church spires in the village were toppling to the ground under the hail of Allied artillery. Shells began hitting groups of German soldiers who were drinking wine and champagne they had found in the ruins of the town, and they threw full bottles at us as we galloped through the rubble. I was sitting at my gun, shooting like a wild man at the approaching Allied infantry, when a British artillery shell exploded fifty feet above me. Shrapnel ripped into both my legs. As I fell backward, I caught a glimpse of my watch. It was exactly 4:10 p.m. and I remember thinking that now, for me at least, the war was over. I was the only survivor from my battery that day.

I had never been in the Verdun sector during the war. But when I took these pictures in 1964, it all looked so familiar. I could see again the water-filled craters and the arms and legs of dead men sticking out of the mud. Even the smell of dead horses and the stench of gas came vividly back.

The stench of death—more than 10 million people lost their lives during that war—lay over the whole world after the Armistice was signed on November 11, 1918. Weary, shocked, disillusioned, men began trying to build a new, different society out of the debris of the old. There were some, like President Woodrow Wilson, who felt passionately that the war had provided a real opportunity to "make the world itself at last free." But the more dominant mood was best expressed by a young German soldier in Erich Maria Remarque's novel, *All Quiet on the Western Front*. "Let the months and the years come, they bring me nothing more, they can bring me nothing more."

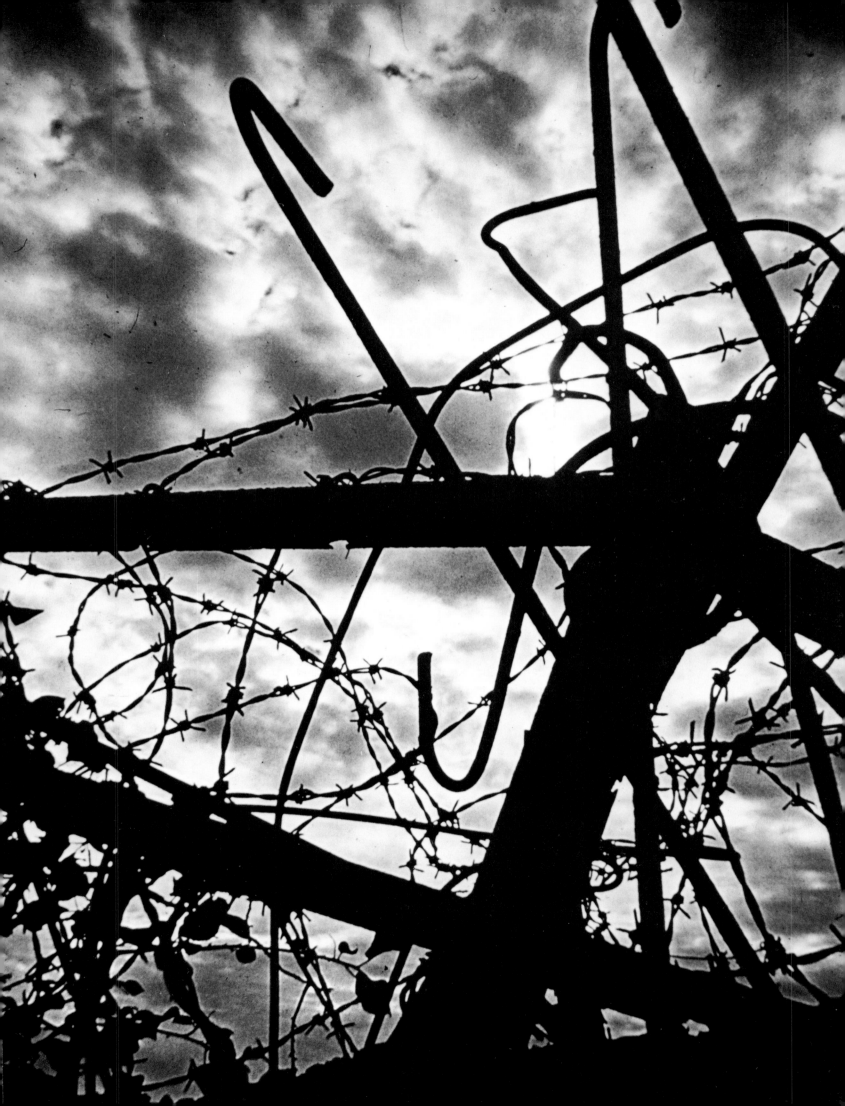

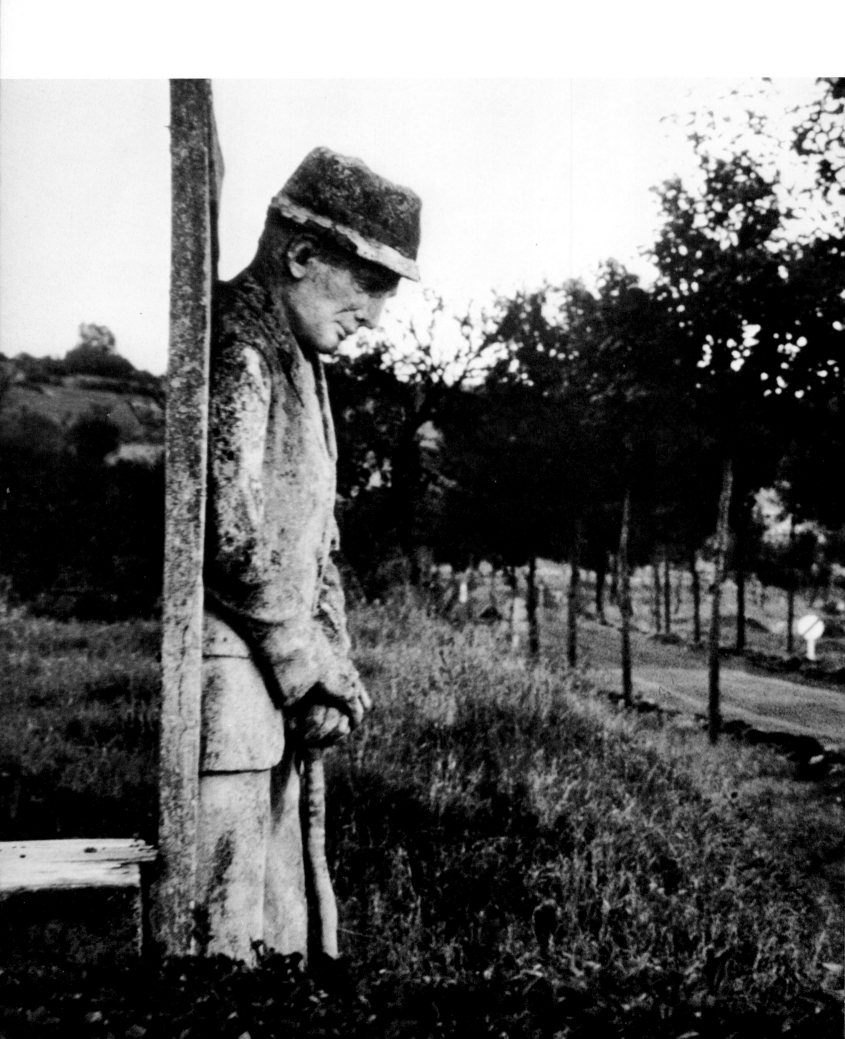

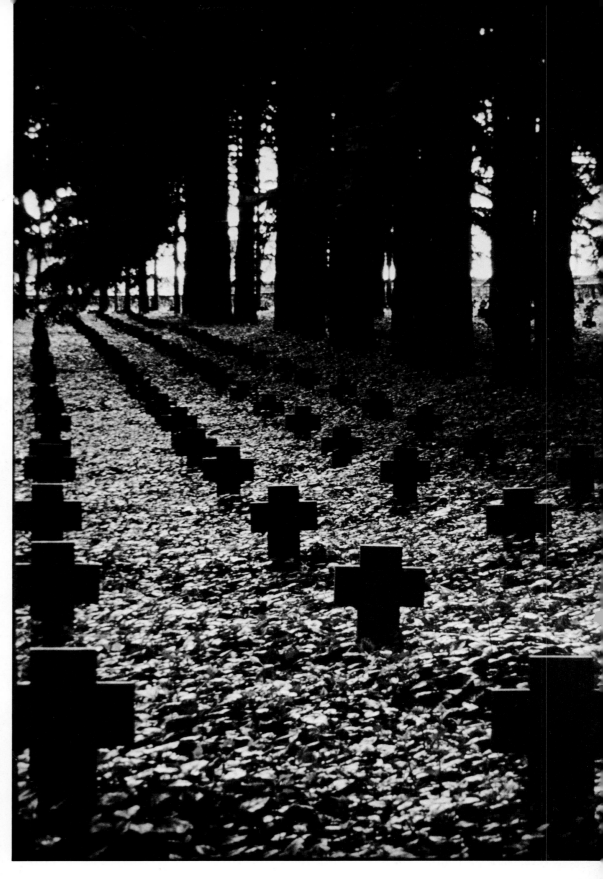

LEFT: A stone monument, *Le Père Barnabé,* broods near a poplar-lined road, a memorial to the village of Samogneux. The village was destroyed by the French, who were unaware that it was still in French hands. ABOVE: Dead in an alien land, 2000 Germans lie in a cemetery at Dun-sur-Meuse. One gravestone bears the legend: ". . . sleep, brave fighter, you were too young . . . *Auf Wiedersehen.*" OVERLEAF: At Montfaucon—where in 1918 the Germans were routed at enormous cost—a village cross holds up a statue of an anguished Christ, shattered by a shell-burst.

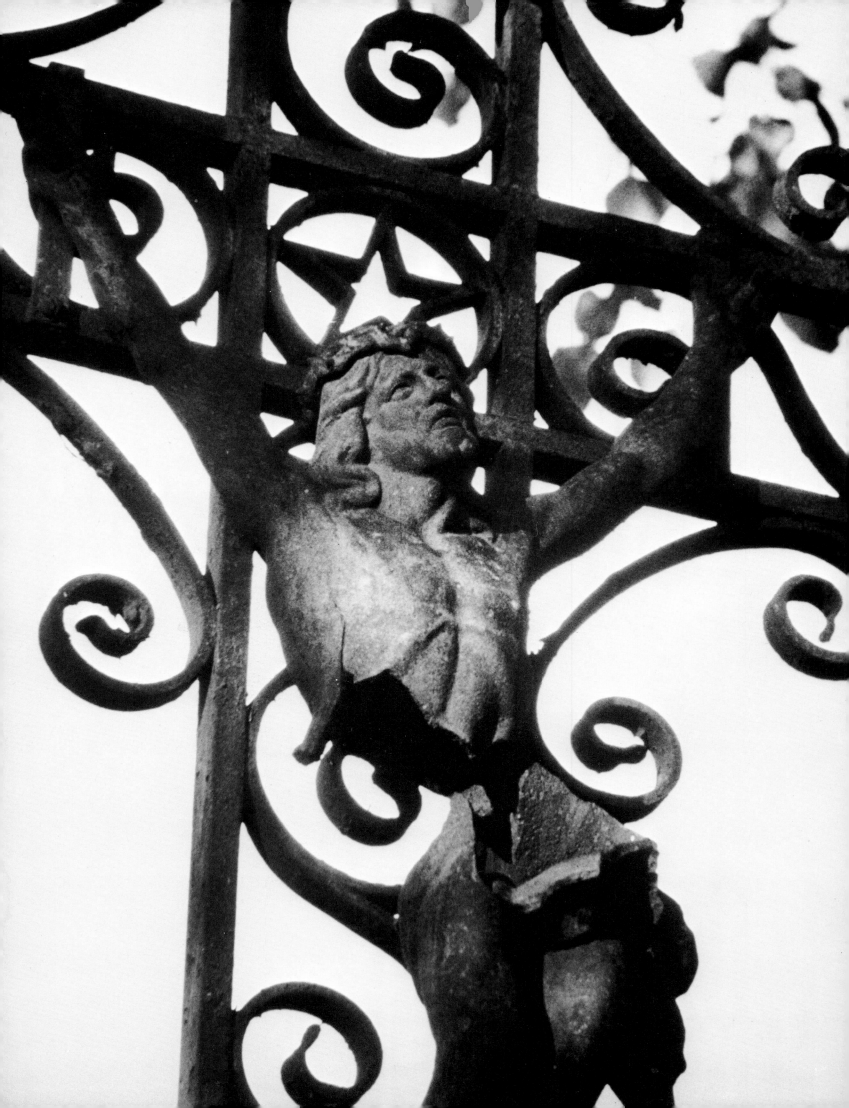

Europe between Two Wars

In Paris, bathed in a pale spring sun, the cafés in the Bois de Boulogne were crowded with idlers—including one lady who brought her pet cheetah. In Milan, bejeweled society jammed La Scala to its rococo ceiling for the gala premiere of Rimsky-Korsakov's *The Legend of the Invisible City of Kitezh*. In Berlin—where Bertolt Brecht and Kurt Weill had startled and delighted the world with their bright, cynical *Die Dreigroschenoper (The Threepenny Opera)*—a stream of renowned musicians such as Stravinsky, Chaliapin, Horowitz, and Rachmaninoff were helping to make the city once again one of the great musical capitals of the world. In St. Moritz, *the* ski resort for international society, extravagant footloose heiresses, Spanish grandees, and Hollywood stars gathered for the annual winter skiing and seeing at the Palace Hotel.

Despite the glitter, Europe, only a little more than a decade after the end of World War I, was already showing signs of the economic, political, and social disintegration that was to lead it into a second great war. The stock-market crash in the United States and the collapse of great European banking combines sent shock waves rocketing through the economies of Europe. By 1932 half its industrial equipment and millions of workers were idle. Ignace Paderewski, the pianist who became President of Poland, blamed the depression on "the vanity of the rich, the envy of the poor, and the greed of merchants in encouraging the poor to live beyond their means through the installment system of buying." Sigmund Freud speculated that "possibly even the whole of humanity—[had] become 'neurotic' under the pressure of the civilizing trend." Pope Pius XI, decreeing a Holy Year beginning at Easter 1933, called on men to "turn their thoughts . . . from the earthly and transitory things in which they are struggling so unhappily, toward eternal, celestial things, abandoning the sadness of present conditions." Stalin, asked by a reporter about the prospects for world revolution, replied: "Prospects good."

The Great Depression gave Adolf Hitler the springboard he needed for the final takeover of Germany. Tens of thousands of desperate, jobless men enrolled as Storm Troopers in the brown-shirted army of Hitler's National Socialists, just as earlier, in Italy, Blackshirts had been the military muscle for Mussolini's Fascist party coup. By 1932 the Nazis had become the largest party in Germany and on January 30, 1933, President von Hindenburg, former field marshal of the German armies in World War I, was forced to name the ex-corporal Chancellor of the Reich. The next night, to the light of 20,000 blazing torches, Hitler's Storm Troopers marched through the streets of Berlin, "an endless sea of brown." The prepared password for the Nazi demonstration was "Grandmother is dead" —an ironic epitaph for a Europe, old and exhausted, that was still trying to recover from its earlier travail. On Hitler's forty-fourth birthday that year Germany celebrated, parading to a Nazi song entitled "When Blood Flows from Our Knives."

Cross at Montfaucon.

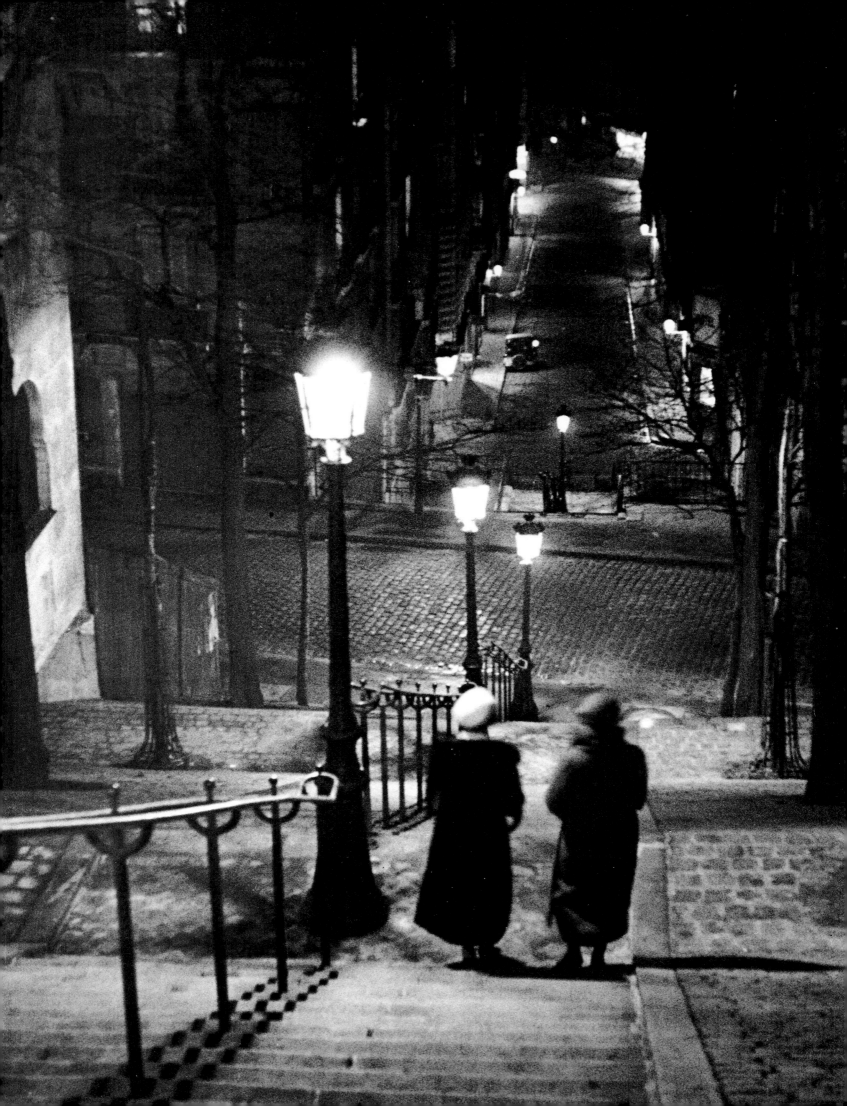

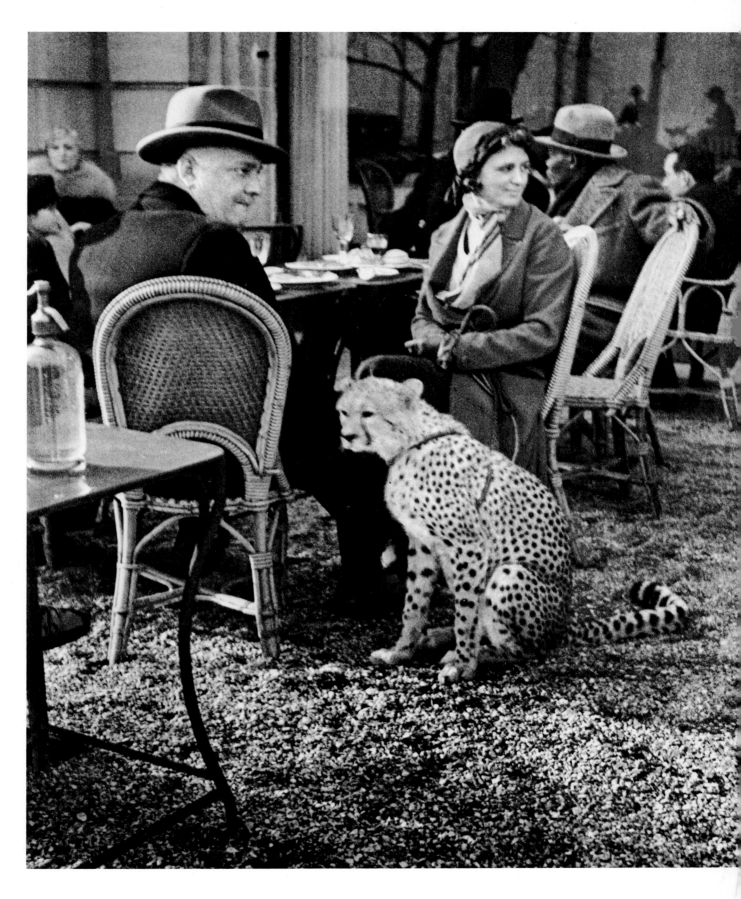

LEFT: In the spring of 1930 two ladies of the evening prowl the streets of Montmartre. ABOVE: at a sidewalk cafe in Paris's Bois de Boulogne a couple and their cheetah enjoy the sunshine.

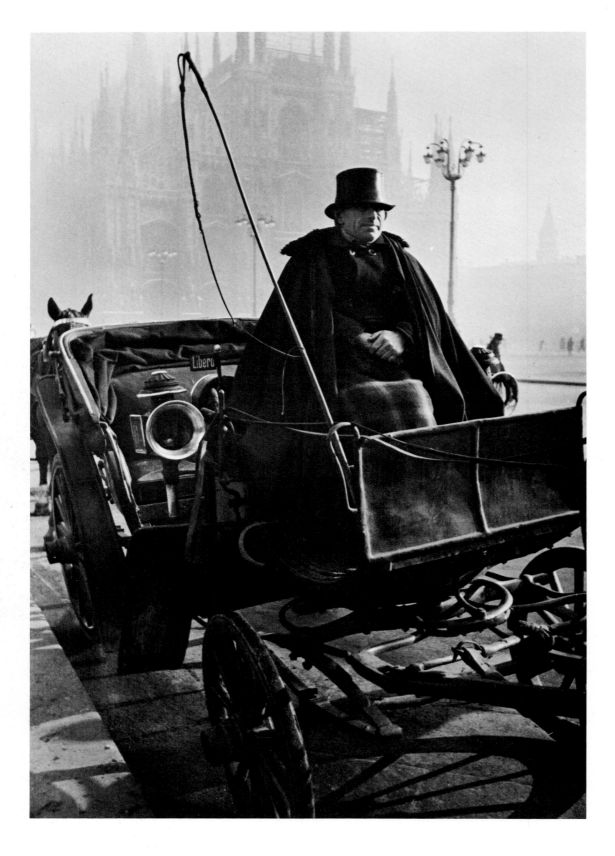

In Milan in 1933 a horse-drawn carriage waits for a fare near La Scala opera. In the background is the Duomo. RIGHT: Milanese society at La Scala in 1933 for the gala premiere of Rimsky-Korsakov's *The Legend of the Invisible City of Kitezh*.

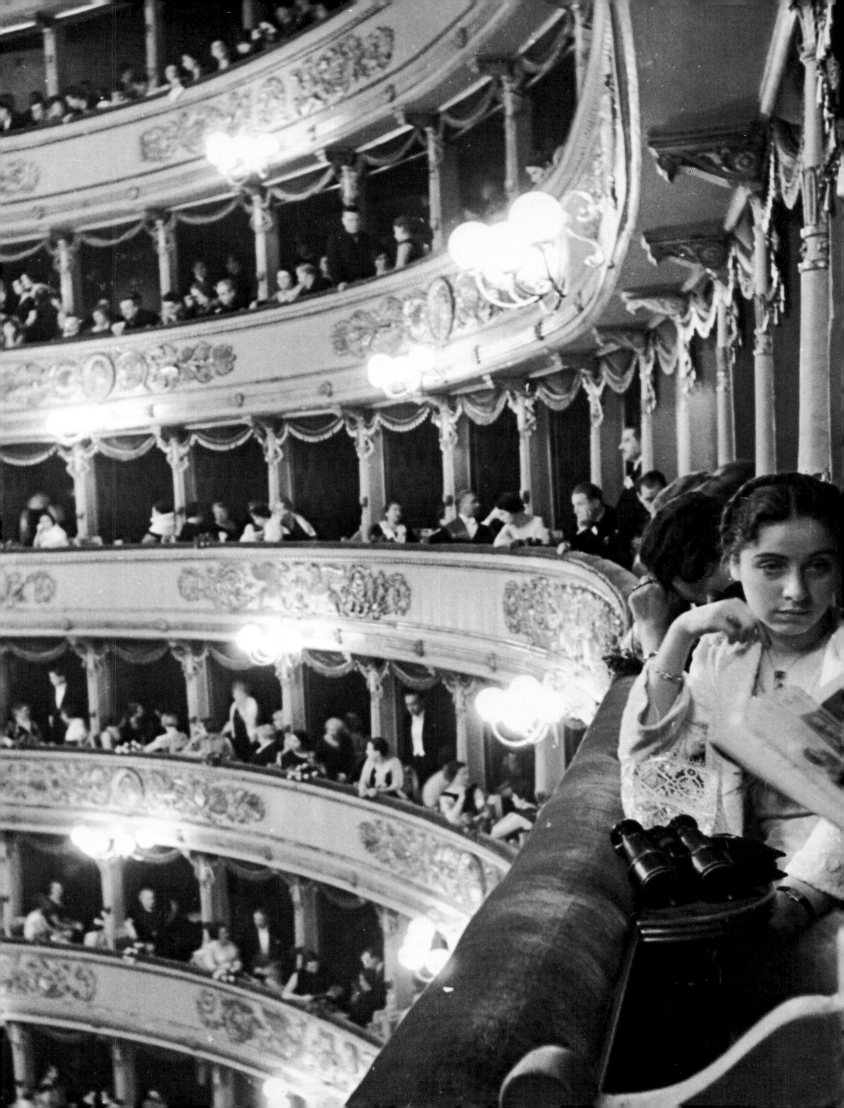

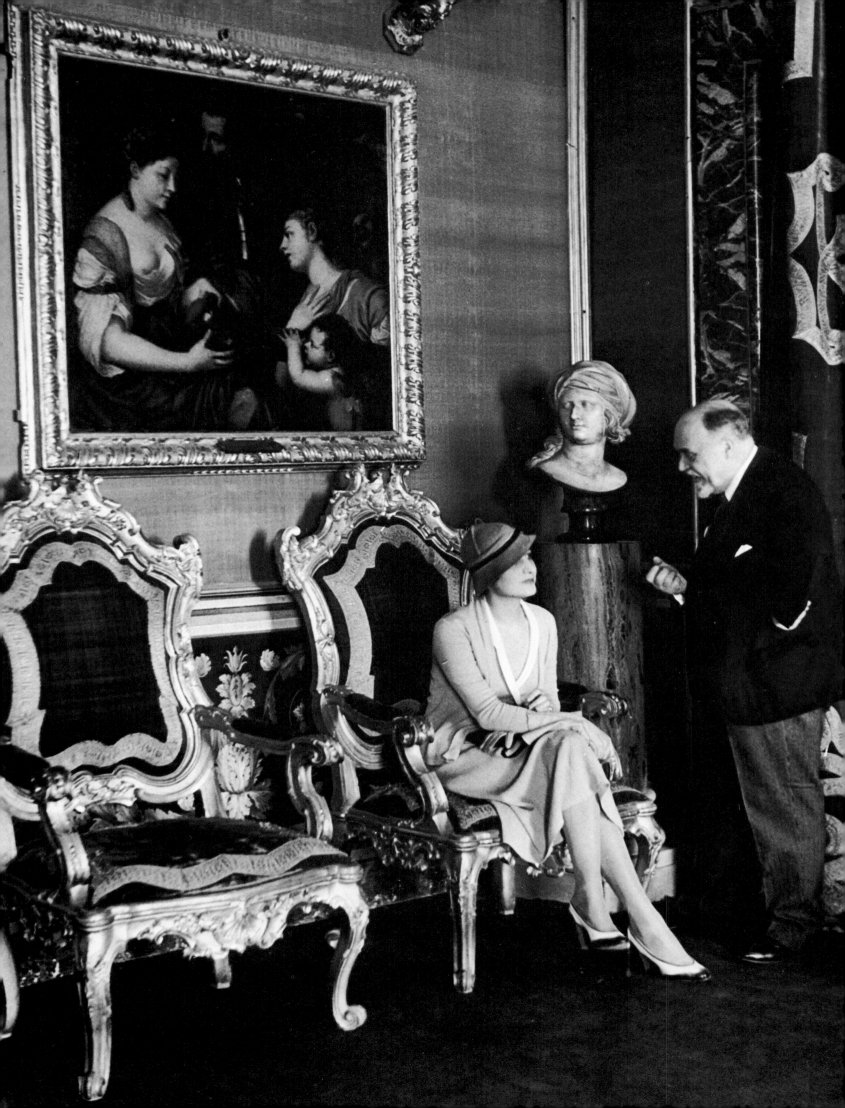

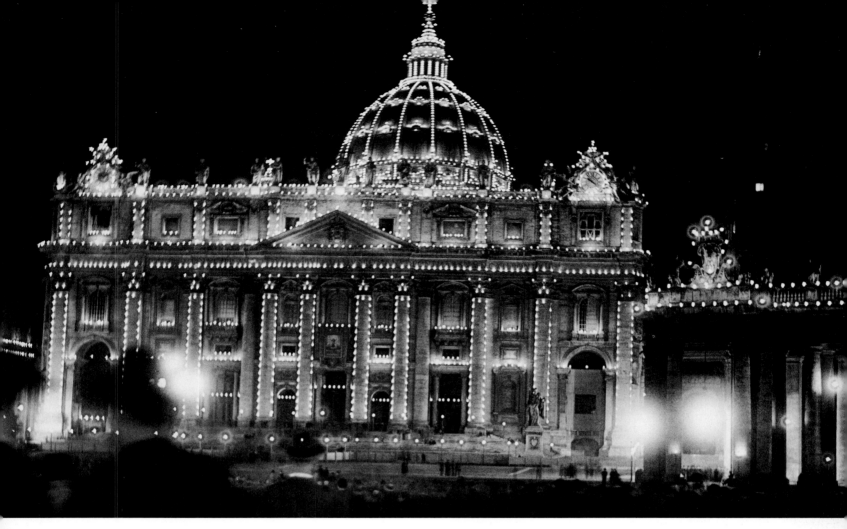

St. Peter's Basilica is outlined by flaming oil torches during Holy Year 1933–1934.

RIGHT: On the Via Veneto in Rome in 1933 a boy carries a copy of *Il Balilla,* newspaper of Mussolini's fascist youth organization.

OPPOSITE: In Rome in 1933 Prince Francesco Massimo chats with socialite Claudia Mutio Vanutelli in the Massimos' family palace.

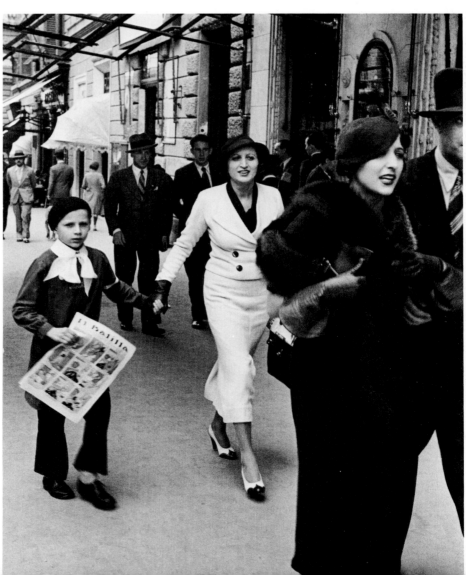

In Berlin in 1928 Charlie Chaplin, whose movies were the most widely known in the world, attends the Berlin Press Ball.

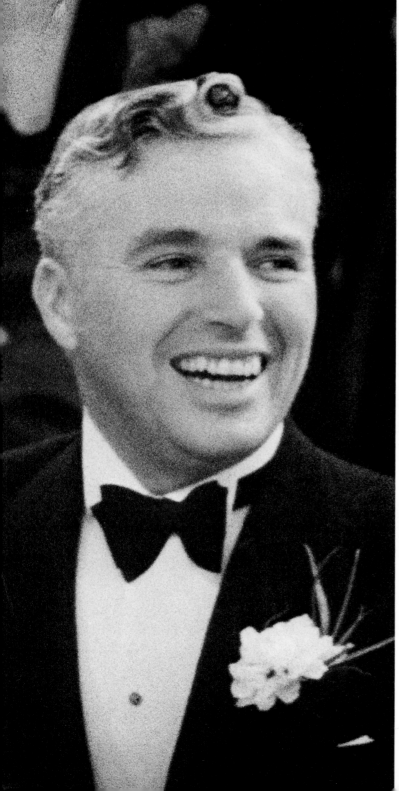

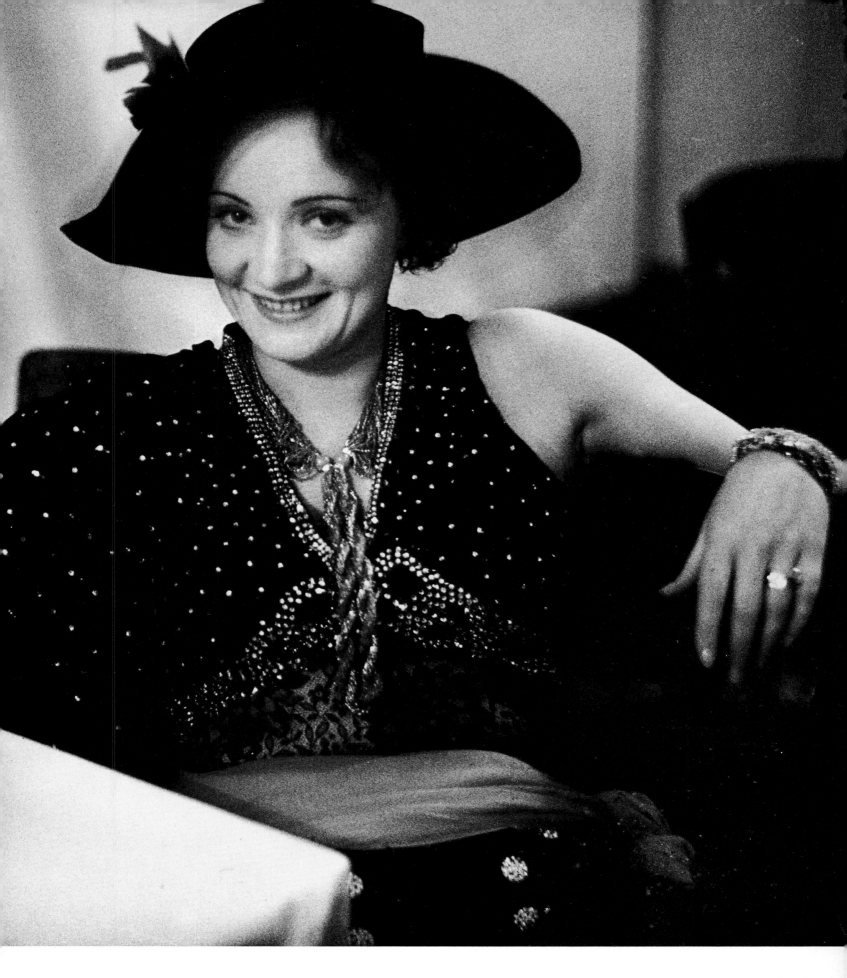

In 1928 Marlene Dietrich, then at the beginning of her movie career, attends an art-school ball in Berlin. Two years later *The Blue Angel* made her an international star.

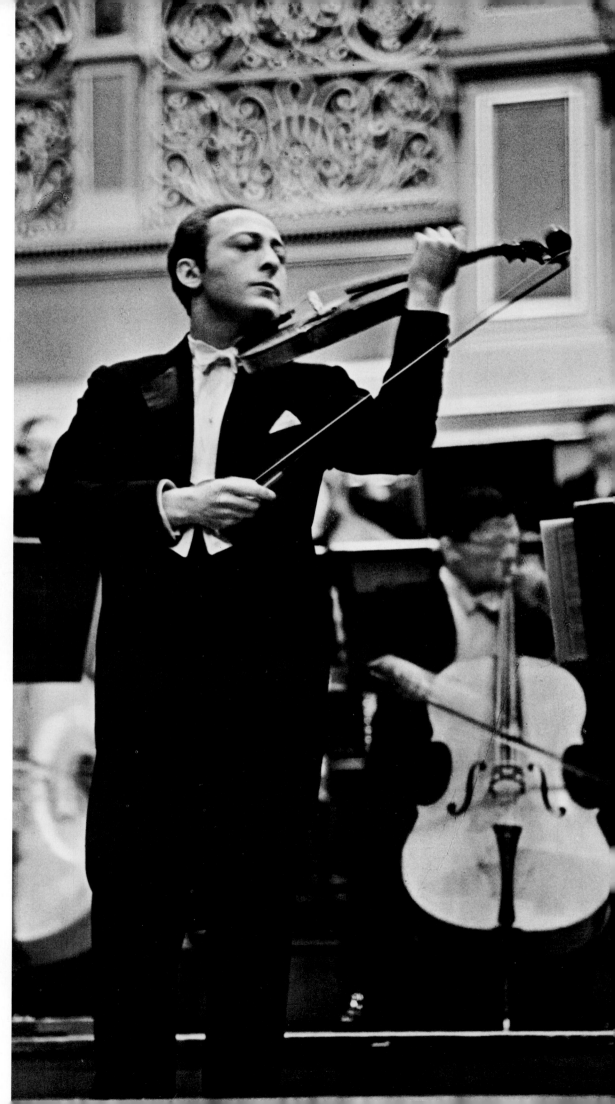

In the early thirties, Berlin Phil-harmonic Hall—where the pictures on these and the following two pages were taken—was a showcase for the greatest musical talent in the world. LEFT: The great Russian basso Feodor Chaliapin sings an aria from his greatest role, Mous-sorgsky's *Boris Godunov*. RIGHT: Jascha Heifetz plays the Beethoven violin concerto. BELOW: Wilhelm Furtwängler conducts the Berlin Philharmonic.

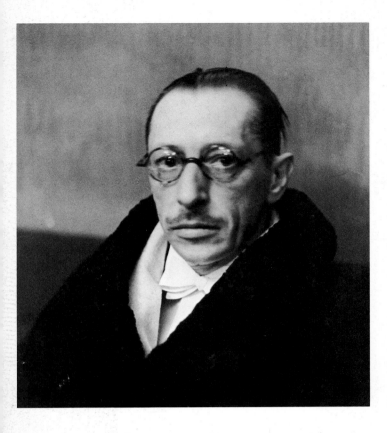

Igor Stravinsky, whose works were booed down as too radical a generation before, was by now accepted as a master.

BELOW: Alfred Cortot, the most famous French pianist of his time for his playing of Chopin.

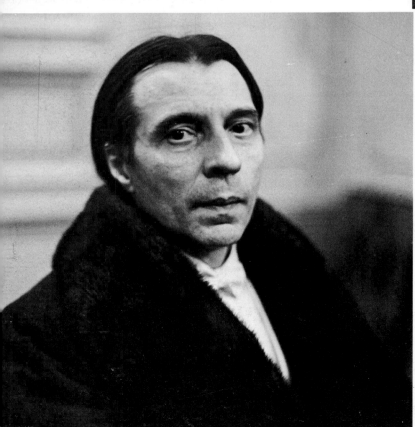

ABOVE: Nathan Milstein, Vladimir Horowitz, and Gregor Piatigorsky relax during intermission after having played a Beethoven trio.

LEFT: Yehudi Menuhin, the child prodigy, at fourteen was a veteran of the international concert scene.

RIGHT: Pianist Composer Sergei Rachmaninoff. FAR RIGHT: conductor Bruno Walter.

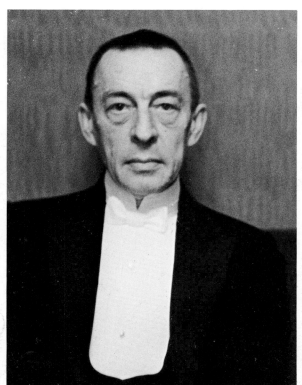

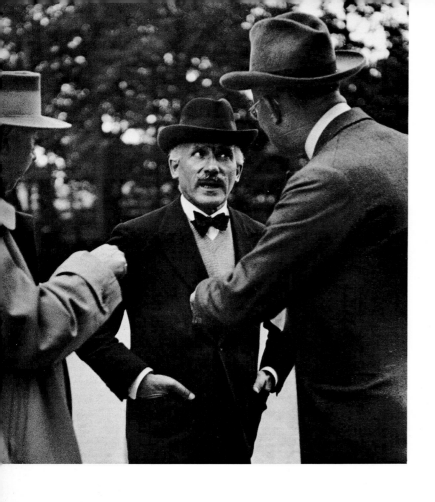

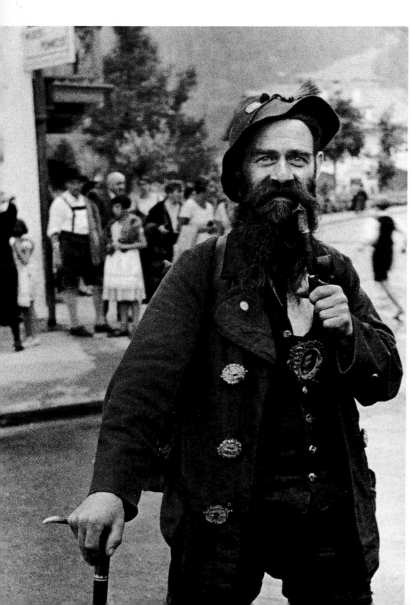

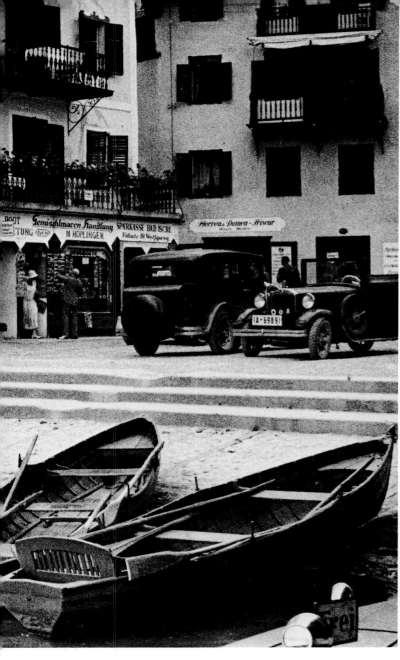

LEFT: The dock of Wolfgangsee, a resort in the Austrian Salzkammergut. FAR LEFT: Arturo Toscanini at Bayreuth.

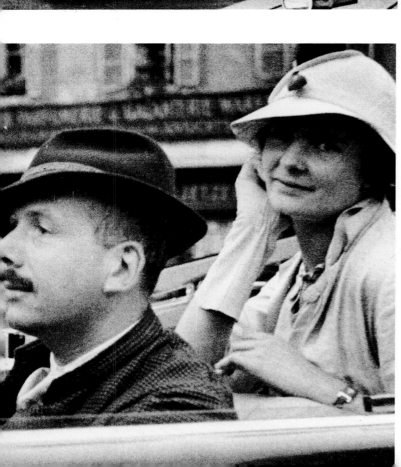

ABOVE: Emil Jannings, one of Germany's greatest actors, plays with his Dachshund on vacation at his estate in Tegernsee. LEFT: Baron Erich von Goldschmidt-Rothschild takes his wife and friend for a drive in Salzburg. FAR LEFT: A Wolfgangsee citizen with his porcelain-bowl pipe.

In Stockholm in 1929 at the Nobel Prizes ceremony, the German novelist Thomas Mann (extreme right in first row behind speaker) was awarded the prize for literature. He left Germany in 1933 in protest against Hitler. The woman seated behind Mann is Selma Lagerlöf, Swedish novelist who had won a Nobel Prize twenty years earlier.

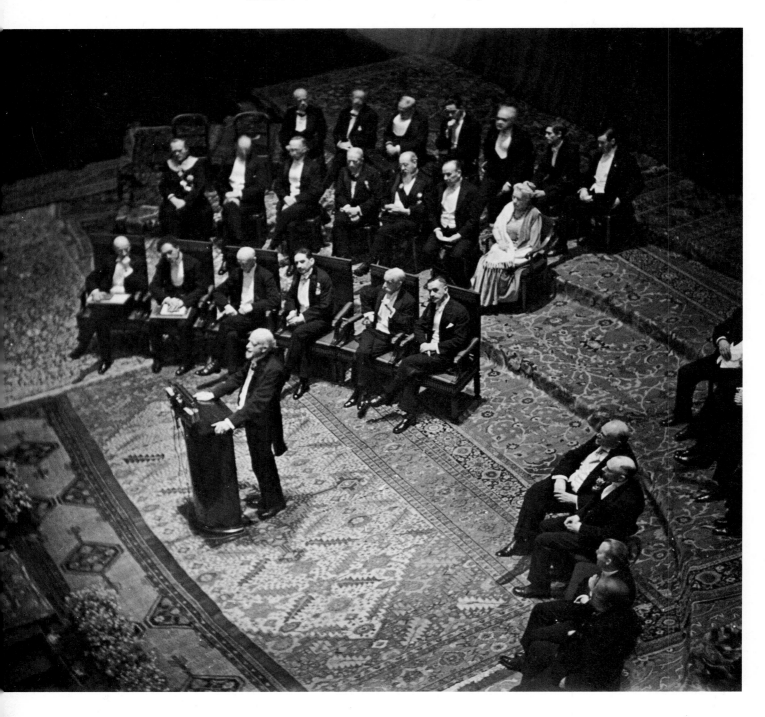

OPPOSITE: At his home in Whitehall Court, London, in 1932 George Bernard Shaw, himself an ardent camera buff, assumed a pose he thought "might be interesting." Shaw, who wrote forty-seven plays between 1893 and 1939, was awarded the Nobel Prize for Literature in 1925.

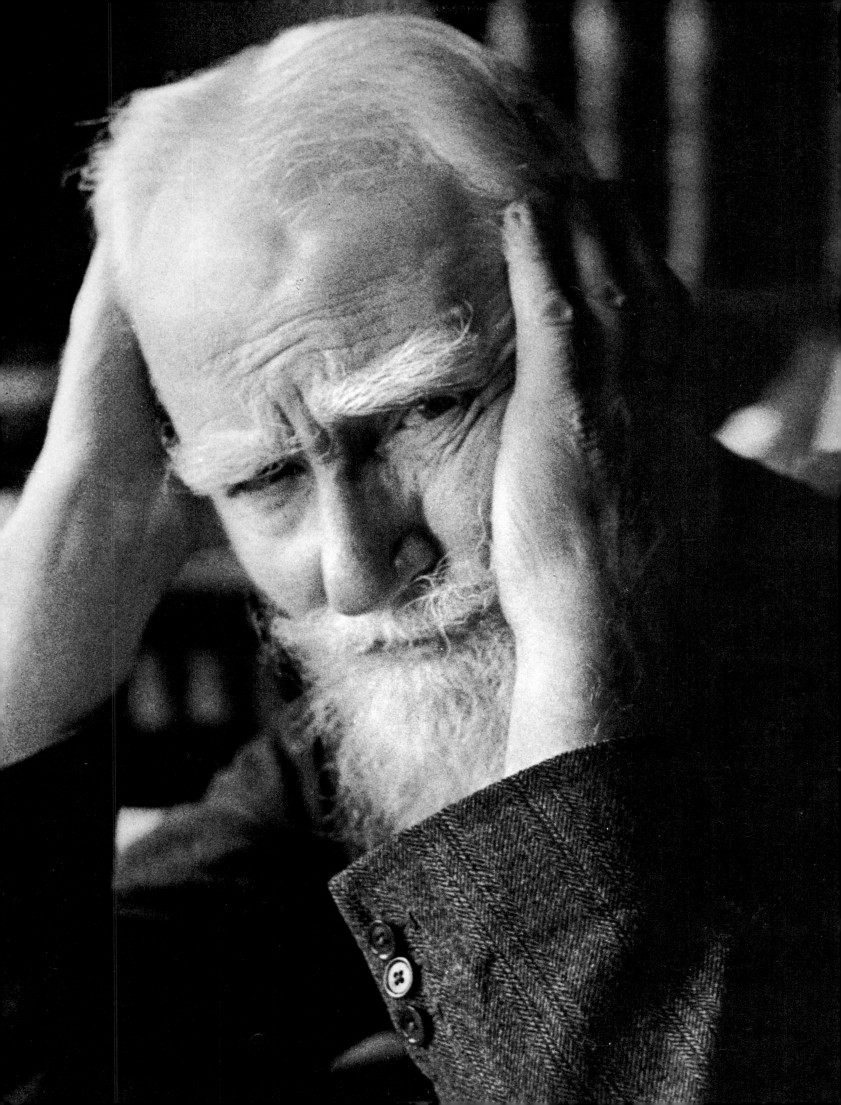

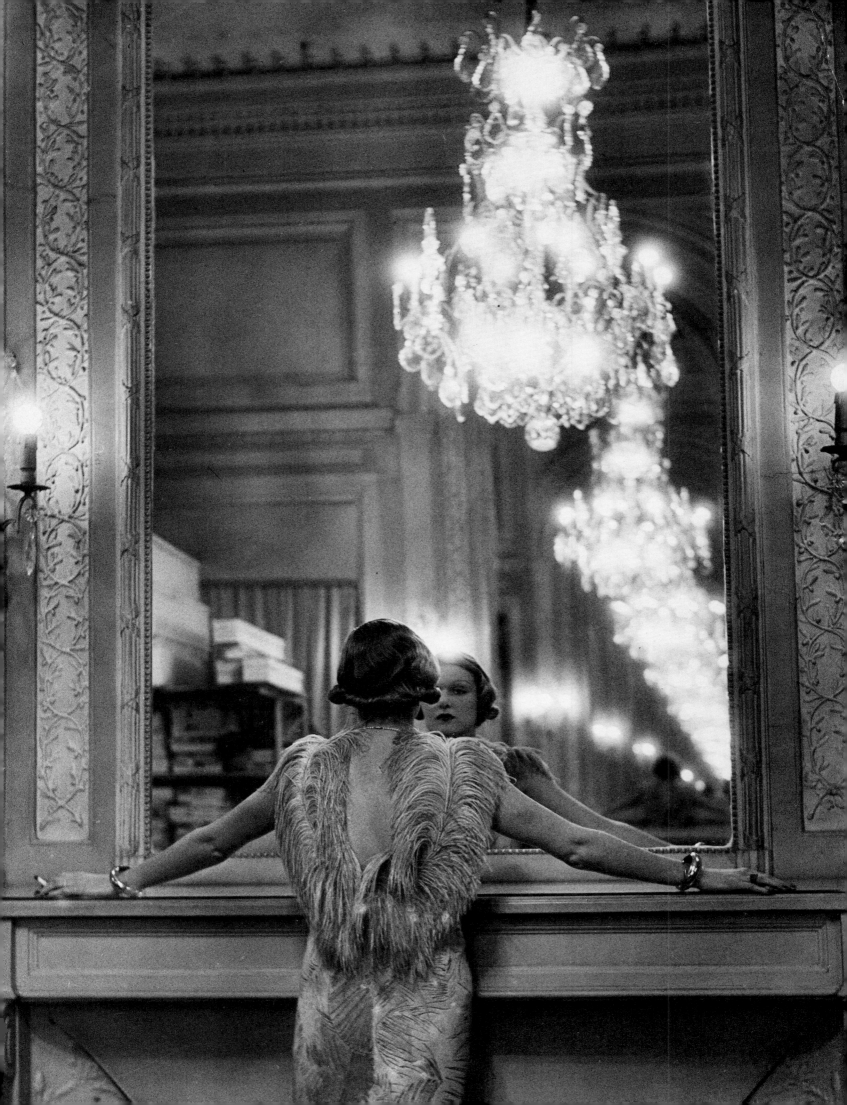

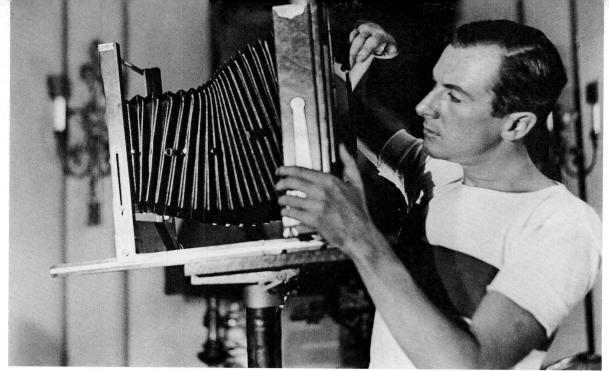

Cecil Beaton, photographer, writer, and designer of costumes and decor for the theater, works in his London studio in 1932.

RIGHT: Elizabeth Arden in 1935 outfits herself for a trip to inspect her European beauty salons.

OPPOSITE: A model shows off her ostrich feathers in the atelier of Molyneux in Paris in 1934.

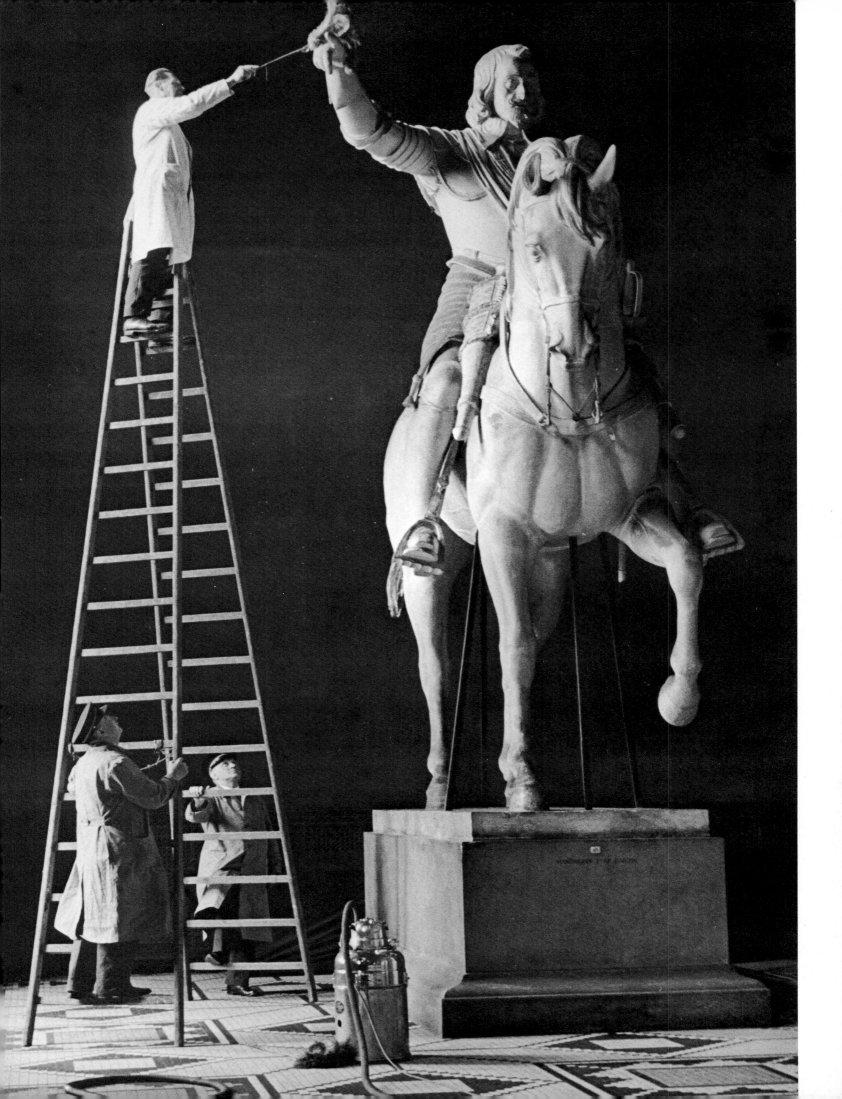

OVERLEAF: King Gustaf V, in his castle in Stockholm in 1934. A redoubtable tennis player right up to his death at the age of ninety-two in 1950, the King sits amid his famous silver collection.

Copenhagen, 1934: America's first lady ambassador, Ruth Bryan Owen (William Jennings Bryan's daughter), was United States envoy to Denmark. OPPOSITE: In the Thorvaldsen Museum workmen dust the statue of Maximilian I, seventeenth-century elector of Bavaria.

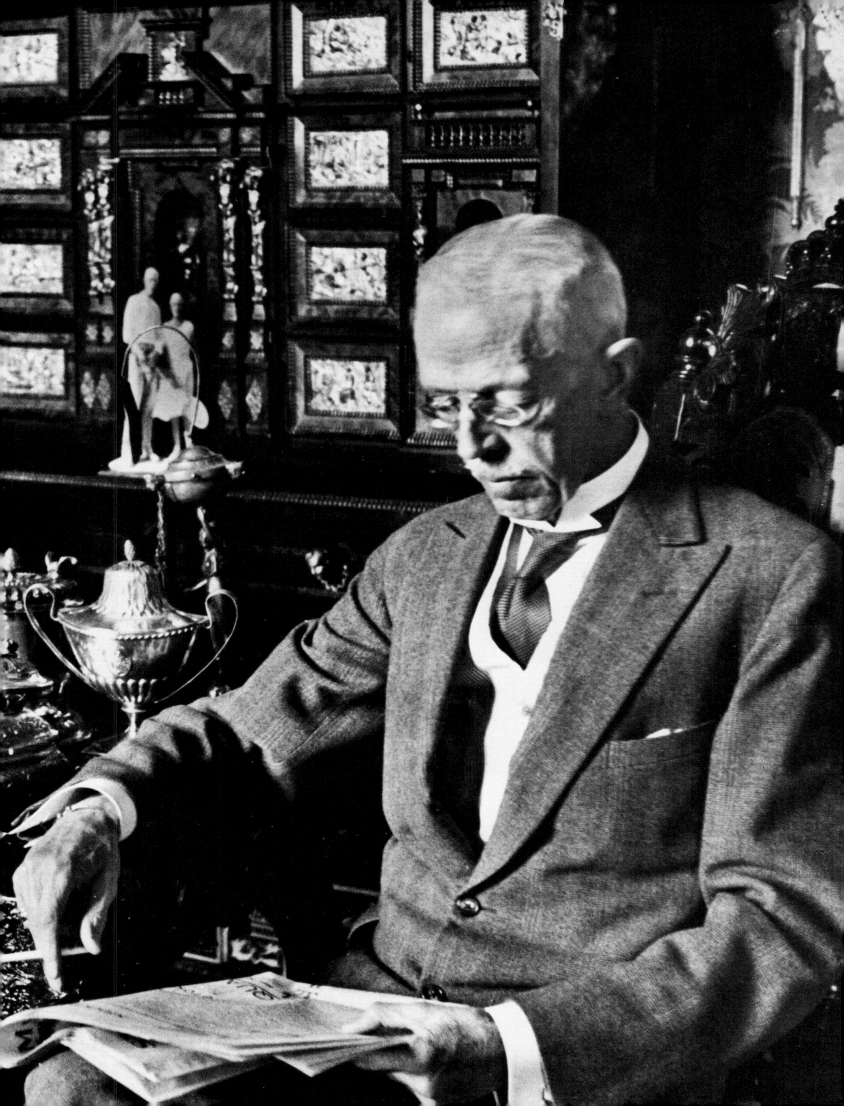

BELOW: Prince Paul of Yugoslavia stands with his wife, Princess Olga, in 1934 in the royal palace at Dedinje, outside Belgrade. The year before, King Alexander of Yugoslavia, on a visit to France, was assassinated in Marseilles—along with French Foreign Minister Louis Barthou—by a Macedonian terrorist. Because Alexander's son Peter was too young to take over, a regency, headed by Alexander's cousin Prince Paul, was set up to rule the country.

Built for the monarchy in 1929, the palace at Dedinje (called the White Palace), with its English-style gardens and reflecting pool, is now the residence of Marshal Tito, President of Yugoslavia.

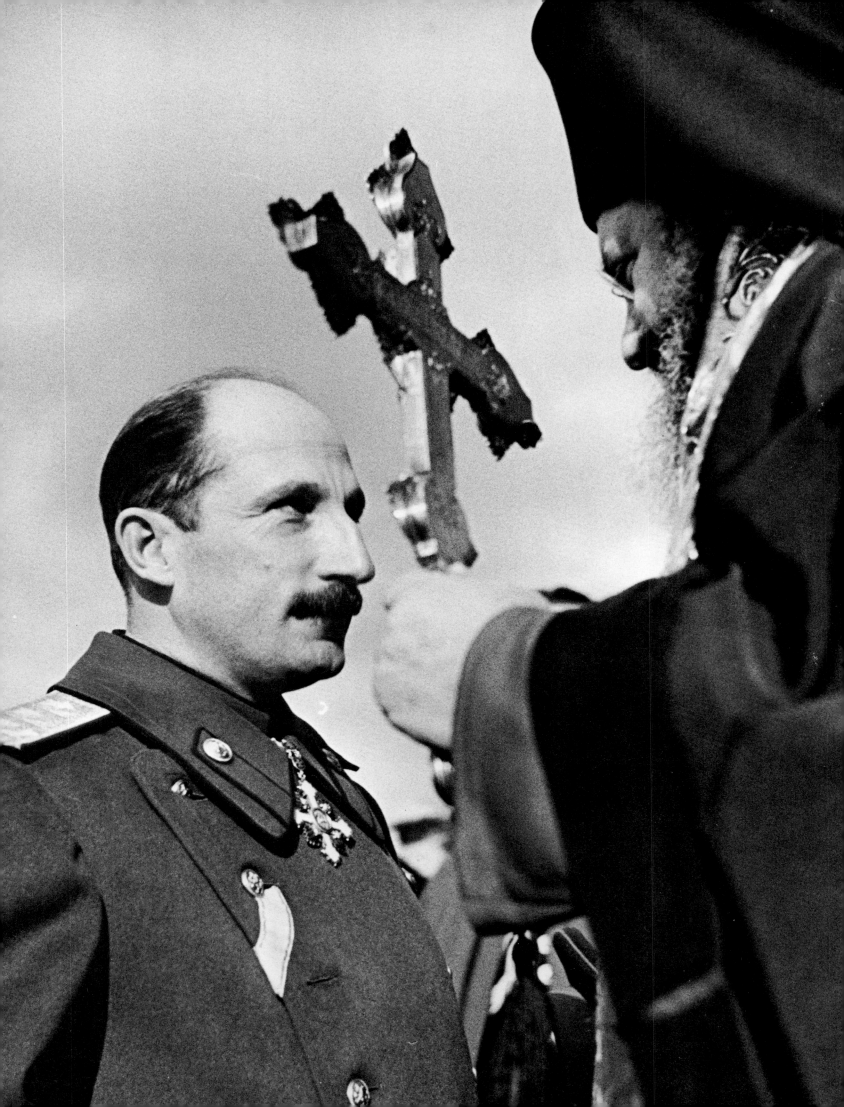

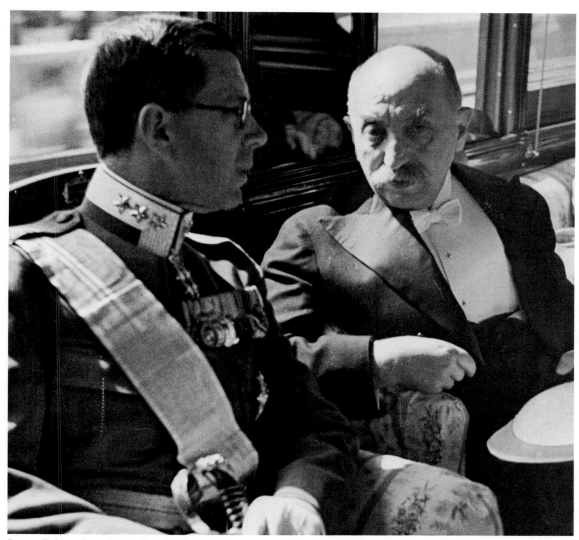

Crown Prince Gustaf Adolf (left) in train traveling to Athens with Greek Prime Minister Panayotis Tsaldaris.

In September 1934 I traveled with Sweden's Crown Prince Gustaf Adolf, his wife, and his daughter Princess Ingrid (who is now Queen of Denmark) on a visit to Greece, Turkey, and Syria. From the port of Salonika, Greece, we went via the royal yacht *Vasaland* through the Dardanelles to Istanbul, and then by rail aboard the Baghdad Express to Ankara to meet Mustapha Kemal Pasha (Atatürk), the first president of the Turkish Republic, which had emerged in 1923 from the wreckage of the prewar Ottoman Empire. To me, at least, the meeting with Kemal was the high point of the trip. Ruthlessly, with a fanatic's vision, he was trying to forge a new, modern Turkey. "*I* am Turkey," he told his people, brutally disposing of all opposition by hanging or exiling members of rival parties. He had outlawed the wearing of the fez ("the fez is a sign of ignorance!"). He had shut down the monasteries and confiscated church property, abolished the harem, made polygamy illegal, advised women to shed their veils, sponsored a new alphabet to eliminate illiteracy, and told the nation it must learn modern dances—he specifically excepted the Charleston and the Black Bottom. He died in 1938, but in his fifteen years of dictatorship he had created a modern Turkey.

OPPOSITE: Boris III, King of Bulgaria from 1918 to his death in 1943, receives a blessing in 1933 from the Archbishop of Sofia.

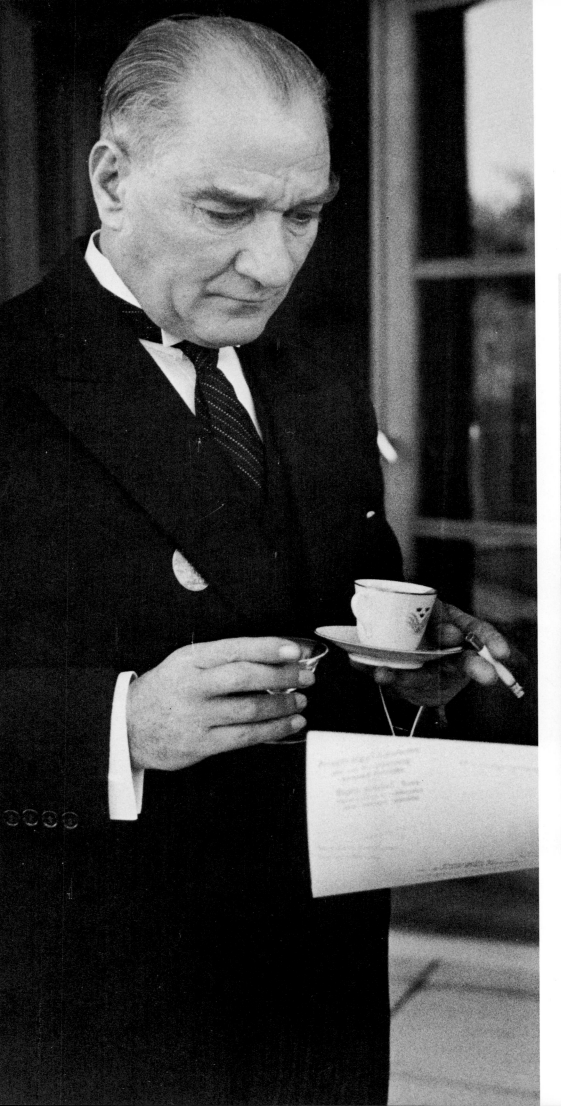

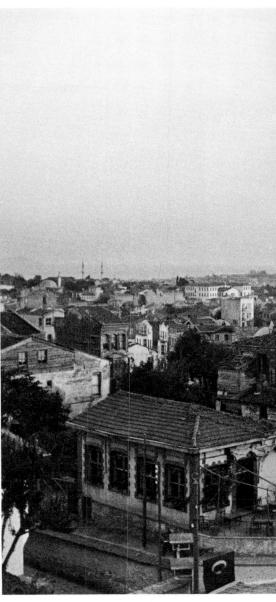

Mustapha Kemal manages to sip coffee, smoke, hold a liquor glass, and look at pictures—all at the same time—at a Swedish Embassy reception.

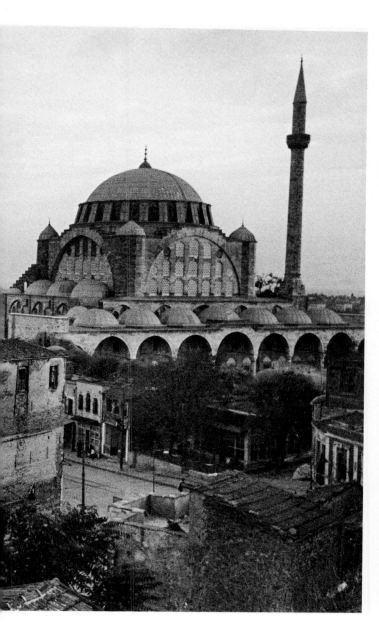

Istanbul, a city of Byzantine mosques. In this picture is the "Blue Mosque" of Sultan Ahmed I, built in the seventeenth century.

Crown Prince Gustaf Adolf in 1934. A man of great culture and learning, with a professional interest in archaeology, he was sixty-seven when he succeeded to the throne of Sweden in 1950.

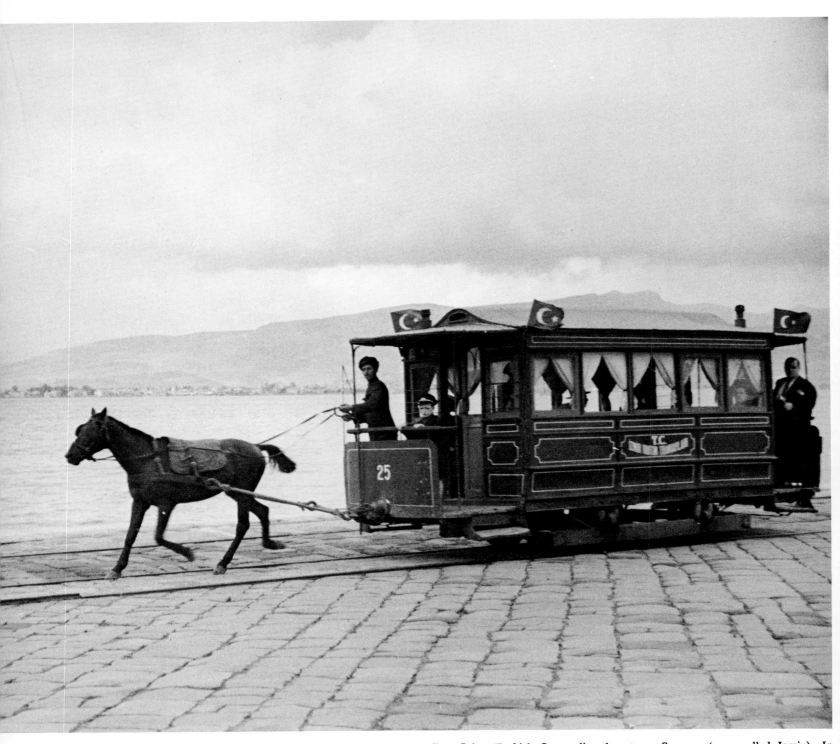

A horse-drawn trolley, flying Turkish flags, plies downtown Smyrna (now called Izmir). In background is the harbor of Izmir Bay. RIGHT: Egyptian fishing boats glide through the Suez Canal, like butterflies in the early morning, en route to Port Said.

OVERLEAF: In the dark bazaars of Aleppo, Syria, Arabs and Bedouins in their flowing robes mill around. The fierce, proud Bedouin face at right looks like a Biblical subject by a master painter.

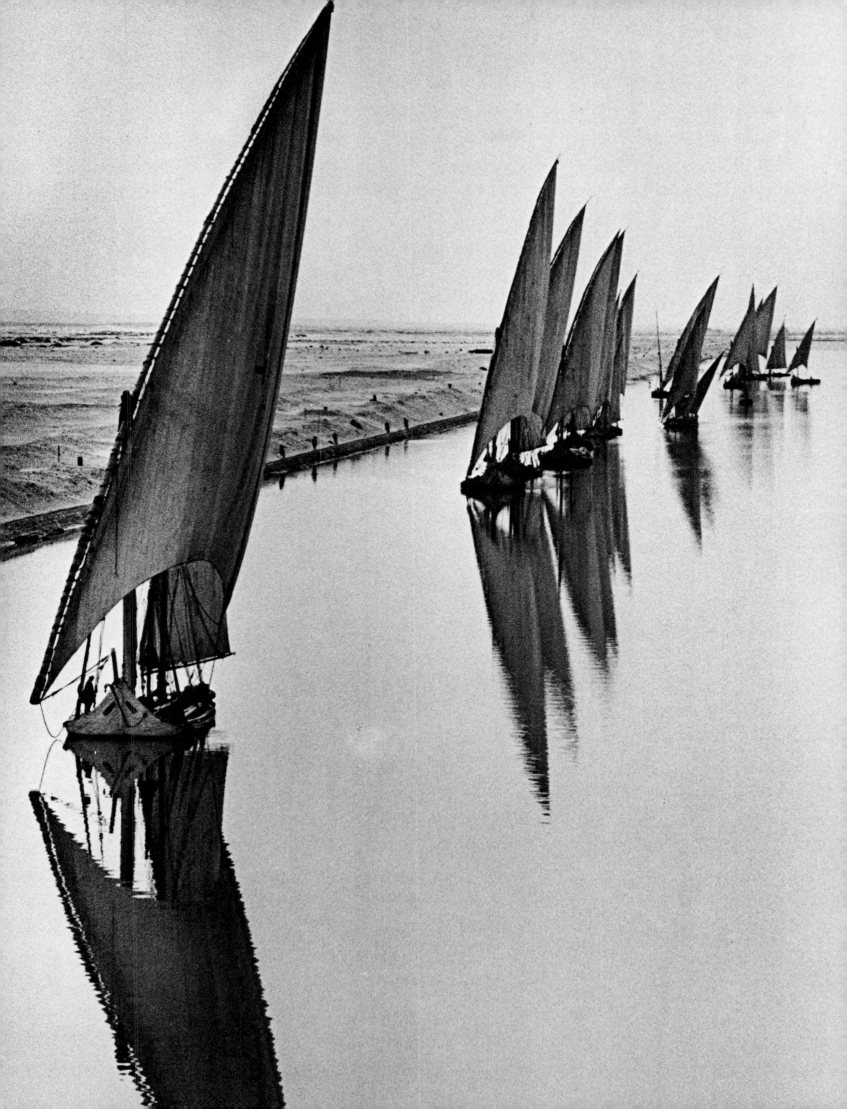

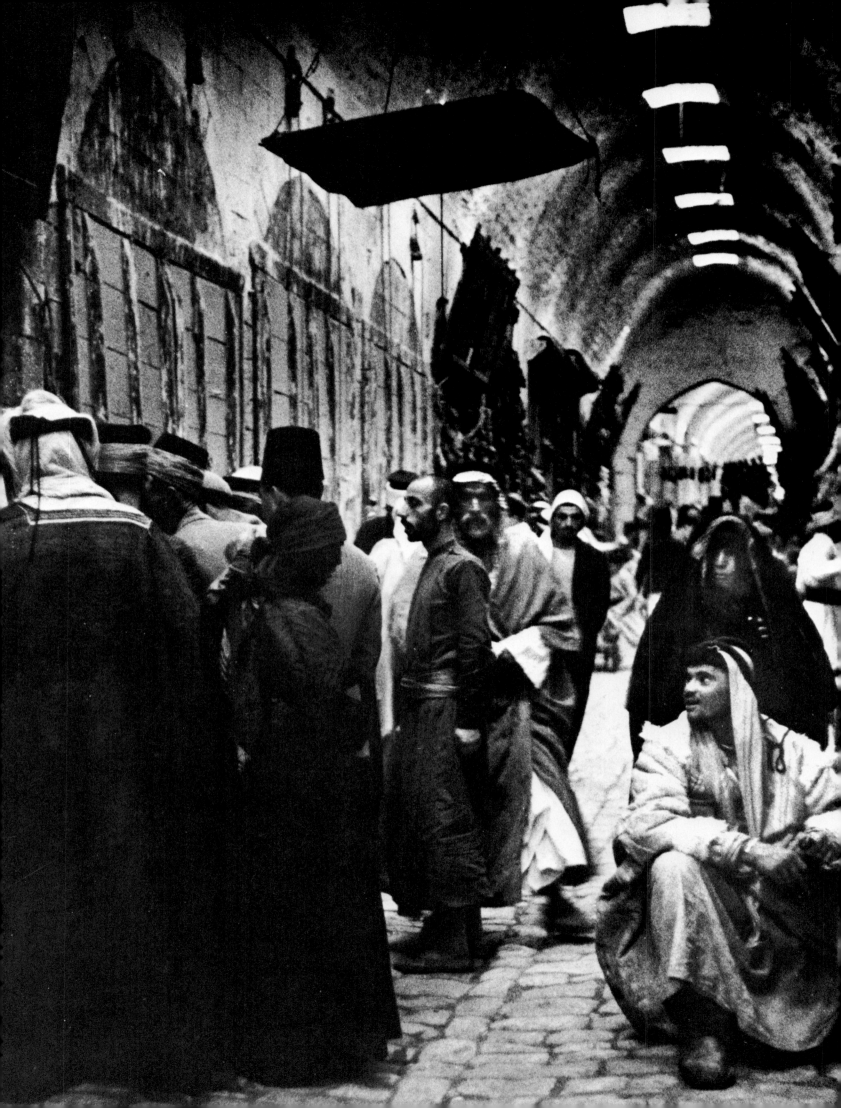

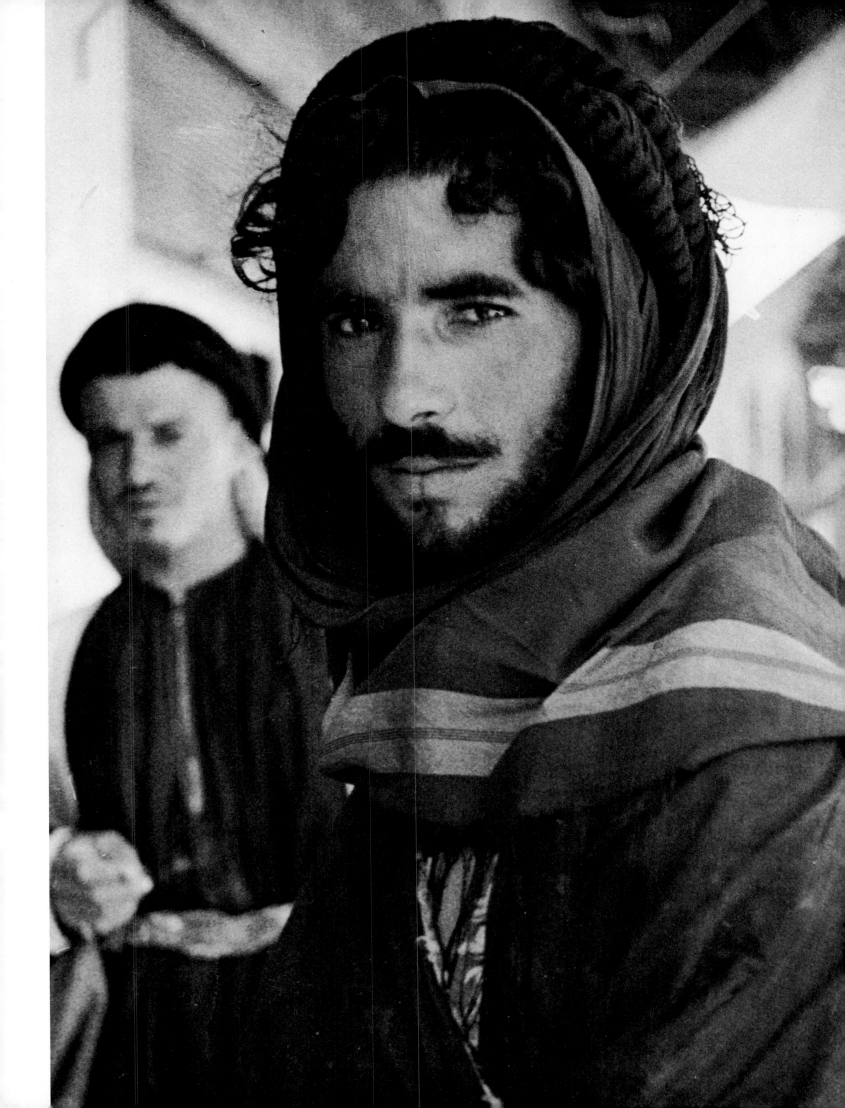

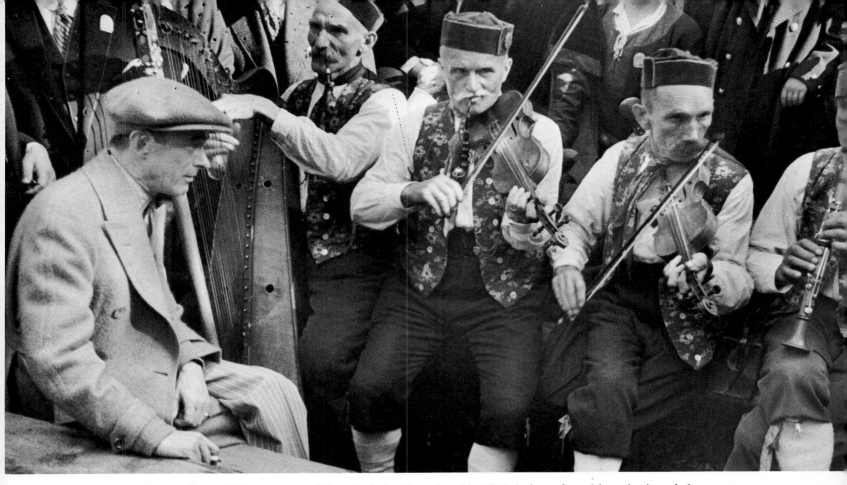

Dapper Jimmy Walker, mayor of New York, hastily resigned in 1932 during a formal investigation of charges of fraud in his administration, and decided to live in Europe. Here, in 1934, he listens to violinists in Bohemia.

OPPOSITE: An officer of the Greek *evzone,* an elite guard regiment, searches for a tasseled fez to top off his uniform. The uniform derives from that worn by Greek patriots who fought the Turks in the nineteenth century to win their independence.

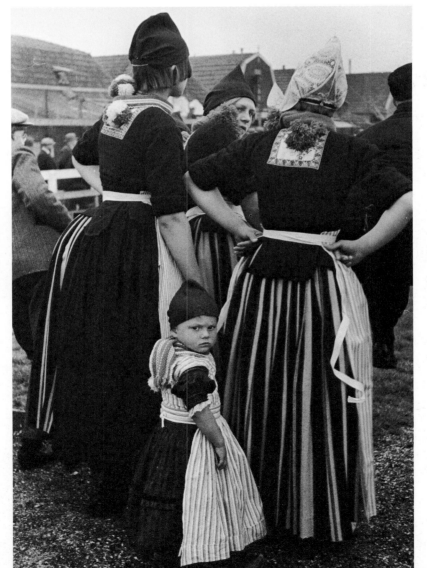

In Volendam, Holland, in 1933 women whose traditional dress—pointed black, or lace-winged caps, pleated black skirts—is still worn today, turn out for a soccer match played against a team from Edam, the home of the famous cheese.

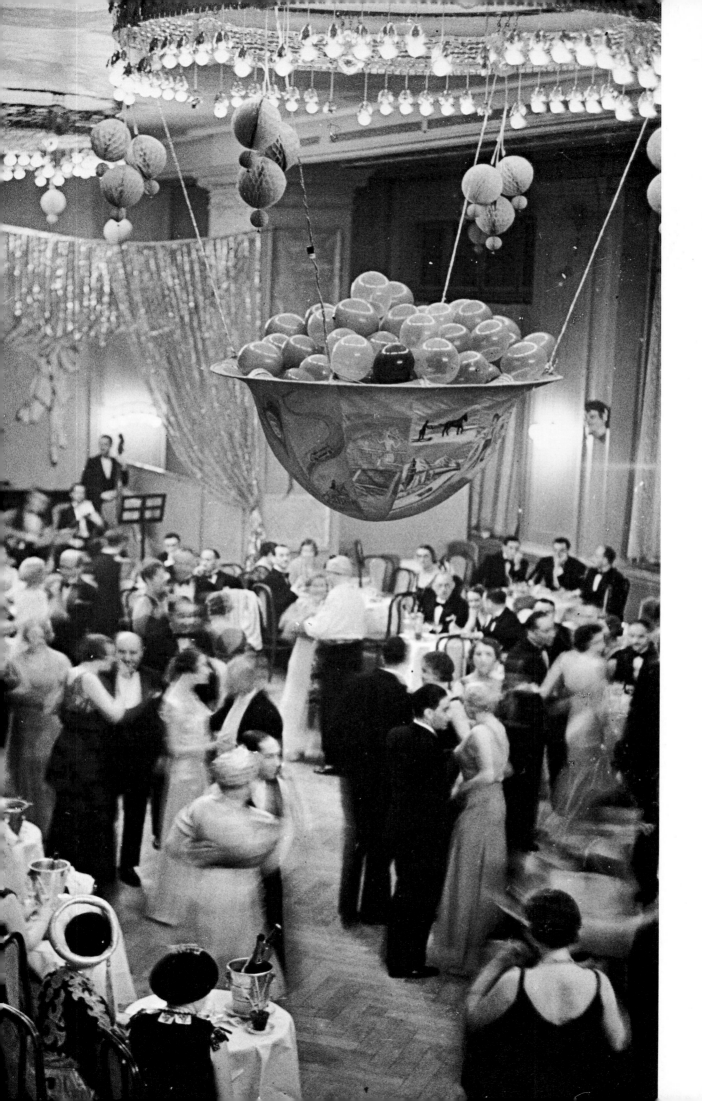

St. Moritz, 1930—a swinging place. ABOVE: A fundraising fashion show at
the Palace Hotel. LEFT: A
gala evening at the Grand
Hotel. ABOVE, RIGHT:
Waiter at the Grand bringing a glass of soda for an
English boy.

RIGHT: Gloria Swanson
and her fourth husband,
Michael Farmer, at the
Palace Hotel fashion show
and ball. Gloria, a former
Mack Sennett bathing
beauty (whose real name
was Swenson), was the symbol of Hollywood glamour.

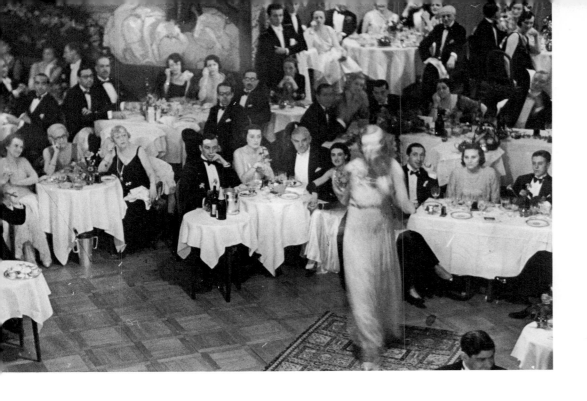

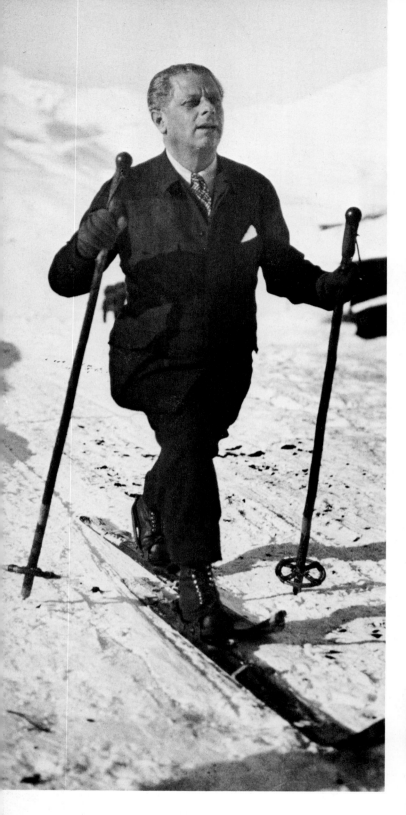

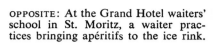

OPPOSITE: At the Grand Hotel waiters' school in St. Moritz, a waiter practices bringing apéritifs to the ice rink.

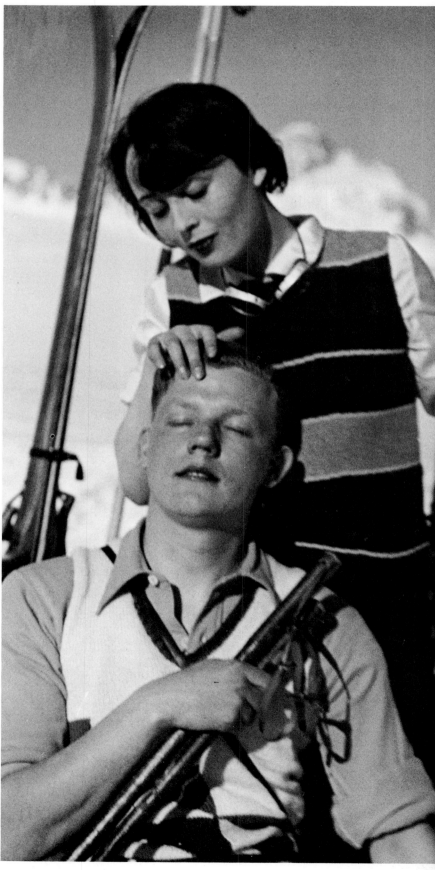

ABOVE: Max Reinhardt, the great Austrian director, plows down a ski slope in Arosa, Switzerland, in 1933. RIGHT: Luise Rainer, Viennese movie star who won two Oscars in the 1930s, soothes the sunburned brow of a friend at St. Moritz.

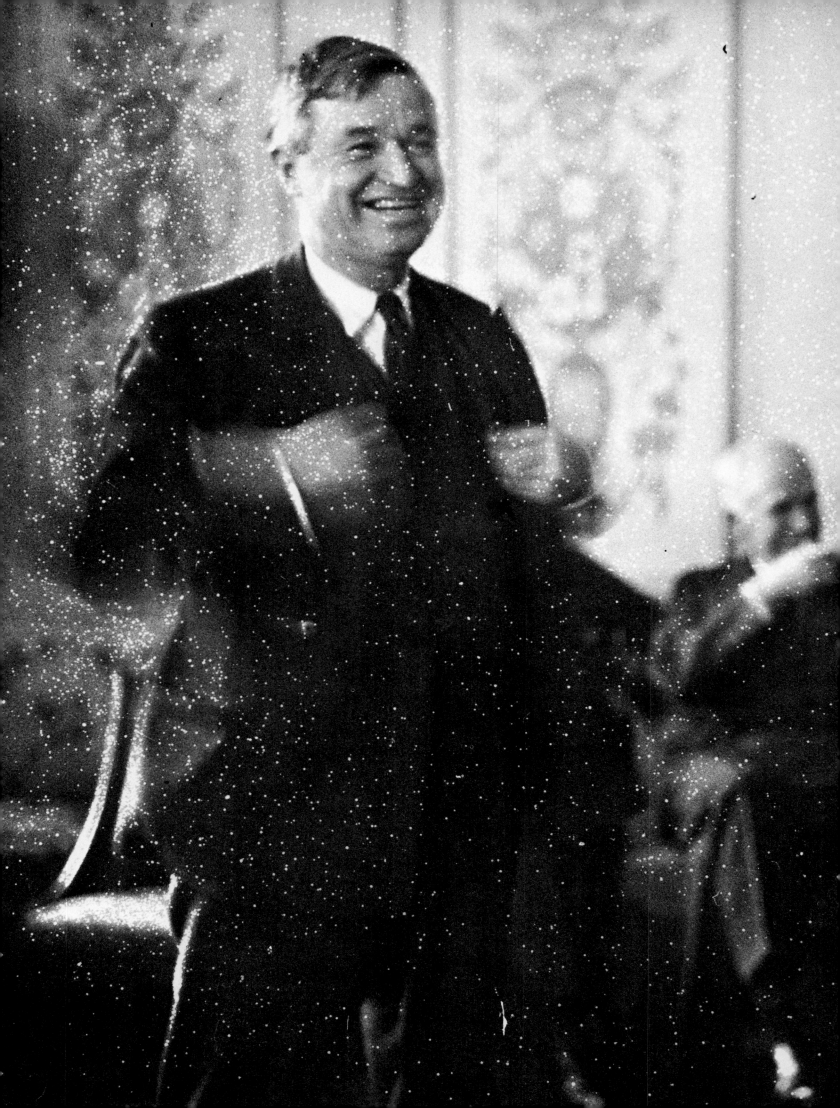

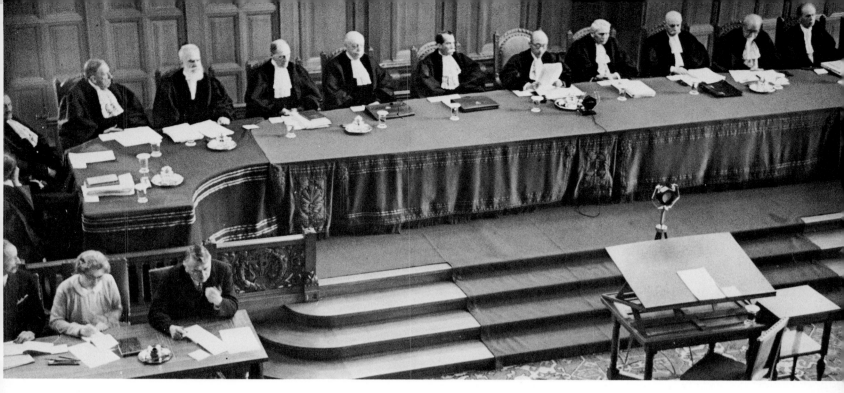

The World Court, set up by the League of Nations, met in The Hague in 1930. Fourth from right is United States Secretary of State Frank Kellogg.

The Search for Peace

Will Rogers, America's cowboy-philosopher, showed up in February 1932 at the Disarmament Conference in Geneva, where diplomats, desperately trying to find a formula for peace, were having their troubles. "There is a lot of nations here willing to throw away two spears and a shield for every battleship we sink," Rogers wrote in his newspaper column. ". . . The conference is off to a flying start. There is nothing to prevent their succeeding now but human nature . . ."

President Wilson's plea for "open covenants . . . openly arrived at" had inaugurated the era of "pactomania." The basic problem was how to reconcile France's desire for security against a re-emerging Germany with Germany's own pressing demands to get out from under what she regarded as an onerous, demeaning Treaty of Versailles. Heads of government and foreign ministers gathered in the capitals of the world for what seemed an endless round of international conferences. For more than ten years they wrestled with problems of German reparations and World War I debts; limitations in the building of battleships and other modest disarmament measures; with the French occupation of the Rhineland. The League of Nations had some minor successes on European matters but its influence on the international scene collapsed when Japan marched into Manchuria in 1931.

How grand an illusion the search for peace had become was strikingly illustrated by the Pact of Paris of 1928—called the Kellogg-Briand Pact after its sponsors, United States Secretary of State Frank Kellogg and French Foreign Minister Aristide Briand. The pact renounced aggressive war as an instrument of national policy, and sixty-two nations ultimately ratified it—including Germany and Italy.

ll Rogers, 1932.

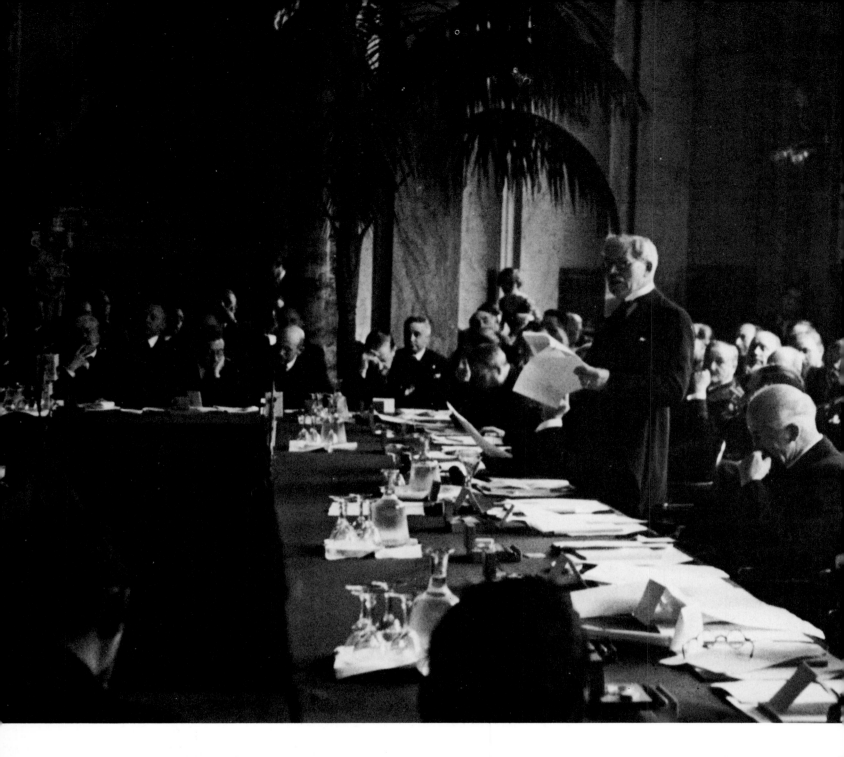

ABOVE: Britain's Prime Minister Ramsay MacDonald spoke at the Lausanne Conference on reparations in June 1932. Its decisions were not ratified by the United States and the following year both war debts and reparations became dead issues.

RIGHT: At The Hague in 1930 German Minister for Occupied Provinces Karl Joseph Wirth and French Foreign Minister Briand toasted an agreement providing for the early evacuation of French troops from the Rhineland. Briand, a leading advocate of international peace, won the 1926 Nobel Peace Prize.

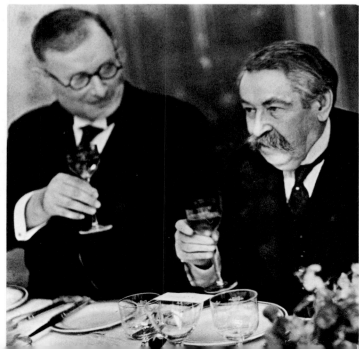

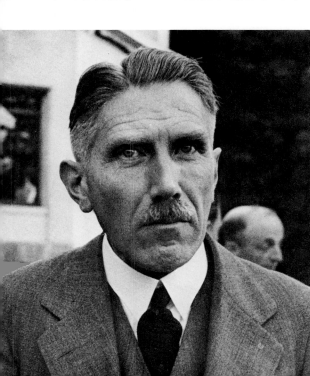

French Premier Edouard Herriot in the garden of the Beau Rivage Hotel between sessions of the Lausanne Reparations Conference. BOTTOM LEFT: German Chancellor Franz von Papen at Lausanne.

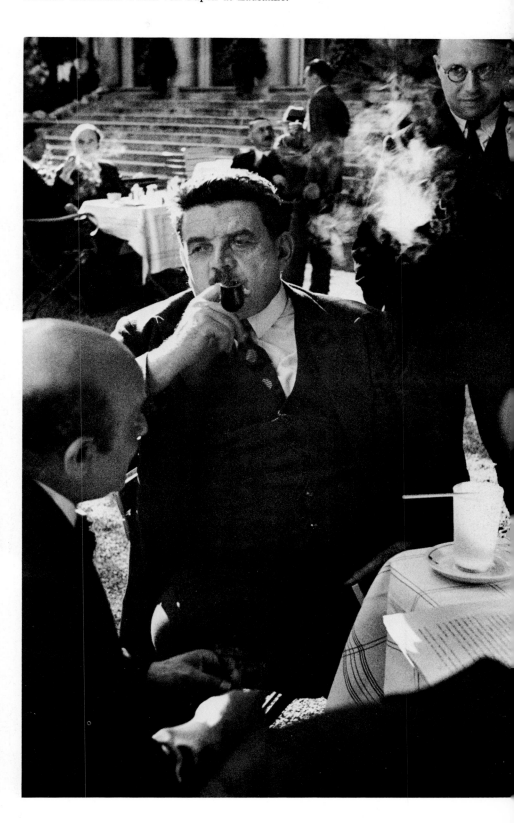

59

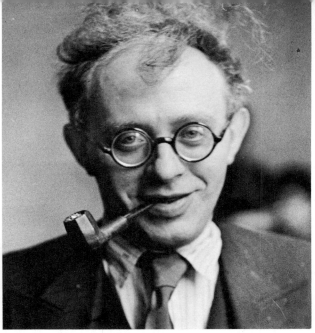

RIGHT: Karl Radek, Russian delegate at 1932 Geneva Disarmament Conference. In Stalin's purge of the Communist Party later, Radek was convicted of treason, and is believed to have died in prison.

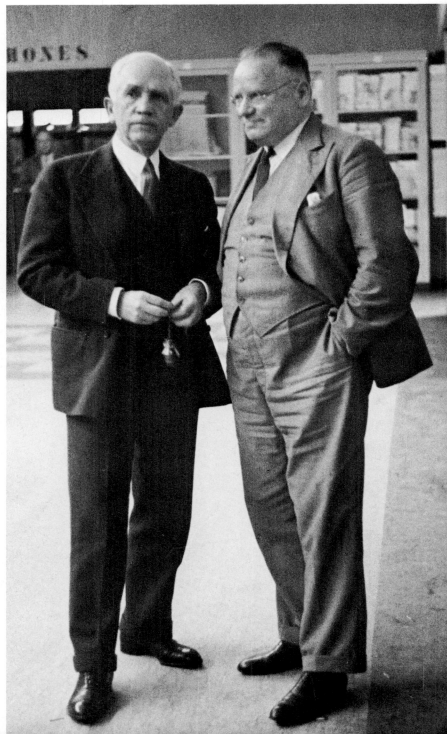

ABOVE: At the Disarmament Conference in Geneva, May 1934, Britain's Anthony Eden talks with Polish Foreign Secretary Colonel Josef Beck (center) and Italy's Baron Pompeo Aloisi. RIGHT: United States Ambassador-at-Large Norman H. Davis and Russia's Foreign Minister Maxim Litvinov (hands in pockets) in the corridors, between sessions of the conference.

OPPOSITE: French Foreign Minister Louis Barthou (bearded) jokes with Spain's delegate Salvador de Madariaga at the League of Nations session in 1933. Barthou was assassinated the following year in Marseilles while welcoming the King of Yugoslavia.

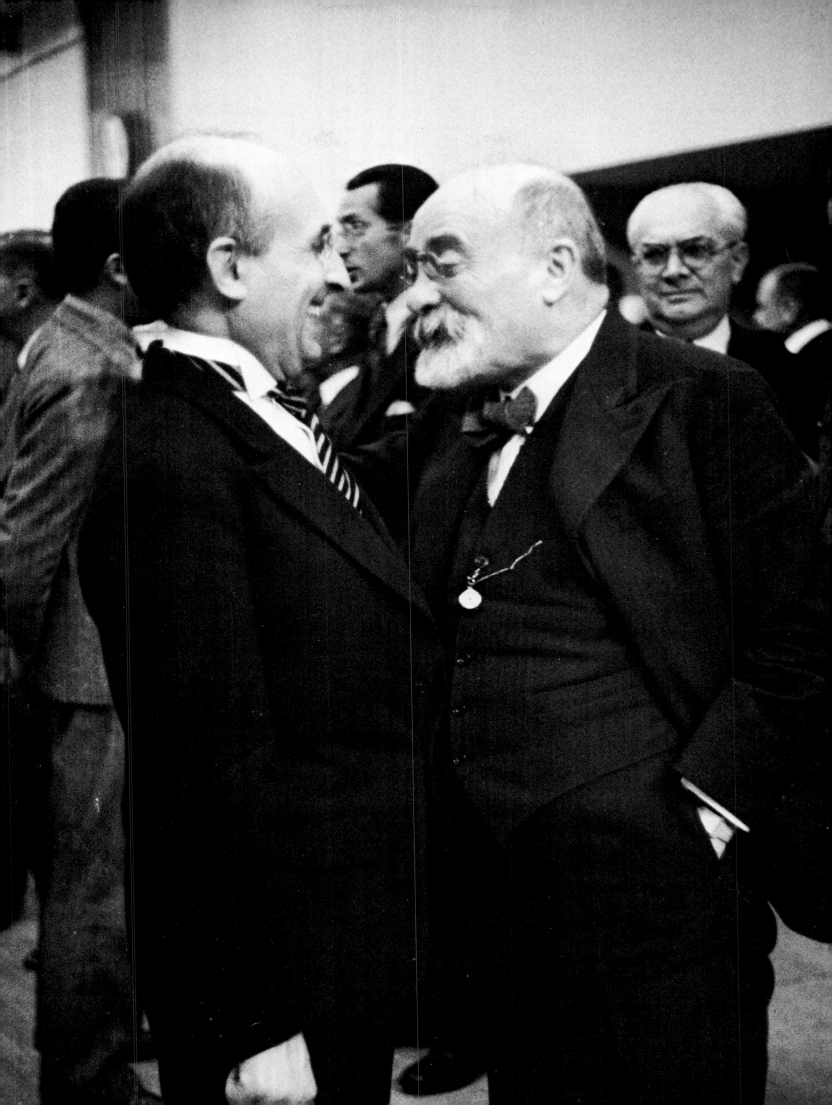

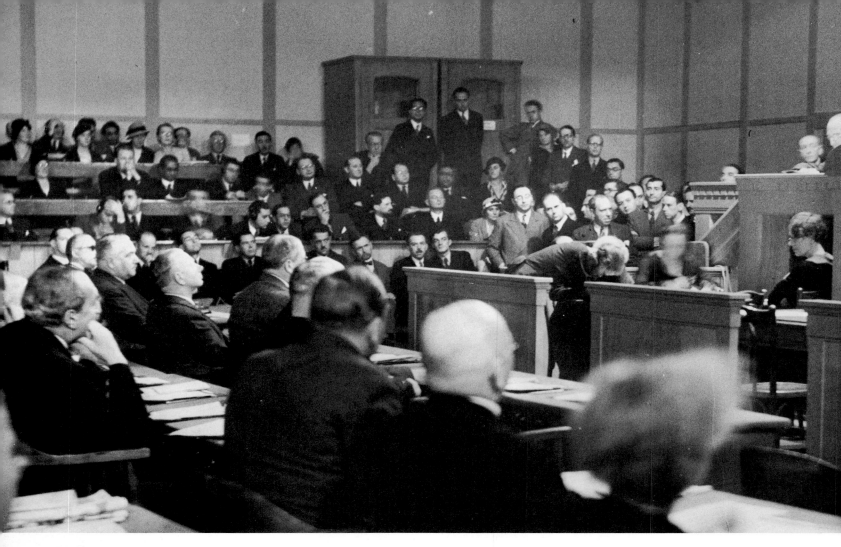

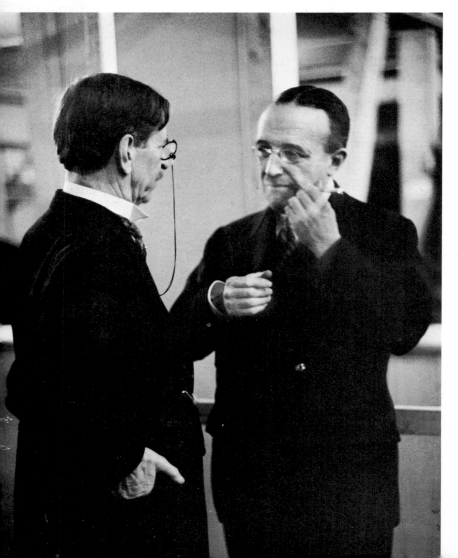

ABOVE: Austrian Chancellor Engelbert Dollfuss addresses the League of Nations assembly in September 1933. He was murdered by the Nazis in 1934. LEFT: United States Secretary of the Navy Claude Swanson talks with French Foreign Minister André Tardieu at Disarmament Conference, Geneva, 1932. RIGHT: British Foreign Secretary Sir John Simon (hand on hip) listens to United States delegate Norman H. Davis at Disarmament Conference.

FAR RIGHT: Dr. Joseph Goebbels' first trip abroad as Hitler's Minister of Culture and Propaganda was to attend the September 1933 session of the League of Nations. He sits glowering in the garden of the Carlton Hotel in Geneva, as Hitler's chief interpreter, Dr. Paul Schmidt, hands him a note.

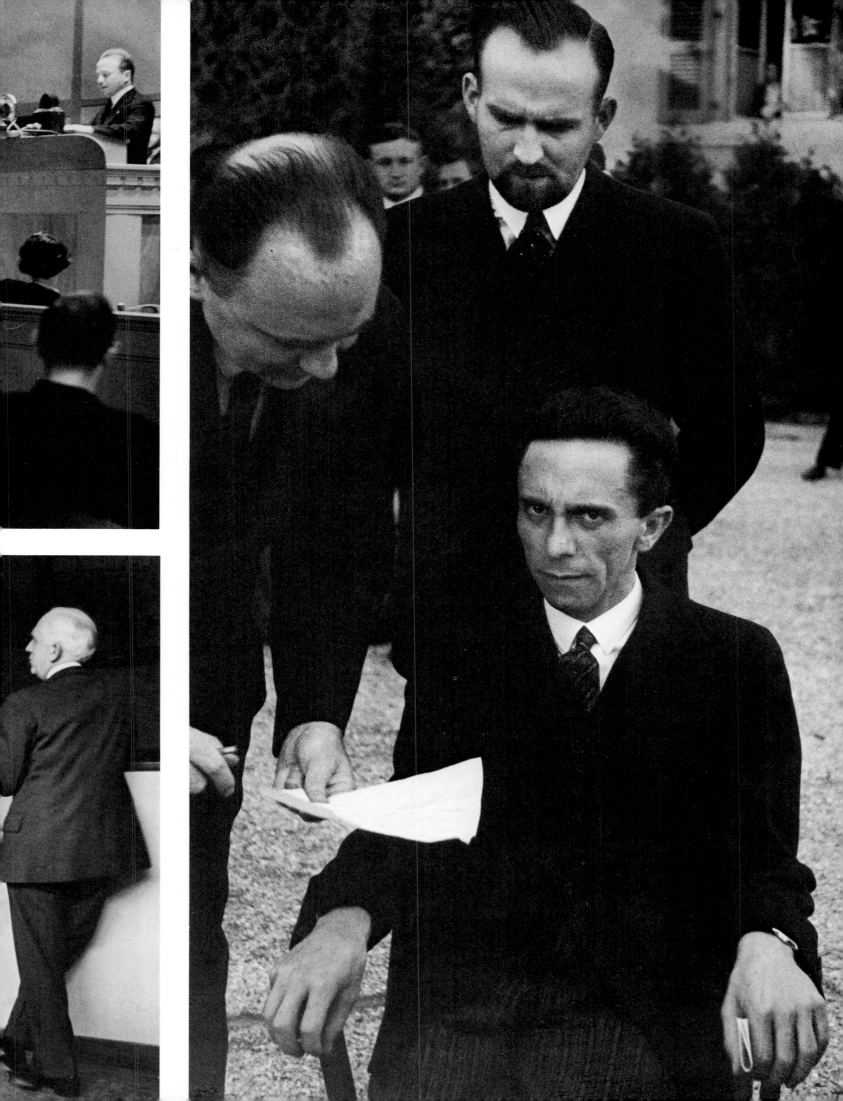

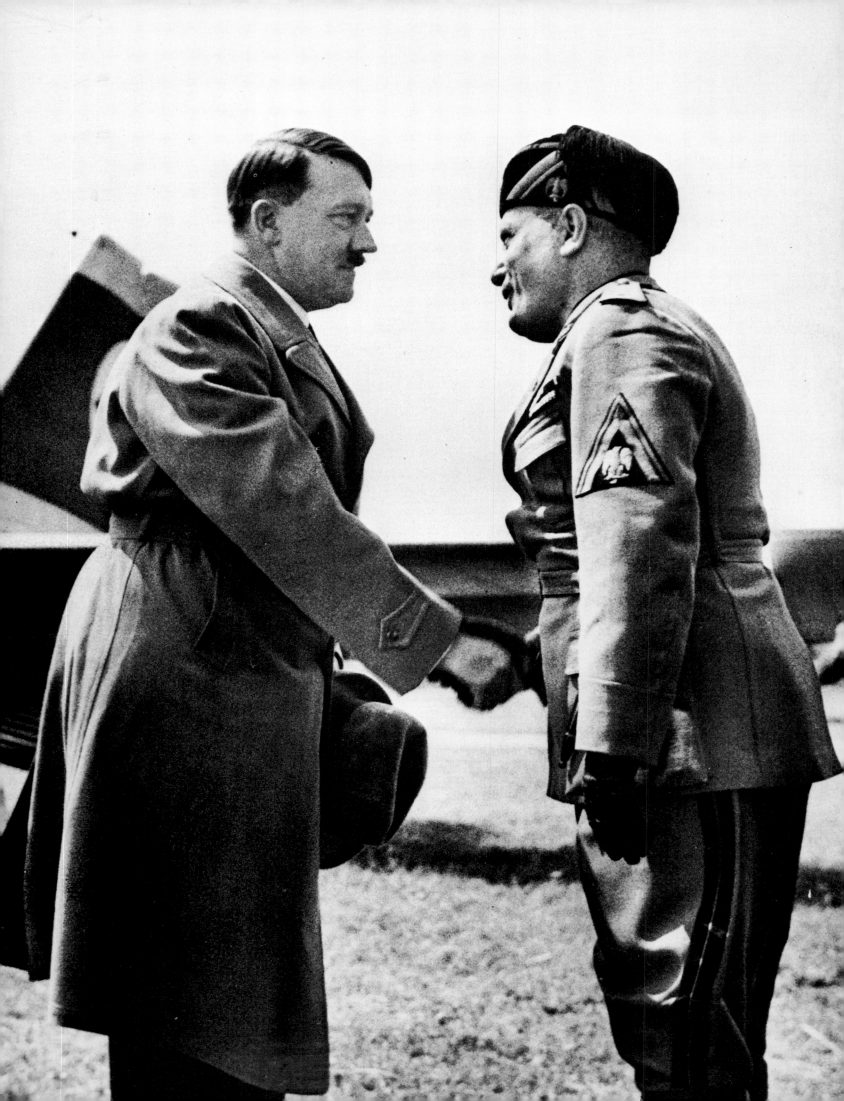

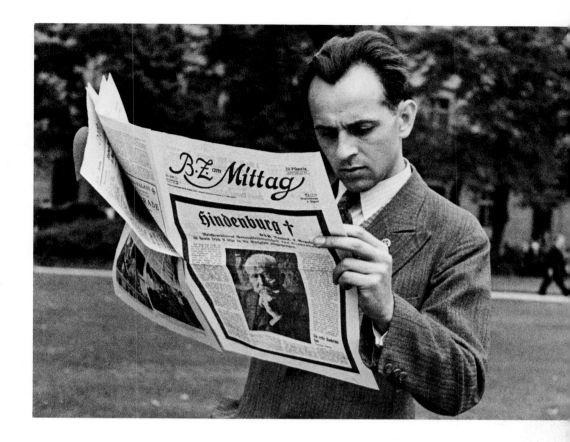

A worried Berliner reads of the death, August 2, 1934, of President Hindenburg, aged eighty-seven. The next day Hitler proclaimed himself both President and Chancellor and the Army swore an oath of unconditional obedience to him personally.

The Rise of the Dictators

Der Führer and Il Duce met for the first time June 13, 1934, in Venice. Mussolini strutted like a peacock in his resplendent fascist uniform. Hitler, on his first visit outside Germany, wore a badly fitting suit and a shabby yellow raincoat. He was awkward and, it seemed to me, ill at ease in the presence of a man who immediately made it clear that he was the senior dictator—by ten years.

Mussolini talked big to impress his guest and the watching world. "We will defend our patrimony by persuasion if possible," he said in his principal public speech during Hitler's visit, "otherwise with the song of our machine-guns." Like so many others, he underestimated the power of both Hitler and his teachings. The death of Germany's President Hindenburg, two months after the visit, changed many people's minds about Der Führer.

But the meeting between the two men was something of a diplomatic fiasco. Hitler had come to get Mussolini's agreement to Germany's *Anschluss* with Austria; Mussolini rejected a German takeover, agreed only that Austrian Nazis should perhaps be permitted to enter the Austrian government. Despite this temporary setback, Hitler was quite taken with Mussolini personally. "The people stand bowed in humility before him, as before a Pope," he reported afterward, "and he strikes the Caesarean pose necessary for Italy." Mussolini's reaction to Hitler, however, was distinctly unfavorable: "Instead of speaking . . . about current problems, he recited me *Mein Kampf,* that boring book which I have never been able to read." It was three years before the dictators got together again.

OPPOSITE: Hitler and Mussolini greet each other for the first time.

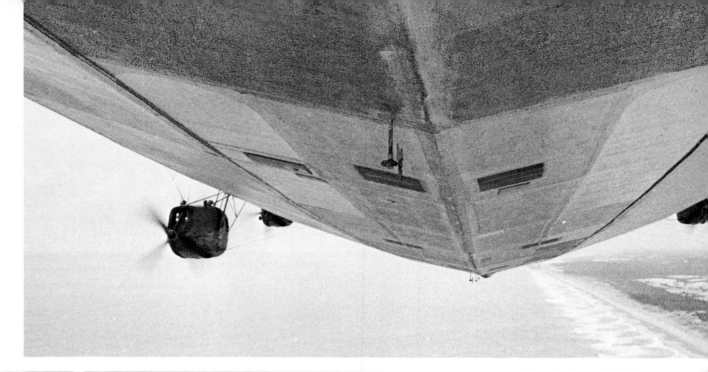

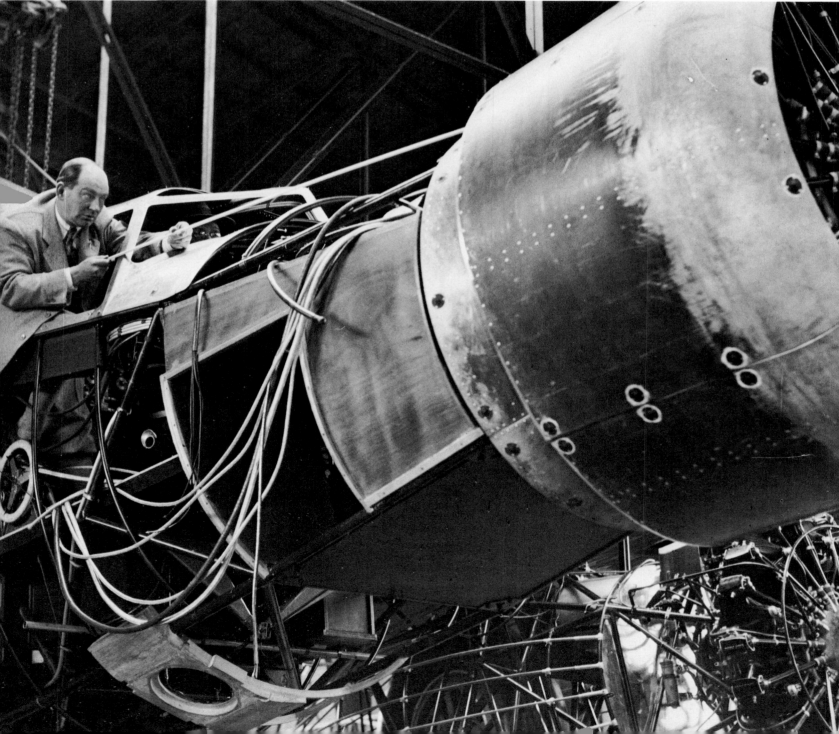

LEFT: The *Graf Zeppelin*. In August 1933, with a big black swastika painted on its side, the giant airship flew from Friedrichshafen, Germany, to Rio de Janeiro, Brazil, solely to pick up Hugo Eckener, who was there negotiating to extend transatlantic flights that had begun three months earlier. Captain of the airship was the man who later was in command of the *Hindenburg* when it crashed upon landing in Lakehurst, New Jersey, May 6, 1937.

BELOW: An engineer climbs into the hull of the dirigible. OPPOSITE, BELOW: Antony Fokker, Dutch designer and builder of the combat planes Germany flew in World War I, inspects a new plane in his factory in Amsterdam in 1933. When the Nazis invaded the Netherlands in May 1940, they took over the Fokker Works for repairing their aircraft.

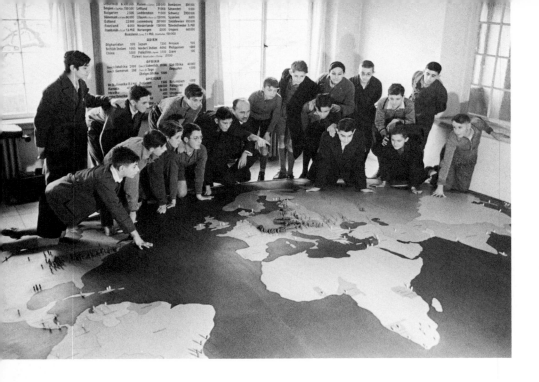

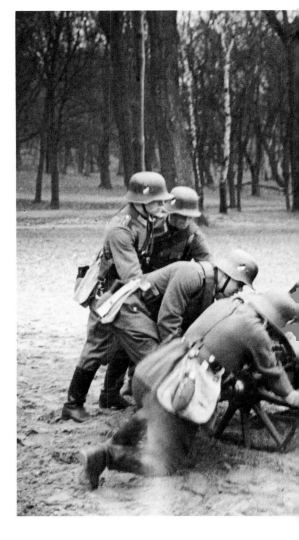

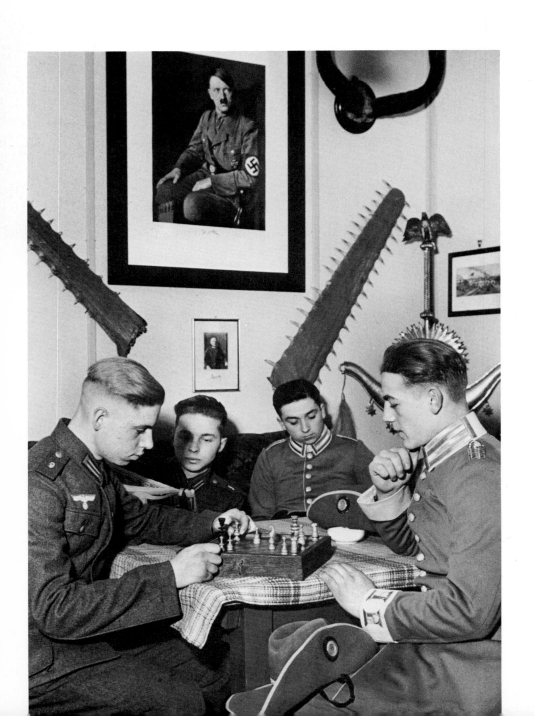

TOP LEFT: Young Nazis at the Stuttgart Institute for Germanism Abroad study a map charting the huge colonial empire—1,760,000 square miles—the Reich lost in World War I. Under the Treaty of Versailles, Germany was deprived of her navy and limited to a volunteer army of 100,000 men, but Hitler got around the restrictions. ABOVE: Cadets of the Ninth Infantry Regiment at Potsdam train with a dummy mine-thrower. OPPOSITE, ABOVE: They aim a dummy machine gun at a dummy plane sliding along a wire. LEFT: Cadets of the Ninth Infantry Regiment play chess under a portrait of Hitler. RIGHT: At an agricultural school in Neudeck, East Prussia, Junkers are taught how to hold reins of horse-drawn transport as a model moves along in front of them.

OVERLEAF: LEFT: Hermann Göring, Minister for Air, who became the second most powerful man in Germany. RIGHT: At funeral services in East Prussia for Hindenburg, Hitler—wearing for the first time his uniform as Reichschancellor and Führer—strides along between a naval guard of honor. At end of third row behind Hitler, head bowed, is Heinrich Himmler, Hitler's Gestapo chief.

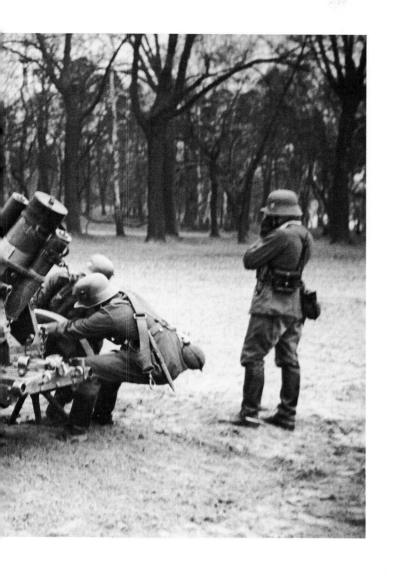

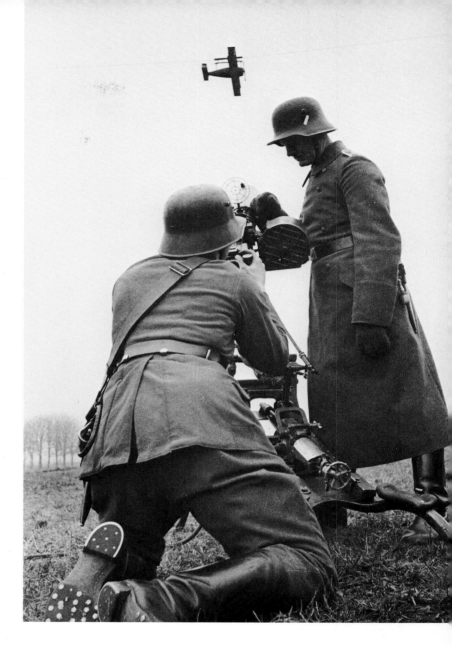

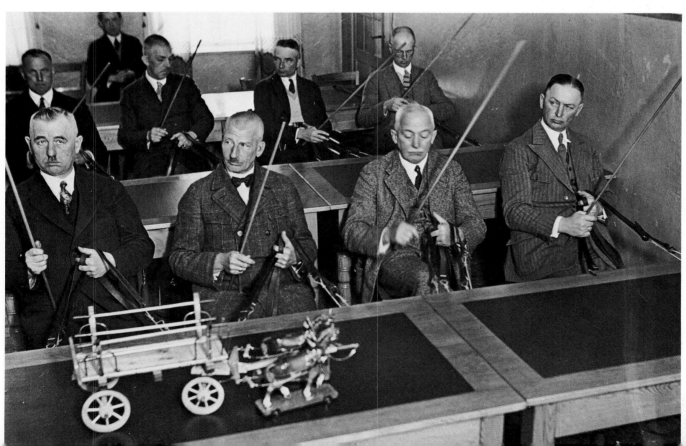

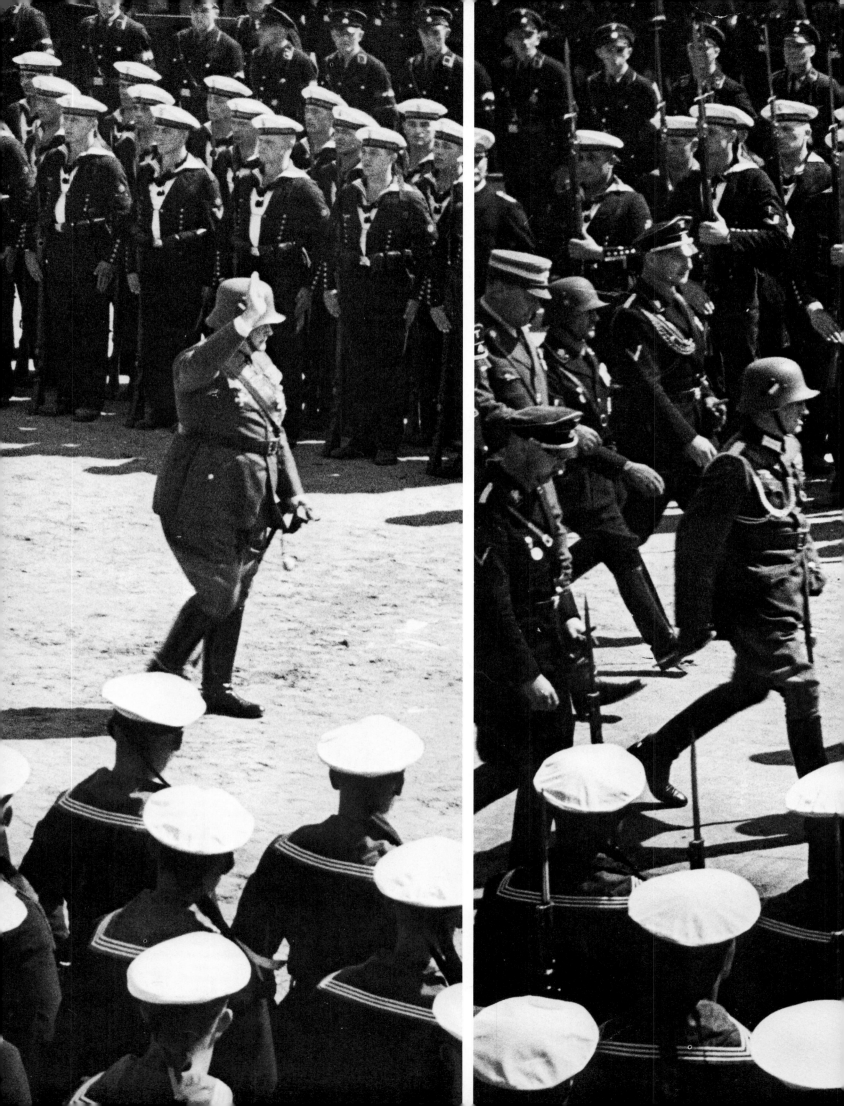

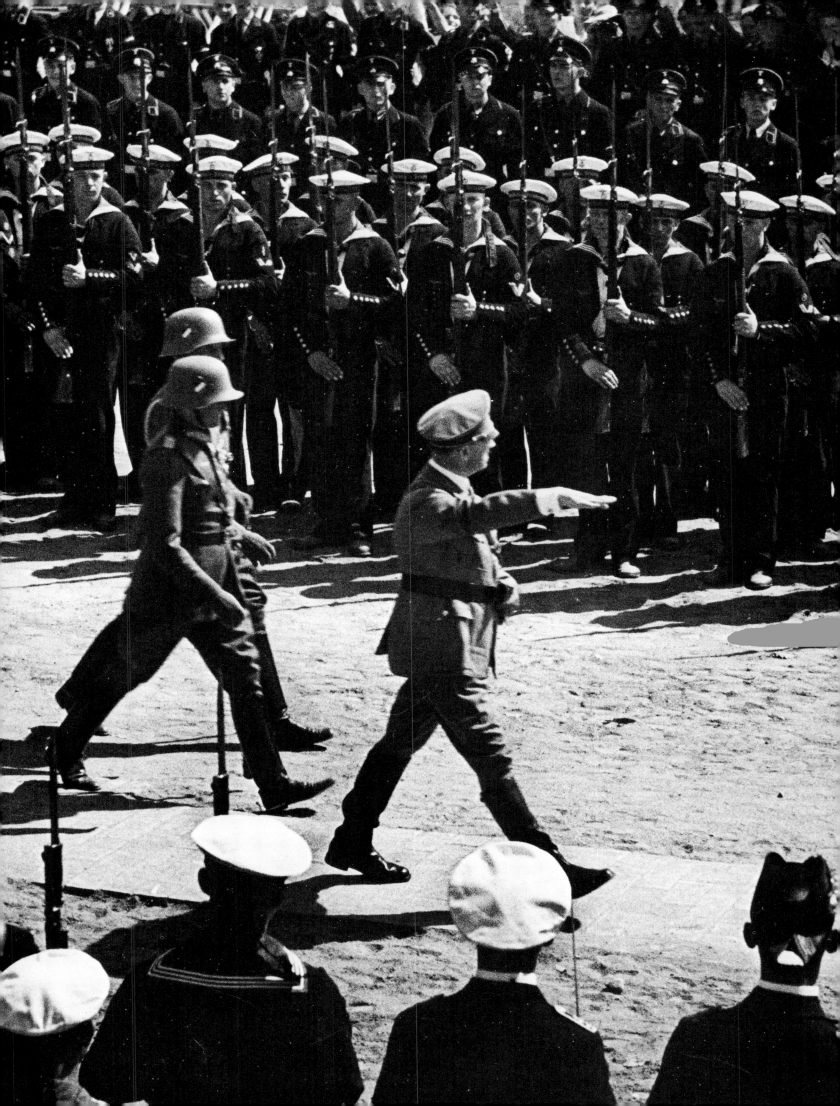

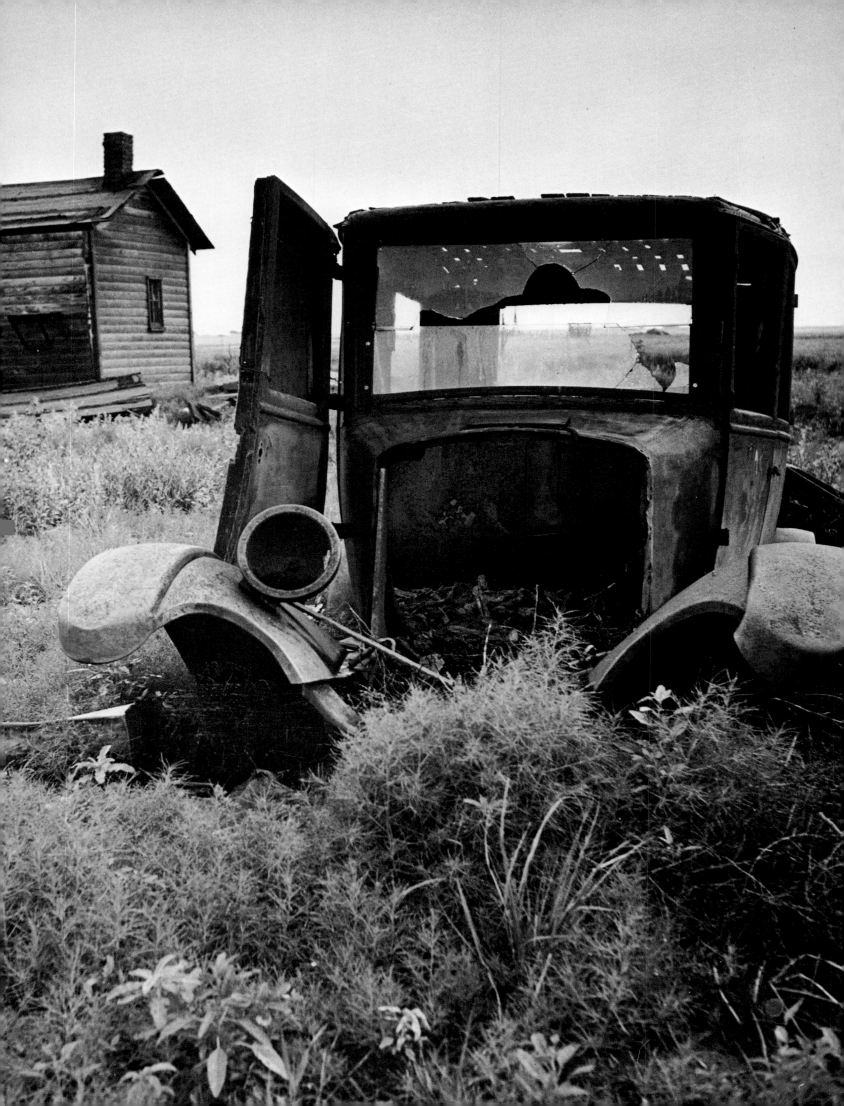

The United States: The Great Depression

The Great Depression kept the United States in its grip for almost a full decade. The stock market crash of October 1929, which wiped out fifteen billion dollars of stock values, was followed by increasing unemployment—12 million in 1932, 20 million in 1933—and by a series of catastrophic bank failures. In that atmosphere of panic and crisis Franklin Delano Roosevelt became President in March 1933. "We have nothing to fear but fear itself," he said in his inaugural address, and his brisk confidence heartened the country. The first "Hundred Days" of his New Deal administration created an array of alphabetic agencies that carried the federal government into all phases of economic life—the AAA, the CCC, the TVA, the NRA, and the WPA. One of the features of the WPA—the providing of employment for artists, musicians, and writers in painting murals in post offices and other public buildings, in writing new plays and producing classic dramas, in cataloguing libraries, et cetera—was quickly labeled a "boondoggle" by many critics, but in the end the program came to be regarded "as humane, democratic and intelligent as any art program the world over." By 1936 the country had begun to perk up from the depression, and Roosevelt was re-elected in the most massive landslide in United States history.

I came to America from Germany in 1935 and, traveling the country, saw how the depression had left its mark. Near the town of Bend, Oregon, an abandoned shack and rusty car were being claimed by a weedy field. In downtown Los Angeles, South Main Street was populated by skid-row drunks, and boasted second- and third-hand clothing stores and pawnshops. You could buy hamburgers or beer for five cents or see a triple movie bill for ten cents. In a hut near Greenfield, Mississippi, Lonny Fair, a sharecropper, his wife Mamie, and their five children lived in unbelievably squalid conditions. Yet when they sat down to their meager lunch they bowed their heads in prayer (pages 76-77) as Lonny said: "Bless, O Lord, this food for our use, and us. Amen."

OPPOSITE: A scene near Bend, Oregon, 1935.

OVERLEAF: South Main Street, Los Angeles. PAGES 76-77: Lonny Fair and family.

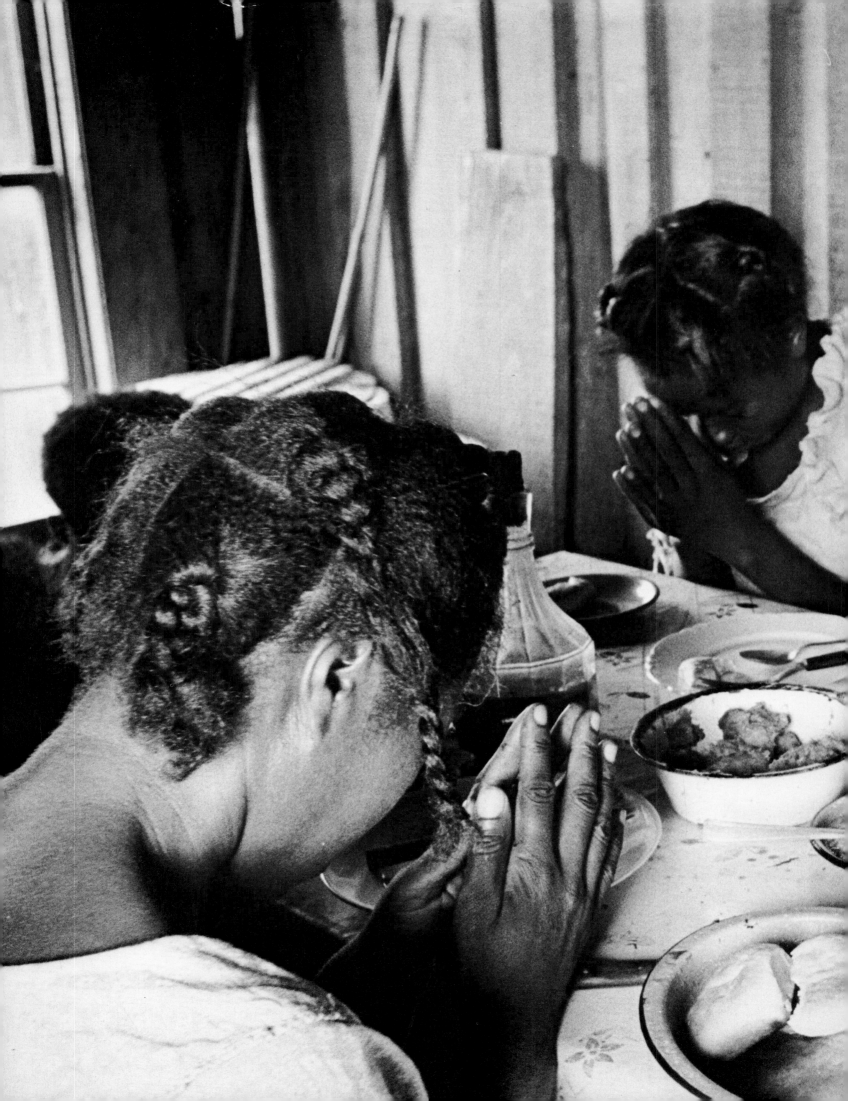

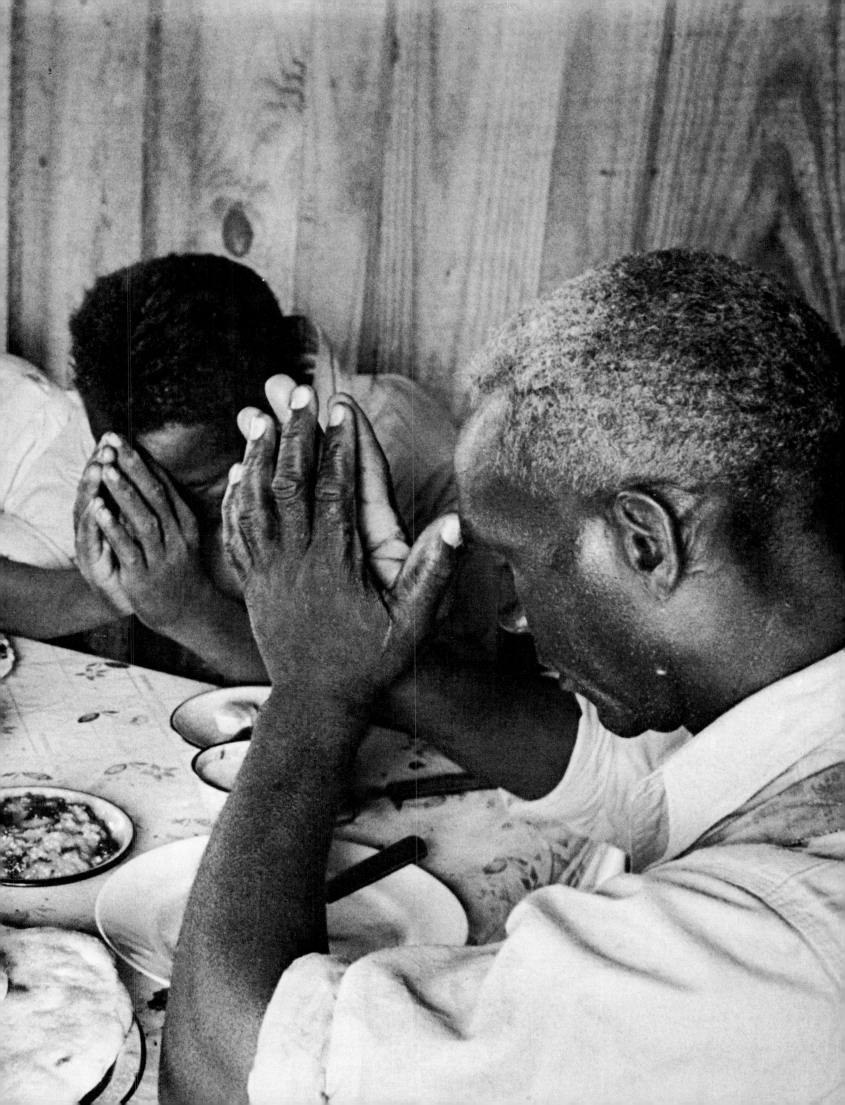

RIGHT: Thomas Hart Benton works on his version of *The Rape of Persephone*, Missouri-style, in the Kansas City, Missouri, Art Institute, where he was teaching in 1939. For this legend of a Greek goddess abducted to the underworld by Pluto, Benton used an Ozark hillbilly to peep around a tree at his nude victim.

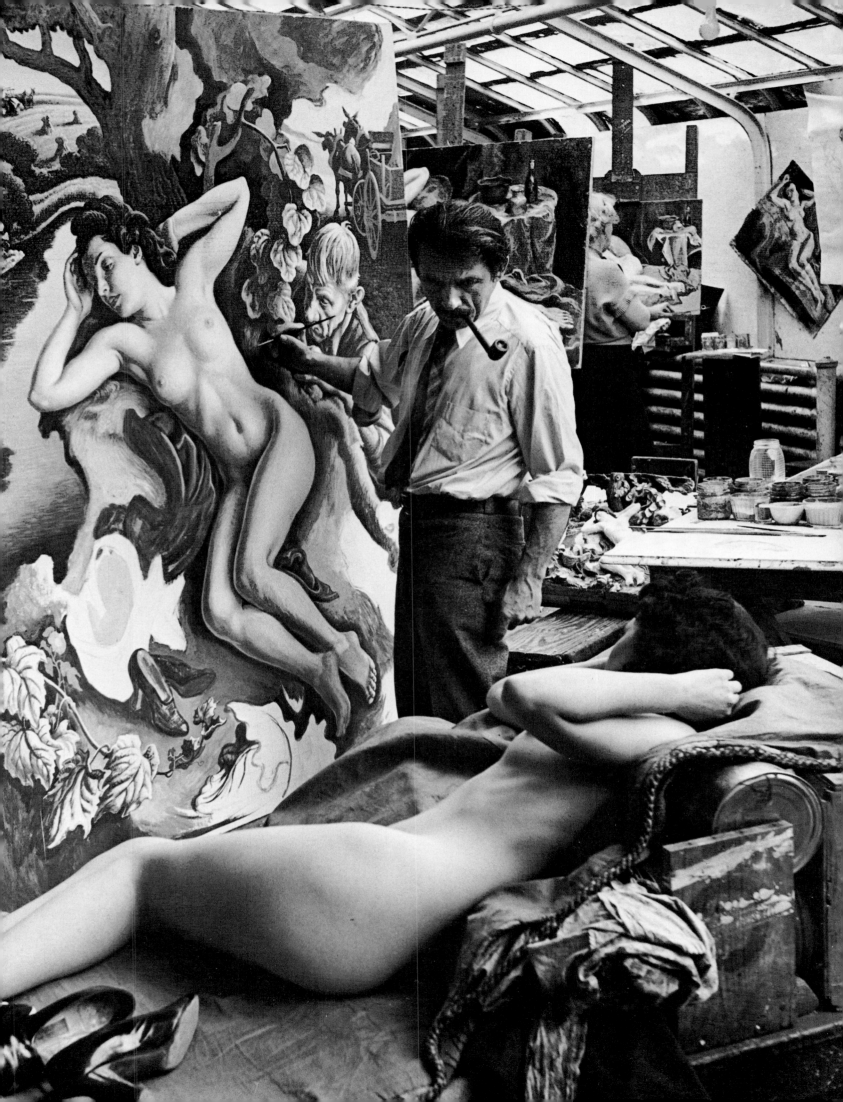

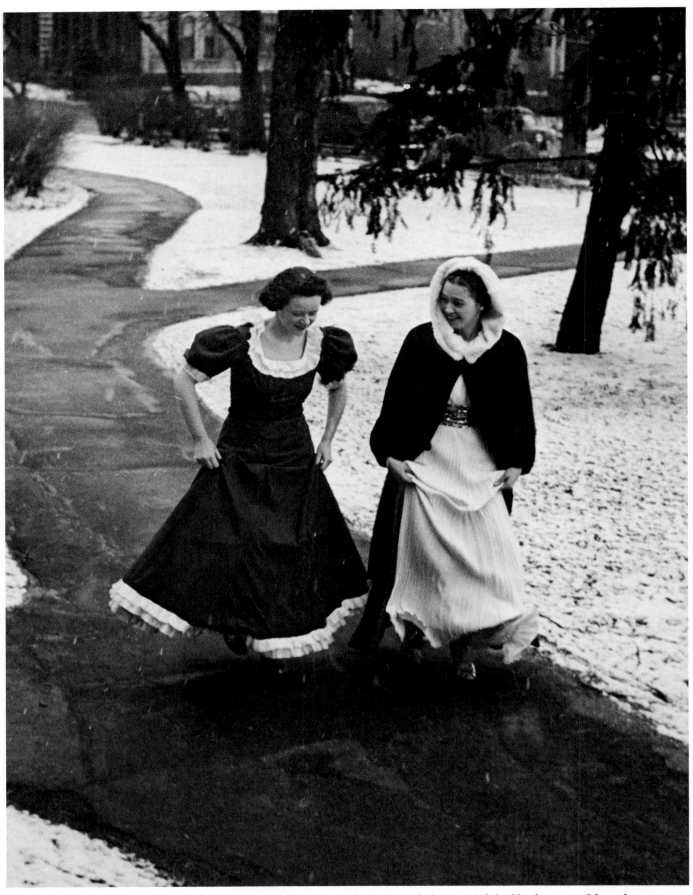

Two dolled-up Smith College girls pick their way daintily through the snow of the Northampton, Massachusetts, campus on their way to a dance. RIGHT: At Stephens College, Columbia, Missouri, two girls bid their dates farewell.

OVERLEAF: President Roosevelt and his son James, then acting as his secretary, aboard the cruiser USS *Indianapolis* in November 1936, en route to a "good neighbor" conference in Rio de Janeiro.

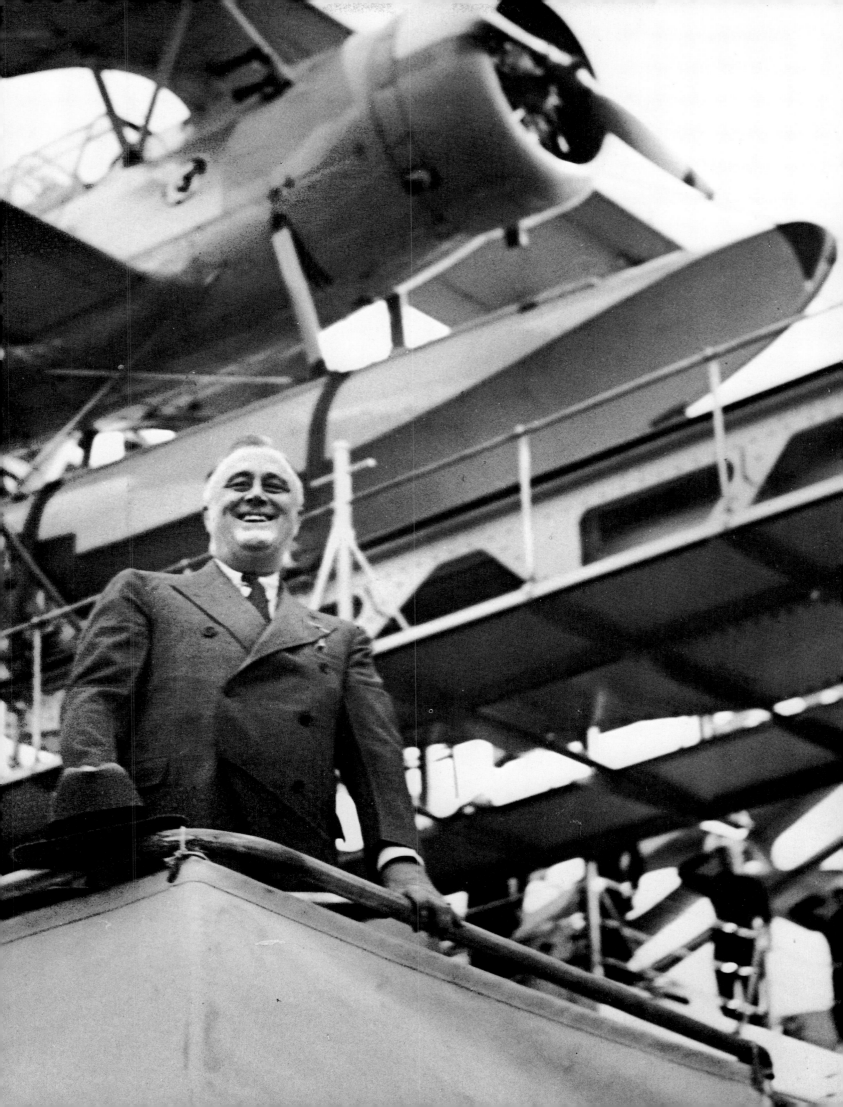

By June 1940, when Hitler, in firm control of Western Europe, was making plans to polish off England, the United States was sharply divided over what role, if any, it should play in the war. Roosevelt's foreign policy was attacked by many prominent Americans as likely to entangle the country in another futile European war. One of the most respected isolationist voices was that of Charles A. Lindbergh, speaking for the America First Committee: ". . . the destiny of this country does not call for our involvement in

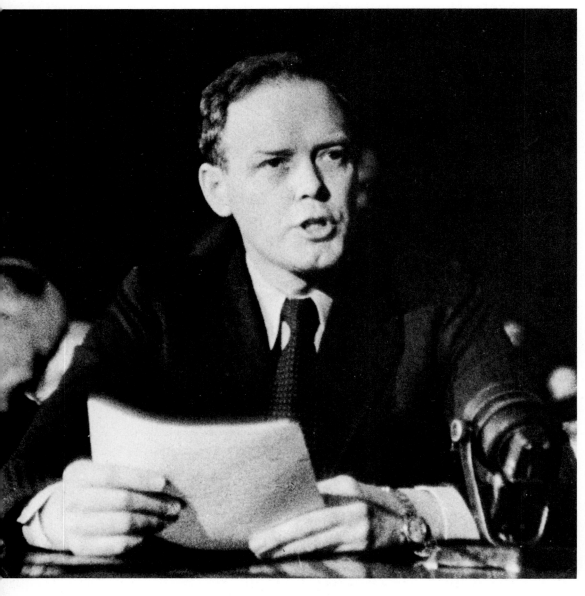

Charles Lindbergh testifies against Roosevelt's Lend-Lease Bill to provide aid to England, at the Senate Foreign Relations Committee hearings in February 1941. "I do not believe," Lindbergh said, "England is in a position to win the war." He favored a negotiated peace then, to get the best possible bargain with Hitler.

OPPOSITE: Sinclair Lewis in 1936. For his novels—*Main Street, Babbitt, Arrowsmith,* and others—he became the first American to win the Nobel Prize in Literature.

European wars. . . . These wars . . . are not wars in which our civilization is defending itself against some Asiatic intruder. There is no Genghis Khan or Xerxes marching against our Western nations. . . . This is simply one more of those age-old struggles within our own family of nations." So strong was isolationist sentiment running that even in August 1941, only four months before Pearl Harbor, the bill to extend the period of Selective Service training beyond its limit of twelve months squeaked by in the House of Representatives by only a single vote, 203-202.

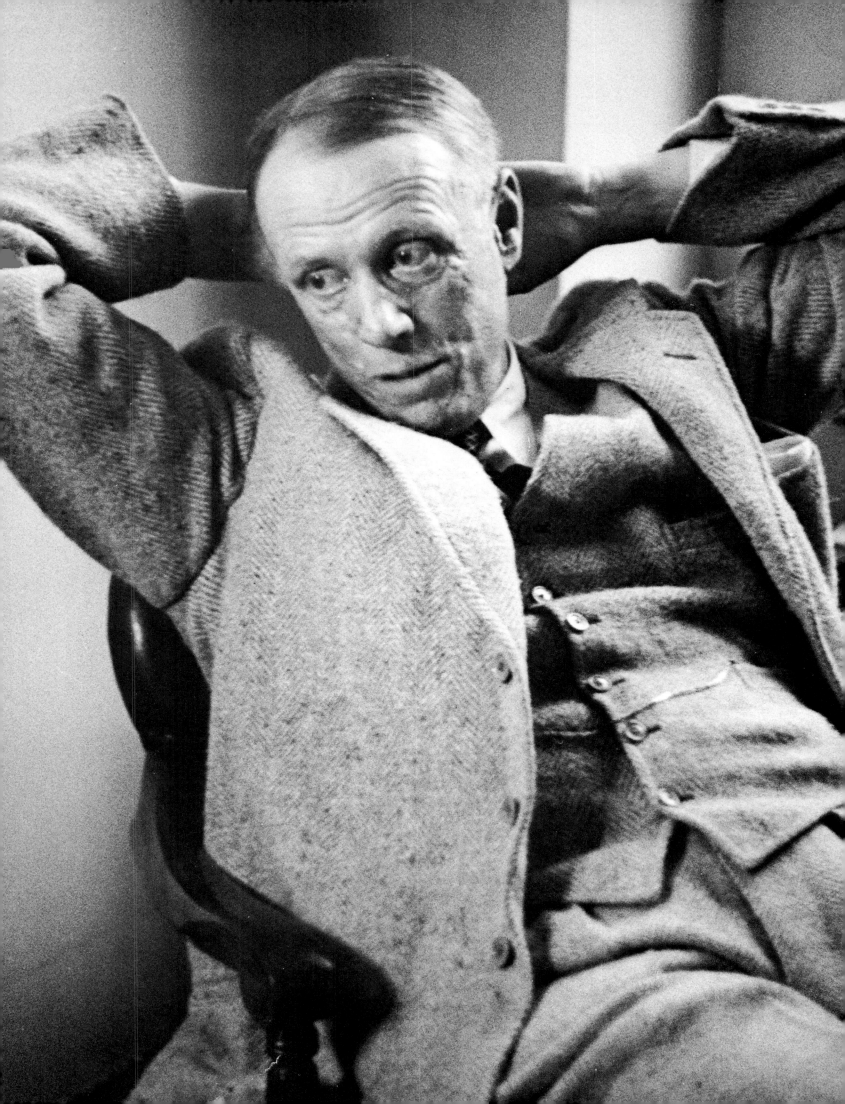

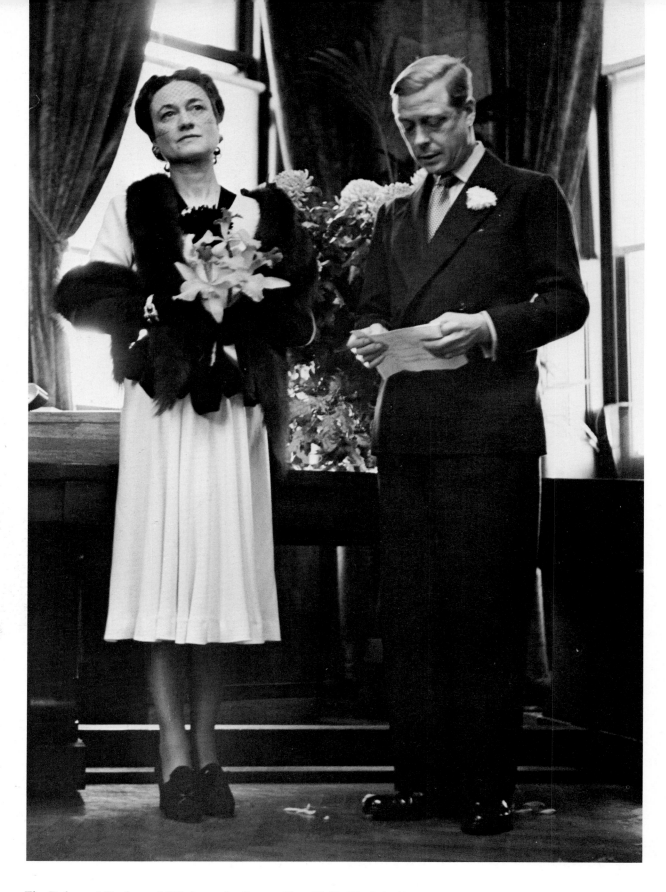

The Duke and Duchess of Windsor—the former Mrs. Wallis Warfield Simpson of Baltimore, Maryland—in November 1941 on their first official visit to the United States since the Duke renounced his throne rather than give up "the woman I love." In New York the Duke reads a short prepared speech at City Hall.

OPPOSITE: In September 1938 a stagestruck girl named Mary Martin came from Weatherford, Texas—famous for its watermelons—to New York to seek fame and fortune. She achieved both overnight, doing a burlesque striptease and singing "My Heart Belongs to Daddy" in Cole Porter's Broadway musical *Leave It to Me*.

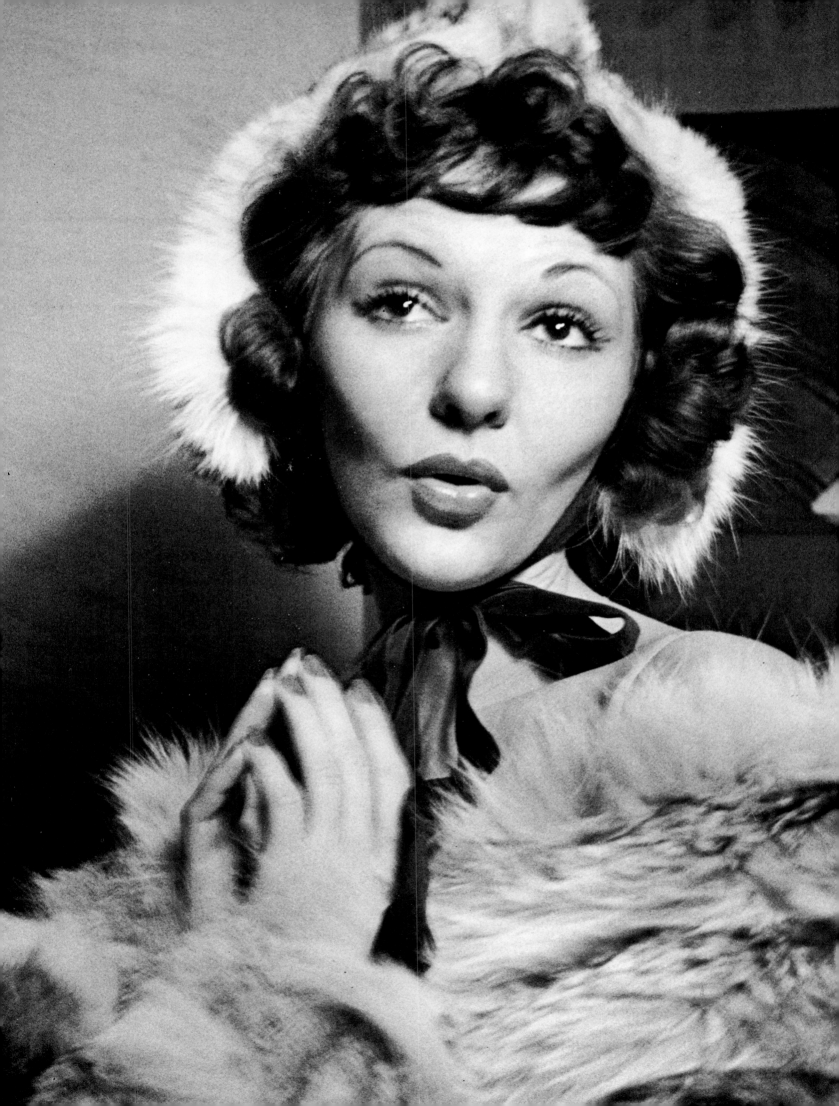

Hollywood

In the 1930s Hollywood had to deal with a colossal revolution: the talking pictures. Filmmakers were calm. "The talking picture has its place," said Irving Thalberg, the movies' most eminent producer, "but I do not believe it will ever replace the silent drama." One single picture proved otherwise. In *The Jazz Singer,* Al Jolson sang two songs, "Mammy" and "Kol Nidre," and everybody demanded talkies. By the middle of the 1930s many of the greatest silent stars were gone, their glamour lost when they opened their mouths. A corps of new stars had taken over, trained on the stage or blessed with musical voices—Claudette Colbert, James Stewart, Henry Fonda, Tyrone Power, Deanna Durbin. And of course the most compelling of them all: Clark Gable, who came out from Broadway to sweep Hollywood and the delightful Carole Lombard off their feet. Even in the depressed 1930s the movies prospered; the new techniques and double bills filled the theaters, and Hollywood had no rival in all the world. If a European star such as Hedy Keisler wanted to become a real international star, she had to come to Hollywood and change the Keisler to Lamarr. The old Hollywood did not die—DeMille still had his grandiose successes—but a dramatic realism came in with Bette Davis and James Cagney, and a new sophistication with the college-girl accents of Katharine Hepburn and the ingenious feet of Astaire. Hollywood not only survived the revolution but triumphed over it to make the 1930s a golden era of the movies.

Hedy Lamarr in 1938. She became a movie star in 1933, cavorting in the nude in a film called *Ecstasy*.

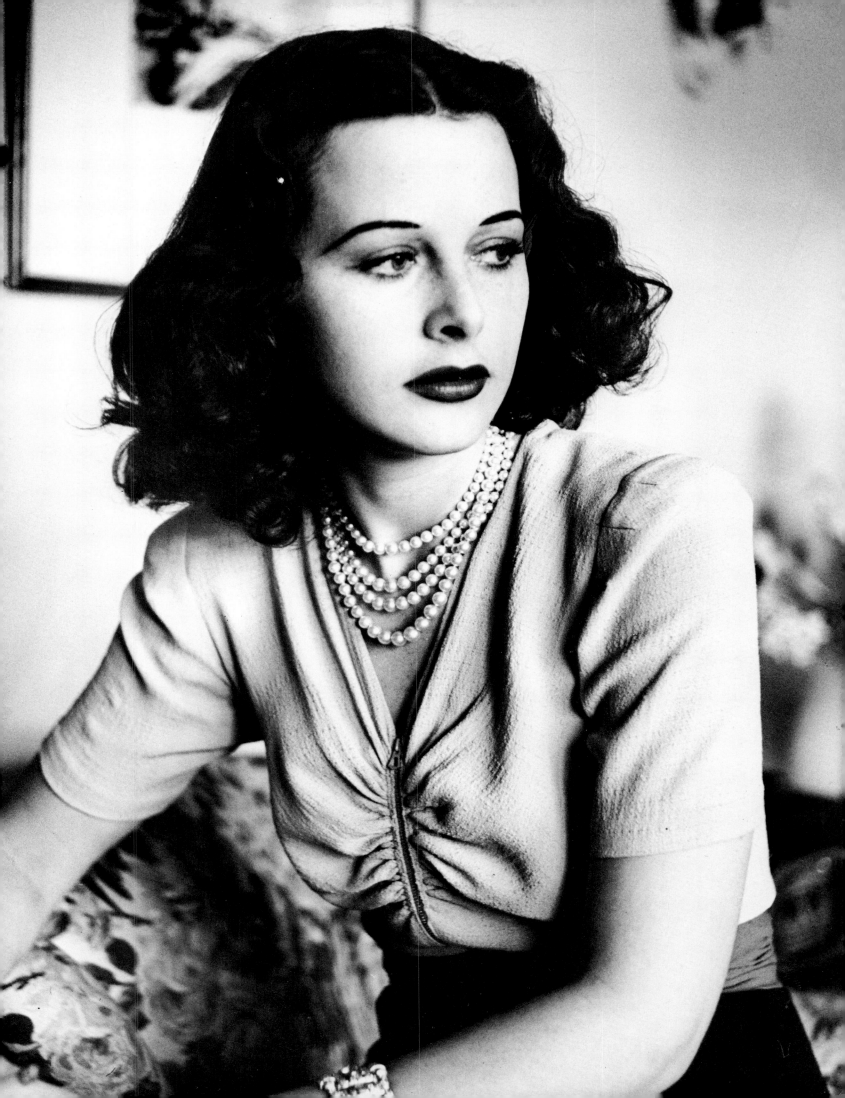

BELOW: Al Jolson, whose *The Jazz Singer* in 1927 was the first Hollywood "talkie," on vacation in Miami in 1940. RIGHT: Claudette Colbert, a sparkling comedienne, in her Hollywood home.

BELOW: Producer Cecil B. DeMille, who in 1913 had made Hollywood's first feature-length film, with his wife. OPPOSITE PAGE: Bette Davis.

OPPOSITE: Ronald Colman, suave, mild-mannered, soft-spoken, was the very model of a modern British gentleman and played leading roles to match. BELOW: Katharine Hepburn during the making of *The Philadelphia Story*, 1940.

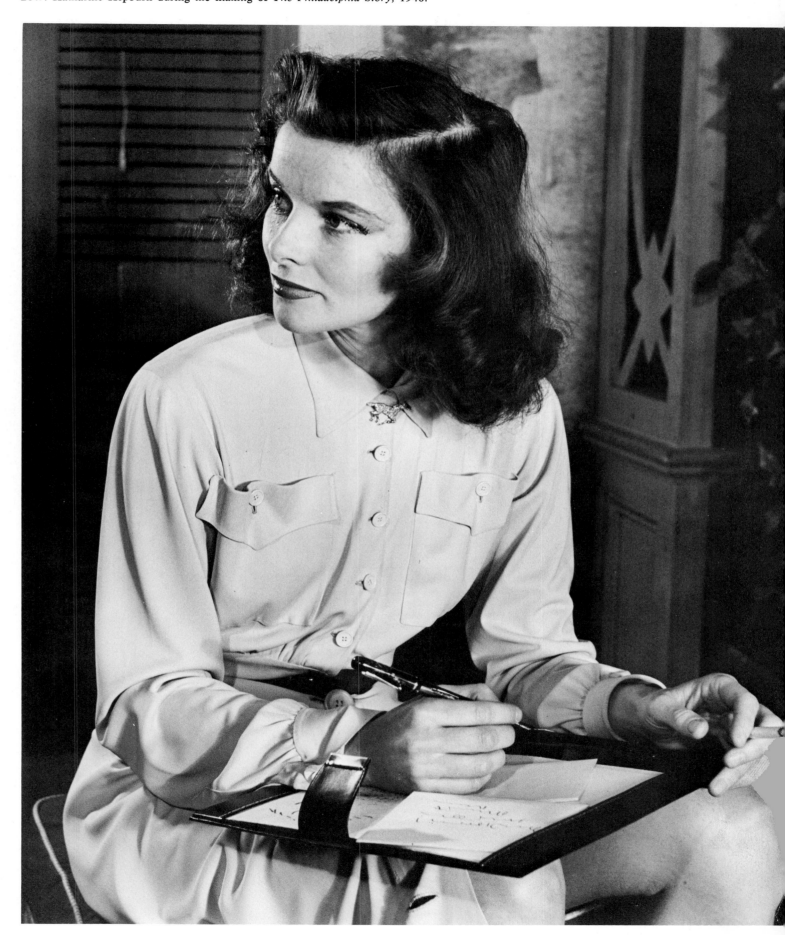

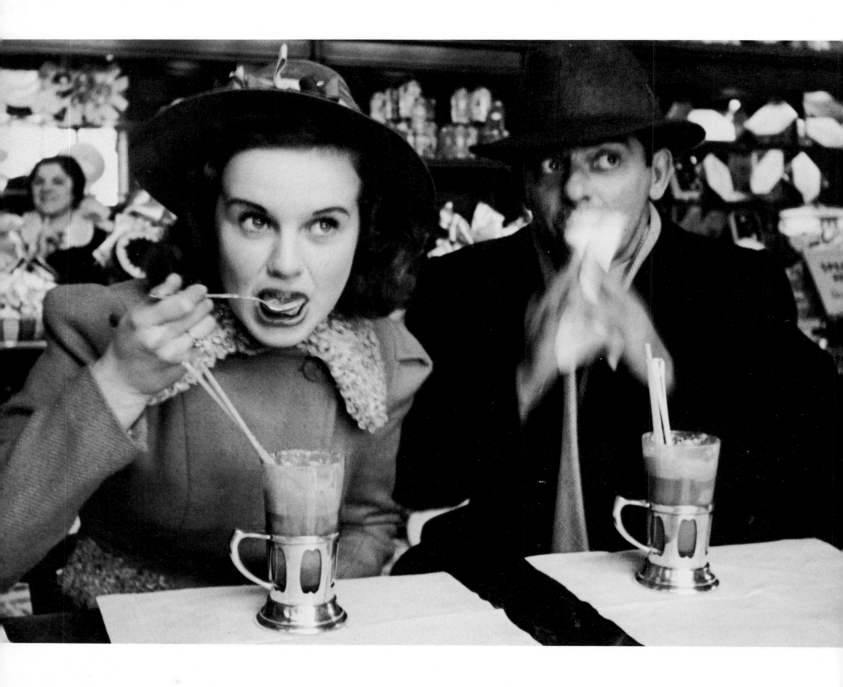

Deanna Durbin and Eddie Cantor, who discovered her in 1935 and put her on his radio program, sipping ice-cream sodas in New York in 1938. Miss Durbin's liltingly lovely voice, dramatic talent, and fresh charm captivated movie audiences all over the world.

OPPOSITE: Clark Gable on the set of *San Francisco*, "bleeding" from a make-up wound suffered during the earthquake scene. Almost to his death in 1960, Gable remained a leading box-office attraction, usually playing the rugged American male.

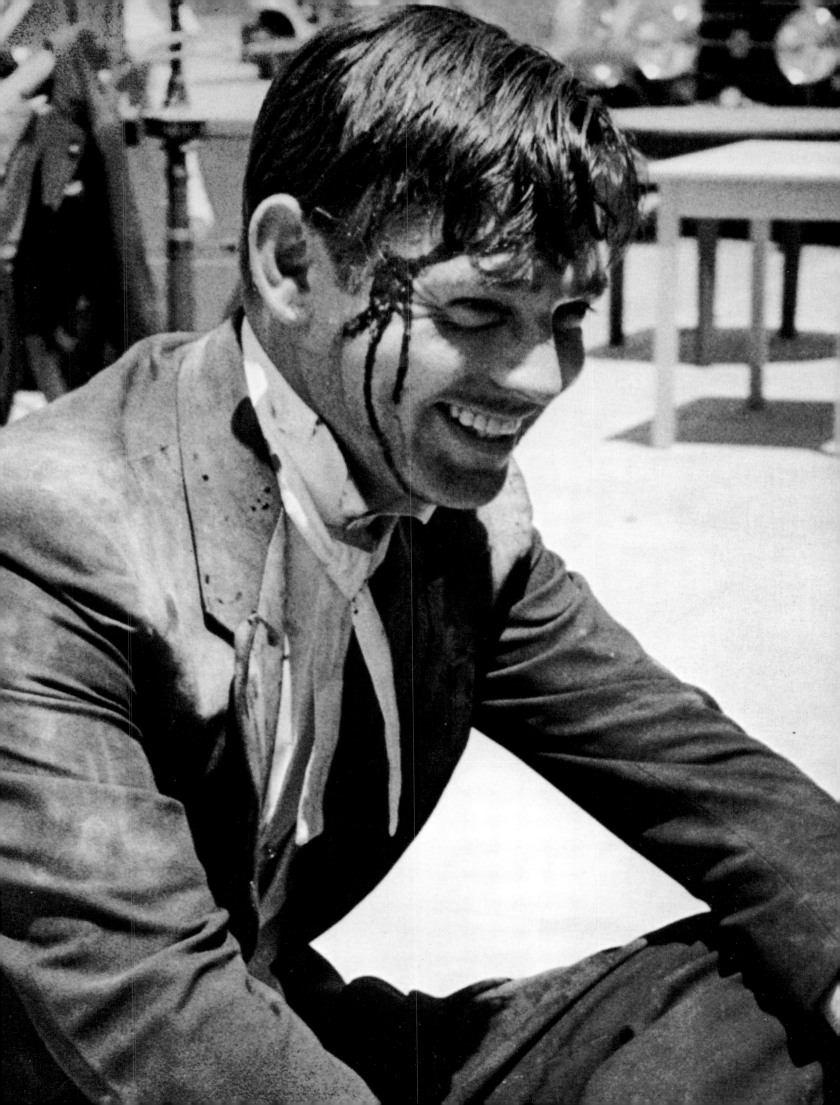

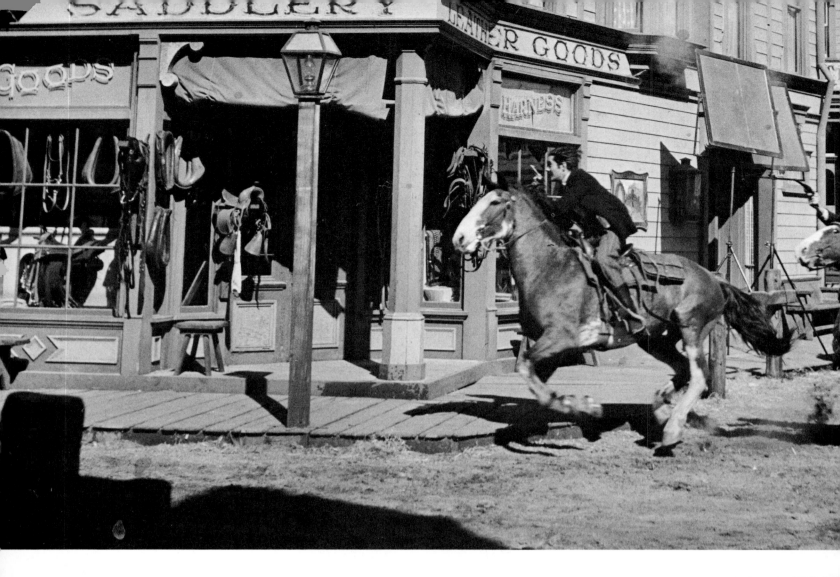

Six-shooters were a-blazin' all over movie locations in 1938. ABOVE: Tyrone Power and Henry Fonda roar through the town of Pineville, Missouri—its main street rebuilt to look like Liberty, Missouri, in 1865 —in a scene from Darryl Zanuck's *Jesse James*. A two-hour Technicolor spectacular, it cost sixteen times as much money as Jesse James stole in his lifetime. RIGHT: Henry Fonda (in center) and Tyrone Power.

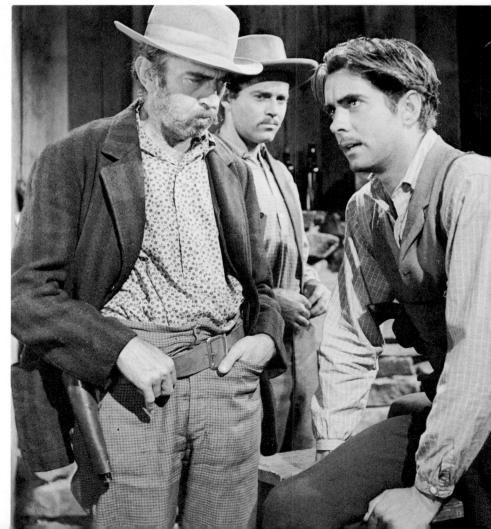

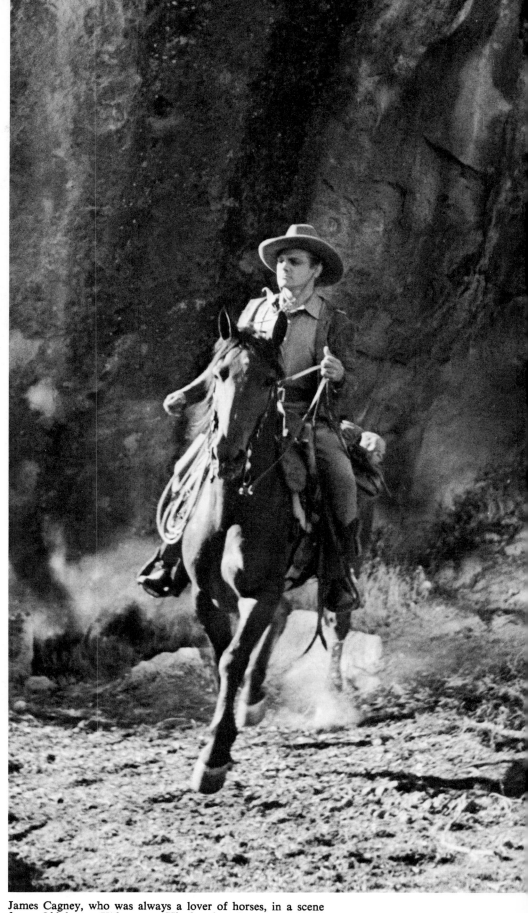

James Cagney, who was always a lover of horses, in a scene from *Oklahoma Kid*. LEFT: His heroine, Rosemary Lane.

Madeleine Carroll plays with her dog. A British-born society lady, she represented that "warm but noble beauty" which led men to brave Chinese warlords (*The General Died at Dawn*) and scale castle walls (*The Prisoner of Zenda*).

RIGHT: Carole Lombard and Jimmy Stewart between scenes of their movie *Made for Each Other*. One of the screen's greatest, gayest comediennes, Miss Lombard was married to Clark Gable when she died in 1942.

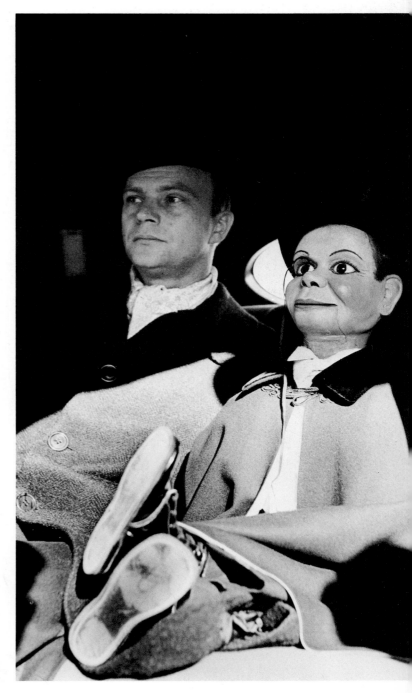

BELOW: Ventriloquist Edgar Bergen and Charlie McCarthy, the sassy backtalking little dummy who made his master's reputation.

Ann Sheridan, then one of the Warner Brothers' up-and-coming stars, poses for a glamour publicity shot by George Hurrell. BELOW: Joan Crawford gets her tresses fixed up on the set of MGM for her title role in *The Gorgeous Hussy*.

Shirley Temple rehearses her lines in *The Little Princess* with her director, Walter Lang.

RIGHT: Loretta Young in *Kentucky*, a movie in which she starred. TOP CENTER: Shooting a scene for *Kentucky*. FAR RIGHT: Fred Astaire, whose musicals with Ginger Rogers made cinematic history, practices for *Swing Time*.

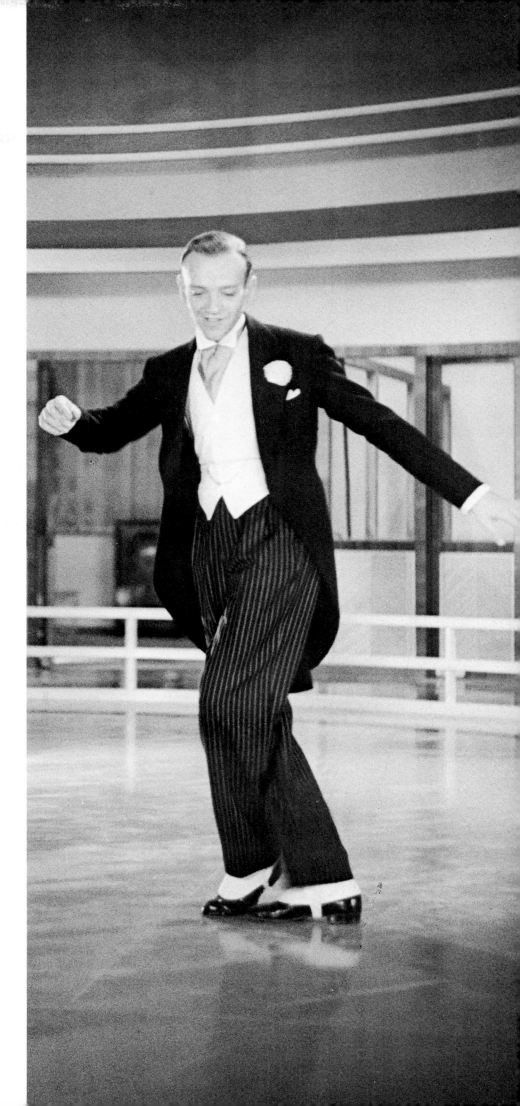

General George C. Marshall, in 1941 Chief of Staff, United States Army.

The United States: World War II

The Japanese attack on Pearl Harbor, December 7, 1941—"a day," Roosevelt said, "that will live in infamy"—put an abrupt stop to all arguments over United States policy. The country began to crank up the machinery of war. In Pennsylvania Station in New York City, and in railroad depots and airports all over the country, women clung to their men going away to war—lonely little islands of grief as hurrying civilians flowed around them. More than 15 million men and women served in the United States armed forces during World War II, two-thirds of them draftees. On the homefront a kind of life went on under the gray, insistent pall of war. Controls and rationing were bearable annoyances; families learned to live without new automobiles, typewriters, bicycles, stoves, and with less coffee, sugar, gasoline, shoes, canned fruits and vegetables, meats and fats. What was harder to live with was the sudden heart-stabbing fear when the doorbell rang: more and more it heralded the arrival of a poignantly formal telegram: "The Secretary of War regrets to inform you . . ." Almost 300,000 Americans lost their lives in battle areas, and more than 600,000 were wounded.

OPPOSITE AND OVERLEAF: Wartime farewells in Pennsylvania Station.

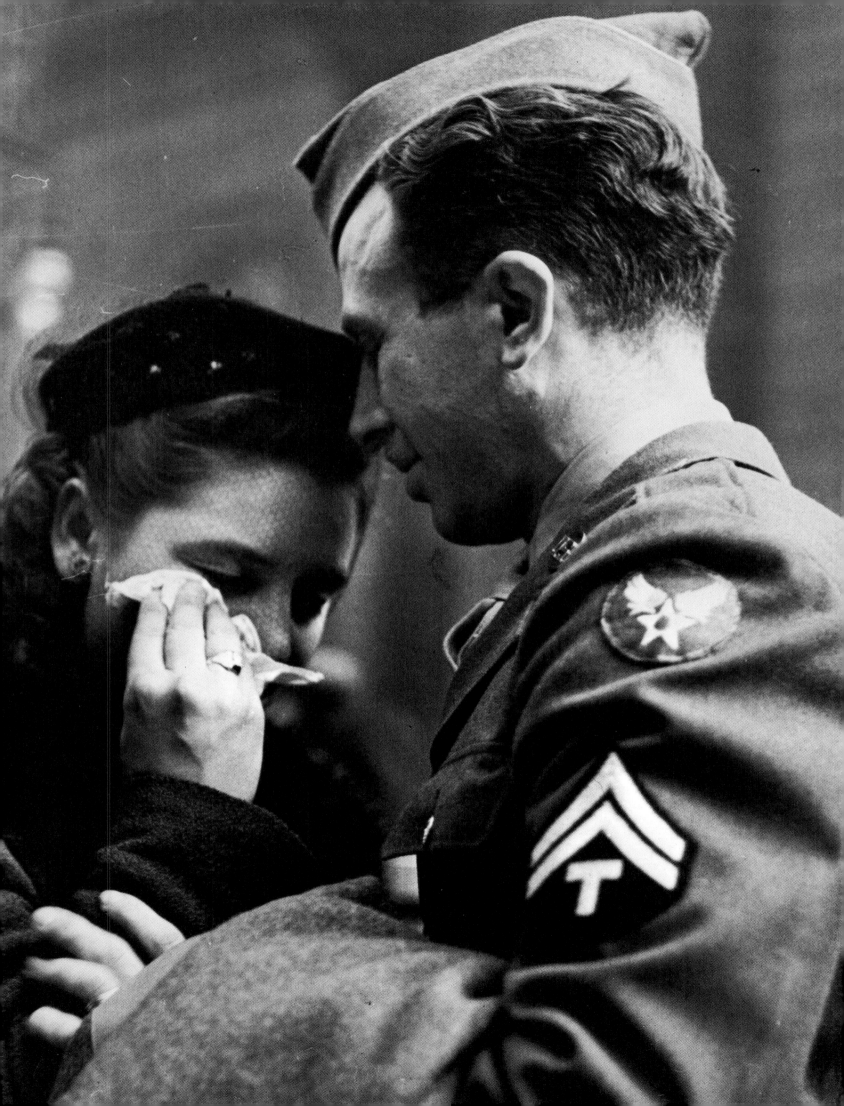

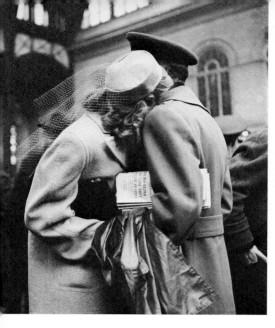
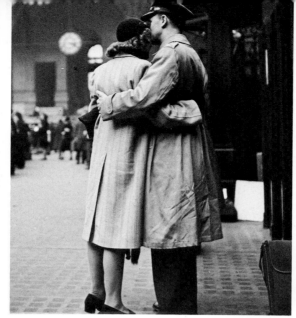

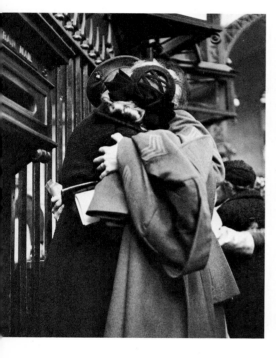
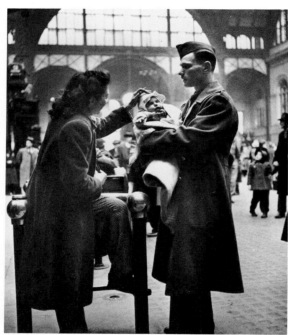
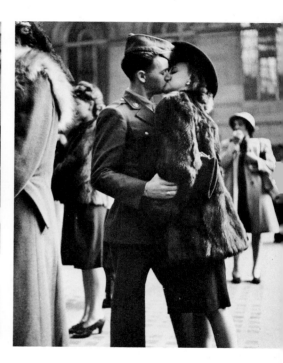
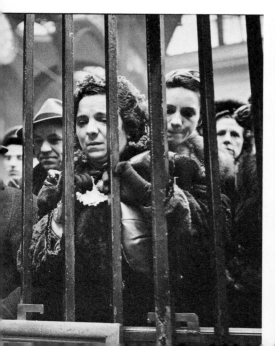
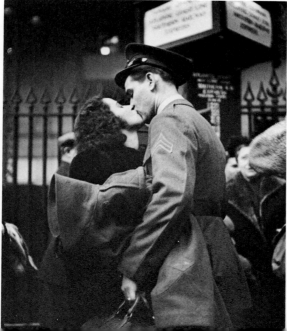
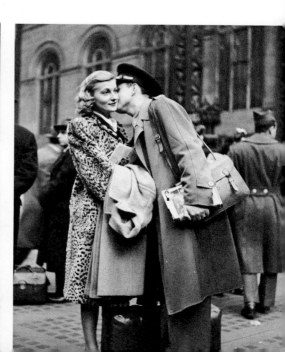

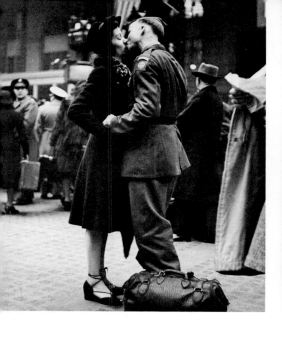
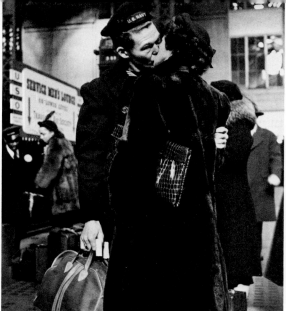
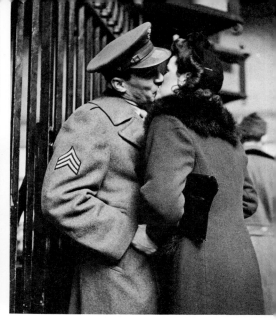
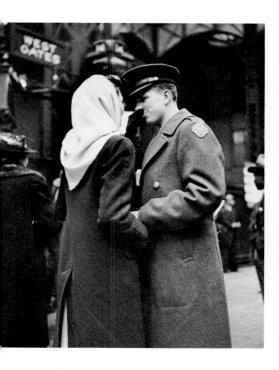
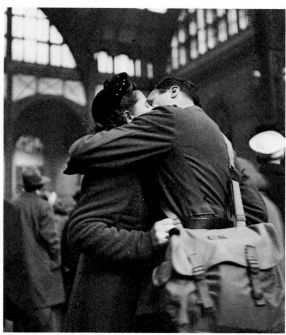
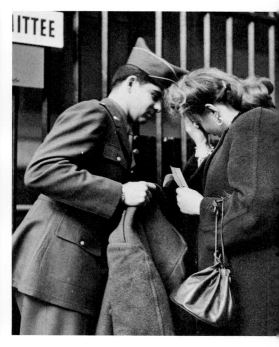
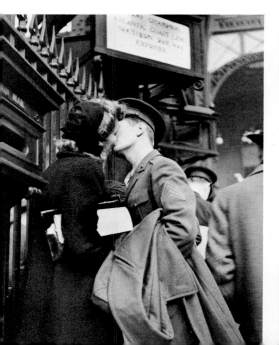
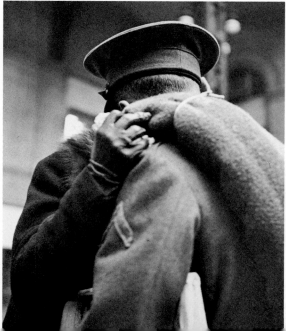
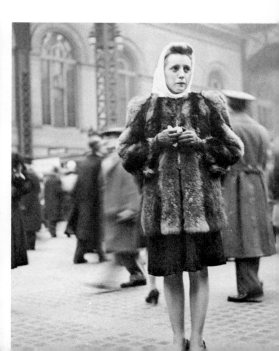

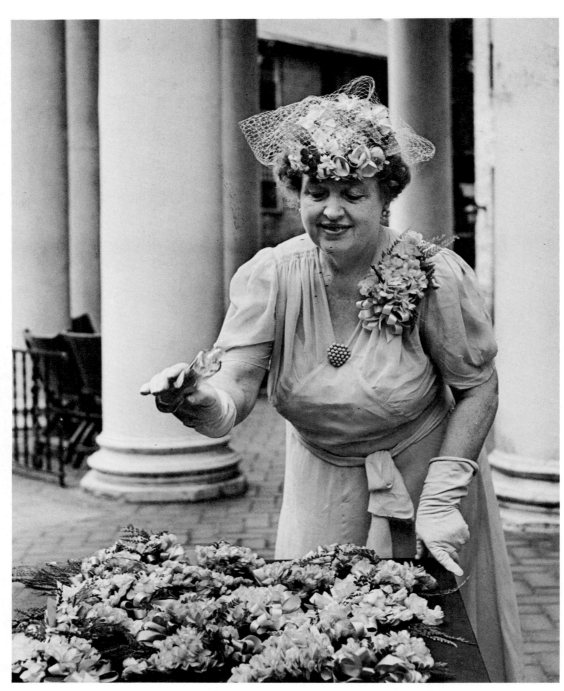

The ladies of the Atlanta, Georgia, chapter of the Daughters of the American Revolution had a tea party in the fall of 1944, in honor of their new national president general, Mrs. Julius Y. Talmadge of Athens, Georgia, the first Southerner ever elected to lead the DAR. The hostess, Mrs. Charles P. Byrd, sprinkled perfumed toilet water over the artificial beach-blossom corsages (ABOVE), the ladies all wore pearls and their ribbon stomachers (LEFT), and a harp ensemble solemnly played soft Southern melodies (OPPOSITE PAGE). Unbeknownst to Mrs. Byrd, somebody spiked the peach punch with two extra bottles of brandy, and all agreed they had never tasted such good punch before.

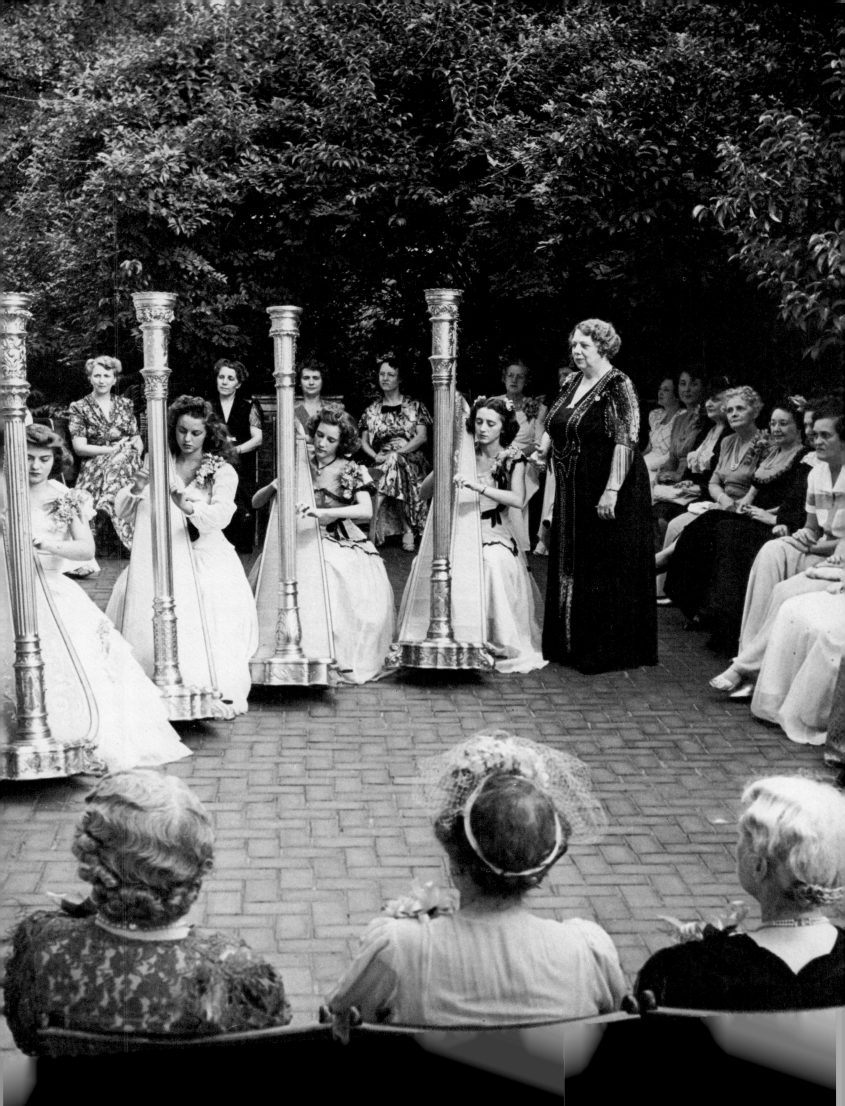

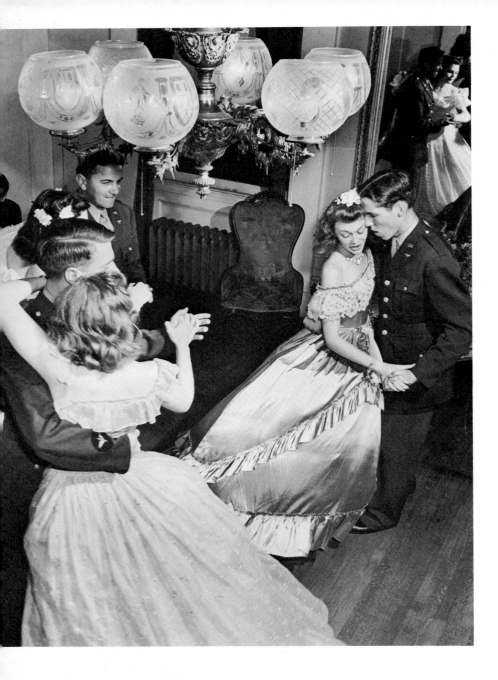

The belles of Columbus, Missouri, put on their mothers' and grandmothers' prettiest hoopskirts and threw an antebellum-type party in 1943 at a Civil War mansion called Riverview. The guests were cadets from the town's Army Flying School. They danced, played games, and used their best Sèvres china to serve coffee (each girl brought a ration of the scarce item for her guest).

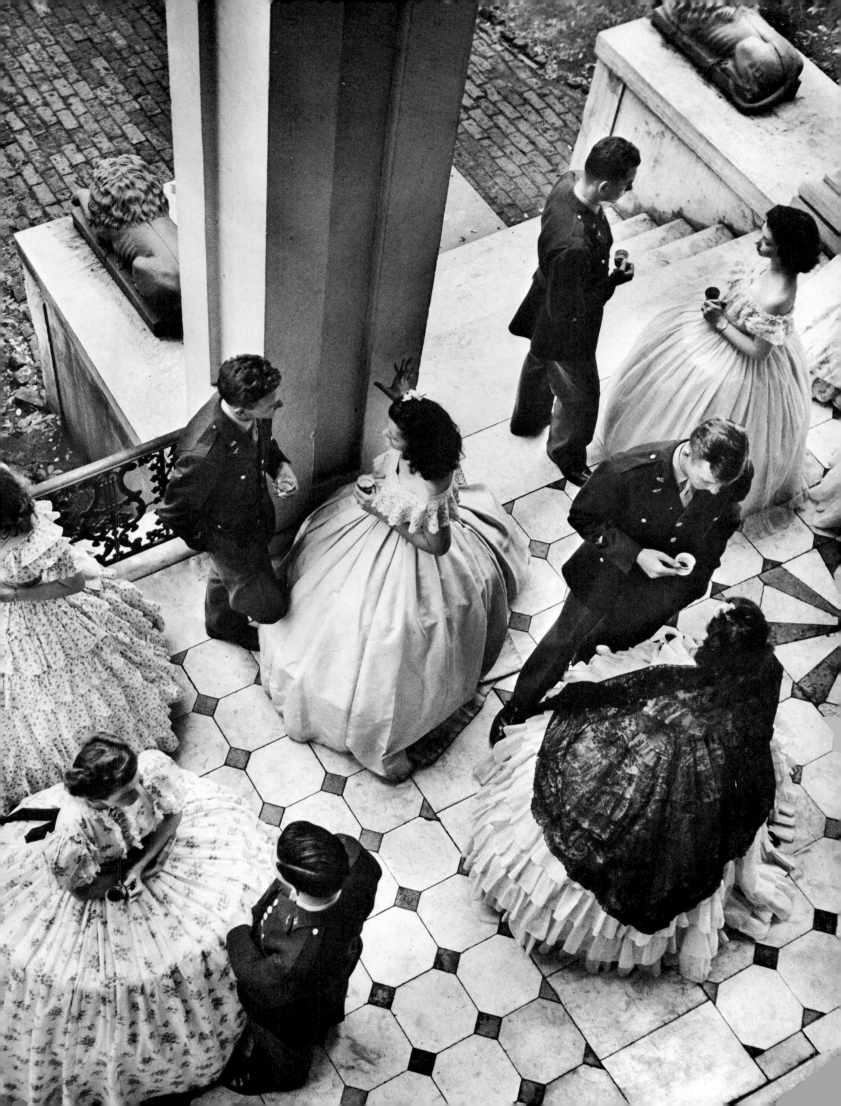

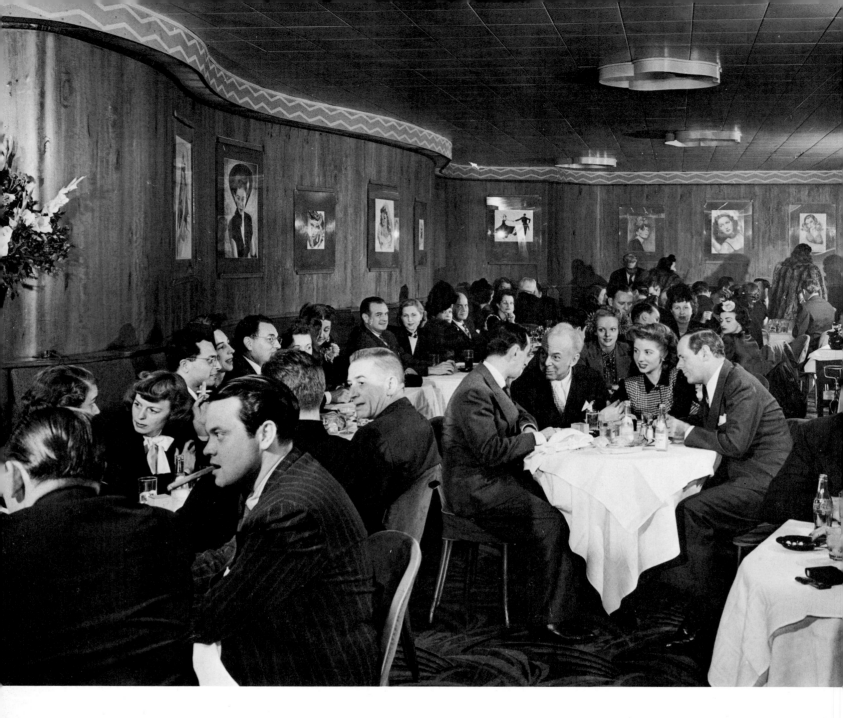

All during the war Sherman Billingsley's Stork Club in Manhattan did its best to keep up morale on the homefront—aided no little by its enormous supply of liquor. The Cub Room, guarded by two knowledgeable waiter-guards, let you in only if you were really *in*. ABOVE: That *sanctum sanctorum* in November 1944. At table in left foreground are Orson Welles, Margaret Sullavan, and, to right of Welles, her husband, producer Leland Heyward (crew-cut). At table in center foreground are Tommy Manville and his ninth bride, seated between Columnist Leonard Lyons, at left, and Billingsley. At table in the right foreground sits tenor Morton Downey.

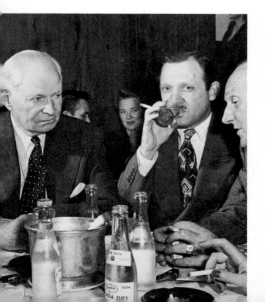

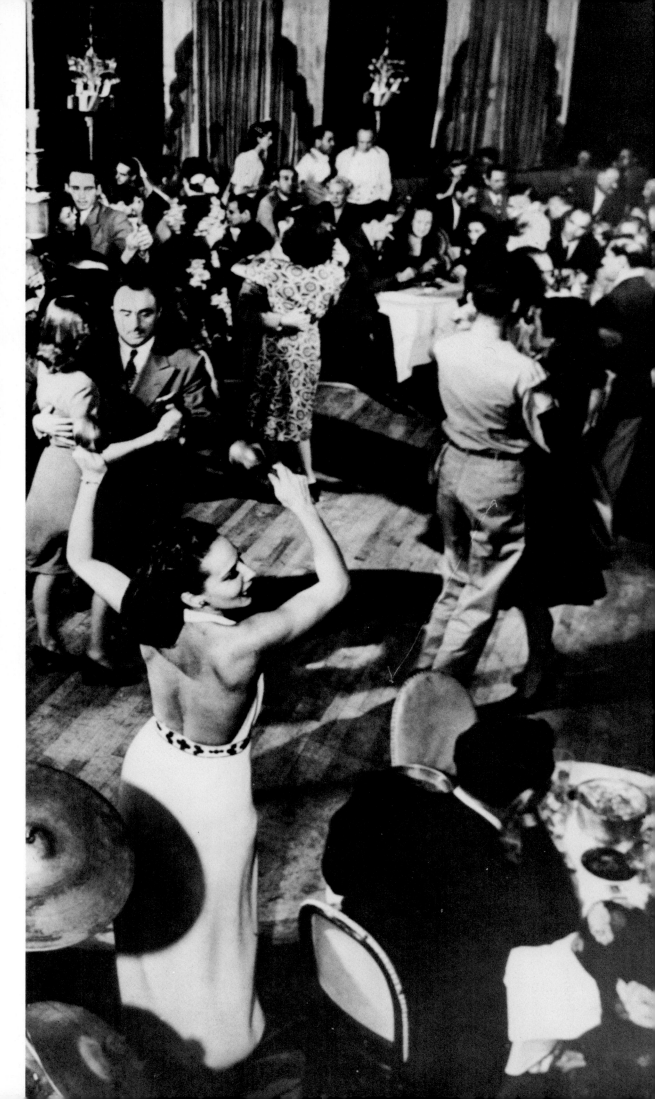

OPPOSITE, LEFT TO RIGHT: United States Senator from Oklahoma Elmer Thomas lunches with Martin Heflin (Van Heflin's brother) and Metropolitan Opera Baritone John Brownlee; Walter Winchell (standing) compares notes with Leonard Lyons; and Gary Cooper and his wife listen to the music.

RIGHT: Anyone—with money —could dine and dance in the main dining room. Decita shook her maracas as her band played rhumbas for the dancers. The Stork Club—a landmark to café society for thirty years—went out of business in 1964, a victim of the discothèque.

Only three miles and several light years from Billingsley's place was Sammy's Bowery Follies, advertised as the "Stork Club of the Bowery." Formerly a haven for drunks, derelicts, the homeless, and the neglected, it had also become during the war a favorite place for slumming by well-heeled uptown New Yorkers. Beer was the main beverage; hard liquor was too expensive. I once even saw a black cat drinking beer, sitting at a table with his homeless master. The oldest entertainer was Dora Pelletier (RIGHT) who was then said to be past seventy. The owner, Sammy Fuchs (BELOW), used to grant credit to his regulars like this lady, who then (BELOW RIGHT) would retire happily into her private world with her glass. Some impulsive patrons simply made love. Sammy's "Mae West" was Norma Divine (OPPOSITE PAGE), who wore black woolly false eyelashes and was usually surrounded by bottles of beer that appreciative customers bought her.

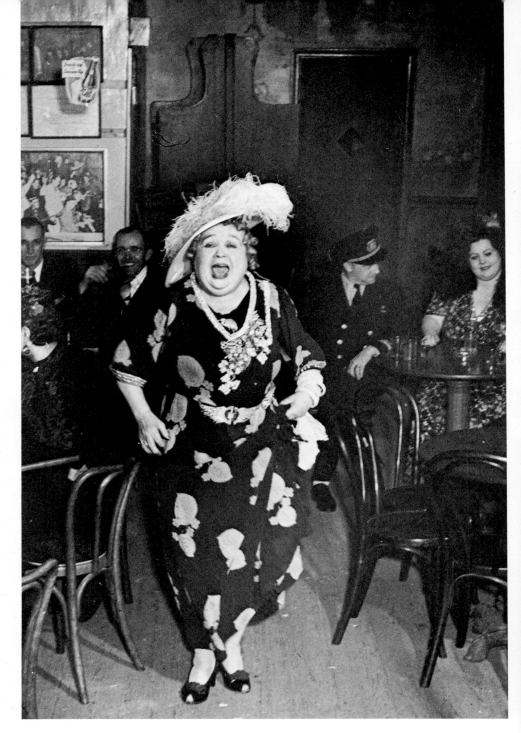

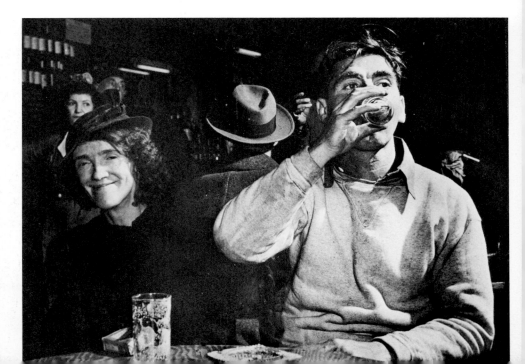

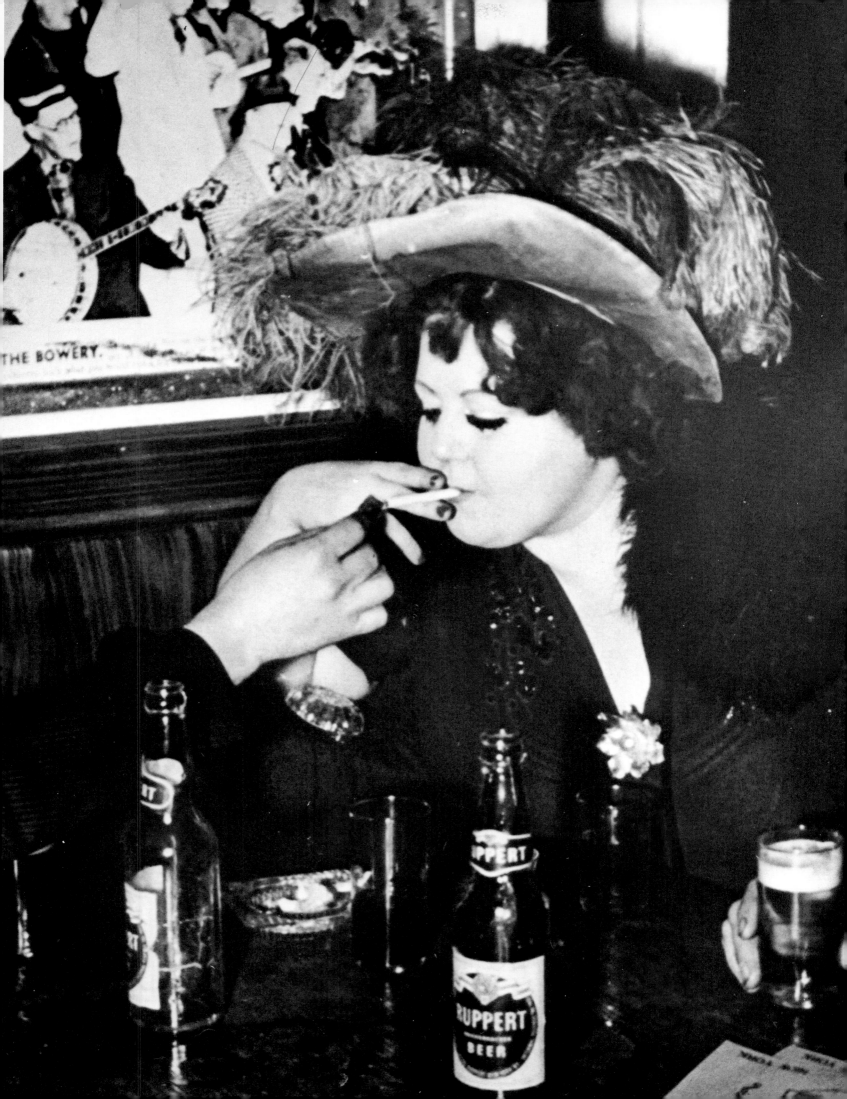

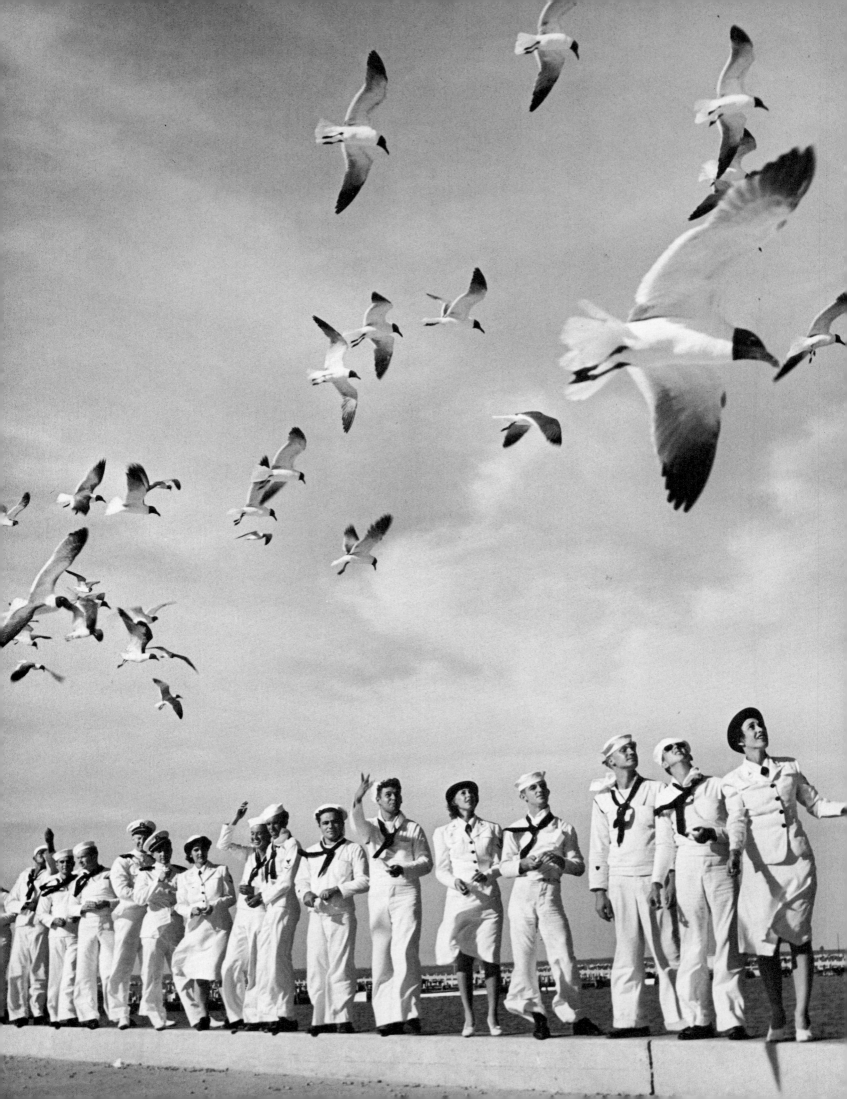

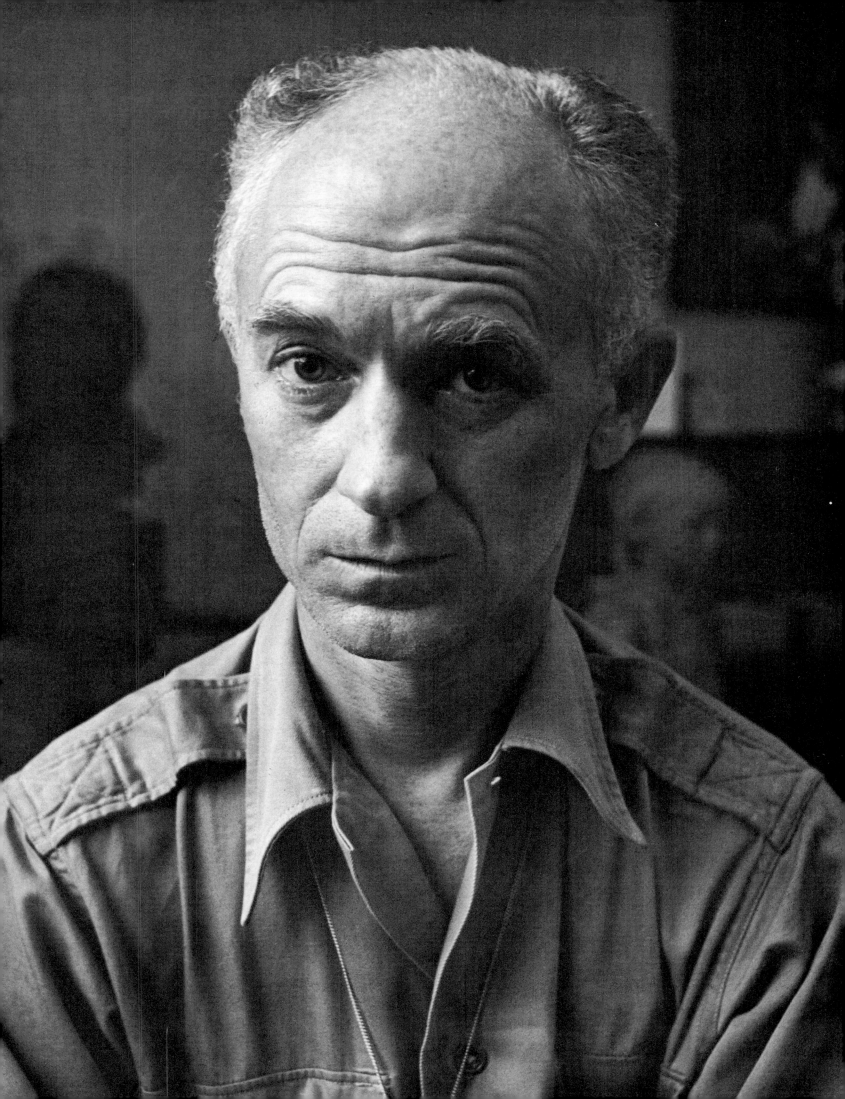

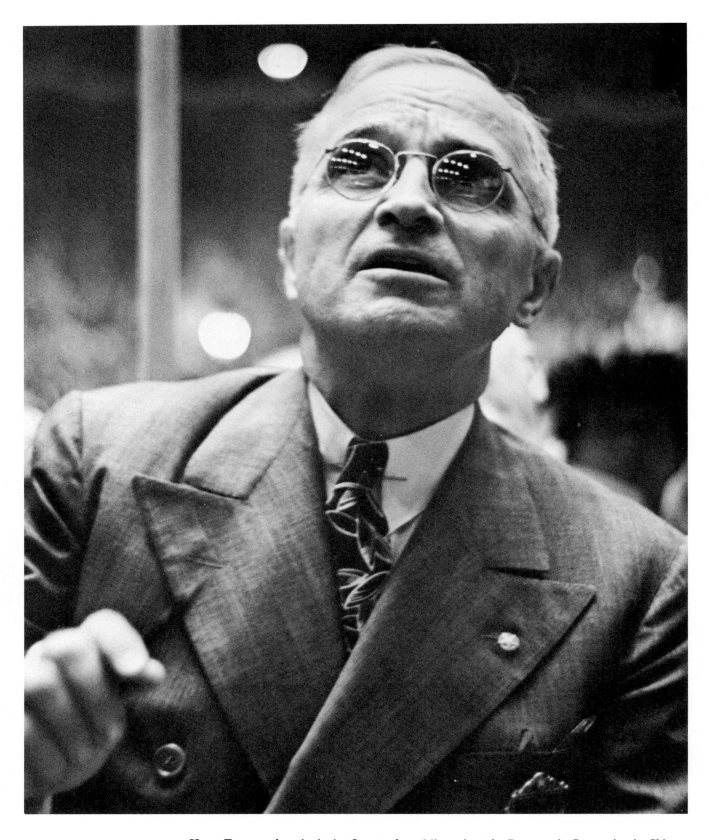

Harry Truman, then the junior Senator from Missouri, at the Democratic Convention in Chicago in July 1944, listening as his name is put in nomination for Vice-President. He became President when Franklin Roosevelt died, April 12, 1945. RIGHT: V-J Day. Smack in the middle of Times Square in New York City, a happy sailor and a passing girl show how the whole world felt about the end of the war.

PRECEDING PAGES: Sailors and Waves at the Corpus Christi, Texas, naval base in 1943 feed the sea gulls. Ernie Pyle, who won a Pulitzer Prize for his war reporting, poses for a bust being done by sculptor Jo Davidson in 1944. Pyle was killed the following year by Japanese machine-gun fire while covering a military operation on the island of Ie.

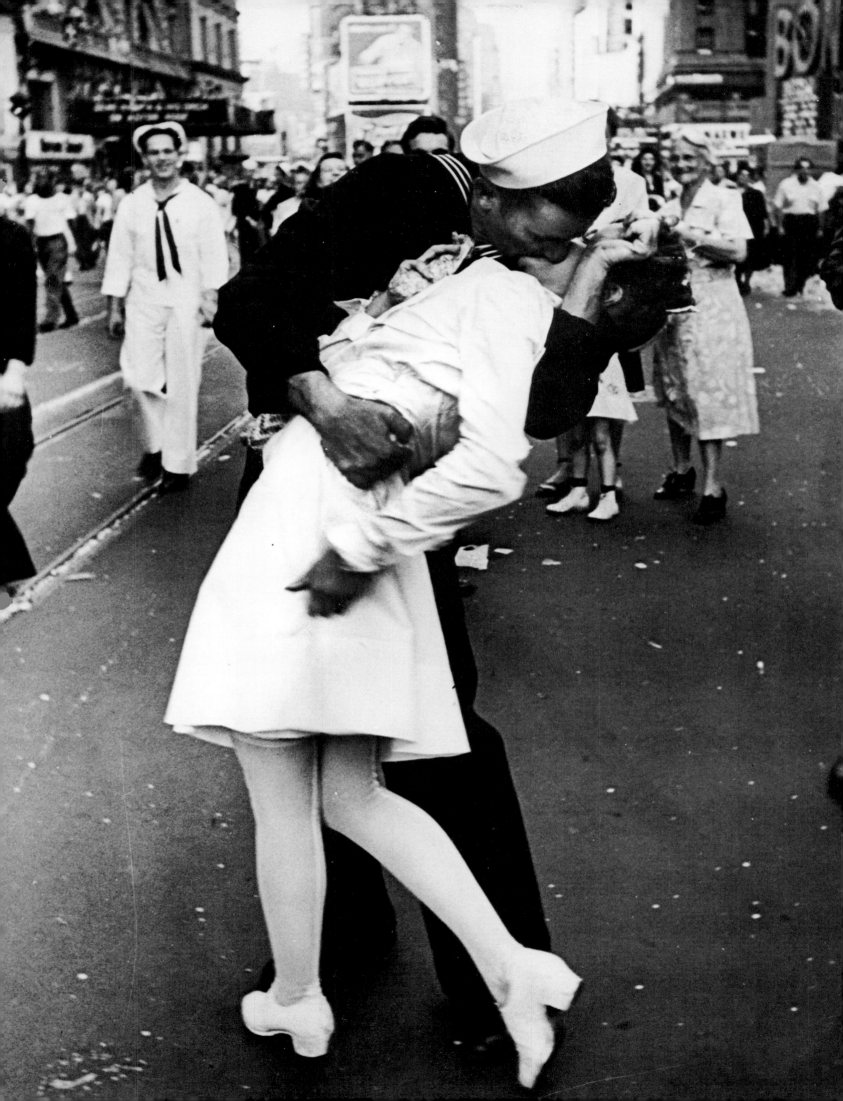

Birth of a Bomb

On August 2, 1939—one month after Germany had invaded Poland to start World War II—Professor Albert Einstein wrote a letter to President Franklin D. Roosevelt: "Some recent work by E. Fermi and L. Szilard . . . leads me to expect that the element of uranium may be turned into a new and important source of energy in the immediate future. . . . This new phenomenon would also lead to the construction of bombs. . . ." Thus was initiated what President Truman later called "the greatest scientific gamble in history"— the attempt by the United States to build an atomic bomb before Germany could.

The attempt took three years. Thousands of scientists and technicians—some of them famous physicists, such as Edward Teller, who had fled Nazi Germany or Fascist Italy— were recruited to work on the "Manhattan Project," directed by Brigadier General Leslie R. Groves. In charge of the technical laboratory at Los Alamos that produced the bomb was J. Robert Oppenheimer, one of the world's greatest theoretical physicists.

At 5:29:45 a.m. Mountain War Time on July 16, 1945, the first atomic bomb—4½ feet wide, 10½ feet long, and weighing 10,000 pounds—was exploded successfully in the desert wastes of southern New Mexico. Watching that first blinding flash, Oppenheimer, a Sanskrit scholar, thought of a verse from the sacred Hindu epic *Bhagavad-Gita:*

> If the radiance of a thousand suns
> Were to burst at once into the sky,
> That would be like the splendor of the Mighty One . . .
> I am become Death,
> The shatterer of worlds.

Twenty days later, a similar bomb was exploded over Hiroshima, Japan. Seventy-eight thousand men, women, and children were killed, 37,000 more injured, 13,000 listed as missing, and 60 per cent of the city was destroyed.

In 1949 Oppenheimer and Teller were major participants in a dramatic secret debate within the government and among atomic scientists about whether the United States should undertake a crash program to build a hydrogen bomb. Oppenheimer argued against the project, chiefly because he, and many of his colleagues—still haunted by the vision of the awful destruction the A-bomb had caused—felt that the superbomb would be an immoral weapon. Teller fought with a fanatic's determination for the idea of a crash program. Eventually President Truman decided to give it the go-ahead, largely because Klaus Fuchs, who had worked on the A-bomb and been privy to United States discussions on the H-bomb, confessed that he had been spying for the Russians since 1942. The H-bomb was built in the United States in 1952, barely a year before the Russians fired their own hydrogen device.

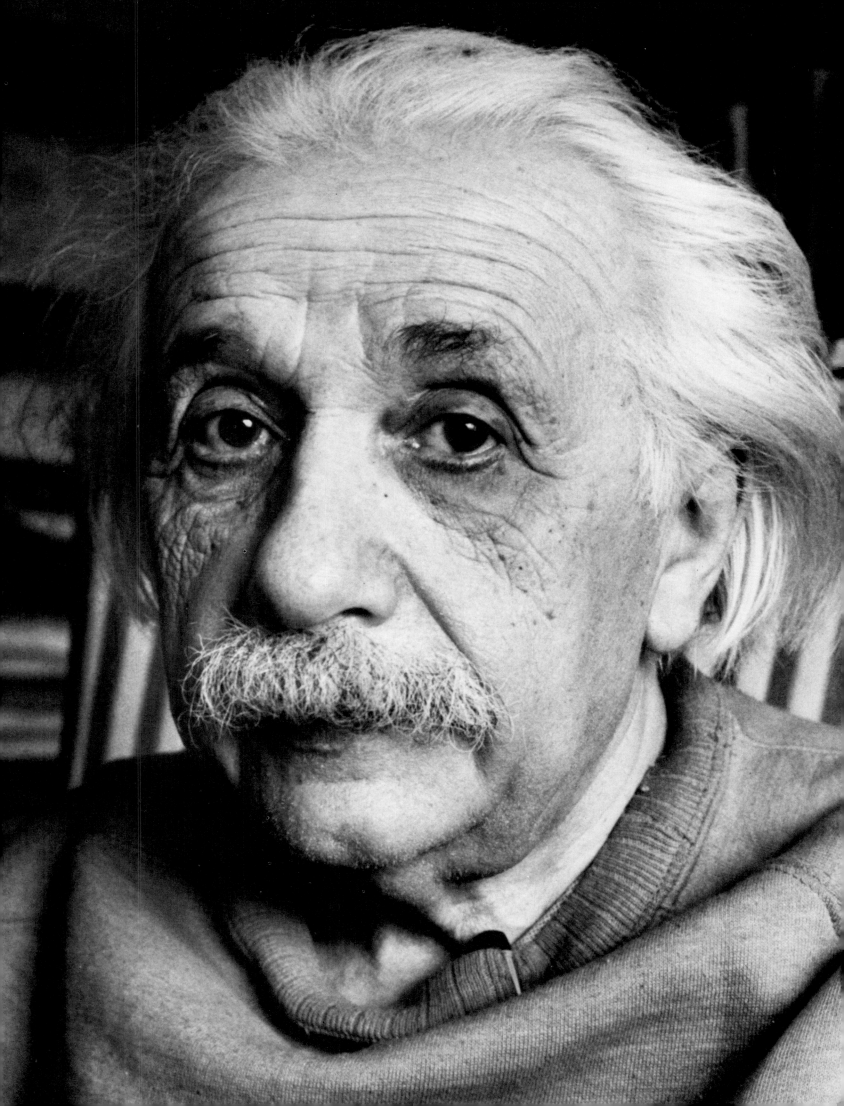

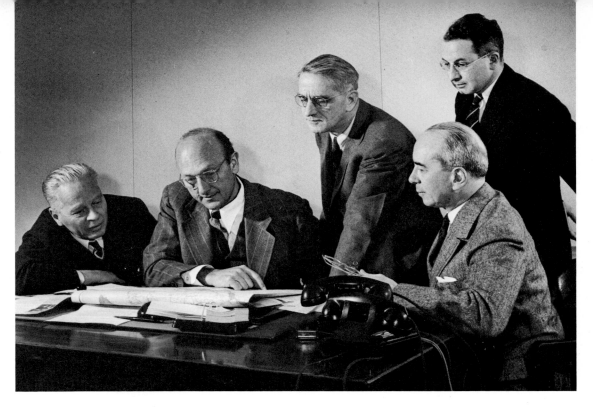

The Atomic Energy Commission supervised the United States program in the field. Members of the first commission were, left to right: Sumner T. Pike, Chairman David E. Lilienthal, William W. Waymack, Lewis L. Strauss, and Robert F. Bacher.

OPPOSITE: J. Robert Oppenheimer. In 1947, when he was director of the Institute for Advanced Study at Princeton, he was denied top security clearance by the AEC, partly because of his having kept company with known and ex-Communists in the 1930s. In my memento book he wrote: "To Eisenstaedt for his latest attempt to record men in their most difficult act: THINKING."

BELOW: Edward Teller, at the AEC hearings, testified in favor of lifting Oppenheimer's top security clearance. OVERLEAF: Eyes of Edward Teller.

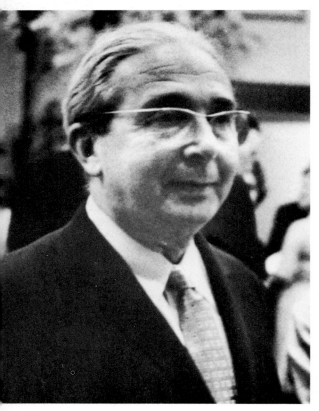

Leo Szilard in 1960.

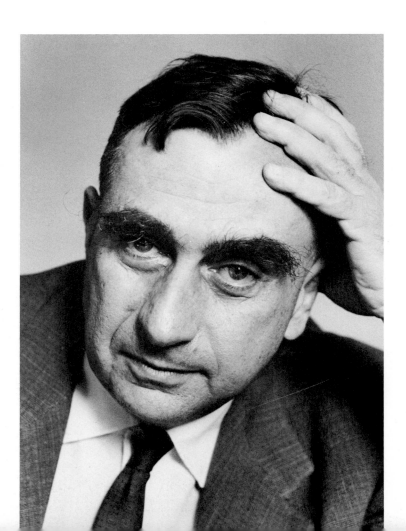

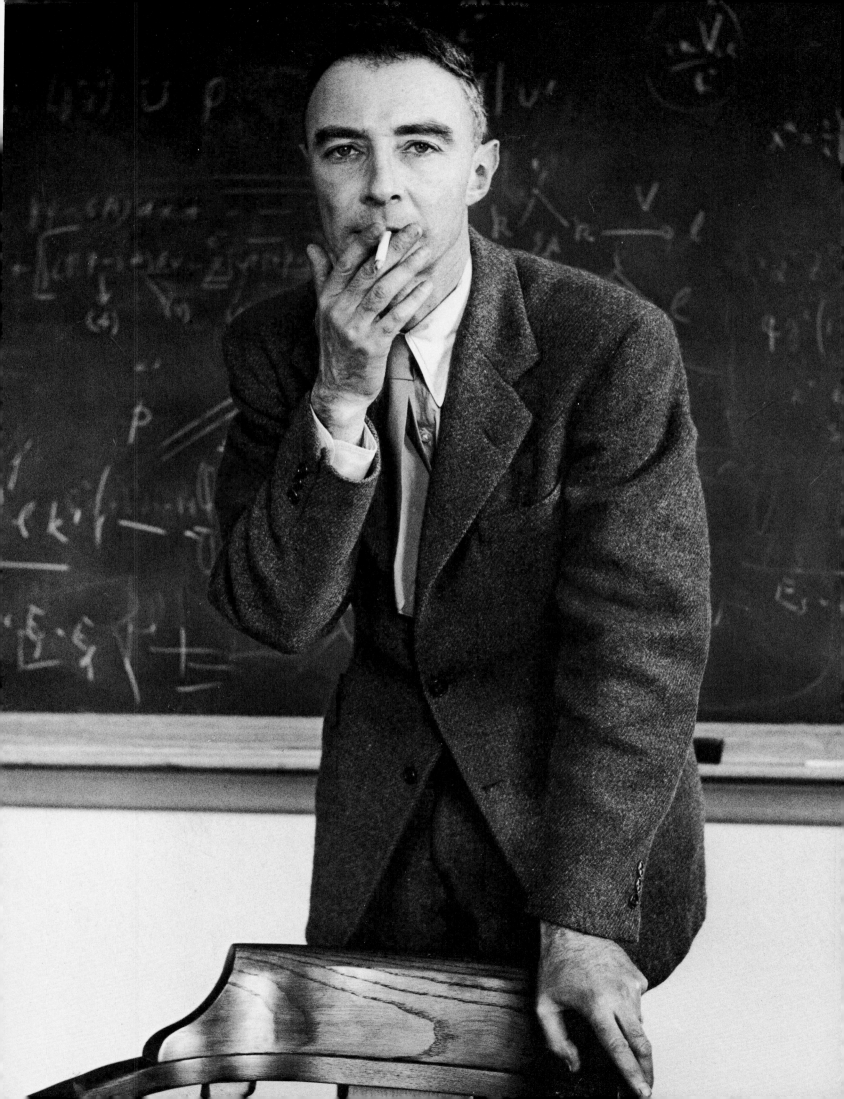

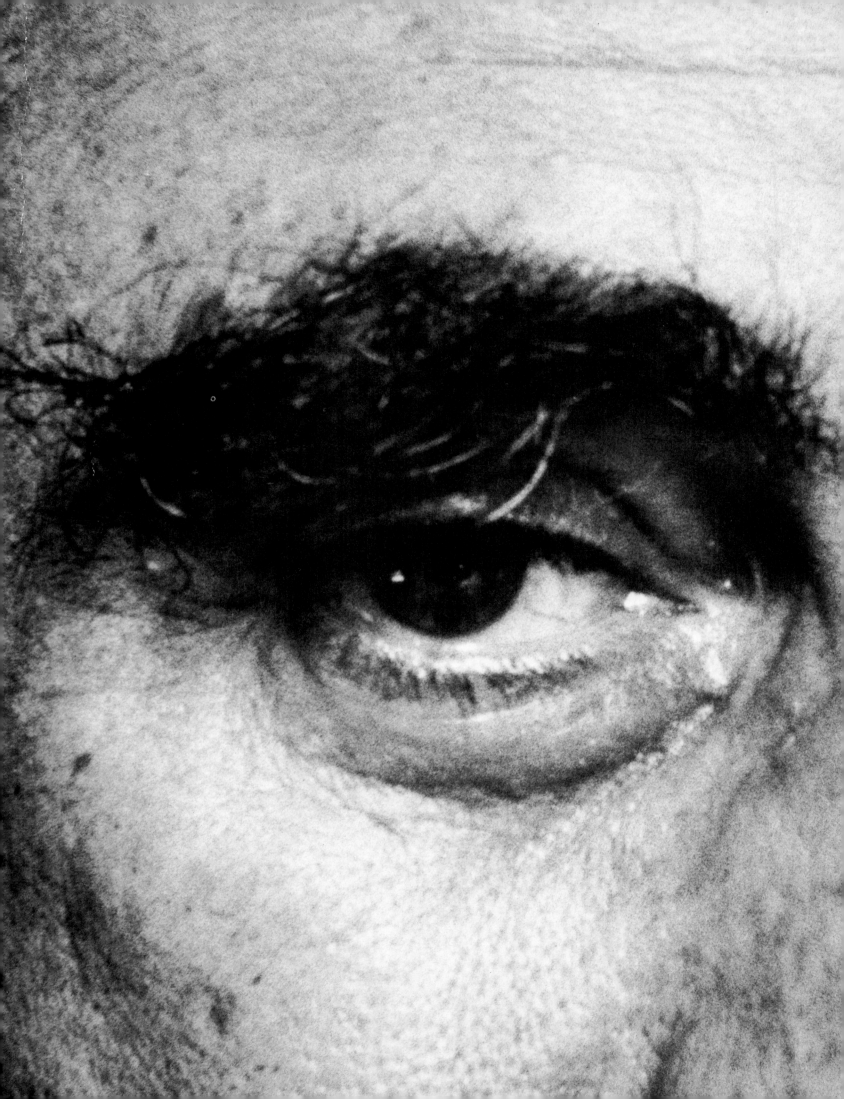

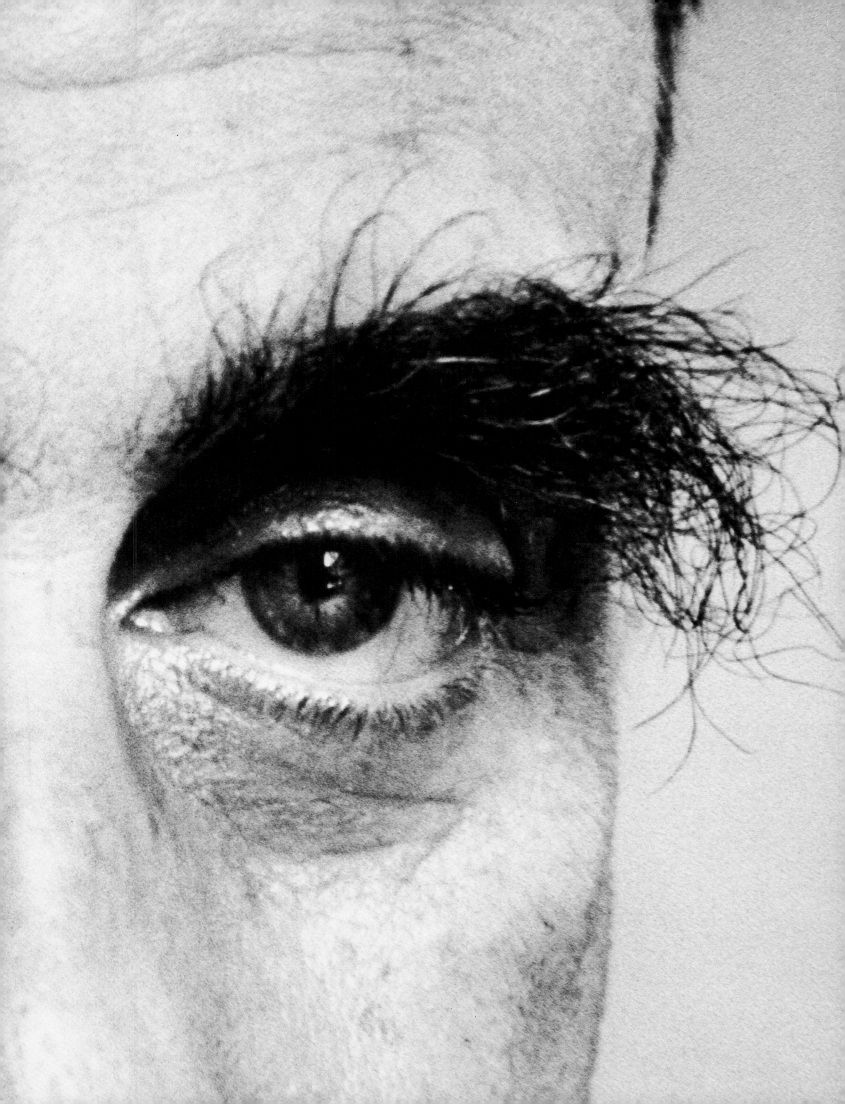

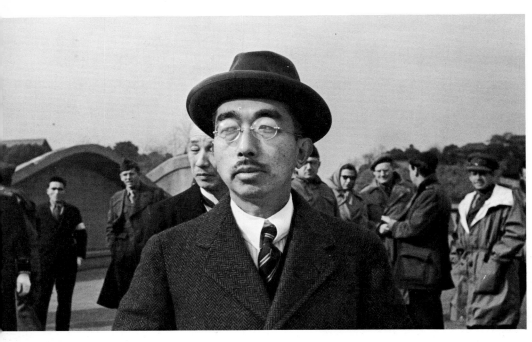

Emperor Hirohito, 1946.

A Defeated Japan

At noon on August 15, 1945, a stunned nation, which had never before heard the voice of its Emperor, listened to his recorded voice broadcasting the Imperial surrender rescript. "A new and most cruel bomb," Hirohito reported, had just devasted Hiroshima and Naga-saki. "We have now resolved to pave the way for a grand peace . . . by enduring the unendurable and suffering what is insufferable." Thus a proud, isolated Japan which had never in its long history known either military defeat or occupation was accepting one and bracing itself for the other.

The Emperor looked more like a tired businessman than the formerly unapproachable "direct descendant of the Sun Goddess" when I went with him on his first tour from Tokyo to Yokahama. He had formally renounced any claims to divine status ("He came down from the clouds," the Japanese said) and he was undertaking a series of unprecedented informal visits throughout the country. Everywhere his closed black limousine passed, adorned with the Imperial flag, the people remained completely silent. Many turned their backs on him, afraid to look, for they had been brought up to feel that the Emperor was godlike. Others kneeled with bowed heads or lay prone on the ground, motionless, till the cavalcade passed. Not a sound was heard, not even a shout from a child. The few people he talked to must have noticed that he was really only a very short man with a voice like the squeaking of a mouse. But they were all overcome: here was the *Emperor*!

Earlier, when I had gone to Hiroshima, hardly a building was standing, but the people had cleared all the rubble from the streets. A mother and child were wandering near a ruined site where once they had lived. They were looking at some green vegetables they had raised from seeds planted in the ruins. When I asked the woman if I could take her picture, she bowed deeply and posed for me. Her expression was one of bewilderment, anguish, and resignation. I did not ask whether her husband had died in the blast or whether he was still in the Army or a prisoner of war. All I could do, after I had taken the picture, was bow very deeply before her.

OPPOSITE: Mother and child at Hiroshima. OVERLEAF: Returned from Manchukuo, China, where they have been on duty as colonial administrators for Japan, two Japanese civilians gaze at paddies near their home in Sasebo that they have not seen for years.

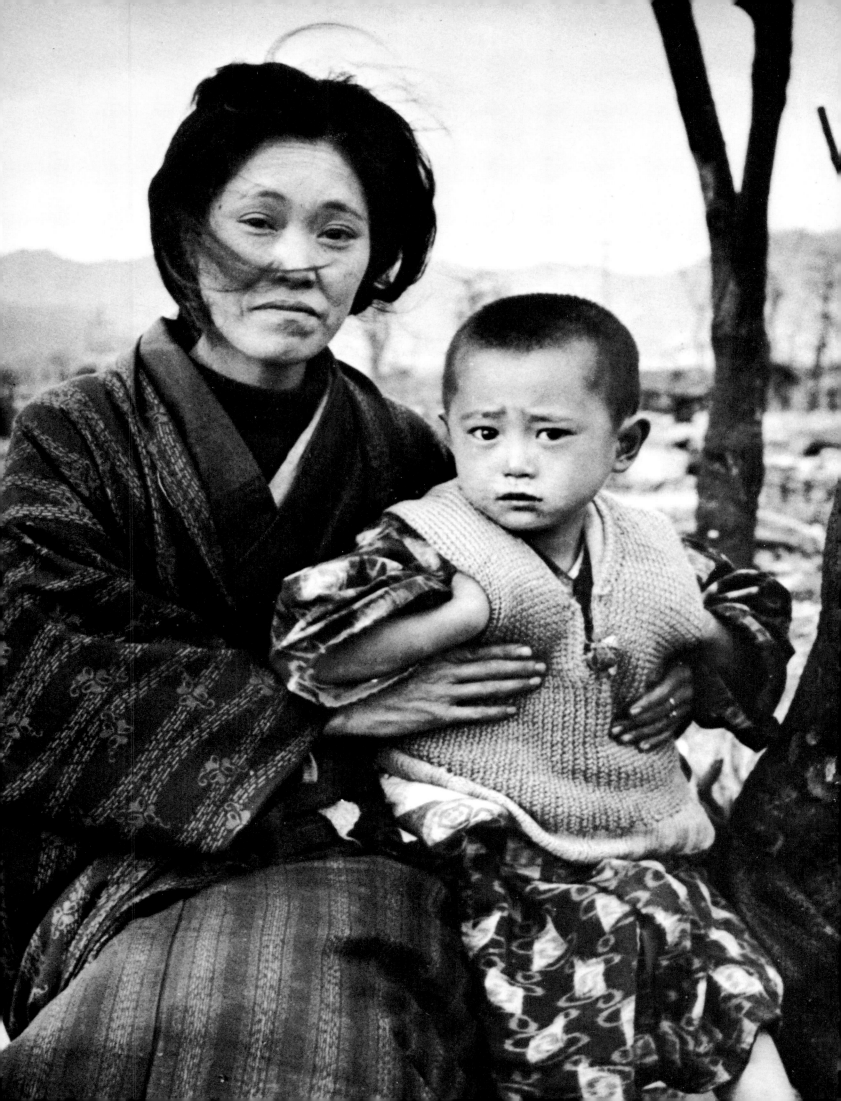

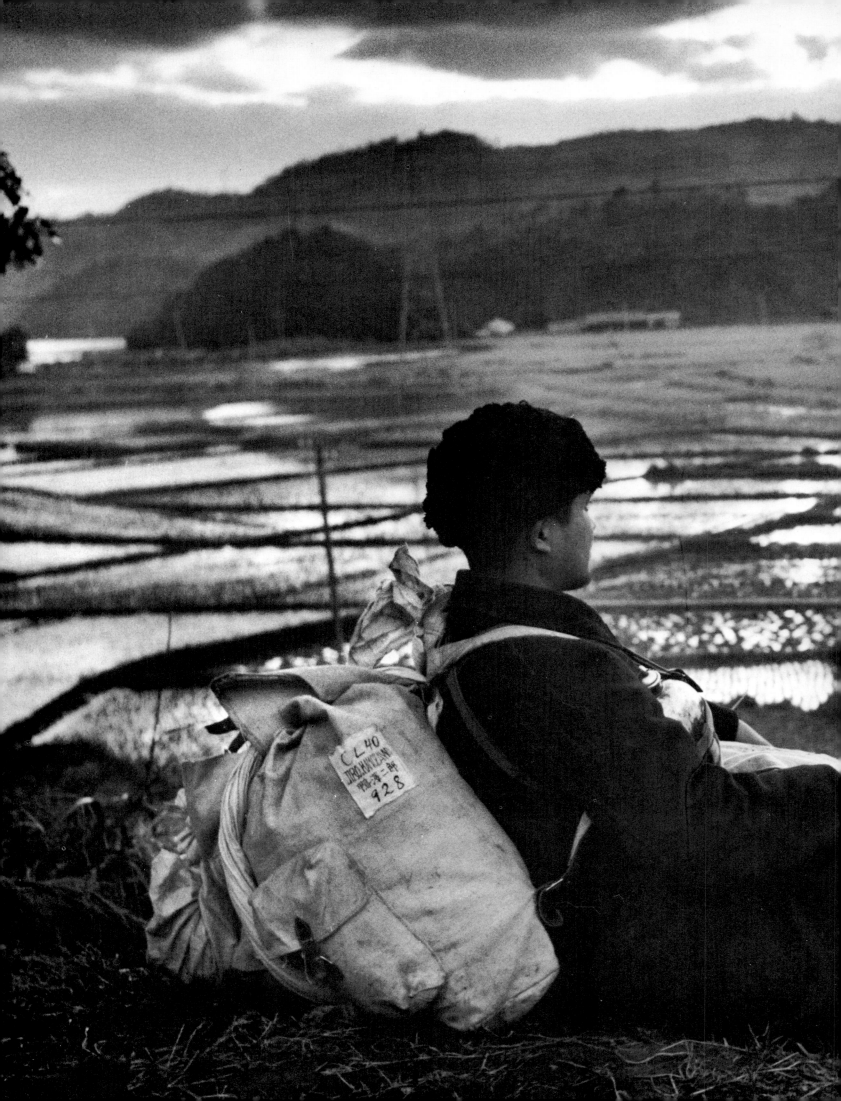

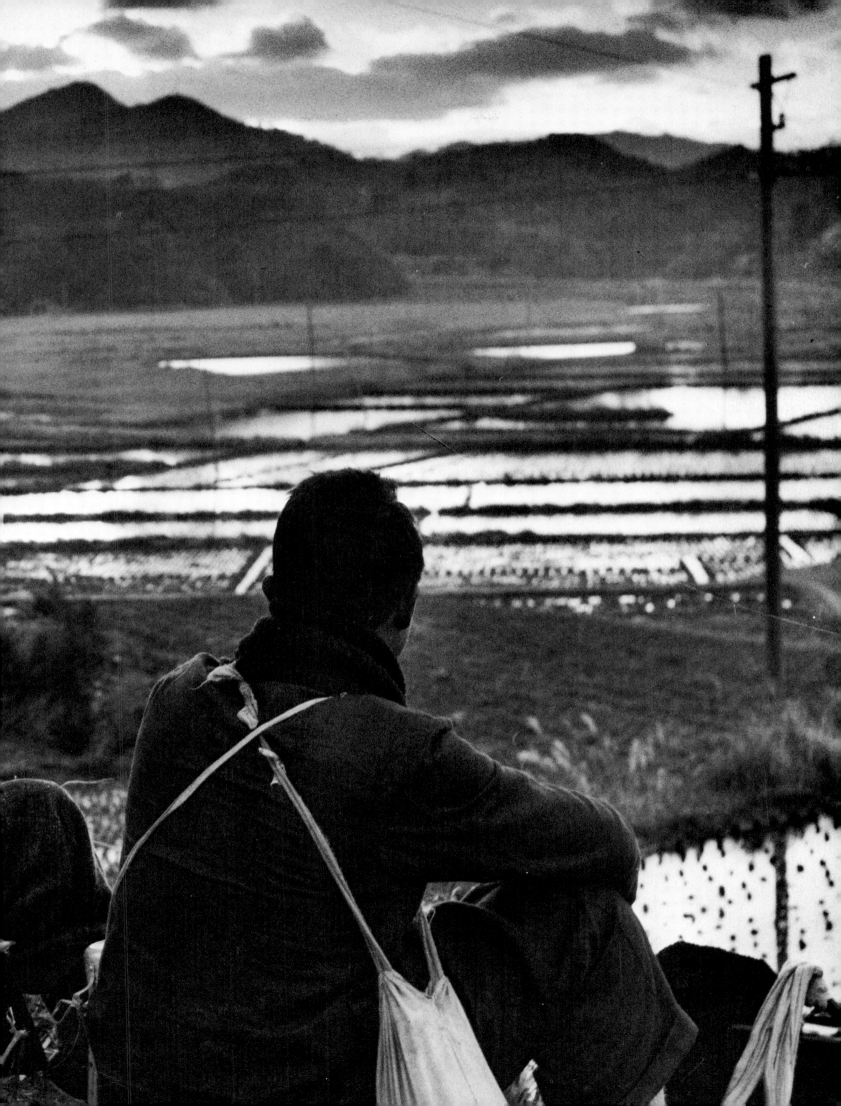

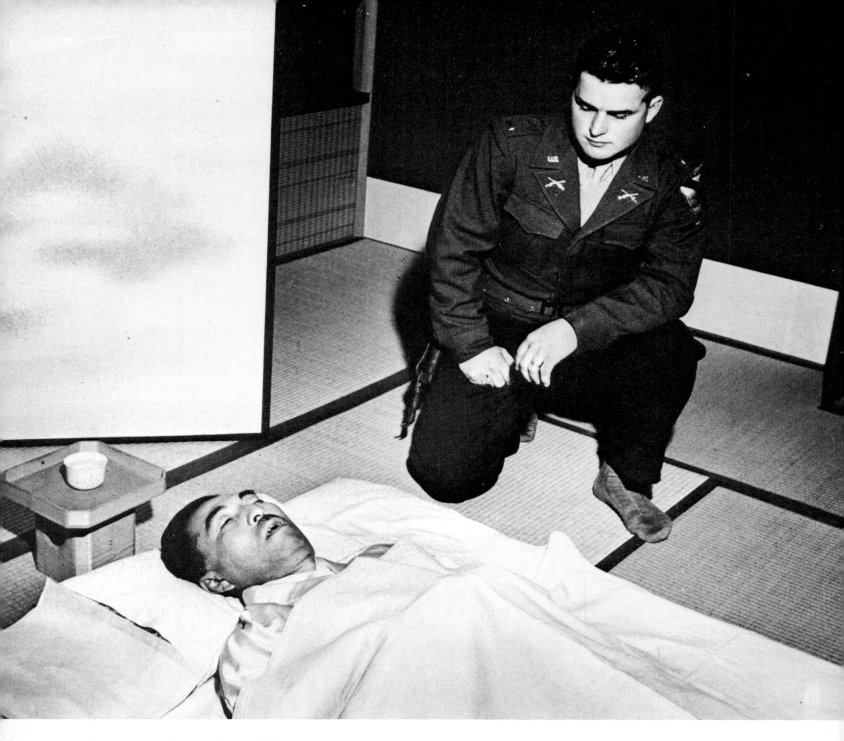

Prince Konoye, after committing suicide.

Prince Fumimaro Konoye, who had been premier of Japan twice, was required in December 1945, along with other political and military leaders, to enter Sugamo prison in Tokyo, pending possible indictment as a war criminal. The night before he was to surrender he gave a party in his home, chatted pleasantly with his guests, and then, after they had gone, poisoned himself rather than undergo what he felt to be an intolerable humiliation. Before American soldiers entered the house to remove the body, they took off their shoes in proper Japanese custom. An international tribunal sat for some two years considering the cases of Japanese war criminals. Seven Japanese leaders, including two former prime ministers, were sentenced to death and eighteen others were sentenced to varying terms of imprisonment. In the spring of 1946 I was present when the war criminals were brought from their cells in a dark green prison van to the former Ministry of War building, where they were indicted. Among them was Lieutenant General Hideki Tojo, who had succeeded Konoye as premier in October 1941 and launched the war against the United States. After Japan's surrender Tojo had tried to shoot himself but had bungled the job. Now he was silent, his head bowed, eyes fixed on the ground, perhaps contemplating the shame and misery he had brought upon his Emperor and his nation. The only way I could attract his attention so that I could get a picture of his face was to yell at him: "Hey, Tojo, look at me." He did—and then continued walking. He was hanged on December 23, 1948.

OPPOSITE: General Hideki Tojo on his way to indictment for war crimes.

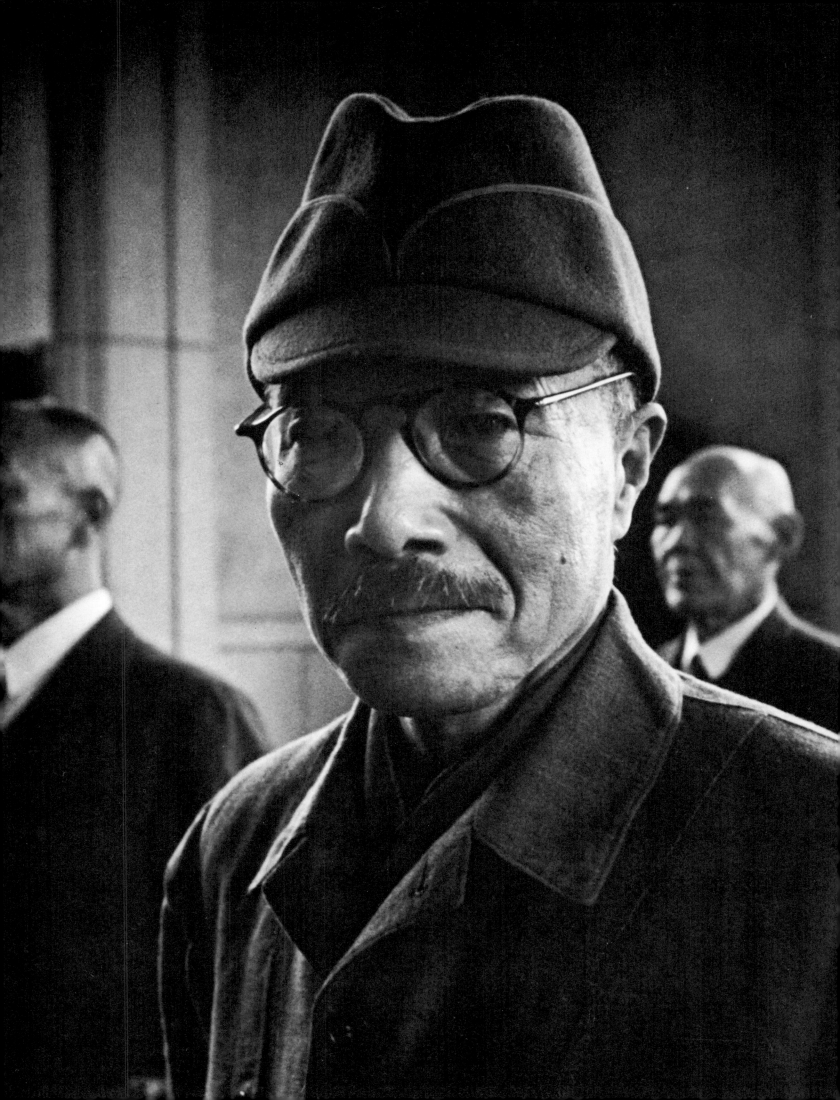

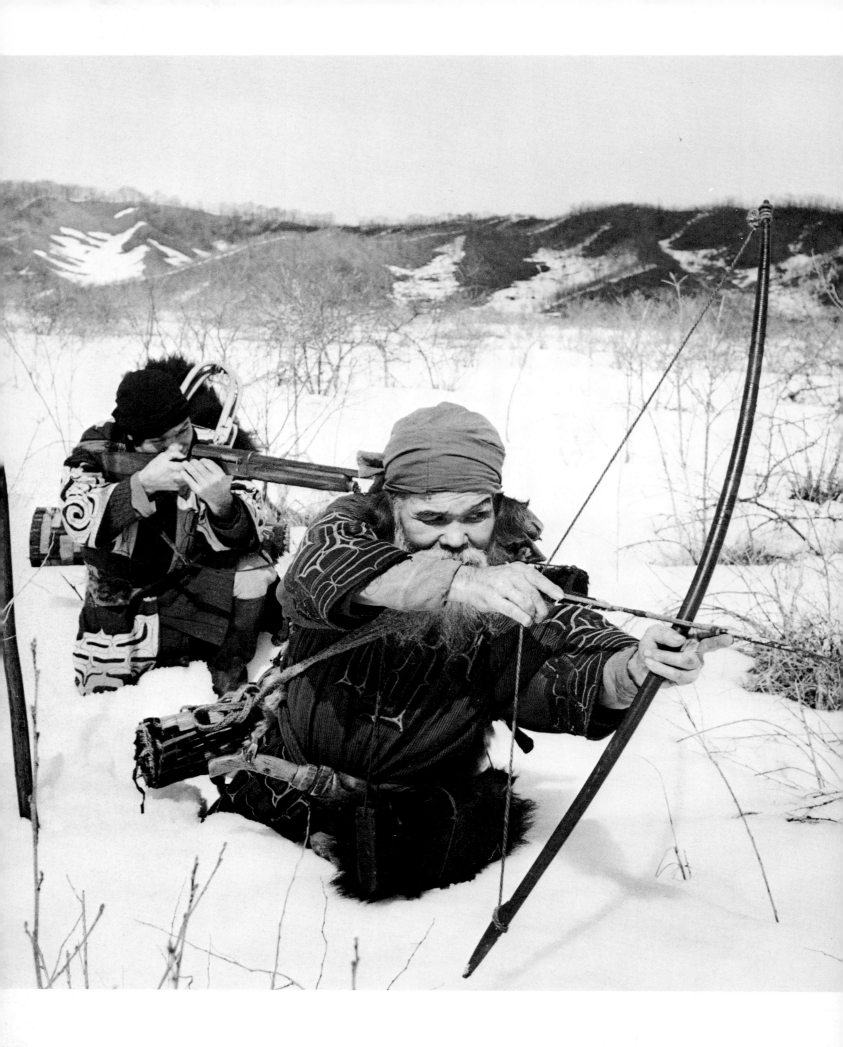

Virtually untouched by the war—or any other outside influence—were the "Hairy" Ainus, one of the world's racial curiosities, who live on the Japanese island of Hokkaido, on the Kuriles, and on the Soviet island of Sakhalin. The original inhabitants of Japan, they numbered only 20,000 in 1946, and I was told that the tribe will be virtually extinct by 1976. Although no more hairy than the average Western man, they were given their name by the relatively hairless Japanese. A primitive superstitious people, they believe they will die if they ever take a bath, and they worship many gods, including bears. The high point of their social and religious year is the Bear Festival. Old Chief Miyamoto and his men on Hokkaido, armed with bow and arrow and musket (OPPOSITE), went off to the hills, deep in snow, to bring back a bear. Then the young hunters, still wearing their Japanese Army uniforms (RIGHT), skinned it and drained the blood. To the chief belongs the right of drinking the first bowl of cold brown bear's blood and eating its testicles. Chief Miyamoto had invited me to share the privileges and I couldn't sleep the night before, wondering how I could get out of it. The next day I faked illness. My eyes were flickering and I was breathing so hard that they thought I was really sick. The chief said, "So sorry," then proceeded to gulp down his bowl *and* mine of bear's blood, while his people sat around a charcoal fire (BELOW), singing ancient hour-long Ainu ballads.

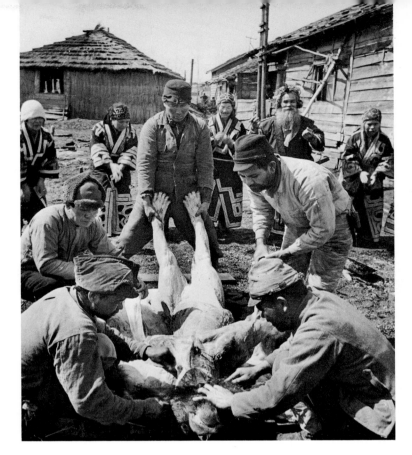

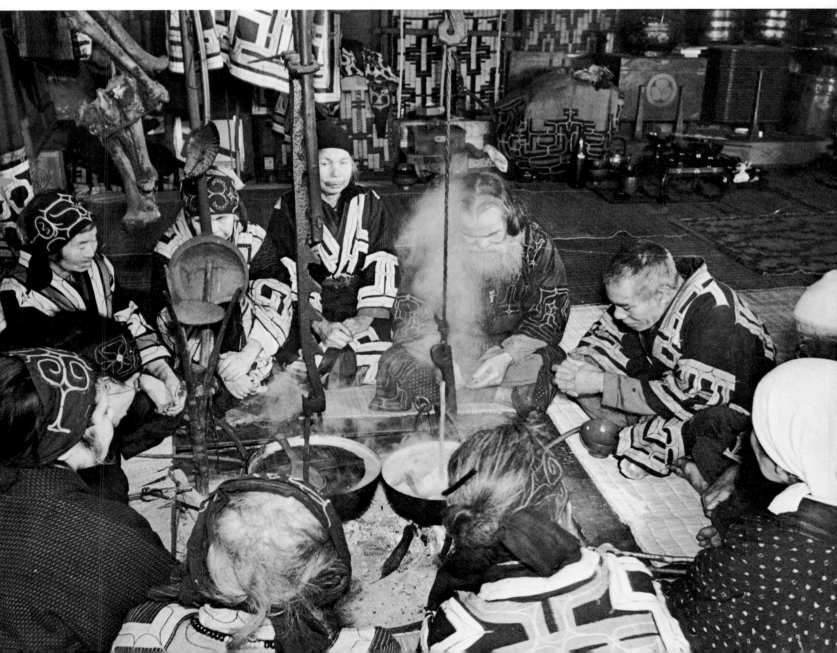

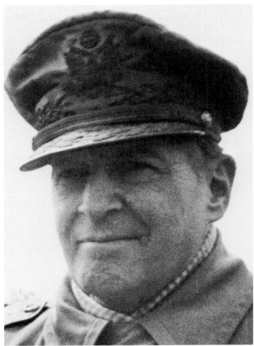

Syngman Rhee, President of South Korea 1948-1960, and General Douglas MacArthur, 1951.

The Korean War

On a desolate, icy, and windswept road just north of Kaesong, two American G.I.s mounted guard along the 38th parallel. It was December 1945, and the parallel was then regarded—by the Americans, at least—as simply an arbitrary convenience for facilitating the roundup of Japanese troops in Korea, now that Japan had surrendered. Russian troops were to pick up Japanese north of the parallel; Americans, those south of the line. It became quickly apparent, however, that the Russians regarded the 38th parallel as a permanent partition of the country, at least until they and the North Koreans should be able to "unify" the whole country into a Communist People's Republic. They tried it in 1950: at 5 a.m. on June 25 North Korean tanks and 75,000 infantrymen poured across the 38th parallel at six points, including Kaesong. Thus began the Korean War, which one observer summed up as the "most disheartening and frustrating, the coldest and the dreariest, the least inspiring and the least popular war in American history." Before the armistice was signed three years later (after two years of truce negotiations) the United Nations Command suffered an estimated one million casualties, including civilians. When Communist Chinese forces entered the war in defense of North Korea, General MacArthur, in command of UN forces, publicly insisted, against administration and UN policy, that the war be carried outside Korea to China itself. On April 10, 1951, President Truman put down the general's challenge to his authority by removing him from all his commands, precipitating a political crisis that reverberated into the 1952 Presidential campaign. The cease-fire line agreed on in November 1951 still divides North and South Korea and runs roughly along the 38th parallel. The sentry post where the two G.I.s patrolled that wintry day in December 1945 is now just on the Communist side of the line.

The 38th parallel

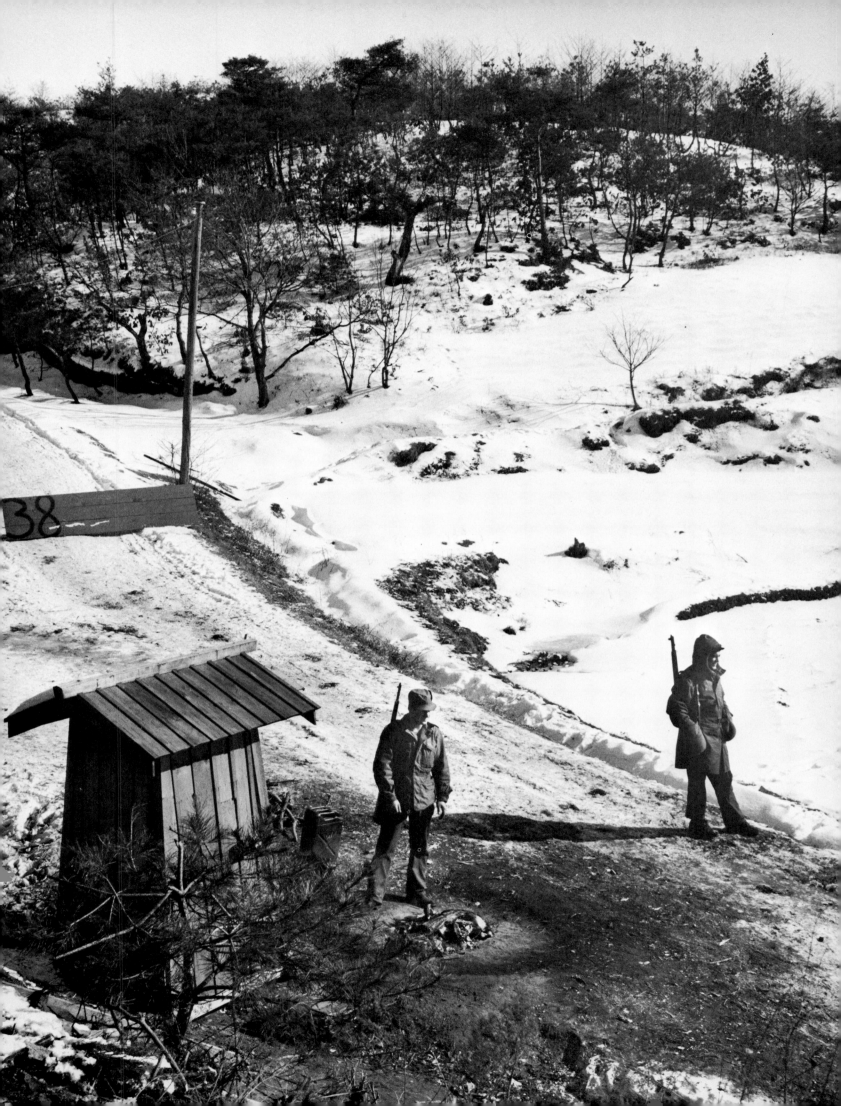

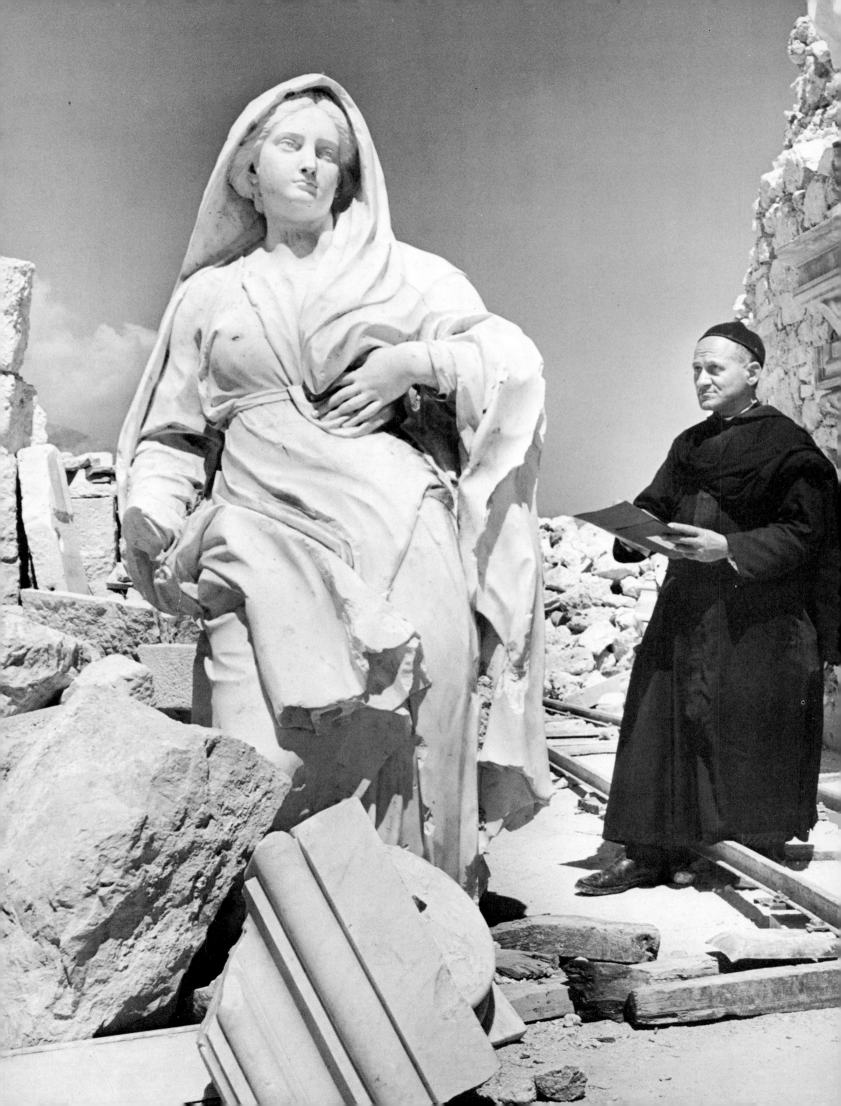

Alcide de Gasperi, Premier of
Italy from 1945 until 1953.

Italy:
The Communists Lose

In the ruins of the Abbey of Monte Cassino in 1947 I found a lay brother making sketches among the damaged statues to aid in the eventual restoration of the sixth-century Abbey that had been almost leveled in 1944 by Allied bombs. Italy was digging herself out from the rubble of war. The country had voted out the monarchy in May 1946 and after twenty years of fascism the infant republic was facing up to age-old antagonisms and divisions—the rich versus the poor, the north versus the south, the anti-clerics versus the Church, the right versus the left.

Two million people were unemployed and, in the south especially, poverty held the peasants in virtual slavery. In Naples (page 138) the slums were a fetid jungle where men, women, and children tried any means to survive—even murder, theft, and prostitution. Children in rags, orphaned by the war, roamed the streets, scrounging a living by picking up discarded cigarette butts, mixing them with straw and other materials, and peddling them as the real thing.

I was chased through a dark alley in Naples by three boys with knives; Neapolitans, I learned, did not like cameras because the police used to send photographers into the slums to get pictures of black-marketeers. In the countryside a peasant, who lived with his family in a one-room, windowless hut and tilled a vineyard for a rich absentee landlord in northern Italy, told me that they had not eaten meat for six months. But now, he confided, they were saving as best they could—to buy the youngest daughter a new white dress for her forthcoming confirmation.

The struggling country seemed ripe for the Communists, who had emerged from the war with 2.5 million members—the largest Communist party in the world, including that of Russia. They had millions of other sympathizers and an armed partisan organization virtually intact, ready for revolution. But Stalin had ordered the Italian Communist party not to plunge the country into civil war; instead they were to seek power through parliamentary means. In 1947 the Communists launched strikes and riots, occupied factories, and disarmed policemen. But in the 1948 elections Premier Alcide de Gasperi's Christian Democratic party trounced the Communists. In every election thereafter, the Communists were to continue to receive almost a quarter of the total national vote, but they had lost their chance to take over Italy.

Monte Cassino, 1947.

LEFT: Pietro Nenni, leader of the Socialist Party, formed a Popular Front with the Communists for the 1948 election.

BELOW: While armed riot police stand by in case of trouble, 50,000 members of Communist labor unions march in silence through Rome.

OPPOSITE: Vittorio Emanuele Orlando, eighty-seven, elder statesman of Italian politics, was the last survivor of the "Big Four" (which included Clemenceau, Wilson, Lloyd George) of the 1919 Peace Conference. He died in 1952.

OVERLEAF: In Naples, a slum section. In Rome, Marchese Don Giovanni Battista Sacchetti and his wife in the dining hall of their sixteenth-century palace, one of the handsomest in Italy.

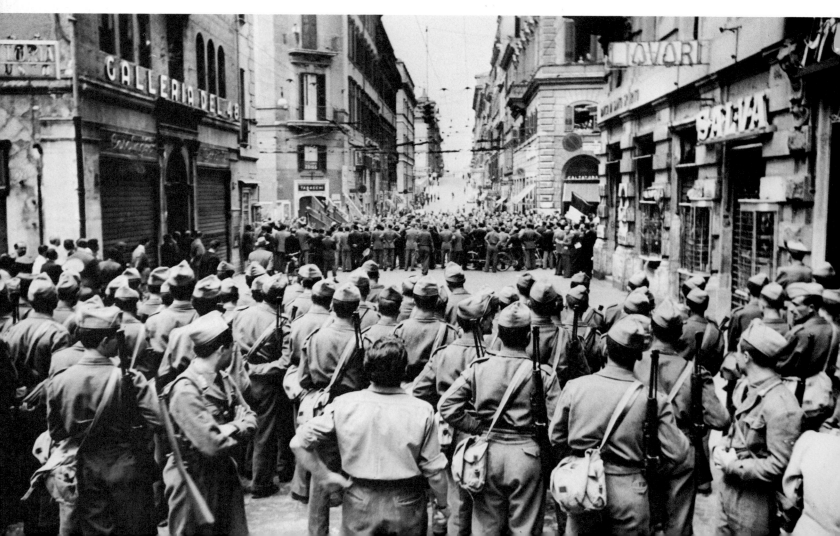

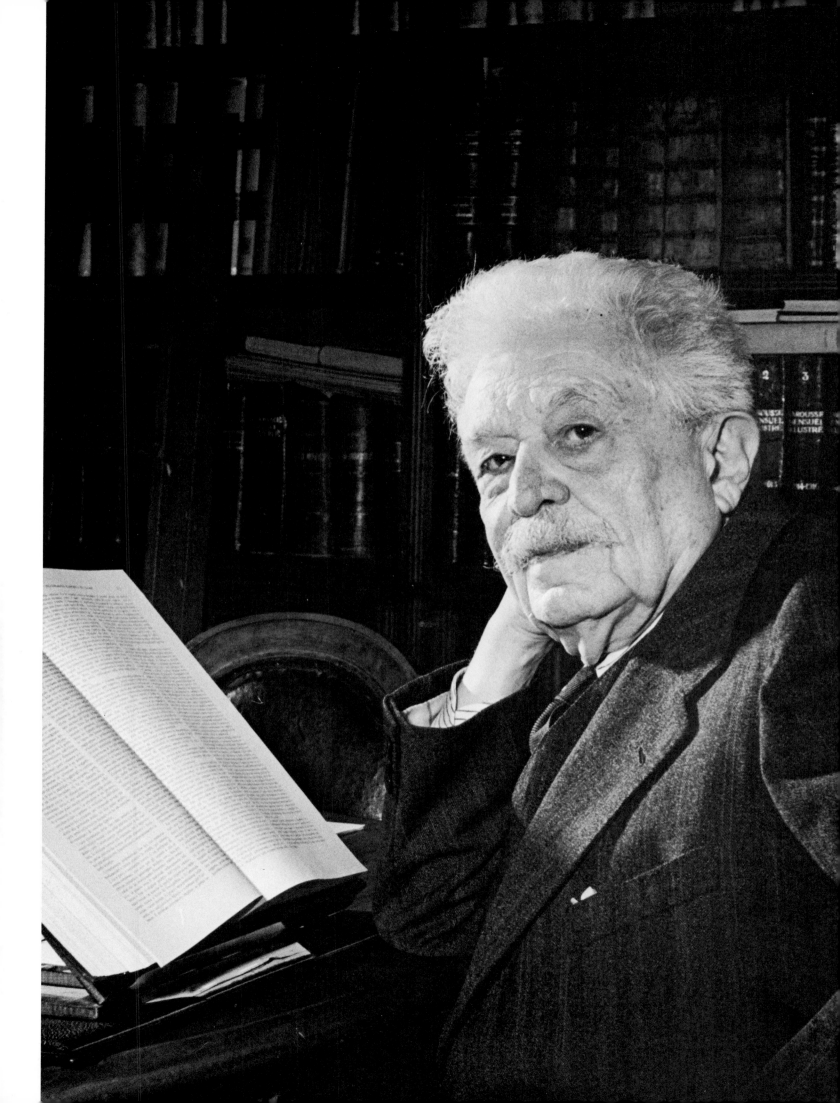

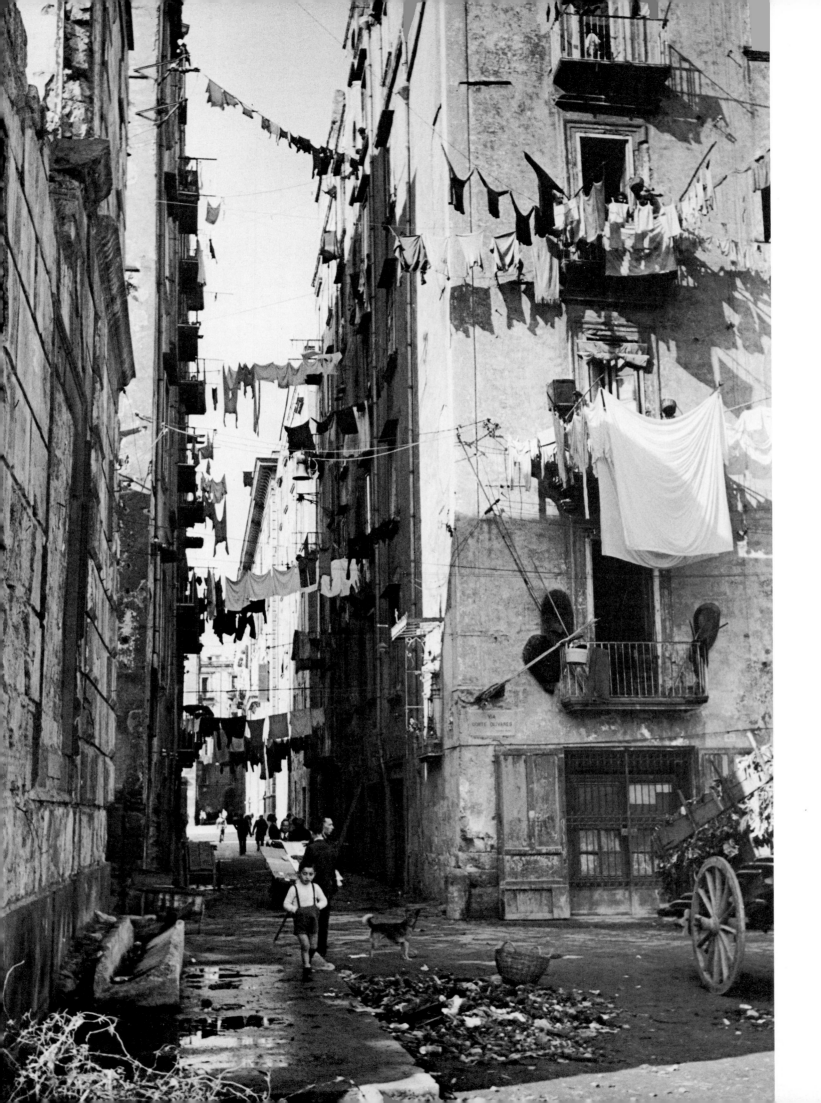

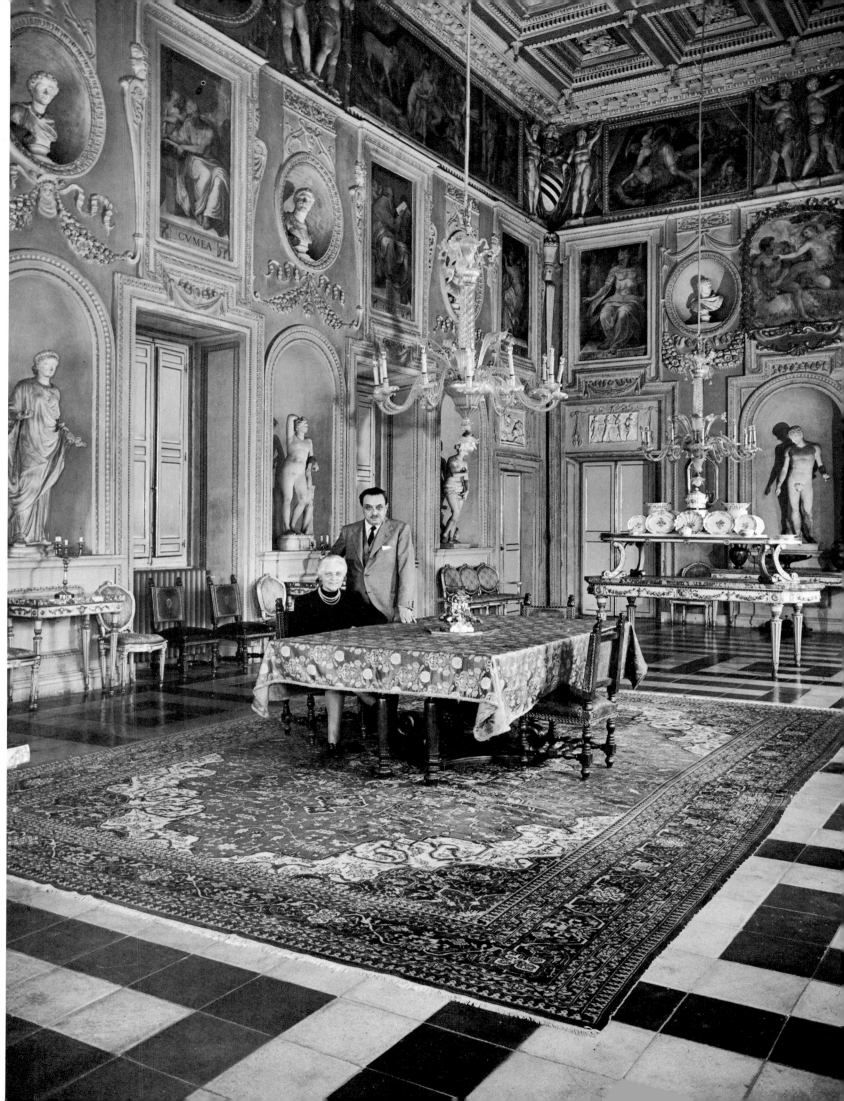

Czechoslovakia: The Communists Win

In the splendor of Prague's ancient Hradcany Castle, President Eduard Beněs and his Foreign Minister, Jan Masaryk, were once again fighting to keep their infant republic alive and free. In October 1938, after the Nazis marched in, the two men had fled to England and established a government-in-exile. Now, in 1947, restored to power, they were waging another delaying action—this time against a Communist attempt to seize power. Masaryk seemed the most cosmopolitan diplomat I had ever met—well-dressed, fond of good food and wine. He loved music, and playing the piano was one of his hobbies. At the Foreign Ministry the next day, he played some Chopin études for me and wrote in my book: "I like folks who know how. Alfred Eisenstaedt is certainly one of them. Good luck to him." I never saw him again. Following a Communist coup d'état in February 1948, Masaryk was found dead in the courtyard of the Foreign Office—either a suicide or murdered by the Communists. Four months later Beněs resigned and the Communists took over.

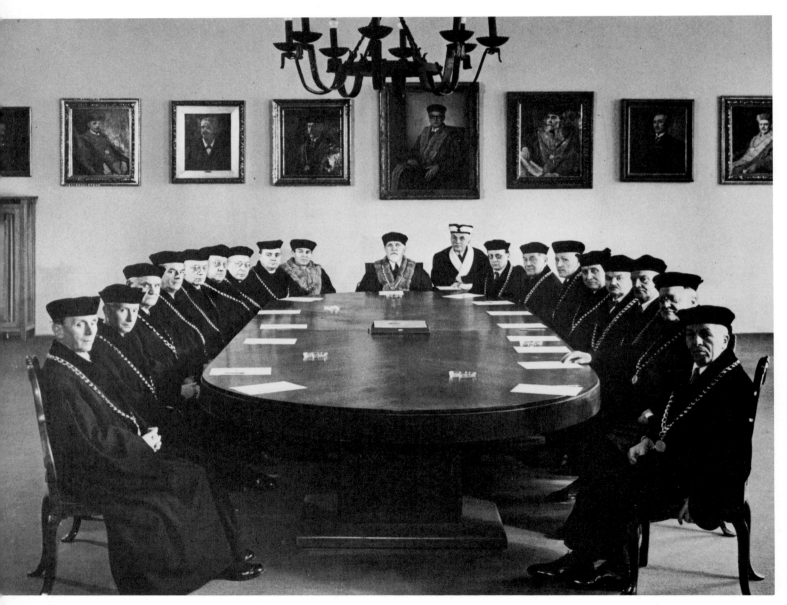

Despite the Nazi occupation, during which thousands of students went to concentration camps and twenty-one professors were executed, Prague's 600-year-old Charles University functioned again after the war, led by its "senate" of educators. OPPOSITE: President Eduard Beneš (seated) and Foreign Minister Jan Masaryk.

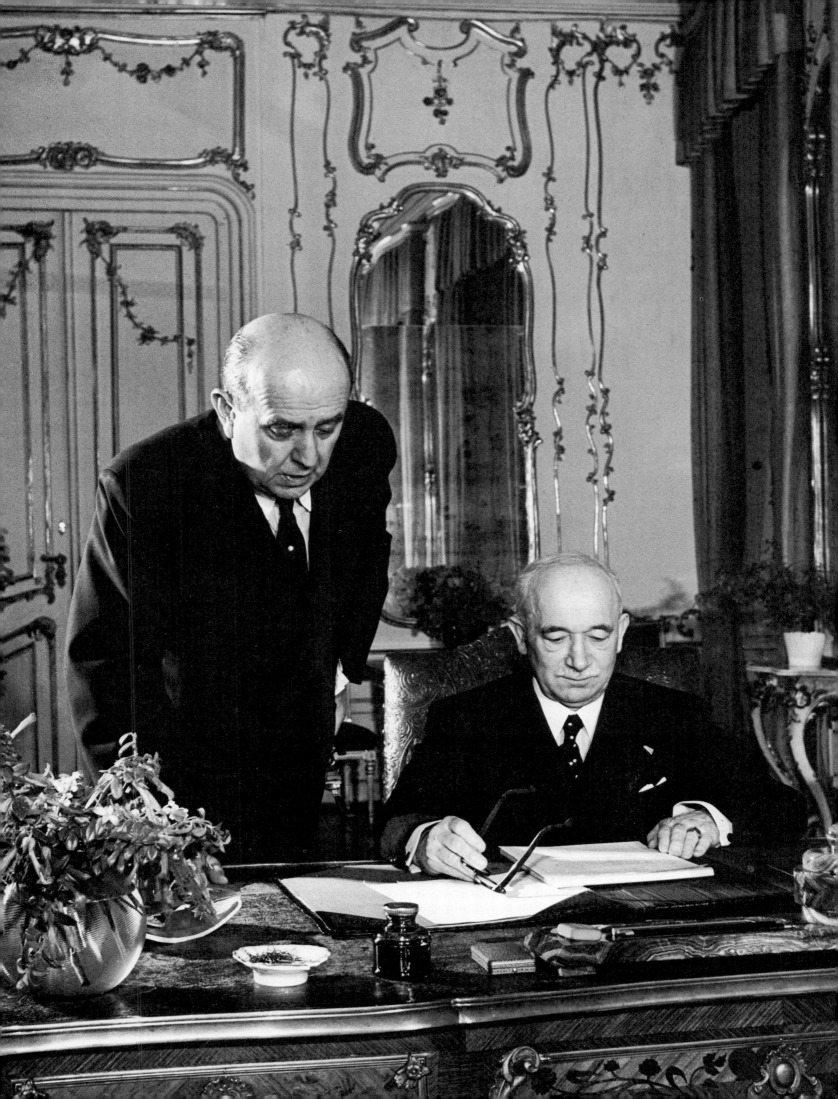

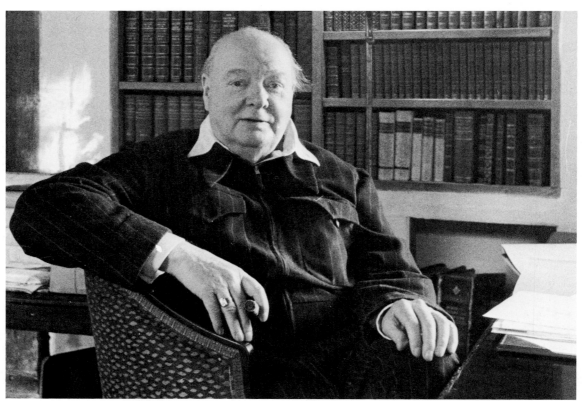

Churchill at Chartwell.

England: Three Prime Ministers

Three men, as dissimilar as their portraits, ran postwar England. In July 1945 Winston Churchill, the war hero, and his Conservatives were overwhelmingly turned out by the voters in favor of Clement Attlee and a Labour government. In six years Attlee's government nationalized transport and utilities and heavy industry and tried to set up a "cradle-to-the-grave" welfare state. Even more outrageous to the Conservatives, Attlee's government speeded up the dissolution of the Empire by giving independence to India, Pakistan, Ceylon, Burma, and Palestine. In 1951 Churchill and the Conservatives were returned to power by eighteen votes. Four years later, aged eighty and ailing, Sir Winston retired to make way for Anthony Eden.

Churchill allowed me to photograph him in October 1951 at his estate, Chartwell. He wore a housejacket and held a half-smoked cigar. (Later, when I asked Lord Beaverbrook how many cigars Churchill smoked daily, he said, "It's all a fake. He smokes only two cigars a day but when photographed he always has one handy. That's his trademark.") Churchill looked straight ahead, almost with blank eyes, and kept repeating to himself a verse about a captain standing on a ship when a big wave came. It may have been a poem about Lord Nelson. When I set up my tripod and camera to photograph him from the angle I wanted, Churchill objected. "Young man"—I was fifty-one at the time—"*I* know how to take pictures. You have to do it from *there*." An aide hurried over, whispering that Churchill always likes to have the last word. I photographed him from the angle he wanted and then from *my* angle—the one above.

Later I went with him to Liverpool on his campaign trip. While I was standing right in front of him, taking pictures, he suddenly fell asleep. The band started to play "God Save the King," but he was still dozing. His son Randolph leaned over and pushed him on the right shoulder, and up shot Winston Churchill, arm automatically upraised.

Churchill in Liverpool

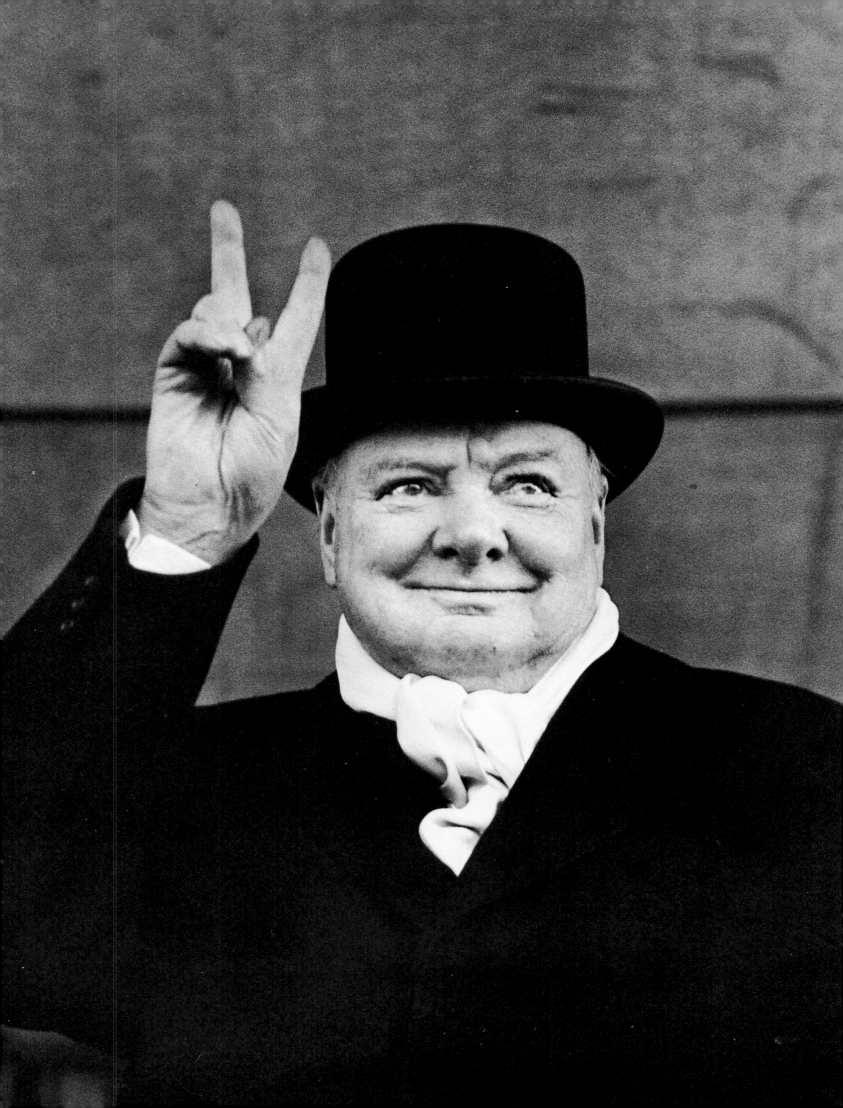

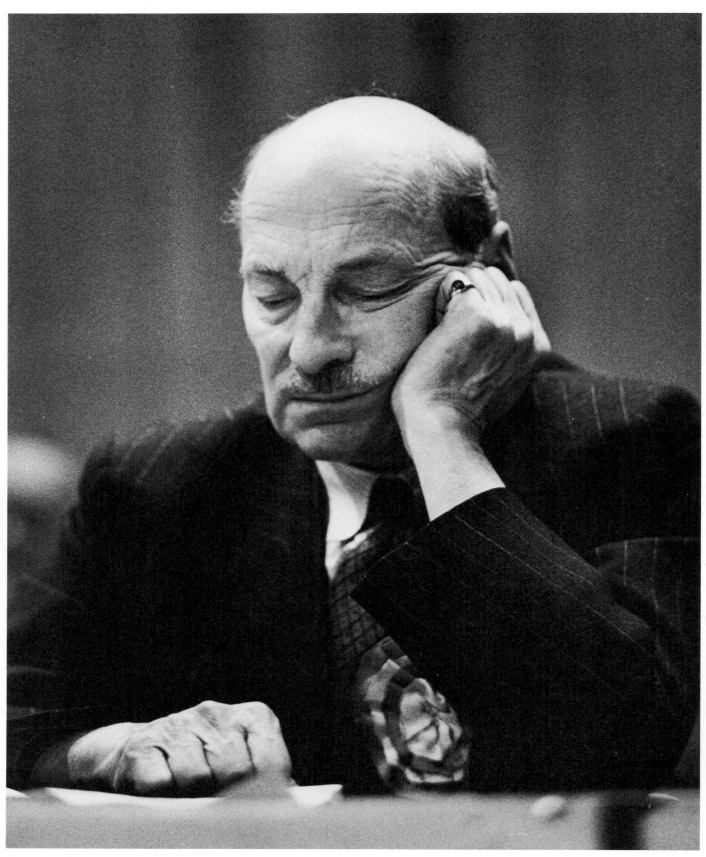

Clement Attlee.

At a London campaign rally a few days later, I found Clement Attlee so exhausted he could not keep his eyes open. The difference in appearance between Churchill and him was enormous. To me, Churchill was a bully boy, Attlee a mouse. Anthony Eden, who became Foreign Secretary after the Conservatives won, was the most handsome, absolute gentleman I have ever met. His whole personality radiated correctness, elegance, and an interest in people. In my autograph book he described me as "a gentle executioner."

Anthony Eden.

144

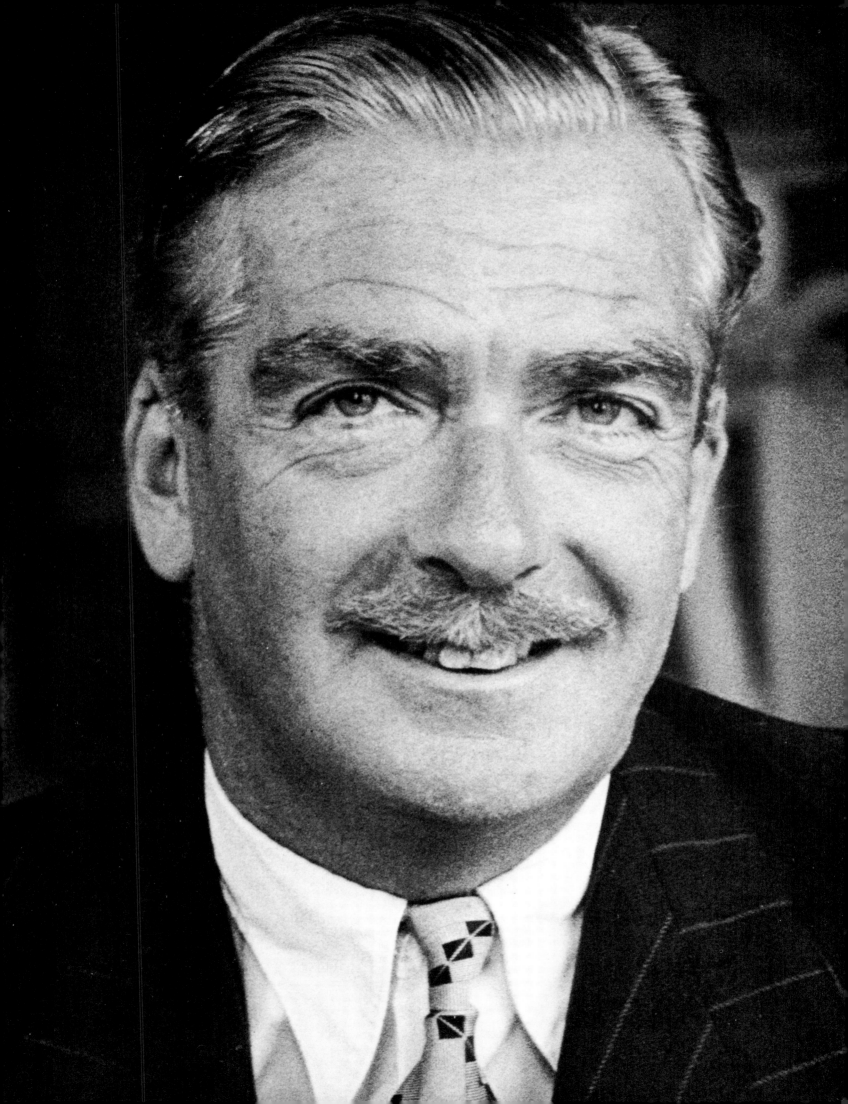

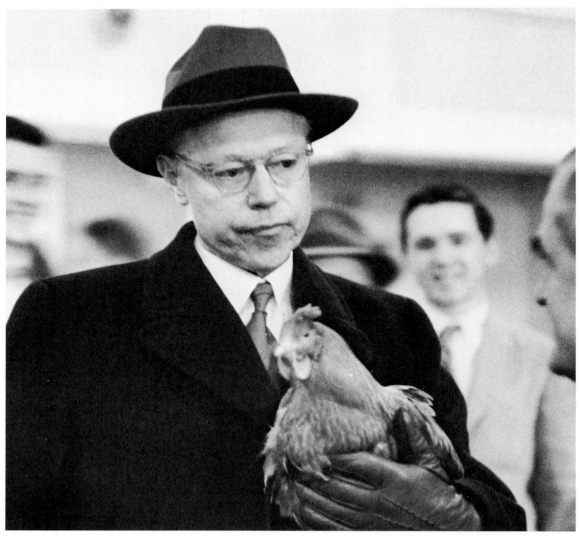

Robert A. Taft, 1952.

The United States:
Eisenhower Becomes President

If people were to ask me who was the "coldest fish" I have ever photographed, I would not have to think twice: the answer would be the late United States Senator from Ohio, Robert A. Taft. My reaction to the brilliant man, who was known as "Mr. Republican," was apparently not unique; enough people felt the same way about him to deny him the main political goal he sought for eight years—a chance at the Presidency of the United States. In 1952, when Taft was running again for the Republican nomination, I photographed him during the New Hampshire primary. The dismay reflected in his face when a farmer forced a chicken into his arms showed again a few days later when he heard the primary results. General Dwight D. Eisenhower had won all fourteen of the New Hampshire delegates.

Eisenhower went on to take the nomination from Taft at the Republican convention. That autumn the war hero with the world-famous grin overwhelmed the Democratic candidate, Governor Adlai E Stevenson of Illinois, and became the first Republican elected President of the United States since Herbert Hoover in 1928.

OPPOSITE: President-elect Dwight D. Eisenhower, John Foster Dulles, and General MacArthur emerge from Dulles' home in December 1952 after a strategy talk.

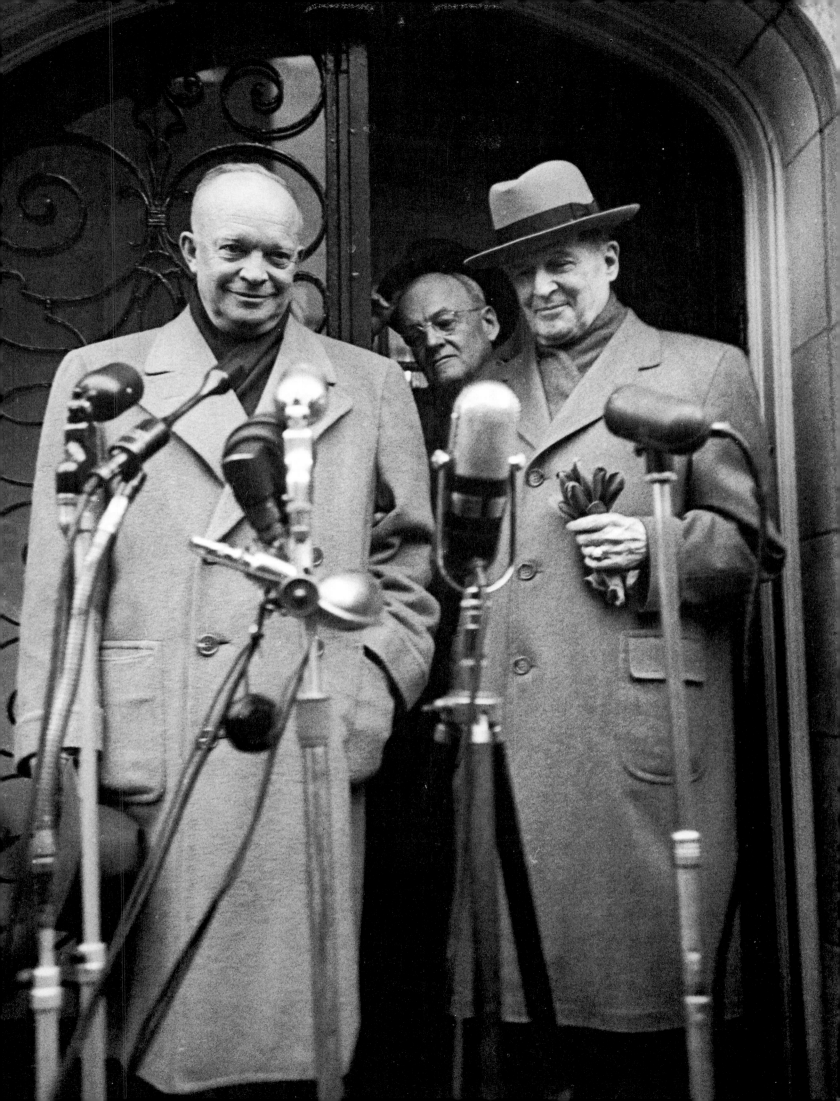

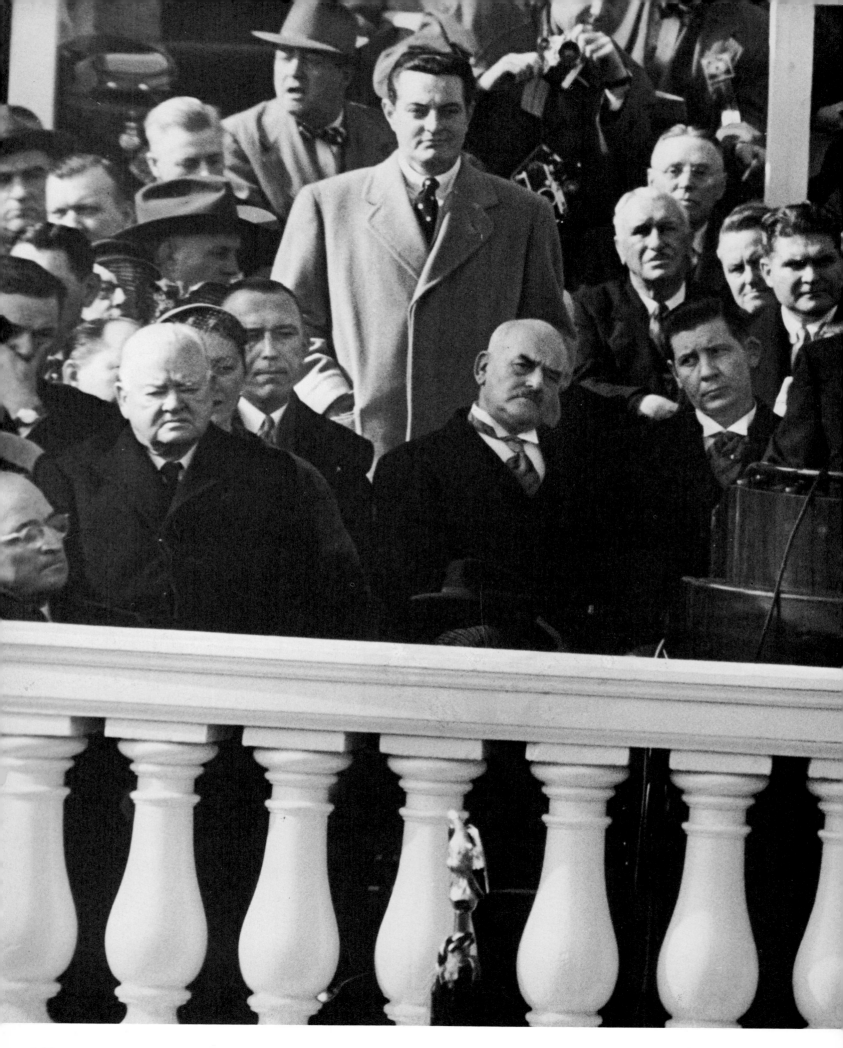

Eisenhower at his inaugural in Washington, January 20, 1953. At extreme bottom left is outgoing

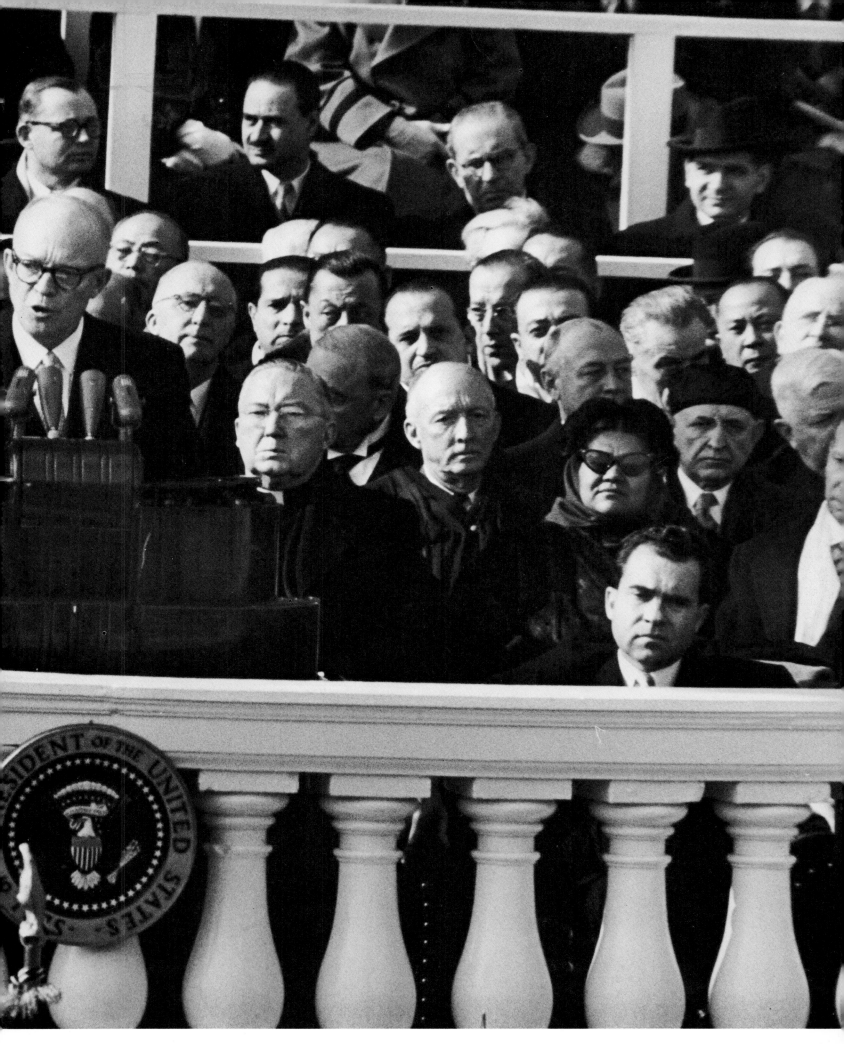

President Truman, with ex-President Hoover next to him. At extreme right is Vice-President Nixon.

149

A Portfolio of
Distinguished Englishmen

My aim when doing portraits has always been to show the subject candidly, as his character might be revealed to anyone meeting him for the first time at home or at work. Indeed, my promise to the distinguished Englishmen I have photographed (most of them in 1951) that a photographic session would not take more than ten minutes was a compelling reason for many of them to allow me into their homes or offices.

I photographed Bertrand Russell in his home outside London. He was seventy-nine. For a man who had been jailed for anti-war articles (in London in 1918), involved in furious uproars over free love (in England in 1933), and barred from teaching in colleges because of his agnostic beliefs (in the United States in 1940), the philosopher seemed remarkably serene as he sucked quietly on his rosewood pipe. He sat still as a stone monument, not moving a muscle or twitching an eyelid. When I marveled over that quality of stillness, Lord Russell replied, "The best occupation of a crocodile is to rest."

T. S. Eliot, too, radiated serenity in his small office at the publishing firm of Faber and Faber in London. He had occupied the same office for more than twenty-five years and had spent many nights there during the Blitz. So small was the room, and so cluttered with books, that I had to crawl under the table to take Eliot's picture. He was very amused and wrote in my book: "To A. E., the acrobatic photographer, with apologies for giving him such a difficult time." Joyce Cary, the novelist, was delighted to don his "working clothes" —a turtleneck sweater—and be photographed against one of the buildings of Oxford University, where he lived. He signed my book: "One doesn't suffer to be fairly beautiful!"

I visited David Low, one of the most distinguished political cartoonists of all time, in his studio in Hampstead—the first time any photographer had photographed him there. I asked Low why no one ever had a vicious expression in any of his cartoons; even the greatest villains looked friendly. "We English are not vicious," he replied. "I don't see any harm in human beings." What about Hitler? I asked. "Hitler," he replied, "was no human being."

Bertrand Russell

150

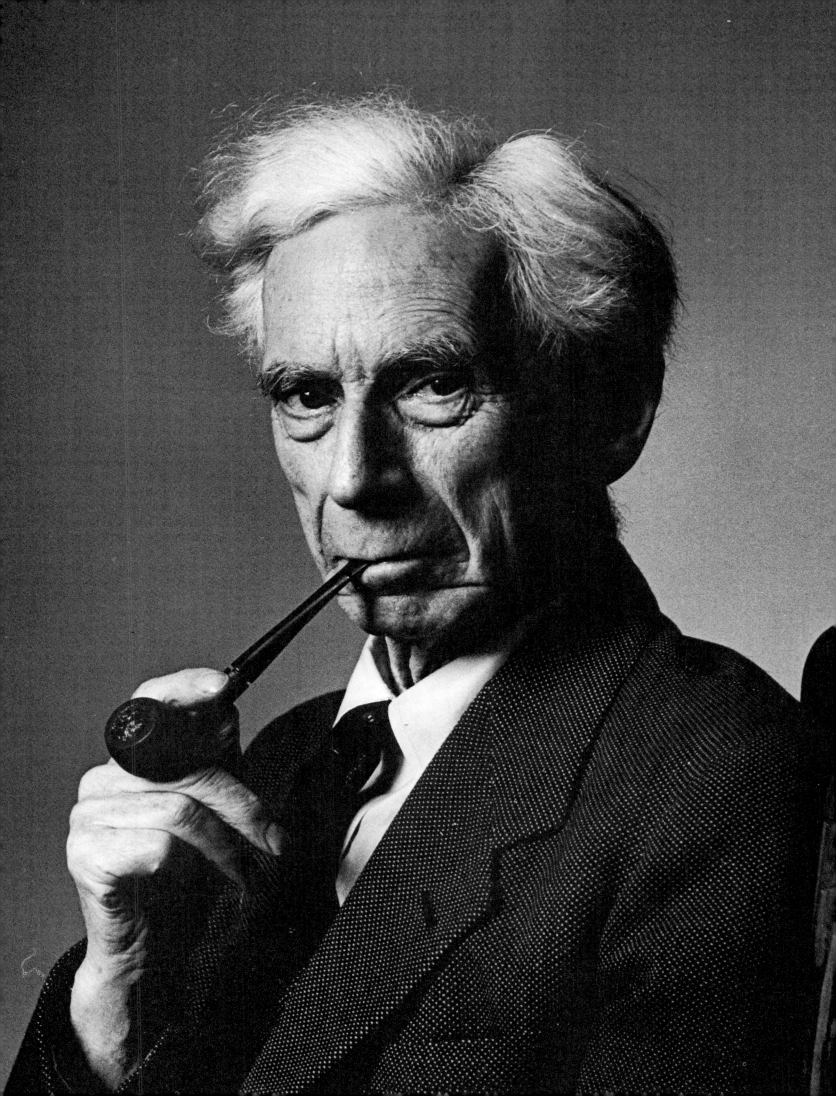

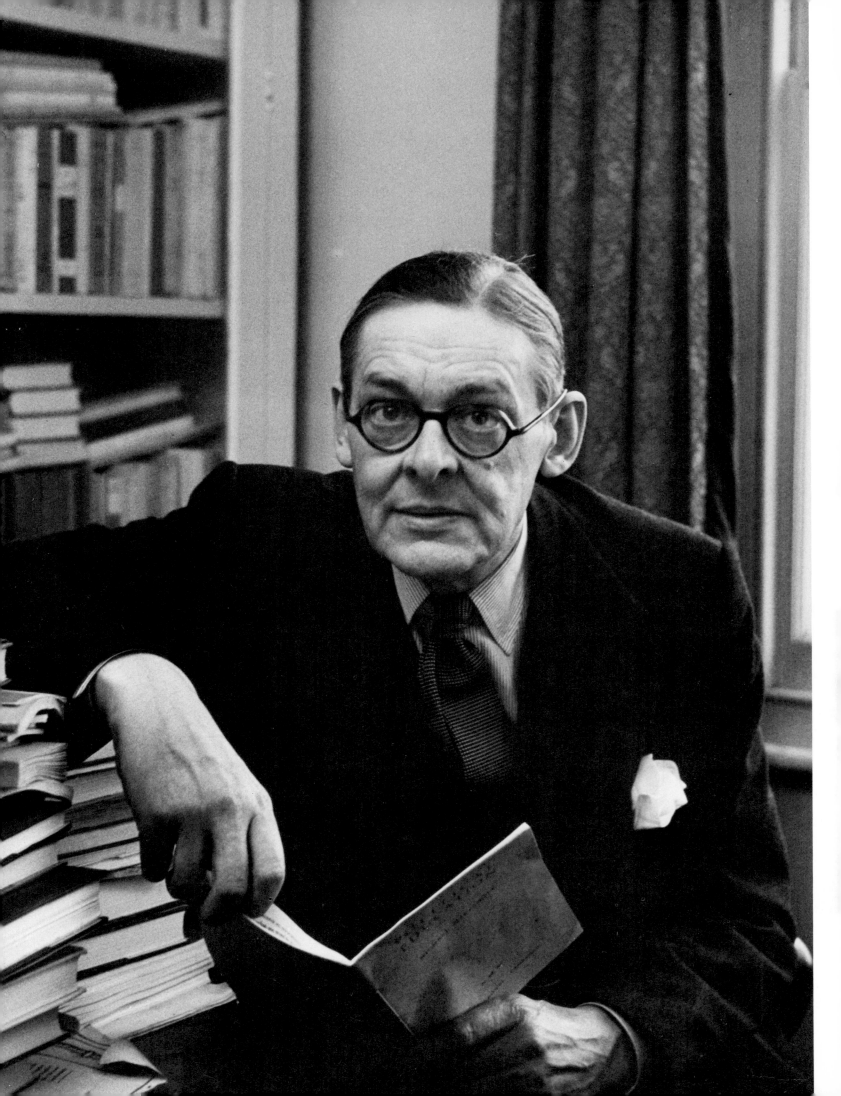

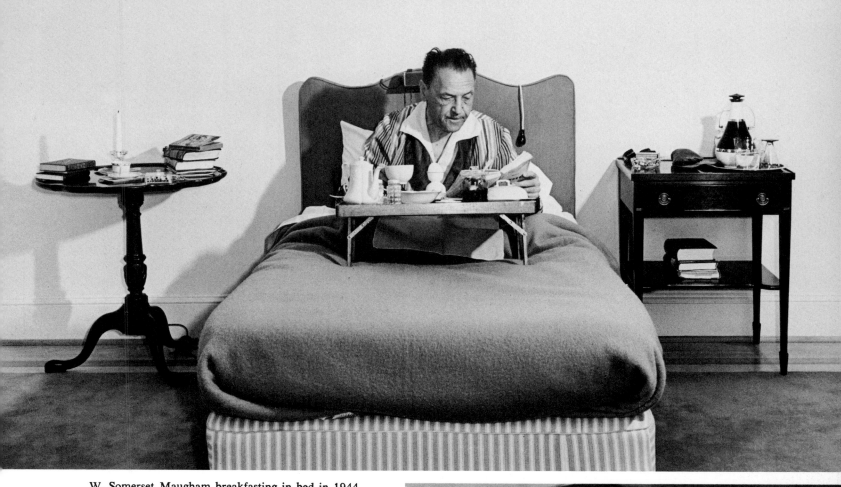

W. Somerset Maugham breakfasting in bed in 1944.

OPPOSITE: T. S. Eliot in his office in London.

Novelist Joyce Cary at Oxford.

Poet W. H. Auden in 1955.

ABOVE: Robert Ranke Graves, poet, novelist, critic, in 1963. OPPOSITE: The Very Reverend Martin Cyril D'Arcy, S.J., in the thirties was mentor of a lively circle of young artists and writers, including Evelyn Waugh. BELOW: Composer Benjamin Britten (LEFT). Sir Alexander Fleming, discoverer of penicillin (CENTER). David Low, political cartoonist, creator of "Colonel Blimp" (RIGHT).

ABOVE: Gilbert Murray, England's great classical scholar, whose translations of Greek dramatists, begun in 1902, have become standard in the language. OPPOSITE: The well-known portrait painter Augustus John putting the final touches to his portrait of Lady Phipps in his Hampshire studio.

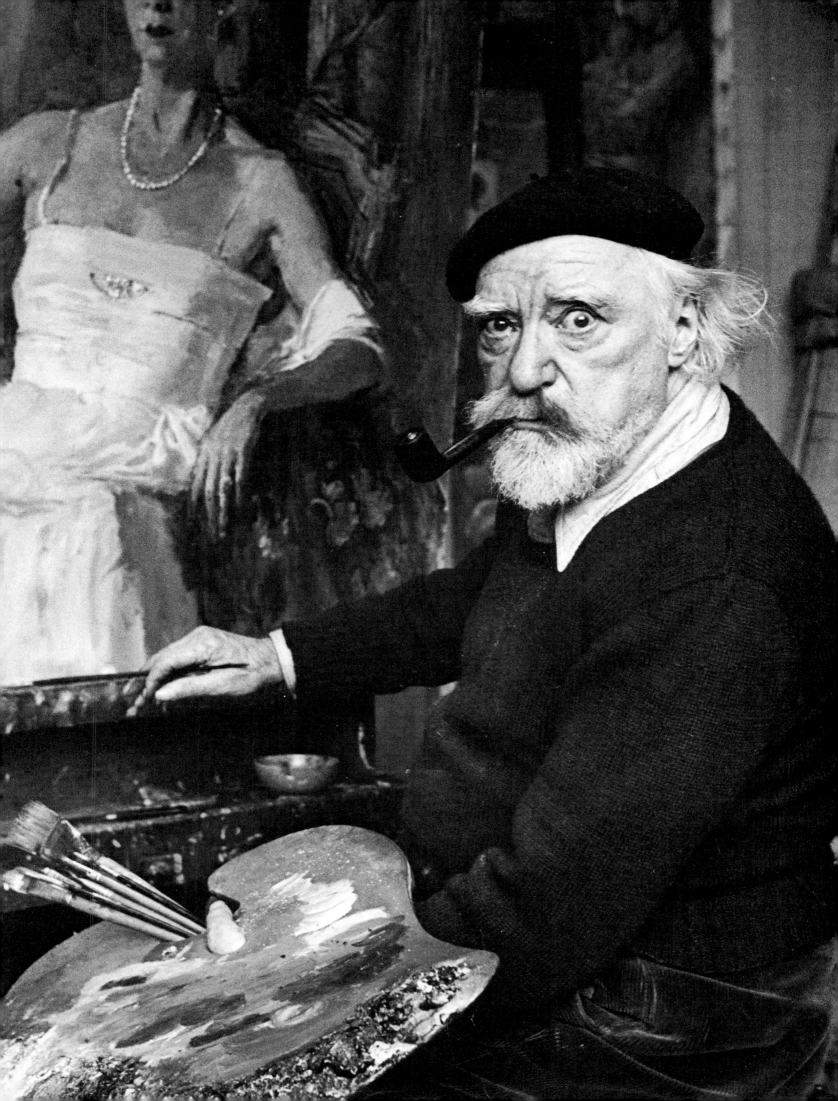

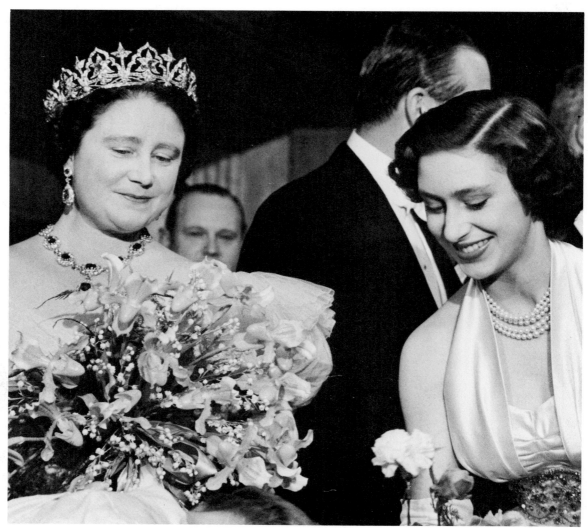

In 1951, the Queen and Princess Margaret.

The Royal Family

I have photographed the British royal family many times, but my most memorable impression of them is still the first. It was at a royal command performance in London in November 1951, of the movie *Where No Vultures Fly*. The film was about a wildlife expedition near Kilimanjaro. Stars were present in abundance—Jane Russell, Lizabeth Scott, Zachary Scott, Margaret Rutherford, to name a few. But all eyes were for the Queen. Holding a bouquet of cyprepidums, she wore a warm sunny smile that illumined the whole room as she moved through the crowd, Princess Margaret at her side, with a gentle dignity and grace I have never seen in anyone else before or since. The King was in ill health (he was to die only three months later), but not a single shadow crossed the Queen's serene face.

OPPOSITE: Queen Elizabeth with her husband, Prince Philip.

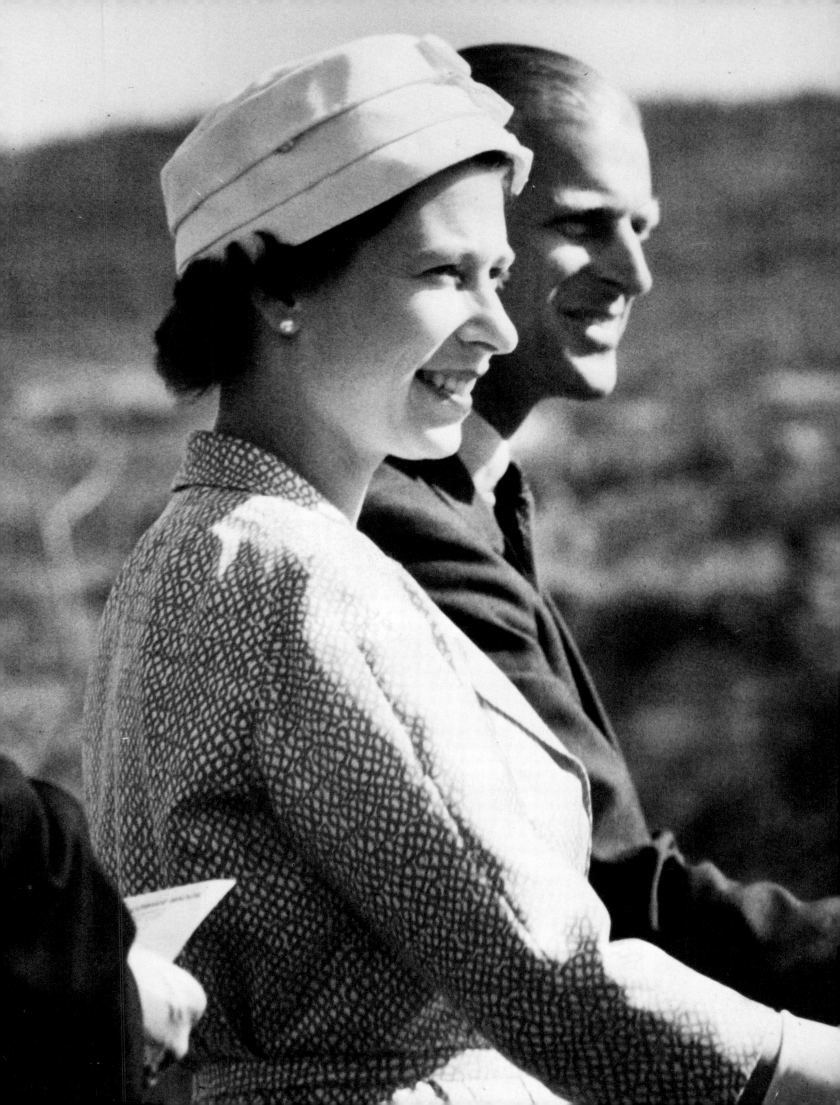

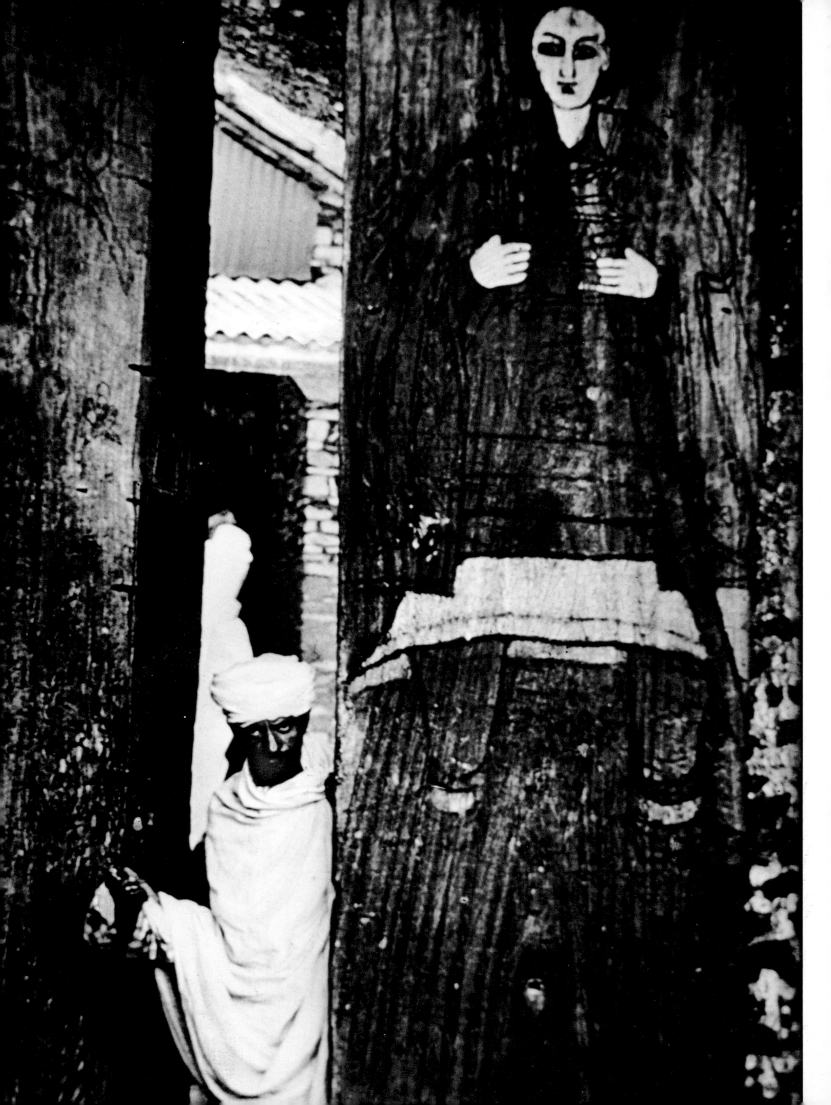

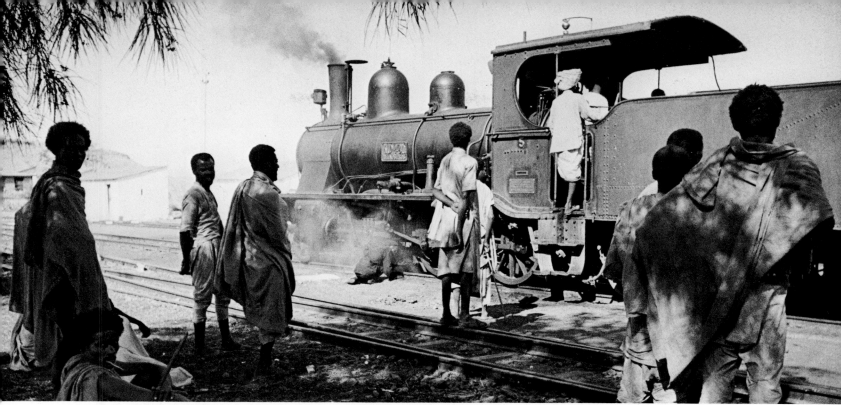

ABOVE: The "Rhinoceros Express," from Diredawa to Addis Ababa in 1935. OPPOSITE: The vicar peers from the doorway of his Christian church in Gondar. The mural of St. Michael on the door was painted four centuries ago.

Ethiopia

In March 1935, on the eve of the Italian invasion of Ethiopia, I visited Emperor Haile Selassie I in his capital at Addis Ababa. It was a trip into ancient times, to a land that had drowsed for 3000 years in feudal isolation. Haile Selassie—Conquering Lion of the Tribe of Judah, Elect of God, who claims descent from King Solomon and the Queen of Sheba —was feverishly mobilizing horse and donkey trains and barefoot armies for the hopeless war against Italy's modern armies. In June 1936, a month after Italian troops marched into Addis Ababa, the Emperor went before the League of Nations in Geneva to plead the cause of his country, Africa's oldest Christian nation. A lonely, slight, but somehow noble figure, he became for that brief moment the conscience of the world as he made a futile plea to the world powers to roll back Italian aggression. "It is the very existence of the League of Nations . . . the confidence that each State is to place in international treaties . . . the value of promises made to small States . . . in a word, it is international morality that is at stake. Apart from the Kingdom of the Lord there is not on this earth any nation that is superior than any other. . . ."

The next time I saw Haile Selassie was in April 1955 at the twenty-fifth anniversary celebration of his coronation. He had been restored to his throne in 1941, and had launched his country on the road to modernization. I noted that, among other things, the ragged barefoot troops I had photographed twenty years earlier (page 164) were now all handsomely clad and very well shod.

Meanwhile the rest of the continent had begun to stir. African nationalist movements were operating openly against the European colonial powers, and out of the bitterness and bloodshed emerged a new generation of black African leaders—such men as Kenya's Jomo Kenyatta and Ghana's Kwame Nkrumah.

OVERLEAF: A soldier who fought in puttees and bare feet against Mussolini's armies in 1935. The Emperor's Master of the Hunt.

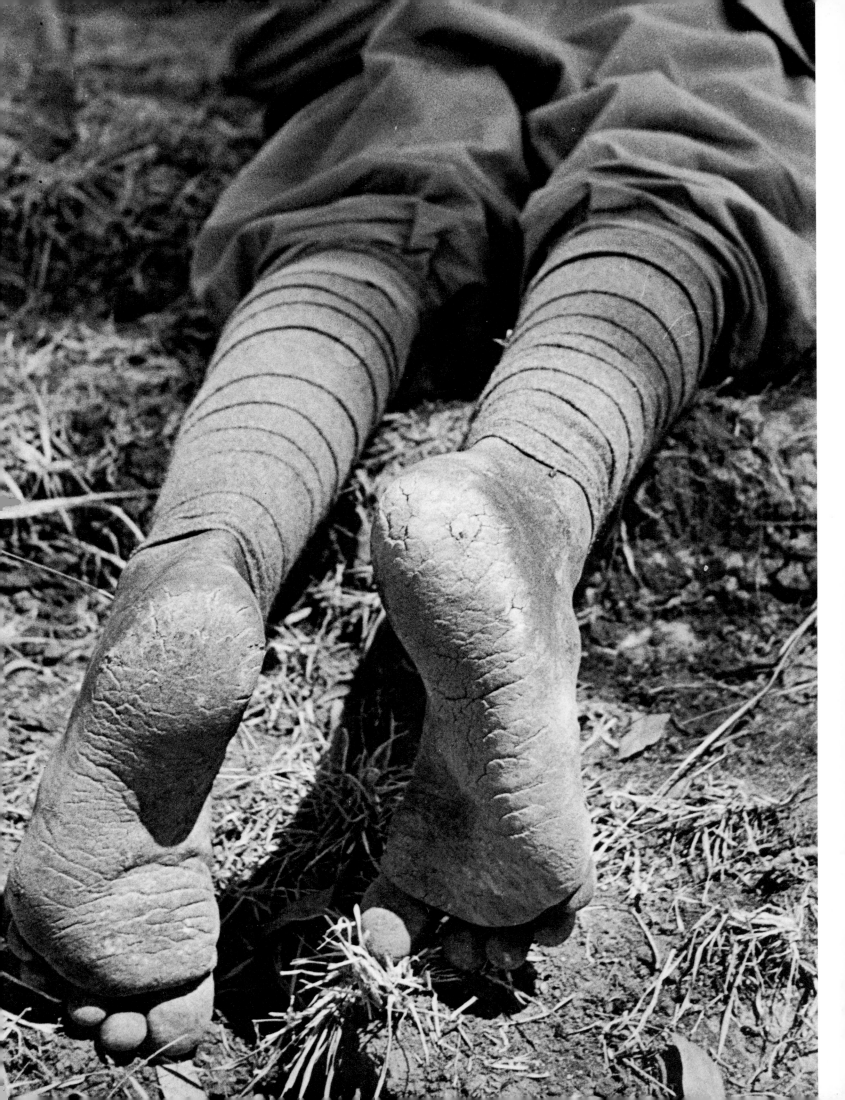

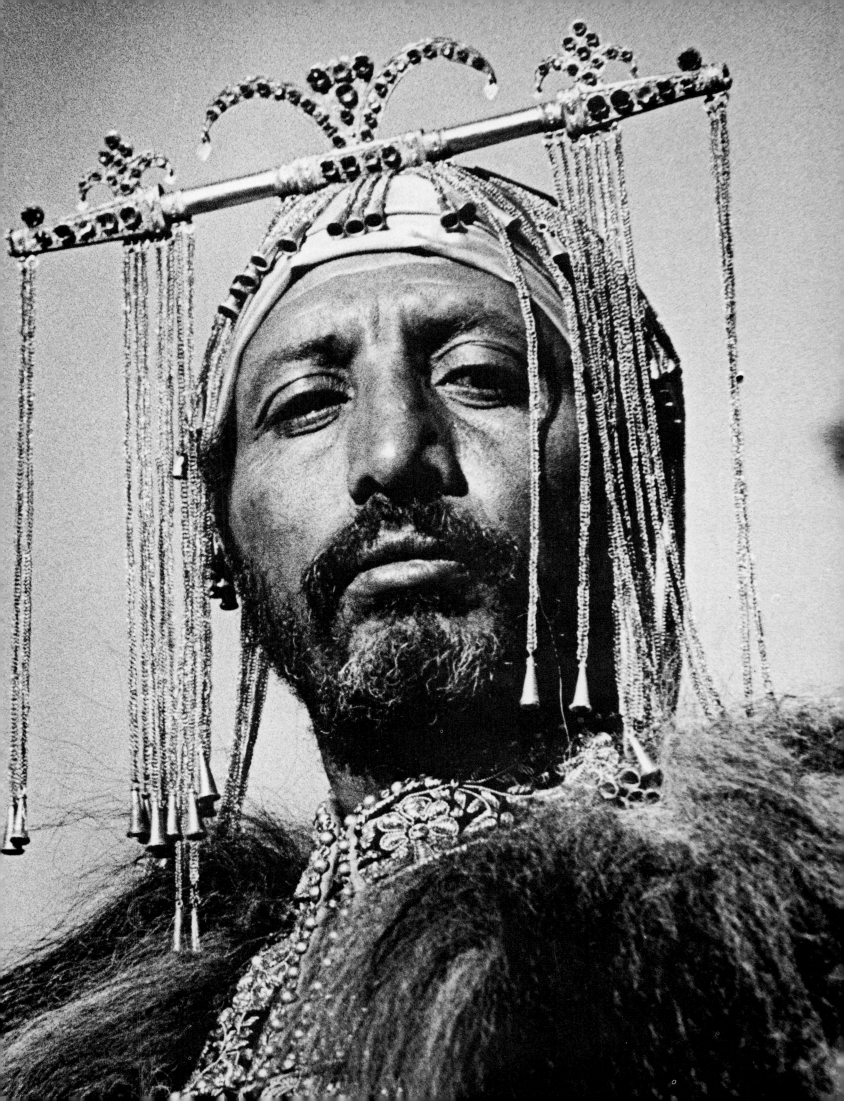

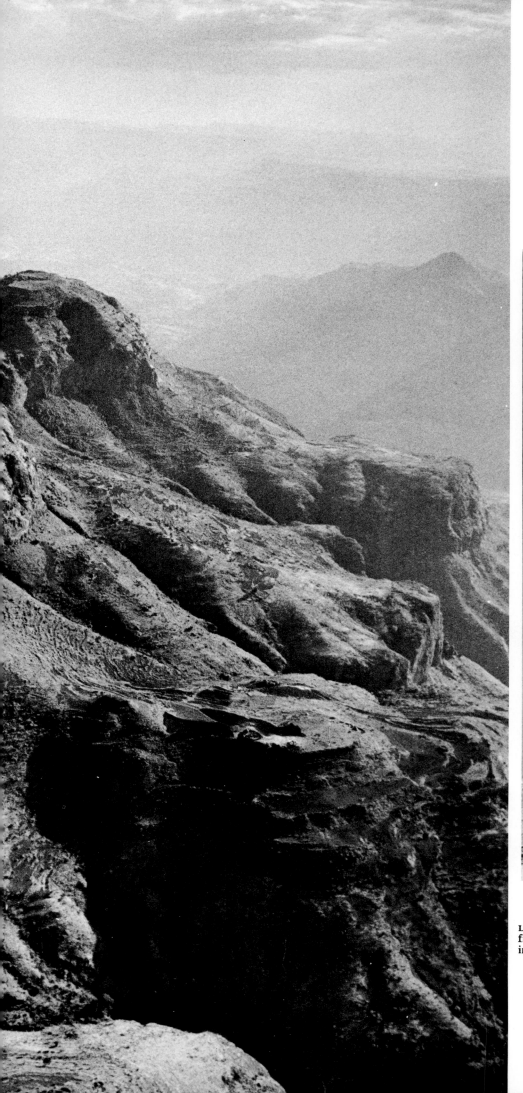

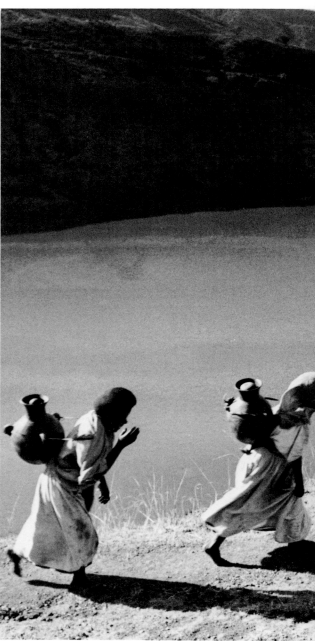

LEFT: The highlands of Ethiopia, photographed from a plane in 1955. ABOVE: Women carrying water jugs above a crater lake near Bishoftu.

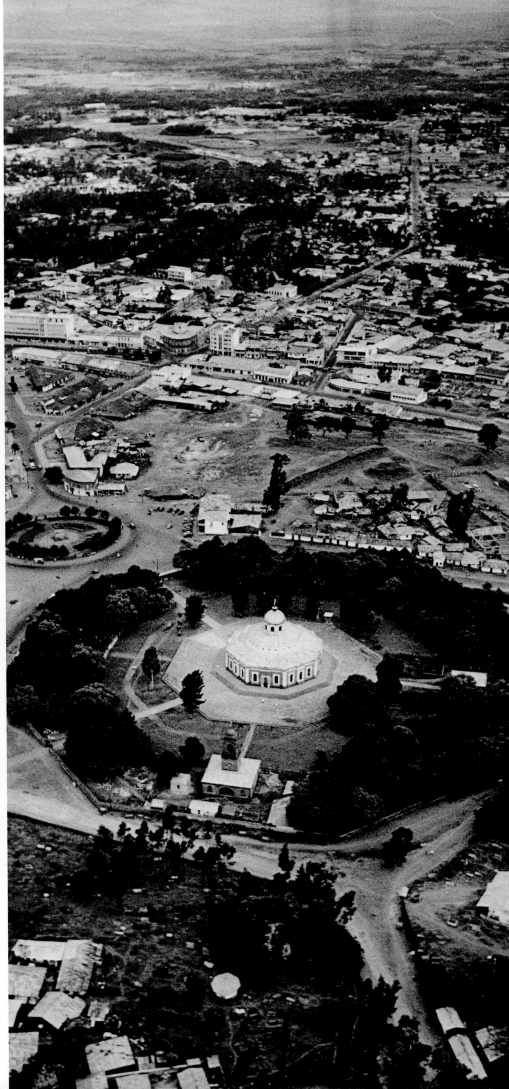

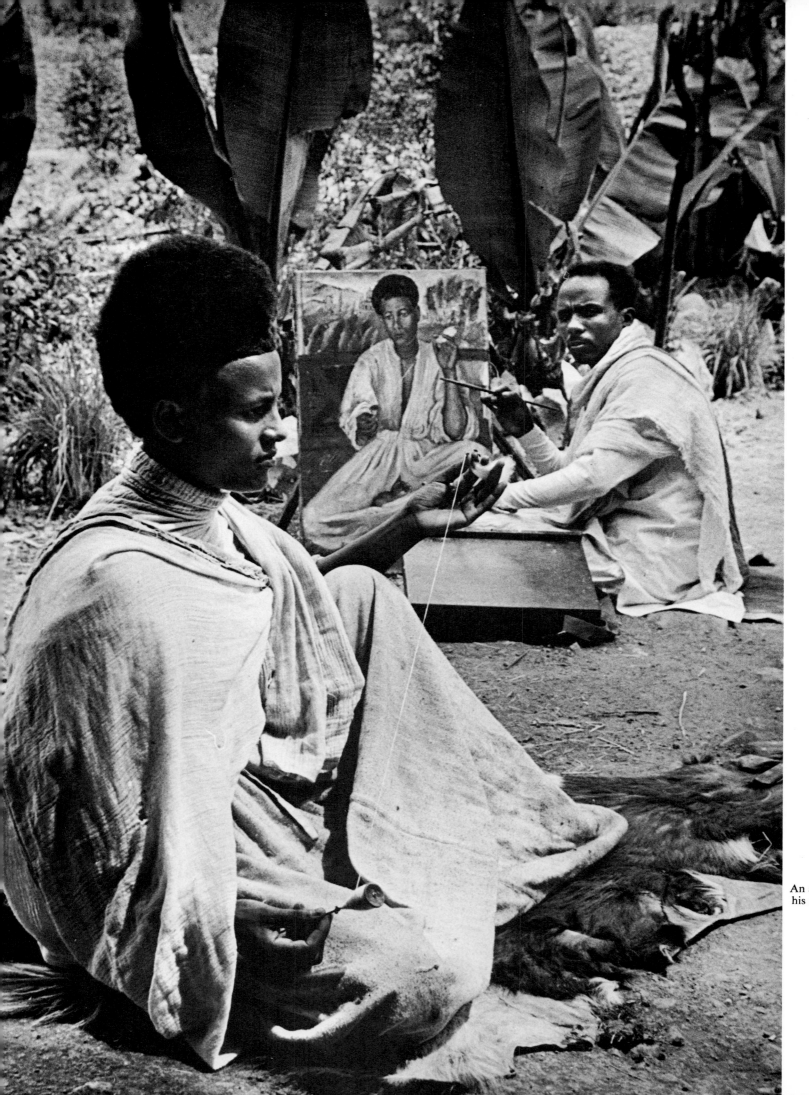

An artist a
his model.

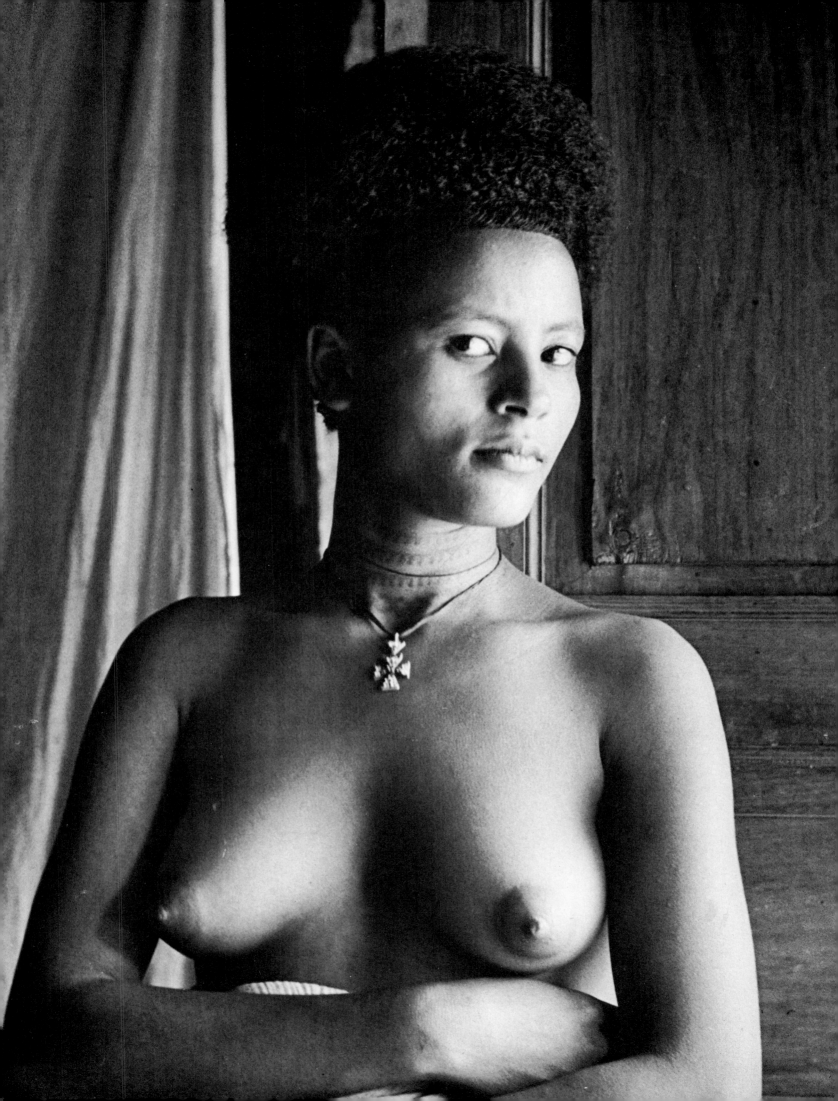

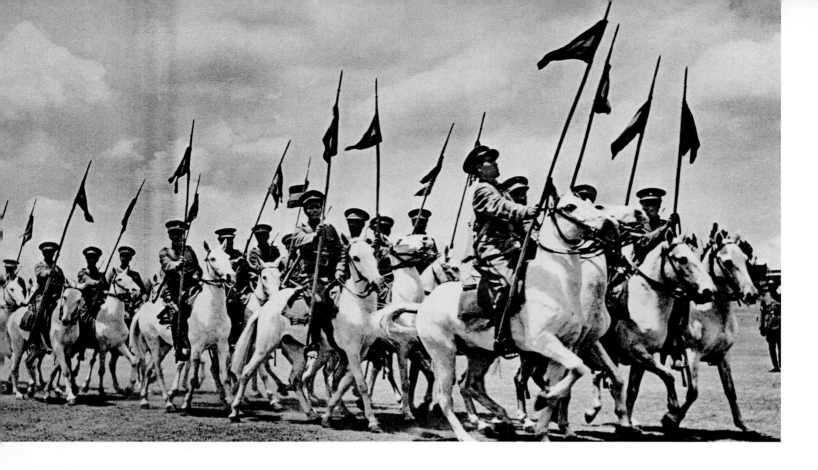

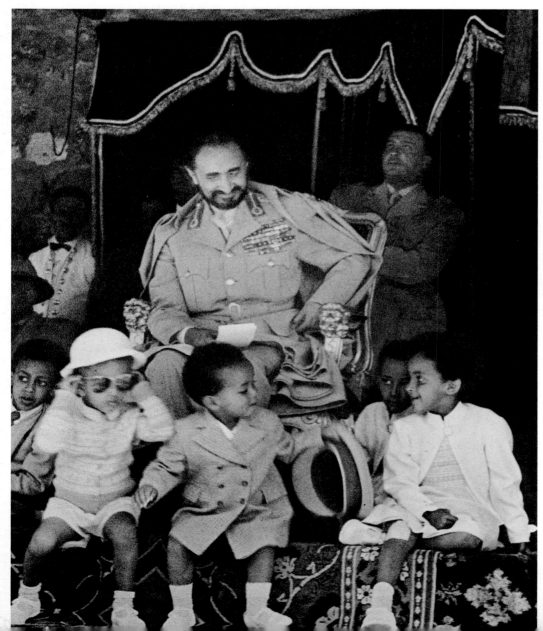

ABOVE: The Emperor's cavalry, carrying Ethiopian flags. OPPOSITE: Emperor Haile Selassie I in 1955, the twenty-fifth anniversary of his coronation. LEFT: The Emperor and his grandchildren during the 1955 celebration.

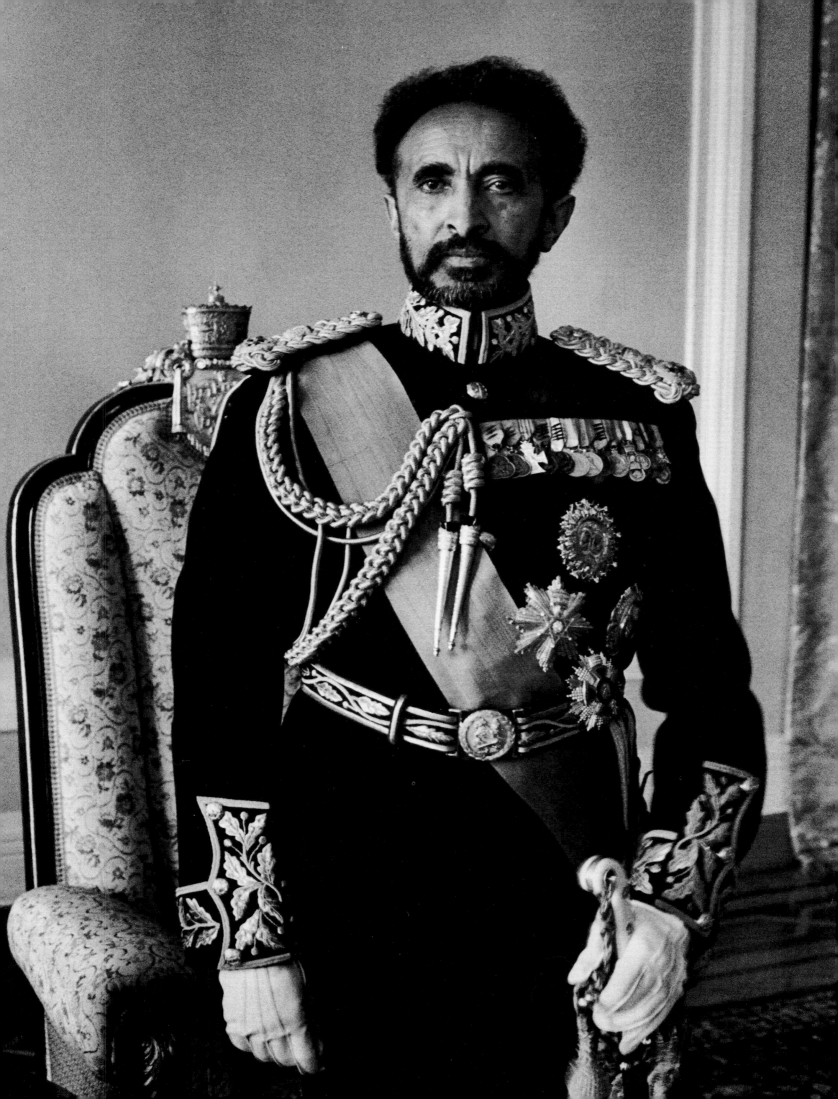

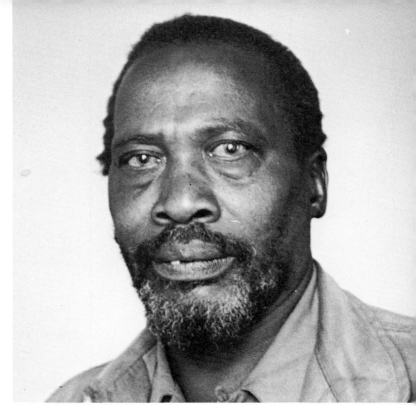

Jomo Kenyatta in 1953.

Kenya

Jomo Kenyatta, the father of independent Kenya, was in jail in February 1953, awaiting indictment, when the British permitted me to photograph him. A member of the Kikuyu tribe, he was the very image of a tribal elder with his beard, his beaded cap, and the two traditional symbols of authority he always carried—a blackwood cane and a zebra-tail fly whisk. The British charged that he was masterminding the savage Mau Mau rebellion that swept over Kenya in 1952, pillaging farms and killing white settlers. In four years of bitter fighting between the terrorist organization and British troops an estimated 13,000 Africans and 95 whites were killed. Kenyatta spent seven years in jail, but his rallying cry of *"Uhuru"* ("Freedom") finally won out. Kenya's 8.5 million Africans were given their independence in December 1963, and Britain's last East African colony was gone. Kenyatta, then seventy-three, the oldest African nationalist leader, became Prime Minister of the new country.

BELOW, LEFT: Mau Mau suspects interned in 1953. RIGHT: An English resident of Kenya, Margaret Campbell, keeps a revolver at her waist against Mau Mau attack, as she changes her son's diaper. OPPOSITE: A killing sword used by the Kikuyu tribe during the Mau Mau uprising.

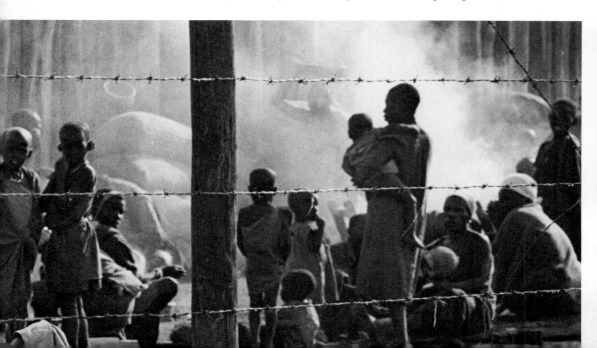

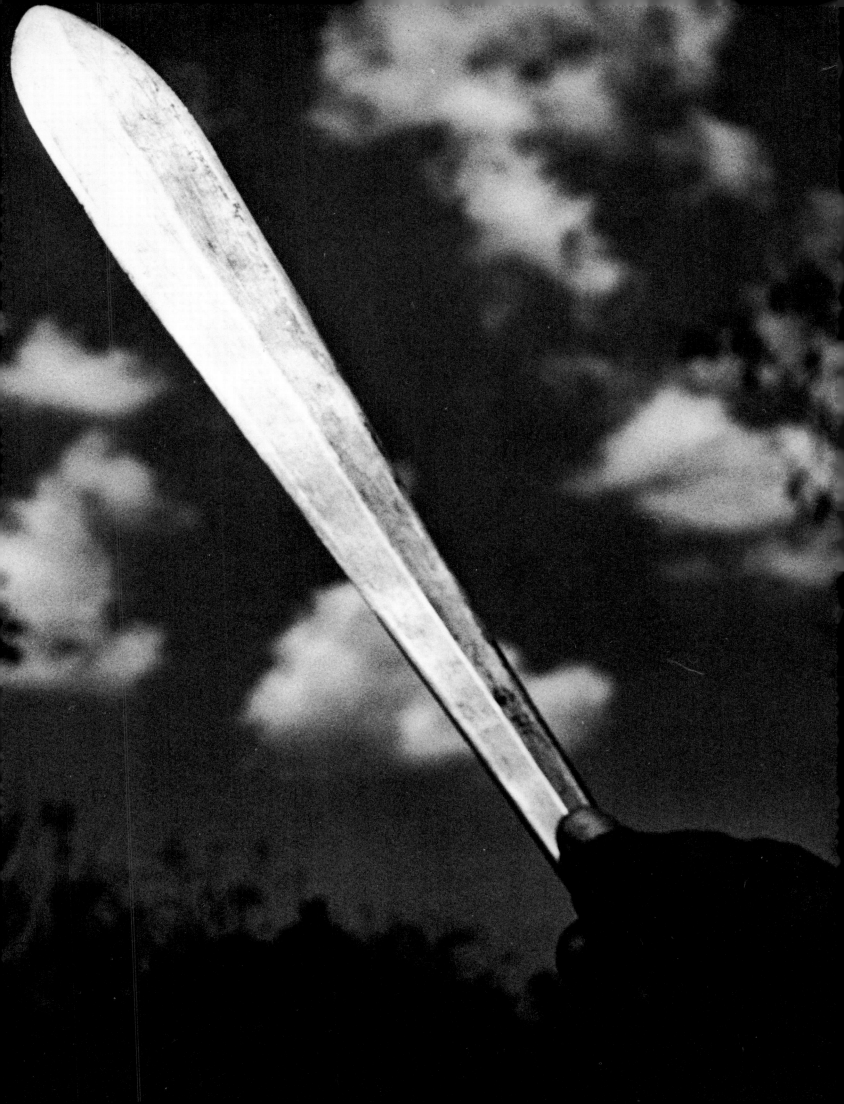

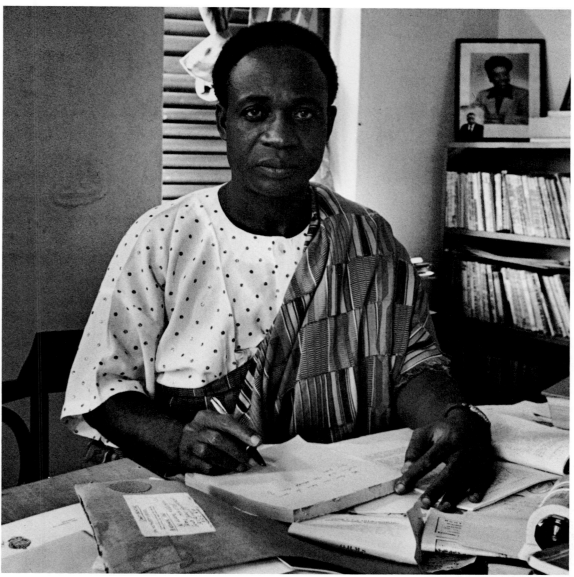

Kwame Nkrumah, 1953.

Ghana

Africa's Gold Coast was still a British territory in March 1953, when I photographed Dr. Kwame Nkrumah in Accra. He was Prime Minister of the country and pushing hard for complete independence. The son of a Twi tribesman who made a living by hammering out gold ornaments for local woodcutters, Nkrumah (his first name means Saturday, the day of his birth) was born in a mud hut on the edge of the jungle. His political struggle was considerably easier than Kenyatta's in Kenya. A few strikes, riots, and boycotts in the rich colony (it grows one-third of the world's cocoa) and almost a year in prison, which made him a highly popular martyr, convinced the British that "creative abdication" of their rule in the Gold Coast was their best hope of gaining a friendly new Dominion. In March 1957 the Gold Coast became the independent state of Ghana, and Nkrumah became its first head—a strong-willed ruler with ambitions to become a leader of Pan-Africa.

OPPOSITE: "Mammy-traders" dicker at an auction for unclaimed goods on a wharf at Accra.

OVERLEAF: Tribesmen paddling cargoes of cocoa from beaches to ships waiting offshore.

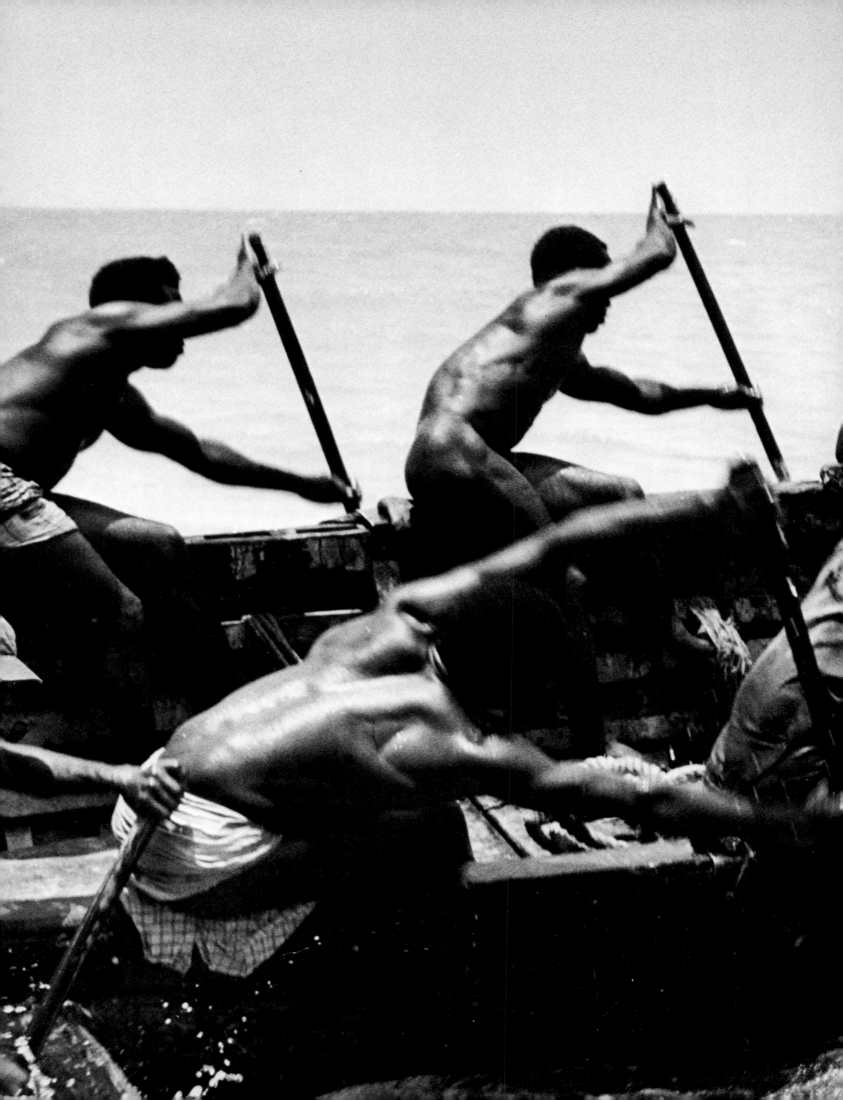

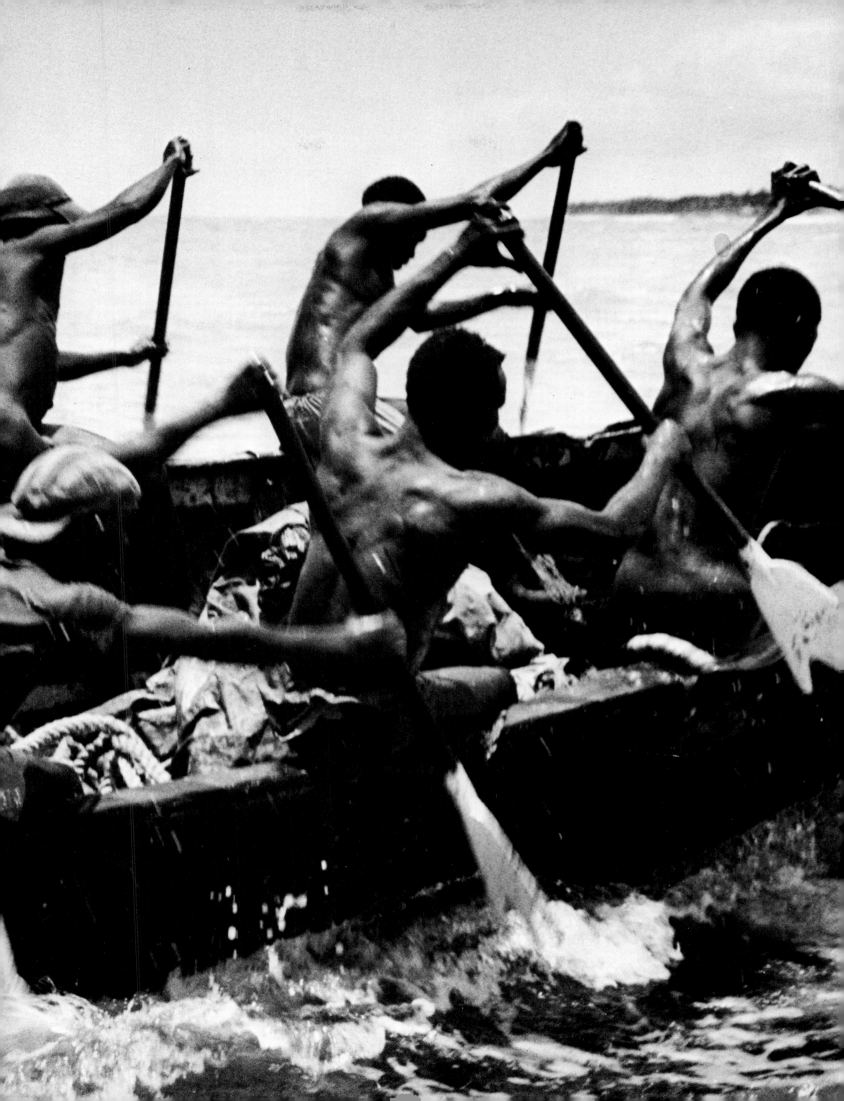

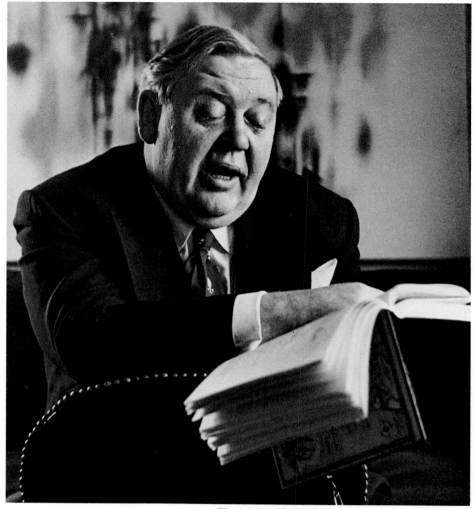

Charles Laughton giving one of his public readings.

"The Fabulous Country"

In 1952 the editors of *Life* invited Charles Laughton, the actor, who had publicly revived the all-but-dying art of reading aloud for entertainment, to choose for a Fourth of July issue his personal anthology of American writings to be read aloud. Two years earlier the British-born actor had become a naturalized American citizen. "While the judge was preparing to administer the oath of allegiance," Laughton wrote, "I kept thinking to myself that I was about to become a citizen of Thomas Wolfe's 'fabulous country.' " To illustrate Laughton's suggested readings I spent several months traveling all over the United States, visiting places I had never seen before in my fifteen years here. At the end of the journey, like Wolfe, like Laughton, I too had rediscovered America. Printed here with the scenes I photographed are excerpts from some of the passages that inspired them.

Where the Falls of Minnehaha
Flash and gleam among the oak-trees,
Laugh and leap into the valley.

There the ancient Arrow-maker
Made his arrow-heads of sandstone,
Arrow-heads of chalcedony,
Arrow-heads of flint and jasper,
Smoothed and sharpened at the edges,
Hard and polished, keen and costly.

With him dwelt his dark-eyed daughter,
Wayward as the Minnehaha,
With her moods of shade and sunshine,
Eyes that smiled and frowned alternate,
Feet as rapid as the river,
Tresses flowing like the water,
And as musical as laughter;
And he named her from the river,
From the waterfall he named her,
Minnehaha, Laughing Water.

—Henry Wadsworth Longfellow,
The Song of Hiawatha

Children toss rocks in Minnehaha Park in Minneapolis, where Longfellow's Indian maiden once played.

America is a fabulous country. . . . It is the place where the women with fine legs and silken underwear lie in the Pullman berth below you, it is the place of the dark-green snore of the Pullman cars . . . it is the place of the stir and feathery stumble of hens upon their roost, the frosty, broken barking of the dogs, the great barn-shapes and solid shadows in the running sweep of the moon-whited countryside, the wailing whistle of the fast express. It is the place of flares and steamings on the tracks, and the swing and bob and tottering dance of lanterns in the yards; it is the place of dings and knellings and the sudden glare of mighty engines over sleeping faces in the night . . . it is also the place where the Transcontinental Limited is stroking eighty miles an hour across the continent and the small dark towns whip by like bullets, and there is only the fanlike stroke of the secret, immense and lonely earth again . . . it is the place of the mile-long freights with their strong, solid, clanking, heavy loneliness at night, and of the silent freight of cars that curve away among raw piney desolations with their promise of new lands and unknown distances—the huge attentive gape of emptiness . . . the place of the huge stillness of the water tower, the fading light, the rails, secret and alive, and trembling with the oncoming train. . . .

—THOMAS WOLFE, *Of Time and the River*

Hudson River, near Hudson, New York.

Whoever has made a voyage up the Hudson must remember the Kaatskill mountains. . . . At the foot of these fairy mountains, the voyager may have descried the light smoke curling up from a village, whose shingle-roofs gleam among the trees, just where the blue tints of the upland melt away into the fresh green of the nearer landscape. . . . In the same village, and in one of these very houses . . . there lived, many years since, while the country was yet a province of Great Britain, a simple, good-natured fellow, of the name of Rip Van Winkle.

—WASHINGTON IRVING, *Rip Van Winkle*

Hudson Valley, near Poughkeepsie.

She was a grand affair. When I stood in her pilot house
I was so far above the water that I seemed perched on
a mountain. . . . She was as clean and dainty as a draw-
ing-room; when I looked down her long, gilded saloon,
it was like gazing through a splendid tunnel. . . . The
boiler deck . . . was as spacious as a church, it seemed
to me; so with the forecastle. . . . The fires were fiercely
glaring from a long row of furnaces, and over them were
eight huge boilers! This was unutterable pomp. . . .

—MARK TWAIN, *Life on the Mississippi*

OVERLEAF: Mississippi River paddler.

183

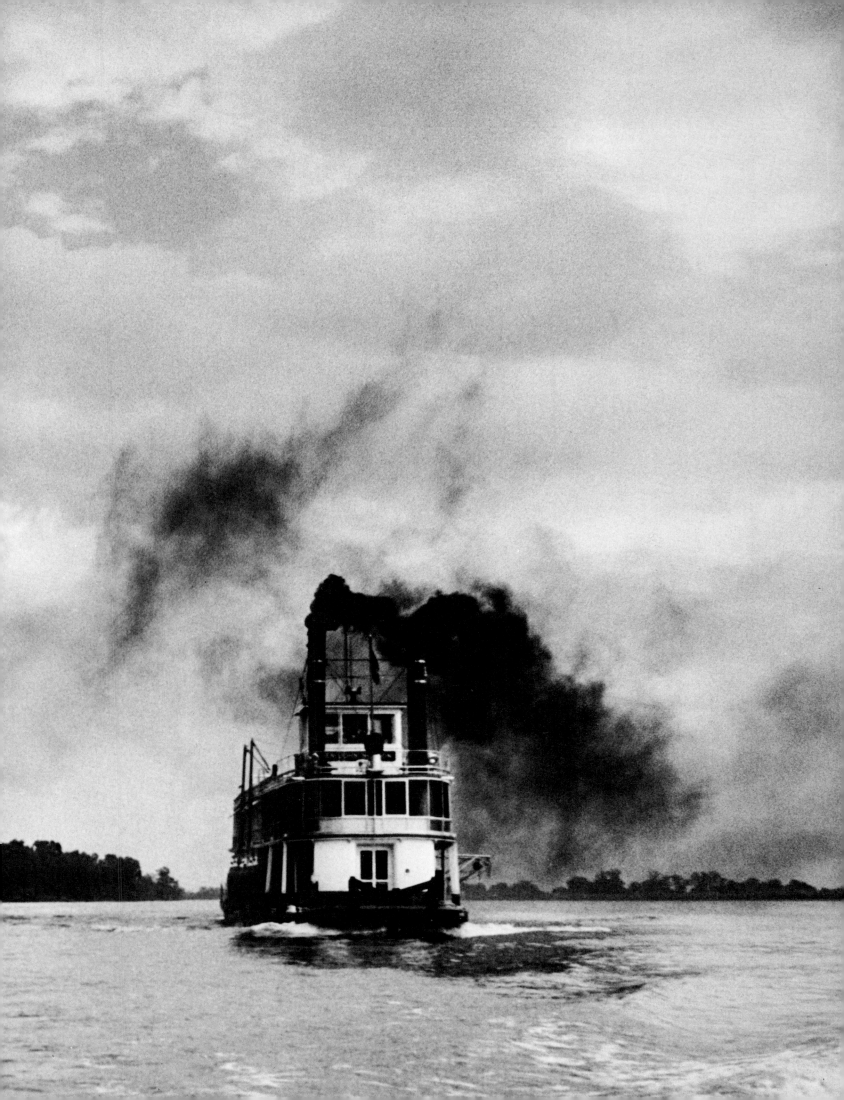

Pickett came
And the South came
And the end came,
And the grass comes
And the wind blows
On the bronze book
On the bronze men
On the brown grass,
And the wind says
"Long ago
Long ago
Long ago"

—STEPHEN VINCENT BENÉT,
John Brown's Body

Civil War battlefield, Gettysburg.

OVERLEAF: Saguaro National Monument near Tucson, Arizona.

187

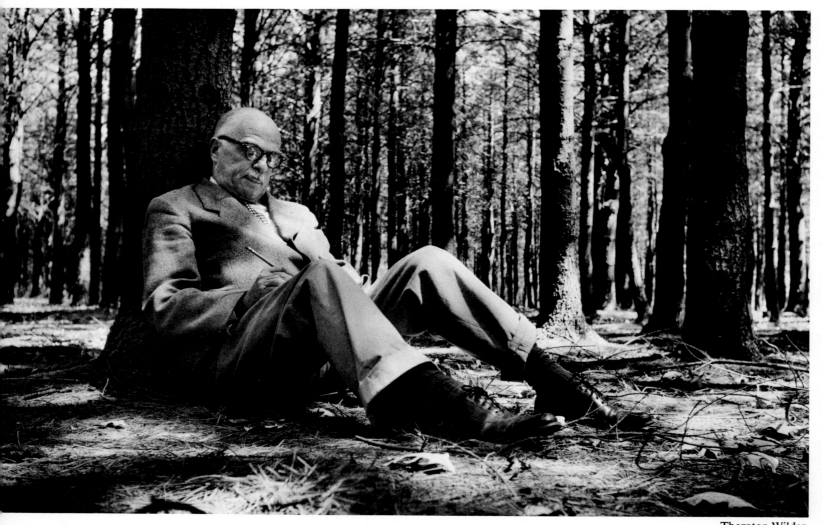

Thornton Wilder.

A Portfolio of Distinguished Americans

In a wood near Saratoga Springs, New York, playwright Thornton Wilder, three-time Pulitzer Prize winner, sat in May 1956, composing a eulogy to the late Thomas Mann. Among the sounds of the birds and the rustling of the leaves the click of my shutter was hardly audible. Later Wilder wrote this in my memento book about me: "a presence so tactful and soothing that I found myself working . . . extra well while he went about his task."

In this section are many of the movers and shakers in the United States—the politicians, authors, big businessmen, and ladies who have dominated the scene for the past fifteen years. Always I tried to keep in mind the most important thing about photographing people: it is not clicking the shutter that counts, it is clicking with the subject.

Poet Robert Frost in 1958.

190

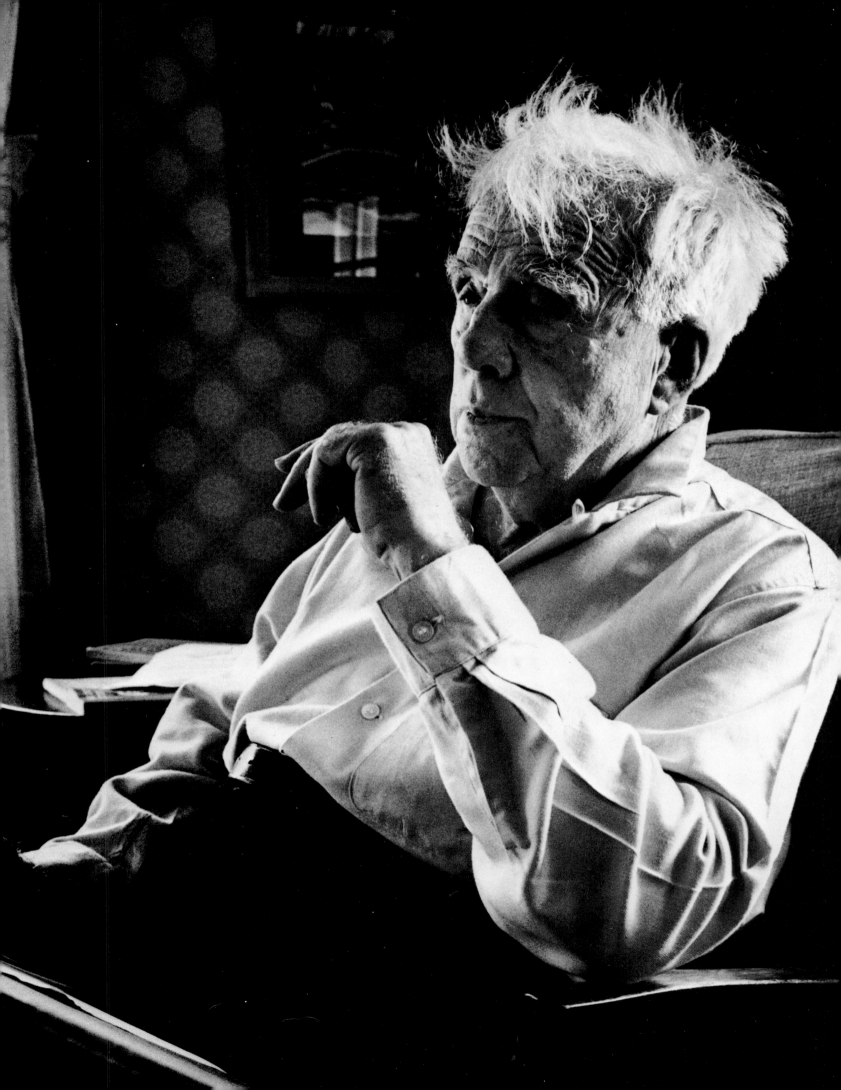

Governor Nelson Rockefeller installing a painting in the Governor's mansion in Albany, New York, in 1960.

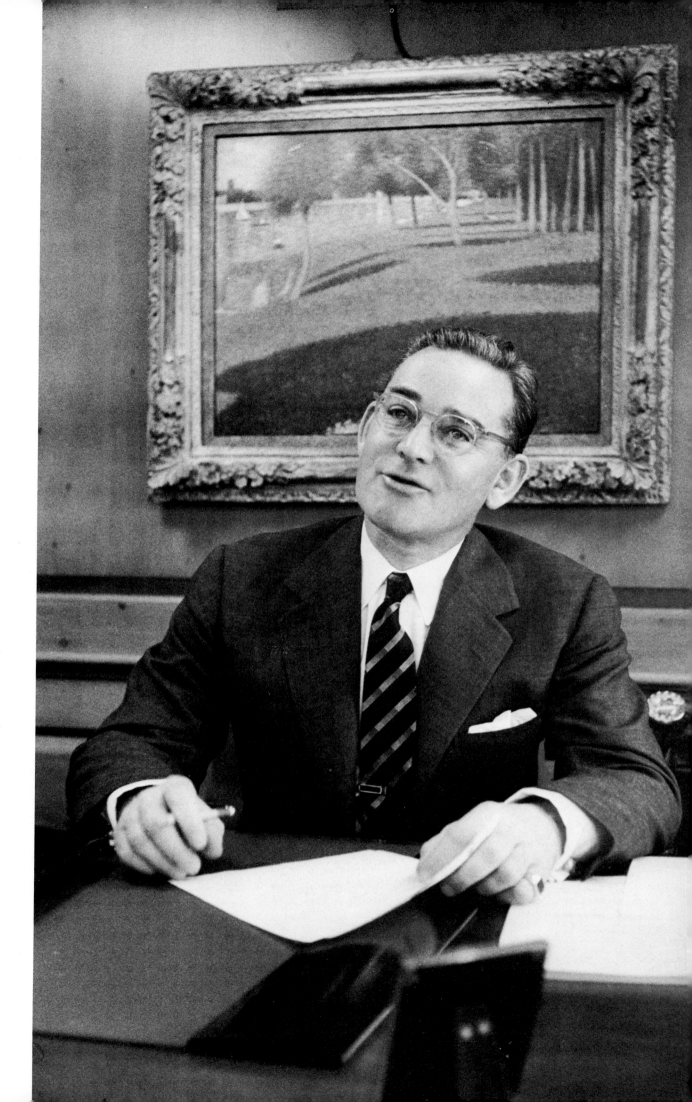

John Hay Whitney, millionaire publisher and art patron, in his New York City home, 1956.

Ernest Hemingway was the most difficult subject I ever photographed. He was living in 1952 with his wife Mary, two dogs, and thirty-one cats in a rambling mansion in San Francisco de Paula near Havana when I went to shoot a story on him for *Life*. Hemingway appeared, gin and tonic in hand, almost nude—a Tarzan wearing only frayed shorts. He offered me a gin but as it was only 10 a.m. I declined politely. That was a mistake: he began berating my editors for not having paid him enough money for publishing *The Old Man and the Sea,* and me for having sold my soul to my editors for money. He was getting more agitated and red-faced by the minute, so when he offered me a gin and tonic again, saying, "It's good for your kidneys, Alfred," I said yes, thank you.

I wanted to photograph Hemingway in a sports shirt, but suggesting that directly to him would not have worked. So I said, "How wonderful your body is and what a shame it would be to cover it with a sports shirt." "What sports shirt?" he grunted. "All women adore my body. But maybe for a magazine like *Life* it *would* be better to have a shirt on." And he was very pleased when I admired his arm muscles.

Once when I was photographing him, surrounded by his cats, they began scratching themselves against my legs and the camera tripod, and I began hopping to shake them off. Up shot Hemingway, glass in hand. He came slowly toward me until his right eye was only one and a half inches away from my right eye, the one I always focus with, and he growled, "Don't-you-like-cats?" "Of course," I said, "I just love them." "That's good," he replied—and then locked the cats in the huge tower where they lived.

Between tantrums and teasings Hemingway was to me the soul of solicitude. When I was bothered by mosquitoes in my room at the Hotel Nacional, he phoned the manager and had a mosquito net put in. When I complained of a headache—brought on by the fact that Hemingway had just eaten a bowl of raw onions and was trying to get me to do the same— he poured cold water on his own napkin to cool my forehead.

On the beach the next day he found himself suddenly surrounded by a group of fishermen with their children, attracted by my cameras. One of the children, pointing at Hemingway, said, "Daddy, who is that actor?" Hemingway went berserk, jumped up and down, smashed his little swagger stick on the rocks, tore his shirt to bits, shouted obscenities, and charged off the beach. Twenty minutes later, exhausted, he was like a lamb.

The following year when I was in Havana covering a deep-sea fishing tournament in which he and his wife were to participate, he warned me beforehand to keep well away from his boat. That evening at the Royal Yacht Club, Hemingway came up to me and said, "Alfred, you came too close to me so I had to shoot at you." Without thinking, I said, "Papa, I don't believe it." Hemingway dropped his gin glass, grabbed me, and started to throw me, cameras and all, into the water. I threw my arm around his neck to keep from falling and he pushed me with his fist—but very softly because he had quickly got control of himself. "Never say again you don't believe Papa," he mumbled. An hour later he, his wife, and I were all at the Floridita Bar, Hemingway's favorite hangout, celebrating her success in the fishing tournament.

OVERLEAF: Walt Disney in 1953 with his cartoon creations. The late Helena Rubinstein (Princess Gourielli-Tchkonia), Cracow-born founder of a worldwide cosmetics empire, in 1958 in her New York City home. The mural, by Salvador Dali, is entitled *Noon*.

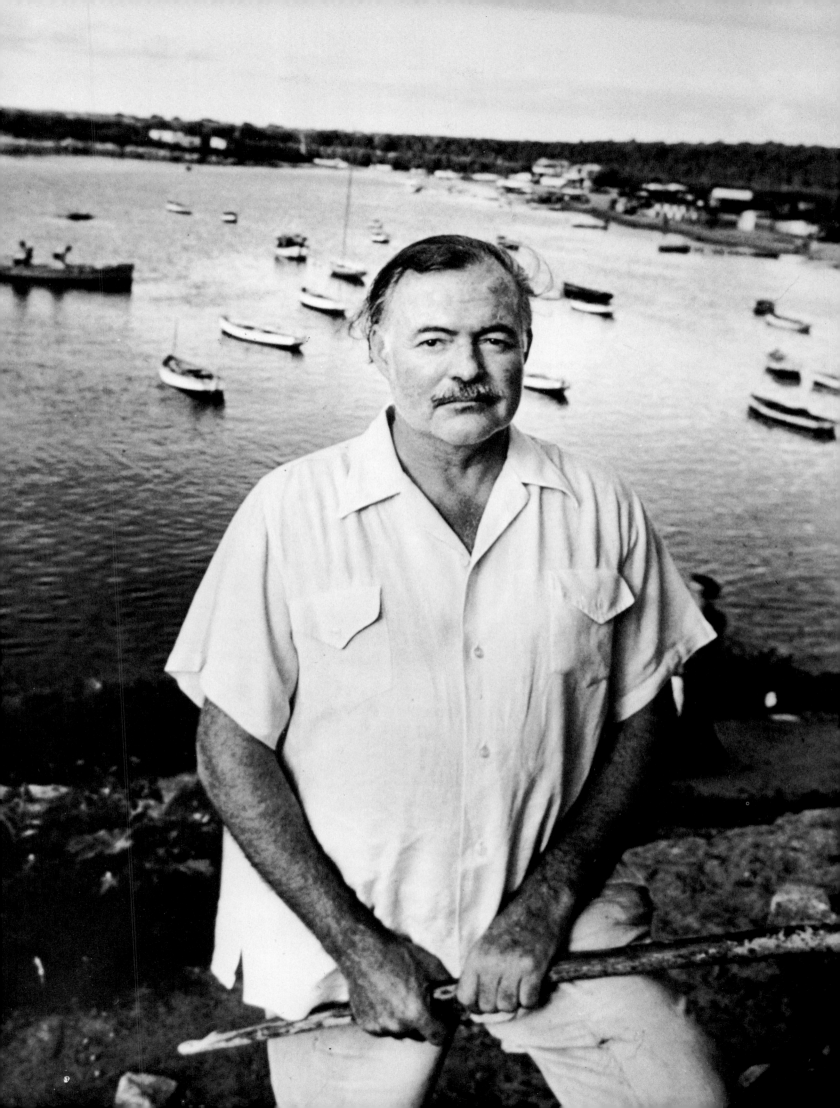

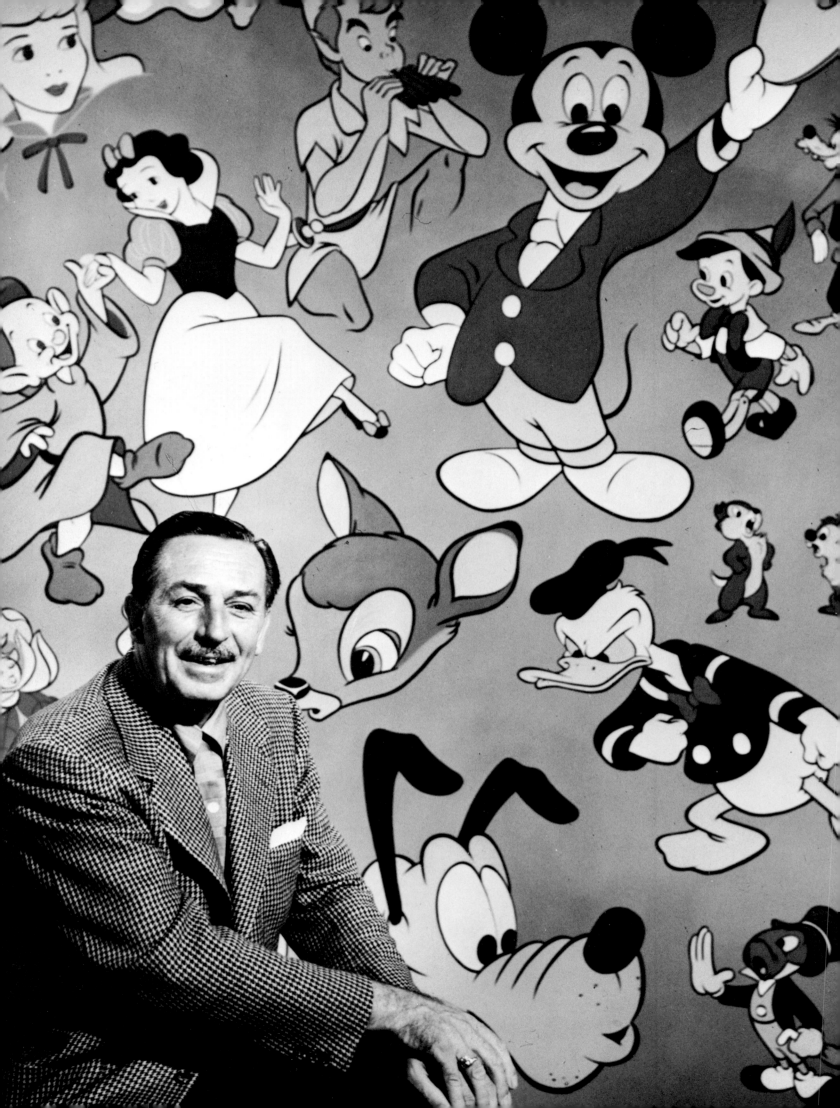

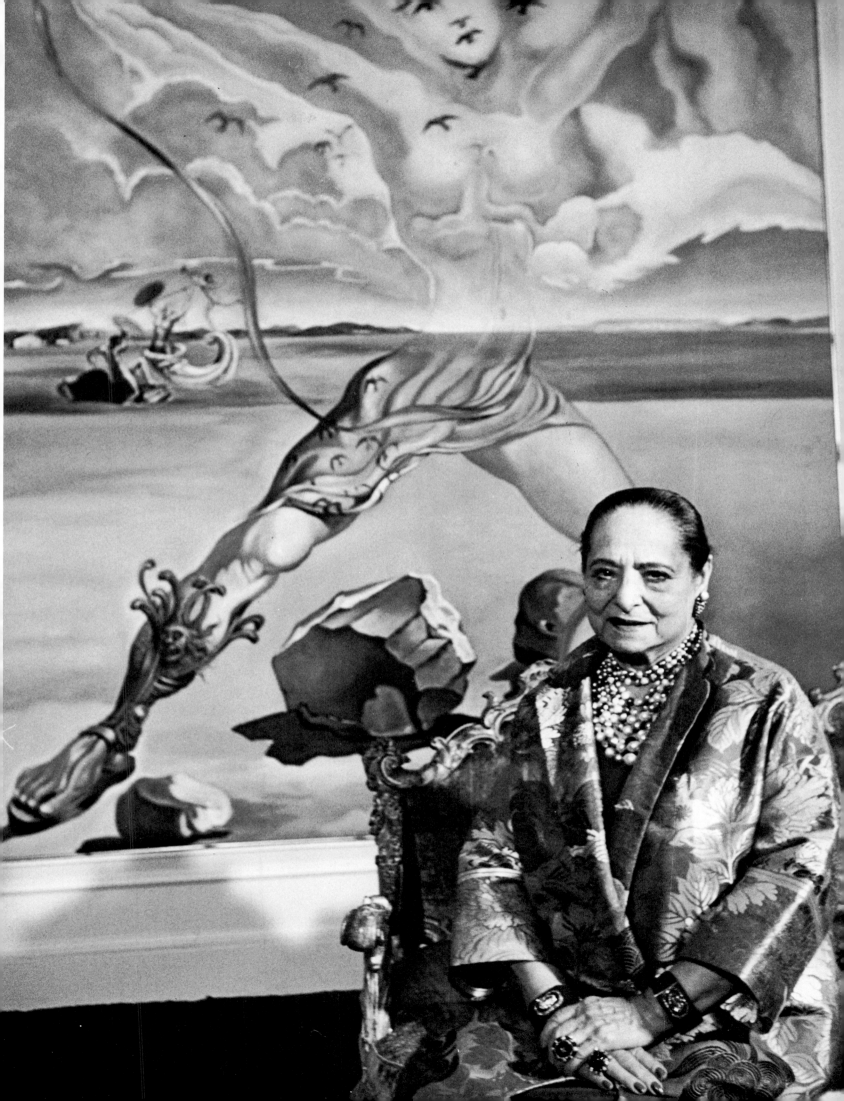

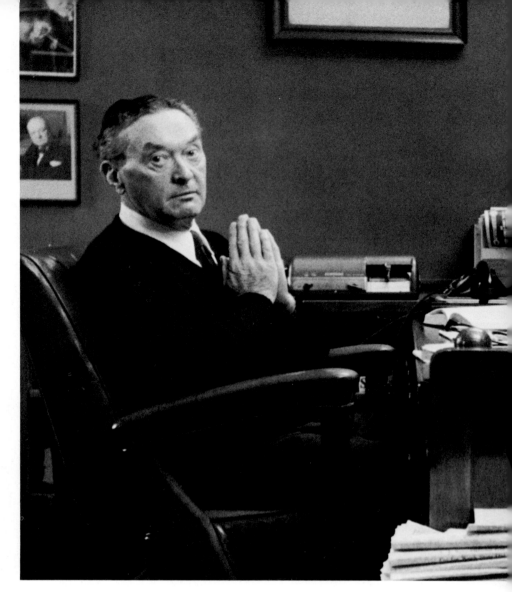

RIGHT: Walter Lippmann, author, editor, and the most respected political columnist of his time, in his Washington, D.C., home in 1956.

BELOW, LEFT: Arthur Hays Sulzberger in 1951, publisher of *The New York Times,* 1935-1961, now chairman of the board.

BELOW, CENTER: Bernard Mannes Baruch in 1958, adviser to United States Presidents since World War I.

BELOW, RIGHT: Alfred P. Sloan, Jr., in 1958, president of General Motors.

OVERLEAF: Playwright Tennessee Williams in 1956.

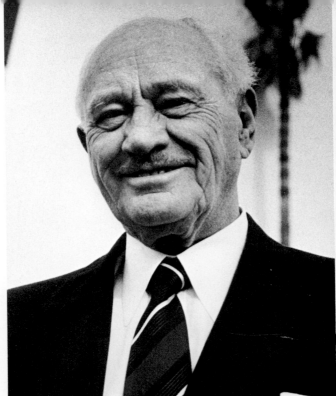

Conrad Hilton, 1955.

Henry Ford II, chairman of the board of Ford Motor Company, in front of a portrait of his grandfather, Henry Ford, who founded the automobile dynasty.

Conrad Hilton built his first hotel in Dallas, Texas, in 1925 and by the end of 1967 he plans to own forty-seven throughout the world.

Thomas Watson, Jr., went to work for International Business Machines in 1937, has been president since 1952 and chairman of the board since 1961.

Roger Blough in 1952, at forty-eight, became chairman of the board and chief executive officer of United States Steel, largest steel company in the world.

Igor Sikorsky, born in Russia in 1889, became a United States citizen in 1928 and spent his life designing and building airplanes, including the first successful helicopter in 1939.

Henry Robinson Luce. Born in China in 1898, he founded *Time* in 1923 with Briton Hadden. It became the cornerstone of the world's largest magazine-publishing company.

Henry Ford II, 1955.

Thomas Watson, Jr., 1955.

Roger Blough, 1955.

Igor Sikorsky, 1957.

ry R. Luce, 1963.

203

Clare Boothe Luce, playwright, editor, ex-Congresswoman, ex-ambassador and wife of publisher Henry R. Luce, on vacation in Majorca in 1963.

RIGHT: Jacqueline Kennedy at the Kennedys' Hyannis Port home in 19

OPPOSITE: Marjorie Merriweather Post, seventy-eight, in her Palm Beach, Florida, home. Financier, philanthropist, confidante of queens, and an ardent practitioner of the square dance, she is the daughter of Charles William Post, who turned out the highly successful beverage called Postum. She was married to the late Joseph E. Davies, United States Ambassador to Moscow.

A gathering of famous Americans in April 1960 at the Waldorf Astoria Hotel in New York City, celebrating the twenty-fifth anniversary of the Research Institute of America. Front row, left to right: Labor leader Walter Reuther, former Vice-President Henry A. Wallace, Eleanor Roosevelt, and radio commentator H. V. Kaltenborn. In second row between Reuther and Wallace is General Mark Clark and behind Kaltenborn is former United States Secretary of State James Byrnes. In back row, fourth from right, is Wernher von Braun, German-born space scientist.

OPPOSITE: Frank Lloyd Wright, maverick genius among architects, working at his home and school in Taliesin, Wisconsin, in 1956.

BELOW: Judge Learned Hand in 1959, a Federal Judge of the Court of Appeals. One of the most respected jurists in United States history, he sat on a federal bench for thirty-seven of his eighty-nine years.

RIGHT: Professor Norbert Wiener in his classroom at MIT in 1950. A Harvard Ph.D. at nineteen, Wiener made studies of the striking analogies between control systems in animal bodies and those in complex machines, which became the basis of his newly created cybernetics.

BELOW: Paul Dudley White in 1956, riding his bicycle in Boston. An eminent heart specialist, he treated, among others, President Eisenhower, and recommended bike-riding as the ideal form of exercise.

RIGHT: Andrew Wyeth in 1965. Son of a well-known mural painter, Wyeth has himself become one of the best-known American painters.

OPPOSITE: Professor Oswald Veblen at the Institute for Advanced Study in Princeton, in 1947. A nephew of the late famous economist Thorstein Veblen, he was one of the world's greatest mathematicians, specializing in differential geometry.

LEFT: Dr. Ralph J. Bunche in 1959. He won the Nobel Prize for peace in 1950 for his work with the United Nations in bringing peace to Palestine.

BELOW, LEFT: Edward R. Murrow in 1959. He raised radio and television reporting to a high level.

BELOW: United States Senator from Maine, Margaret Chase Smith, in 1956. She has served in elective office in Washington longer than any other woman.

OPPOSITE: Former Vice-President of the United States John Nance "Cactus Jack" Garner, then ninety, at his home in Uvalde, Texas.

LEFT: William Franklin ("Billy") Graham, Baptist preacher, who since 1946 has been preaching his evangelism all over the world.

BELOW: W. E. Hocking, Professor of Philosophy at Harvard for twenty years, whose books deal with the religious aspects of philosophy.

LEFT: Protestant theologian Reinhold Niebuhr was Professor of Applied Christianity at Union Theological Seminary until he retired in 1960.

OPPOSITE: In 1952 Roman Catholic Bishop Fulton J. Sheen had a regular television program on religion which competed successfully against Frank Sinatra and Milton Berle.

215

Sandhill cranes flying north to Arctic nesting grounds.

Conservation in the United States

The curiosity and love of nature have, from the United States' earliest days, inspired a host of great naturalists. The Bartrams, John and his son William, hiked through the New World in the mid 1700s, discovering and collecting plants. Alexander Wilson and John Audubon painted and catalogued birds. Henry David Thoreau sought the simple life, communing with nature for two years in a cabin on Walden Pond near Concord; he wrote that the earth "is more wonderful than it is convenient; more beautiful than it is useful; . . . more to be admired and enjoyed than used." And the late Aldo Leopold, who spent his life in conservation, once wrote: "For us of the minority, the opportunity to see geese is more important than television, and the chance to find a pasque-flower is a right as inalienable as free speech."

Today a new elite of American naturalists—artists, writers, scientists, philanthropists —has inherited the enthusiasm of those early giants. Some of them are shown on these pages, photographed in 1961. All were passionately concerned with protecting what remains of the original heritage from the encroachments of civilization—a problem that scarcely disturbed the ancients. A predominantly rural people in 1900, Americans are now predominantly (70 per cent) urban and suburban. As a result, the "opportunity to see geese . . . and . . . to find a pasque-flower" may slowly be eluding us all.

OPPOSITE: Roger Tory Peterson, high priest of bird-watching and inventor of a revolutionary system for identifying birds. In one year Peterson sighted 572 different species in North America. Here, holding a movie camera, he inspects a nest of osprey, too young to fly away.

BELOW: Joseph Wood Krutch, in 1961, holding a tame desert bobcat near his home in Tucson, Arizona, not only has been a drama critic, a biographer, and an educator of distinction; he is also an eminent naturalist-philosopher. He once summed up his philosophy of nature: "Those who have never found either joy or solace in Nature might begin by looking not for the *joy they can get,* but for the *joy that is there* amid those portions of the earth man has not entirely pre-empted for his own use. And perhaps when they become aware of joy in other creatures they will achieve joy themselves, by sharing it."

ABOVE: Albert Hochbaum, a famous Canadian biologist, is hemmed in by friendly trumpeter swans. "A dart of ducks against the morning sky," he says, "is still the most beautiful thing in the world."

LEFT: Brothers Adolph and Olaus Murie have spent their lives studying and writing about wildlife in the West and Alaska.

OPPOSITE: A raccoon peers out of his home along the mangroves.

OVERLEAF: An alligator in the Everglades.

PAGES 222 AND 223: A young sandhill crane takes its first steps and otters cavort along the main canals and waterways of Everglades National Park in Florida.

A spoonbill takes wing, looking like a flying orchid, in the Florida glades.

RIGHT: Rachel Carson was not only a trained biologist, but also a superb writer. Her poetic, evocative *The Sea Around Us* was immediately a distinguished literary success when it was published in 1951. Eleven years later, her second book, *Silent Spring,* projected her into the middle of a nationwide debate. In the book Miss Carson charged that a serious threat to our environment was being posed by the "unrestricted" use of chemical pesticides, and she conjured up a nightmare world where meadows and woodlands wither and the balance of nature is tilted toward oblivion. The chemical industry and some top officials of the Department of Agriculture disagreed vehemently with Miss Carson's claims. "I have no wish to start a Carry Nation crusade," Miss Carson said. "I wrote the book because I think there is a great danger that the next generation will have no chance to know nature as we do—if we don't preserve it the damage will be irreversible." She died in 1964 at fifty-six.

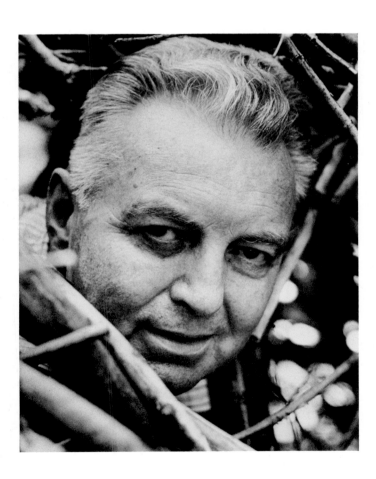

Edwin Way Teale is one of the top writers on nature subjects.

Ethel Barrymore, in Washington, D.C., for the celebration of Franklin D. Roosevelt's re-election, 1940.

The Performing Arts

For decades the theater and the concert stage were pretty much special preserves, limited to large cities and sophisticated audiences. Then came World War II and a postwar phenomenon called, aptly, the cultural explosion. Films became a world-wide industry, TV laced the land with antennas, community symphony orchestras sprouted like wildflowers, improved techniques in record-making made music a really universal language, and even ballet—originally the feast of kings and courtiers—became a palatable dish that anyone could enjoy.

These pages are my own exposure to the cultural explosion—a panorama of the performing arts since 1940.

OPPOSITE: Ralph Bellamy as Roosevelt with his dog Fala, in Dore Schary's play about the President, *Sunrise at Campobello,* 1958.

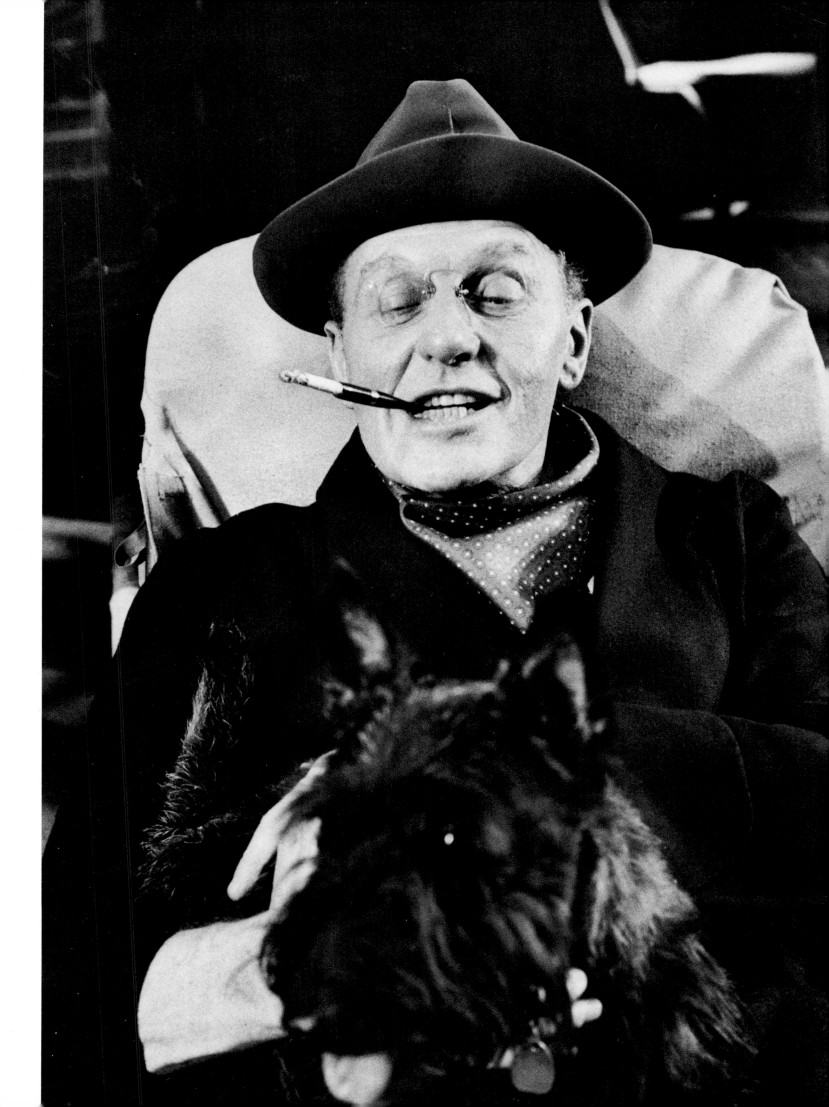

Alec Guinness, bundled up against the cold of a London studio, rehearsing in 1951 for the movie *The Card*.

OPPOSITE: Dame Edith Evans at sixty-three, in 1951. She began her stage caree[r] in 1912 and was still going strong in movies—for example, *Tom Jones*—in 1963[.]

ABOVE: Lex Barker and Cheetah during the filming of another Tarzan movie. RIGHT: Producers Joe Pasternak and Louis B. Mayer in the MGM Studios.

ABOVE, CENTER: Lucille Ball and Bob Hope in *Where Men Are Men*. ABOVE: Janet Leigh and Robert Mitchum making *Holiday Affair* in 1949. LEFT: Betty Grable in *Wabash Avenue*.

Shirley Booth and Sidney Blackmer in a scene from *Come Back, Little Sheba* by William Inge (1950).

OPPOSITE: Eugenie Leontovich as the grandmother in *Anastasia* (1955).

BELOW: Tom Ewell and Nancy Olsen in the stage version of Peter De Vries' *Tunnel of Love* in 1957.

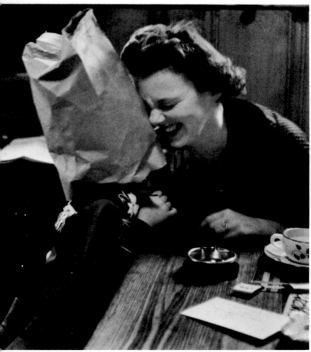

ABOVE: Jean Kerr, author of the stage comedies *Mary, Mary* and *Poor Richard*, with her son in 1955.

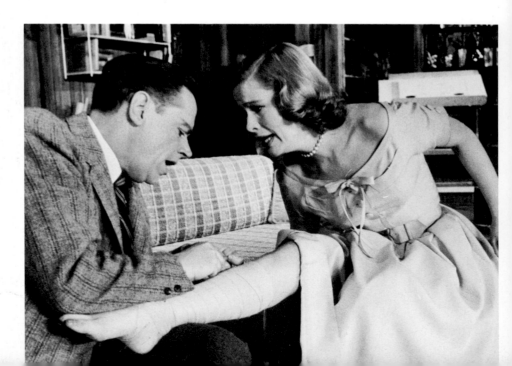

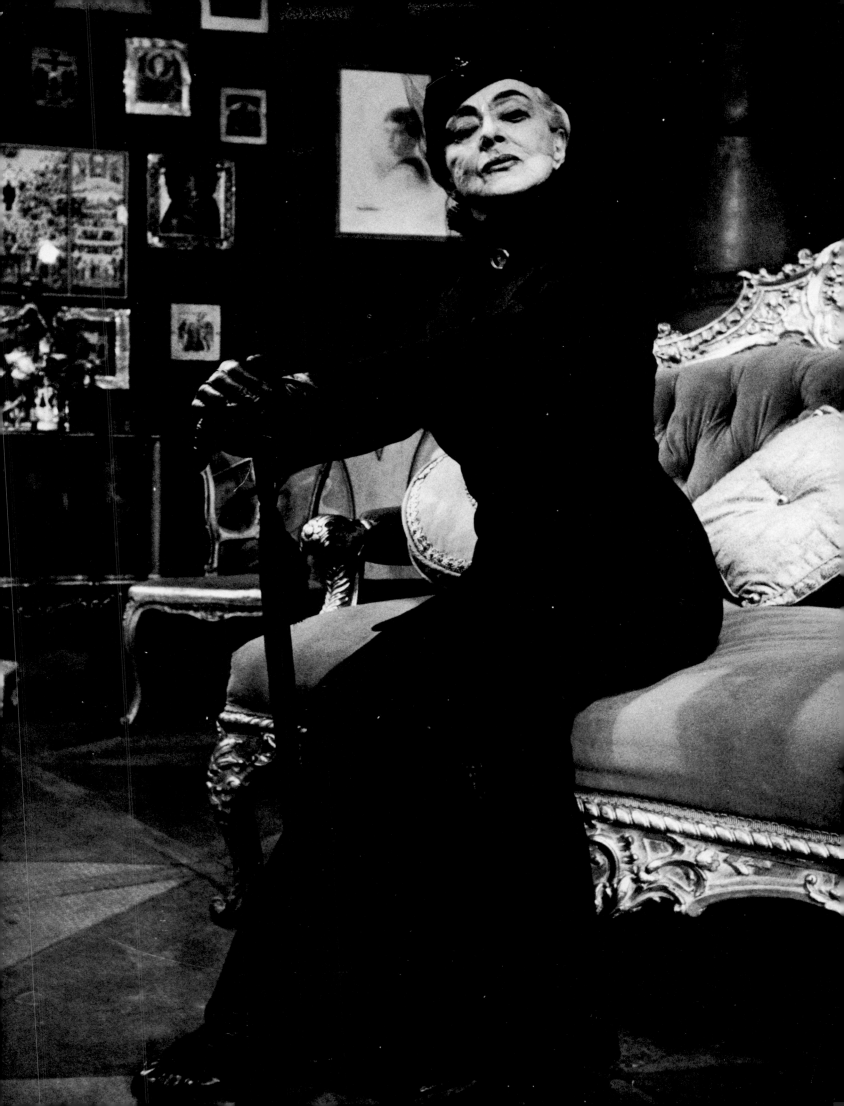

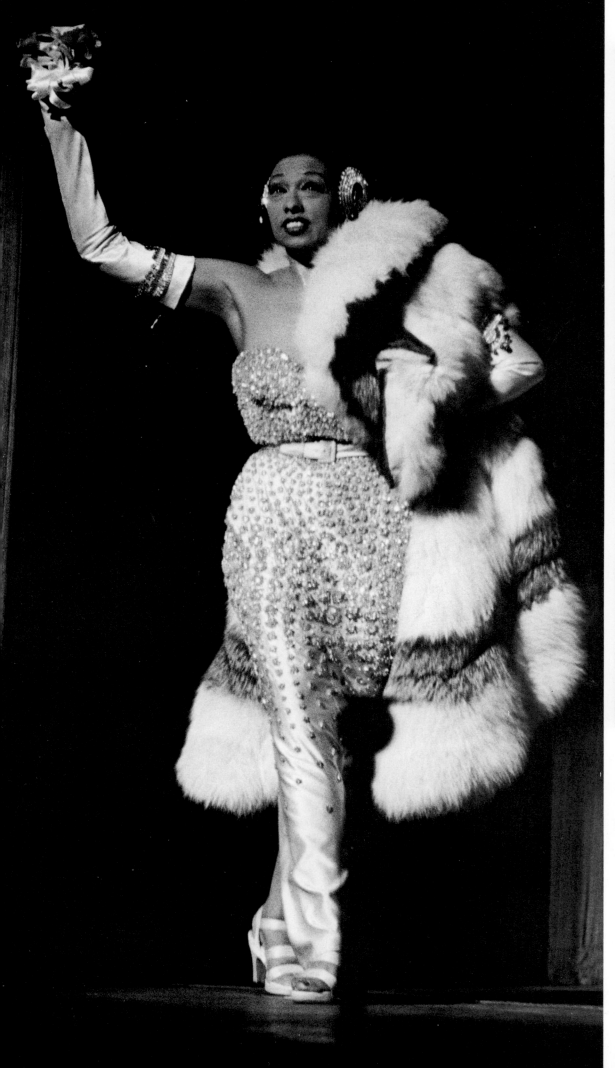

LEFT: Josephine Baker, the daughter of a Negro washer-woman from St. Louis, who became an international *chanteuse*. Her first hit, in Paris, was singing "Ave Maria" while clad only in a girdle of bananas. Here, in 1951, she wears a Dior dress and furs costing a small fortune.

Tallulah Bankhead in 1951. At forty-eight she was still what she said people said she was: "a cello-voiced witch, a honey-haired holocaust."

BELOW: In March 1959 Prince Aly Khan gave a party for many of his old café-society and actor friends. Among them, left to right: Douglas Fairbanks, Jr., Zsa Zsa Gabor (who announced she had just given back to her latest fiancé a 45-carat diamond ring). RIGHT: Charles Boyer, Rex Harrison, and Artur Rubinstein at a party given in 1956 by producer Gilbert Miller.

OVERLEAF: A scene from Rodgers and Hammerstein's 1953 musical, *Me and Juliet*.

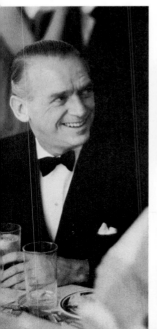
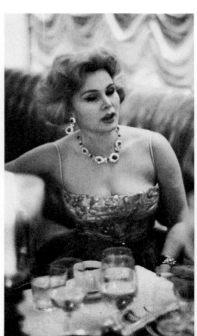
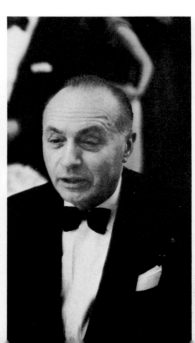

ABOVE: Hollywood columnist Hedda Hopper, 1949.

LEFT: Actor Gregory Peck at Laguna Beach, California, 1949.

RIGHT: Author Truman Capote in 1959 at Rockefeller Center ice-skating rink in New York.

BELOW: The cigar-chewing entrepreneur Mike Todd and Dr. Brian O'Brien, a scientist who developed the Todd-AO process, an offshoot of Cinerama. Todd, then married to Elizabeth Taylor, was killed in an air crash in 1958.

Sophia Loren, whether wearing blue jeans (ABOVE) while rehearsing with Marcello Mastroianni in *Marriage Italian Style,* or the prostitute's costume she wore in the film (OPPOSITE), is the most captivating—and the nicest and the hardest-working—movie actress I have ever met. "Beauty is no handicap if you don't think about it," she said to me. Once, en route to her birthplace in Pozzuoli, a suburb of Naples, we stopped to pay tolls at the Autostrada entrance. "Watch," she said to me, "the soldiers at the gate won't even look at my face." She was right: all they did was move their eyes from her legs up to her shoulders, slowly, like a caress. Then we all— including the soldiers—broke out laughing.

Leonard Bernstein, 1960.

OPPOSITE: Marilyn Monroe photographed in Hollywood, 1954.

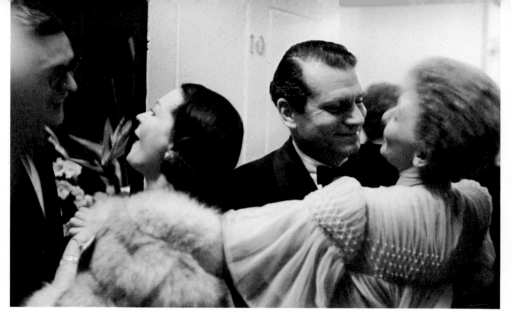

Kay Kendall in 1957. Married to Rex Harrison, she died in 1959.

Vivien Leigh (then Lady Olivier), Laurence Olivier, and Mary Martin at the London première of *South Pacific* in 1951. BELOW: Playwright-director Moss Hart and wife, Kitty Carlisle, in 1959.

Judy Garland (ABOVE) and Salvador
Dali and his wife (RIGHT) in 1957.

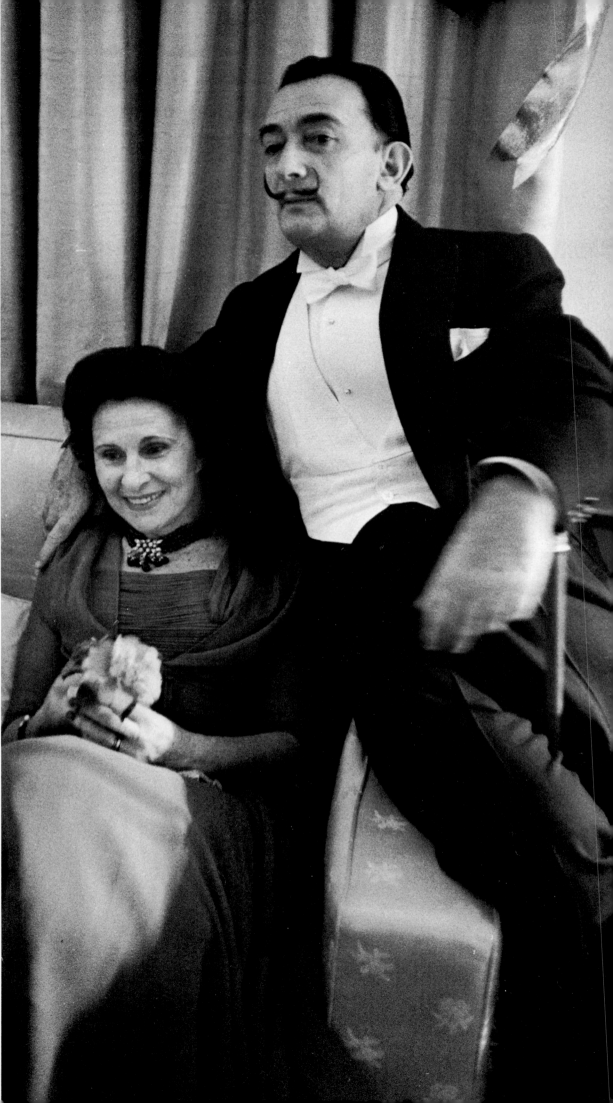

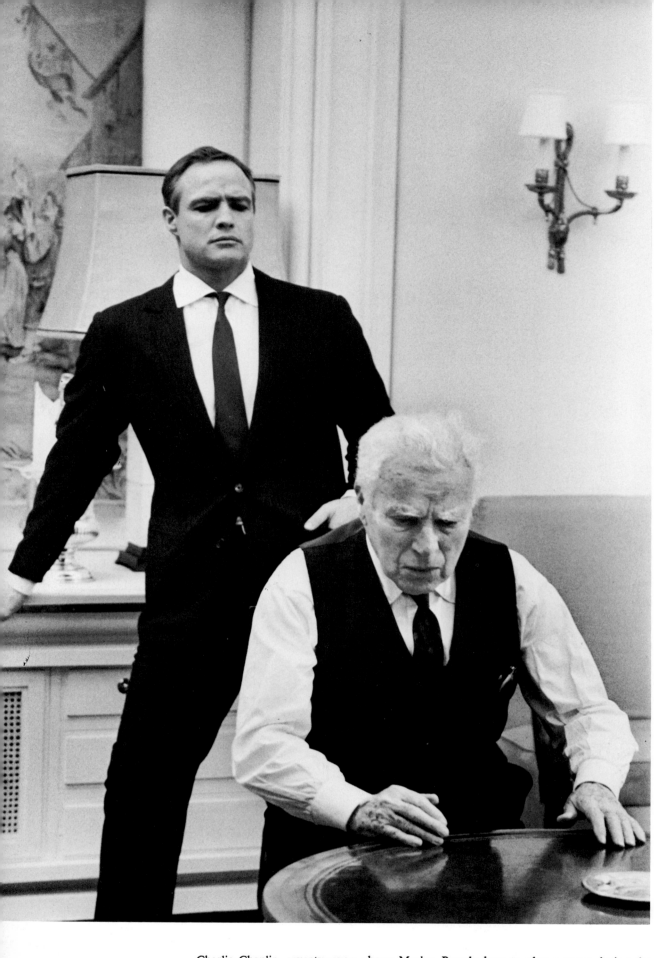

Charlie Chaplin, seventy-seven, shows Marlon Brando how to play a scene during the filming in London of Chaplin's first movie since 1956, *A Countess from Hong Kong.*

RIGHT: Jason Robards and Maria Schell rehearse the TV adaption of Hemingway's *For Whom the Bell Tolls* in 1959 under the direction of John Frankenheimer (lying on floor). It was an ambitious three-hour production.

RIGHT: Jason Robards and Maria Schell rehearse the TV adaption of Hemingway's *For Whom the Bell Tolls* in 1959 under the direction of John Frankenheimer (lying on floor). It was an ambitious three-hour production.

BELOW: One of the most absorbing successes of the London stage in 1958 and the New York stage in 1960 was *A Taste of Honey,* written by a nineteen-year-old theater usher named Shelagh Delaney. Joan Plowright (Laurence Olivier's wife), at left, acting with Angela Lansbury and Nigel Davenport.

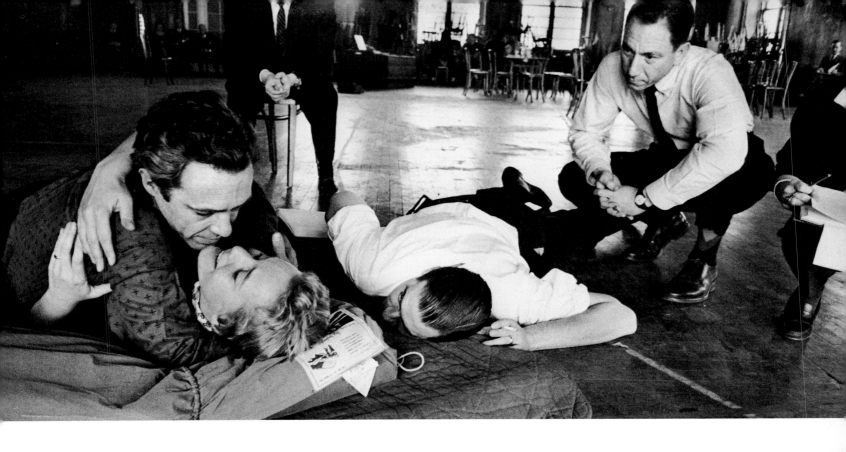

An evening at the Bolshoi Ballet. RIGHT: Second act of Prokofiev's *Romeo and Juliet* with Ulanova as prima ballerina. BELOW: Marlene Dietrich and English actor Murray Matheson during intermission. At extreme left is Rudolf Bing, general manager of the Metropolitan Opera Company. BELOW, RIGHT: Impresario Sol Hurok.

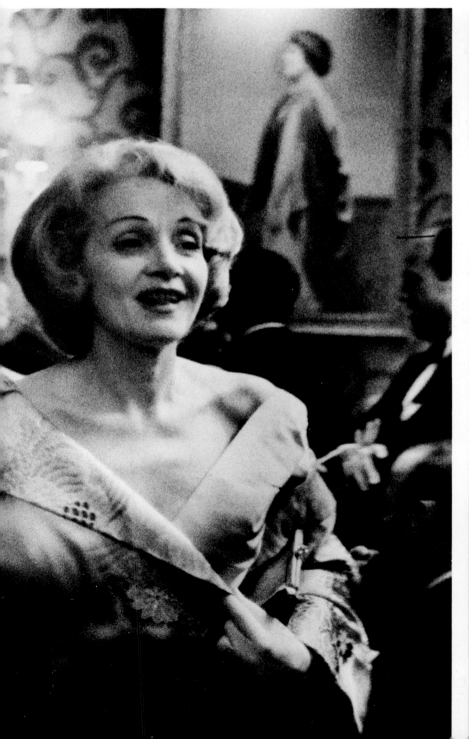

ABOVE: Irving Berlin, the prolific popular song-writer, wrote his first song in 1907 and was still composing in 1957.

LEFT: Gian Carlo Menotti, whose melodramatic operas in English made musical history, photographed in 1958.

OPPOSITE: Greek-born conductor Dmitri Mitropoulos goes over a score at his desk in 1946.

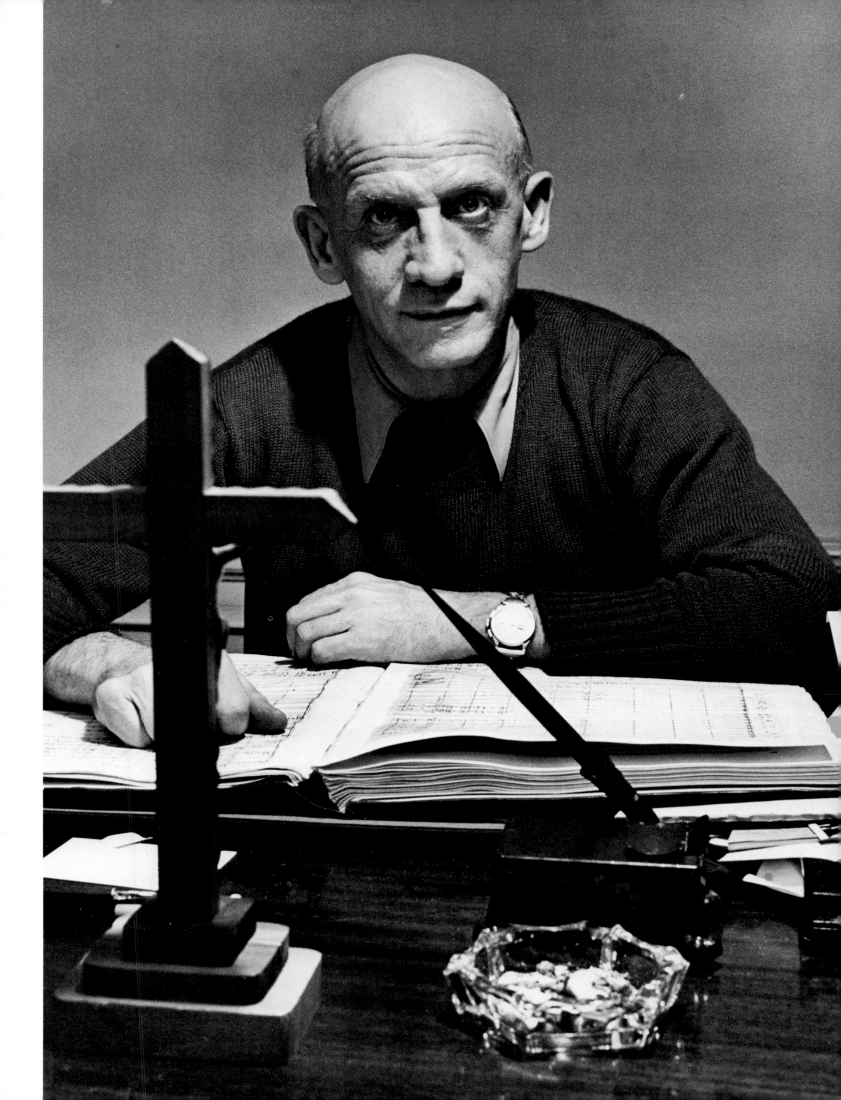

Lauritz Melchior, Danish-born heroic tenor, was the leading Wagnerian tenor at the Metropolitan Opera from 1925 to his retirement in 1950. He appeared in more than five hundred presentations of Wagner's operas. RIGHT: His huge girth encased in a corset, he makes up in his dressing room for the role of Tristan and comes down the stairs, ready to make his entrance.

LEFT: Melchior as Tristan and Helen Traubel as Isolde sing a duet in a performance in 1944.

RIGHT: Lily Pons, the French-born coloratura soprano, sings in a 1942 production of Donizetti's *Daughter of the Regiment*.

Richard Tucker in 1952. A former member of a synagogue choir on the Lower East Side of New York, he has been one of the Metropolitan Opera's "golden" tenors for more than twenty years.

RIGHT: The auburn-haired Australian beauty Joan Sutherland—called *"La Stupenda"* by the Italians—as Lucia in Donizetti's *Lucia di Lammermoor*.

OVERLEAF: LEFT: Leontyne Price in *Il Trovatore* in 1961. RIGHT: Anselmo Colzani as Falstaff in 1964, with Gabriella Tucci.

BELOW: Pianist Vladimir Horowitz taking his bows at New York's Carnegie Hall in 1965, his first concert appearance in twelve years. RIGHT FROM TOP TO BOTTOM: Conductors George Szell, Charles Munch, and Leopold Stokowski. OPPOSITE PAGE: Van Cliburn in 1958 rehearsing for a concert.

OVERLEAF: Maria Tallchief and Nicholas Magallanes in *The Nutcracker* in 1954.

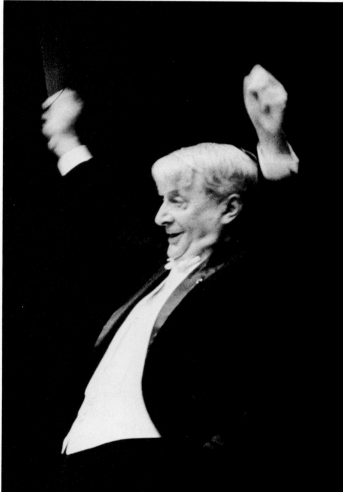

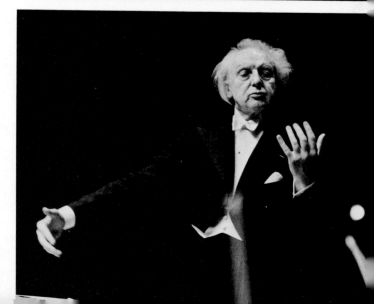

New York harbor.

The Travel Boom

High on the bridge, the captain of the *Queen Elizabeth* loomed over the New York skyline as his ship eased into the harbor. World War II had shrunk the world psychologically; the jets and new, bigger, faster ocean liners were now shrinking it physically. A generation that had fought in, or read about, all those places with exotic names now had the leisure time—and the money—to enjoy them, creating a postwar travel boom of miraculous dimensions. The Grand Tour, once the exclusive province of the very rich and the very social, had become almost a commonplace. Everywhere tourists went, they took thousands of pictures. So did I on my travels to the new playgrounds of the world. On the following pages are my favorite travel pictures.

OPPOSITE: London's "Big Ben." In the foreground are statues of Viscount Palmerston (left), and Field Marshal Jan Christiaan Smuts (right).

OVERLEAF: Paris: Artist in Montmartre, and the Eiffel Tower.

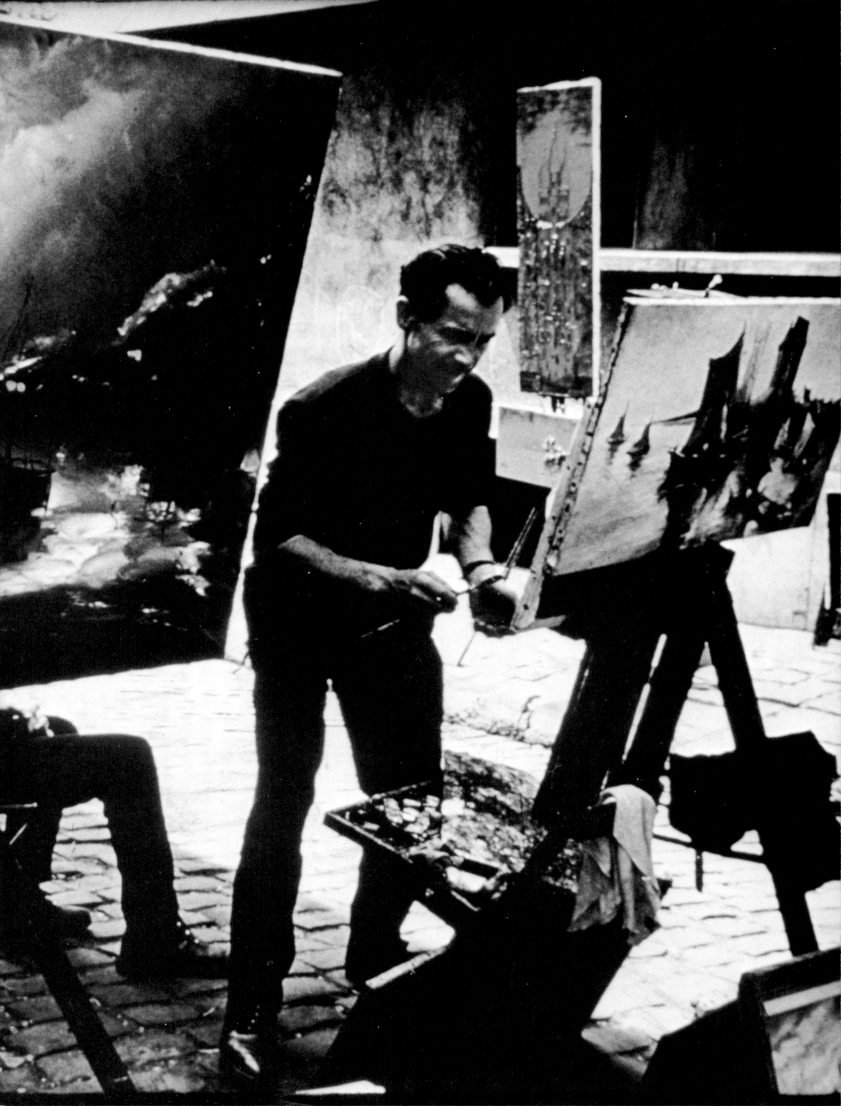

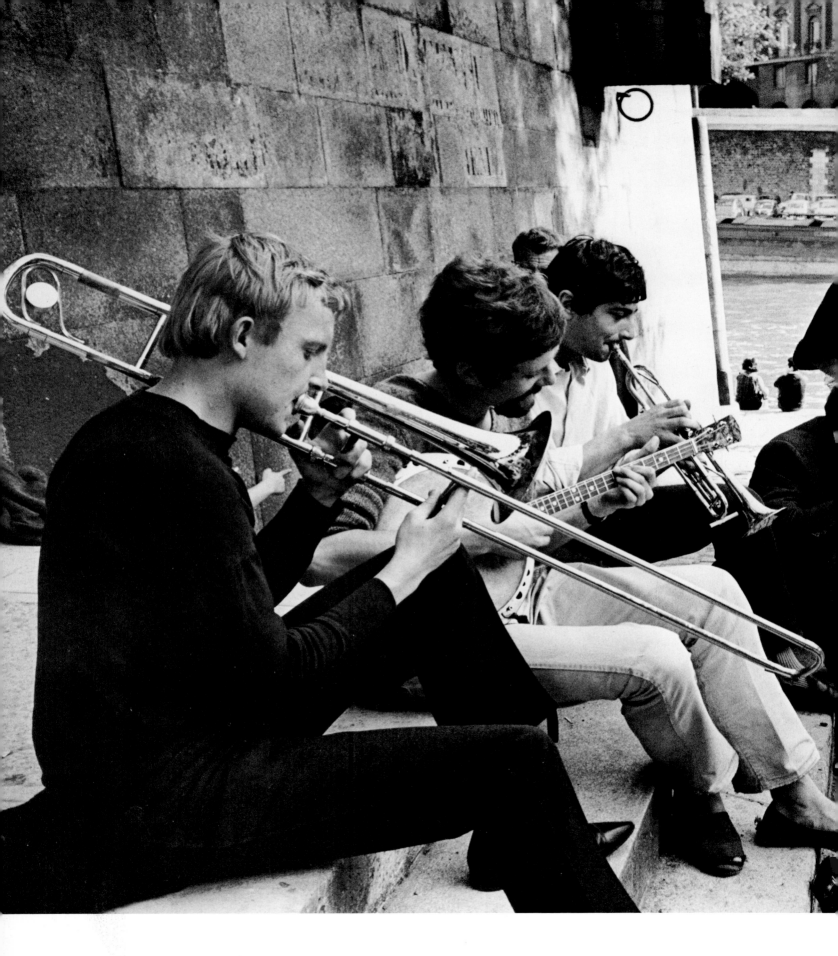

Paris: On the Ile de la Cité, music students from the Sorbonne give an impromptu jazz session.

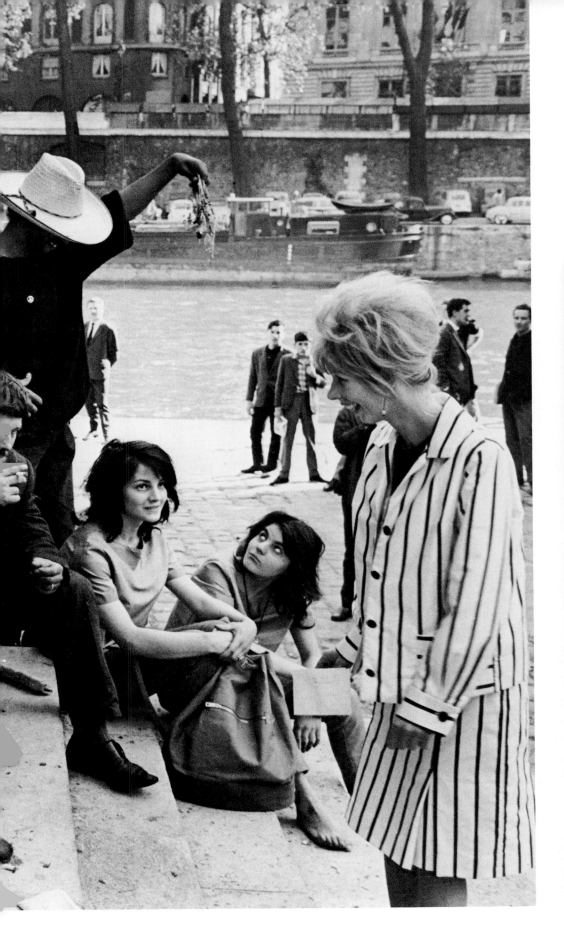

RIGHT: Paris, anywhere, any time.

Palio in
Siena.

Tower
of Pisa.

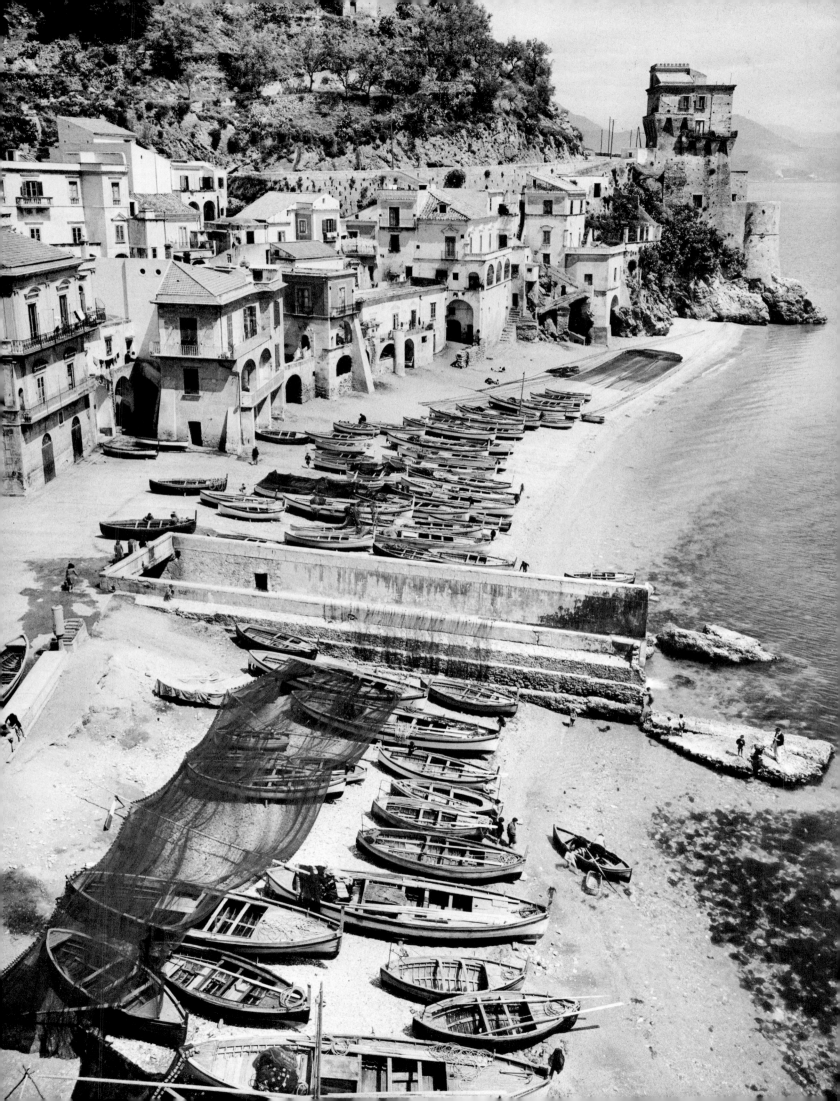

Toledo, Spain.

The Acropolis.

PREVIOUS PAGES: Gondolas in Venice, and view along the Amalfi Drive.

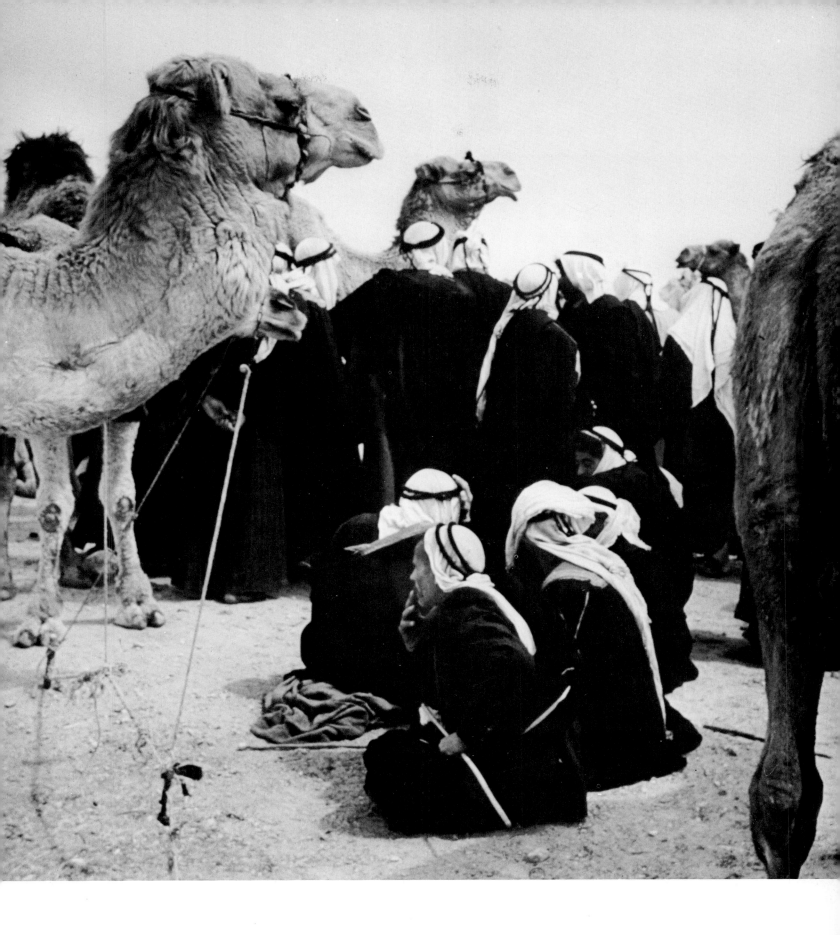

LEFT: The Blue Nile Falls in Ethiopia. ABOVE: A camel market in Beersheba, Israel.

Israel: An old rabbi in Jerusalem. RIGHT: The morning before Passover, Orthodox Jews watch kerosene-soaked loaves of bread being devoured by flames, representing the final act of cleansing before Passover.

276

OVERLEAF: India, the ghats at Benares.

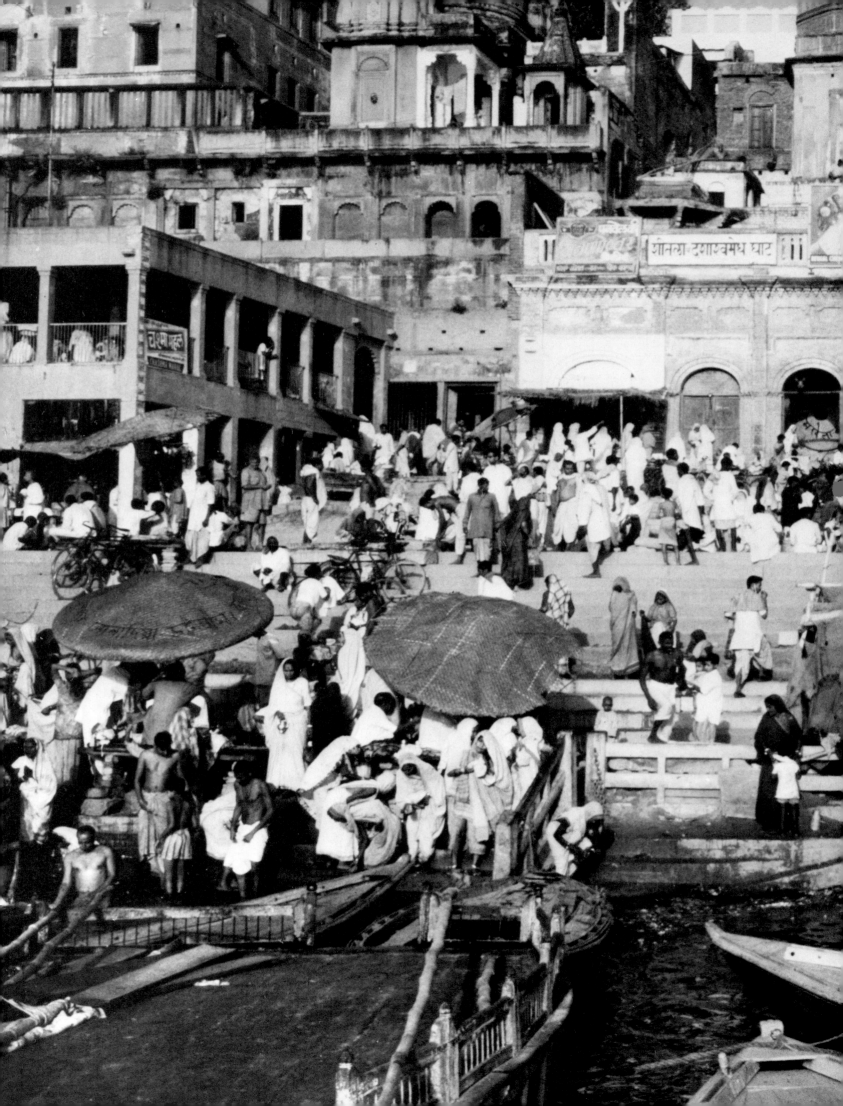

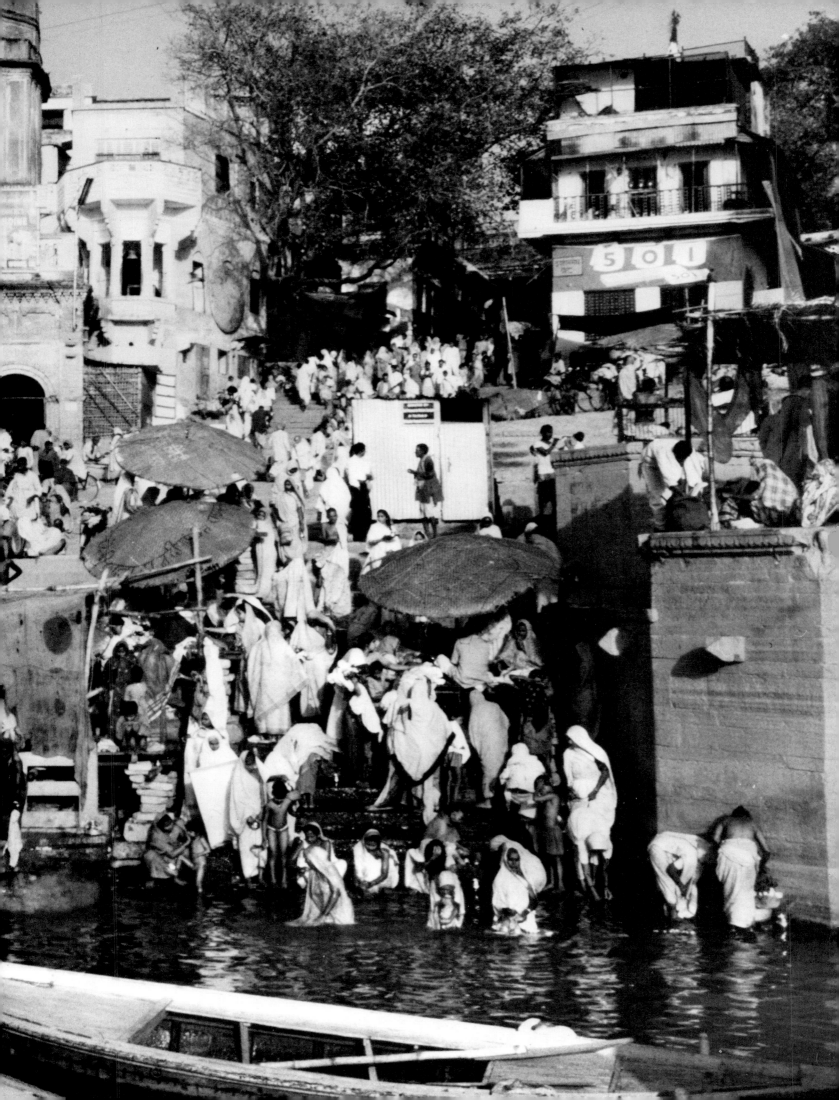

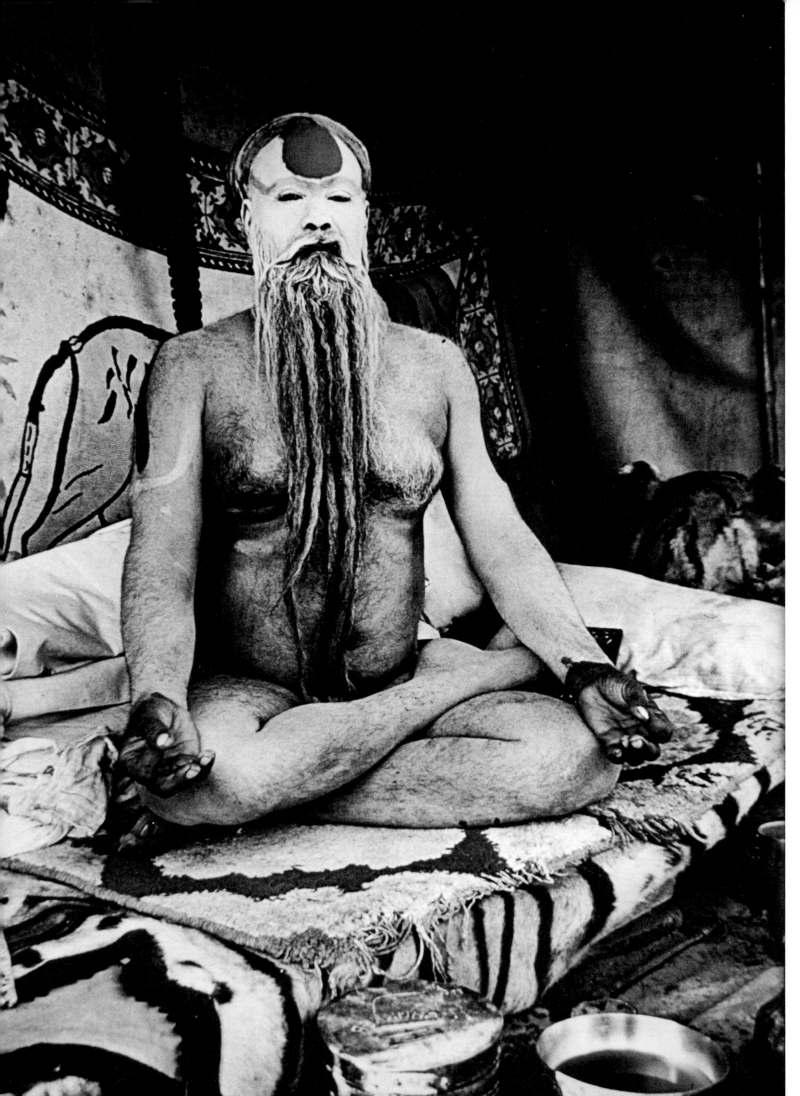

India:
A Sadh

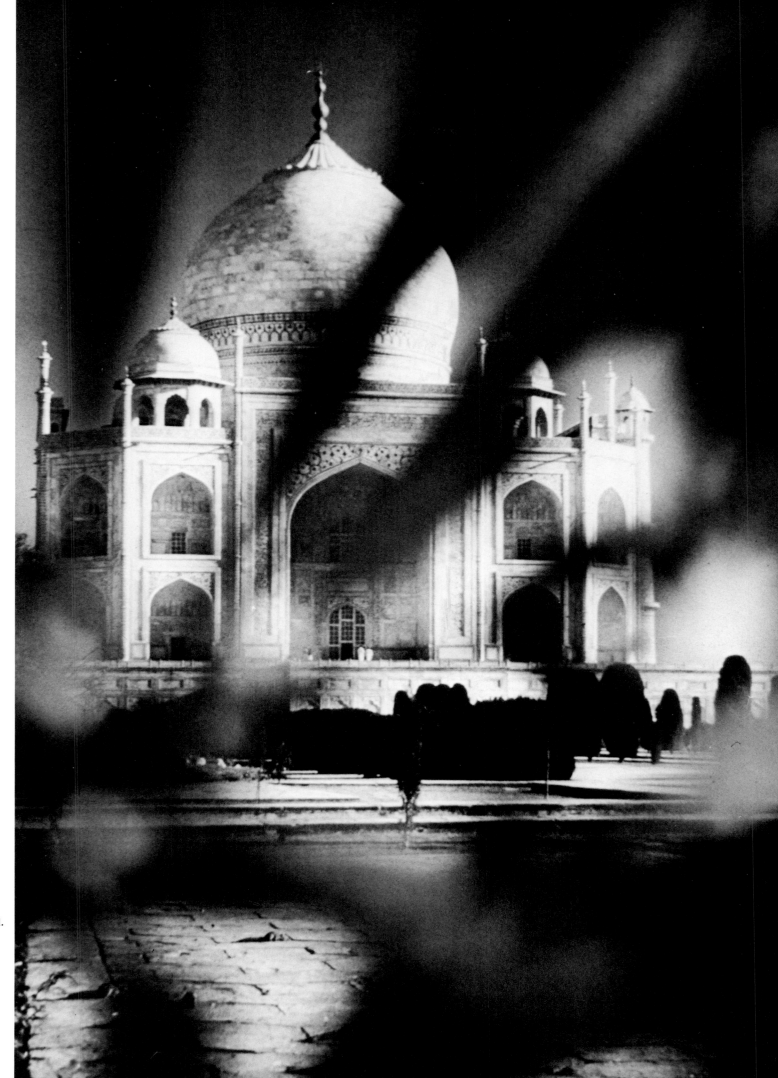

Taj
Mahal.

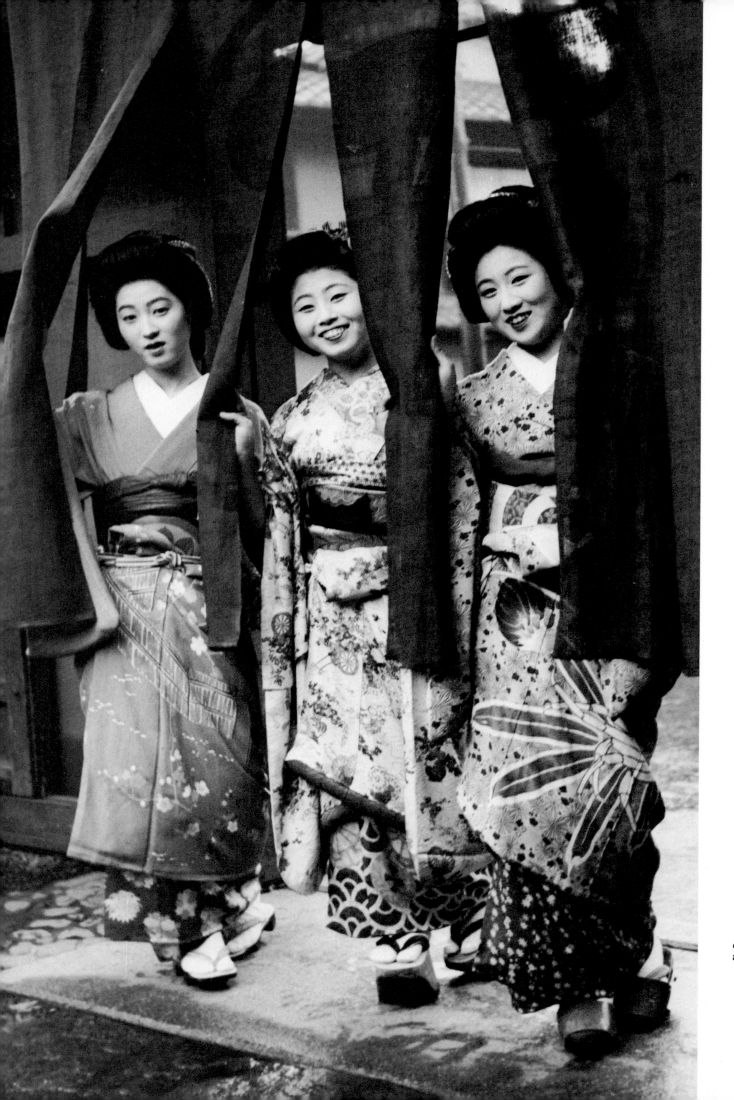

Geishas in Kyoto.

OPPOSITE: Kabuki
actor in Tokyo.

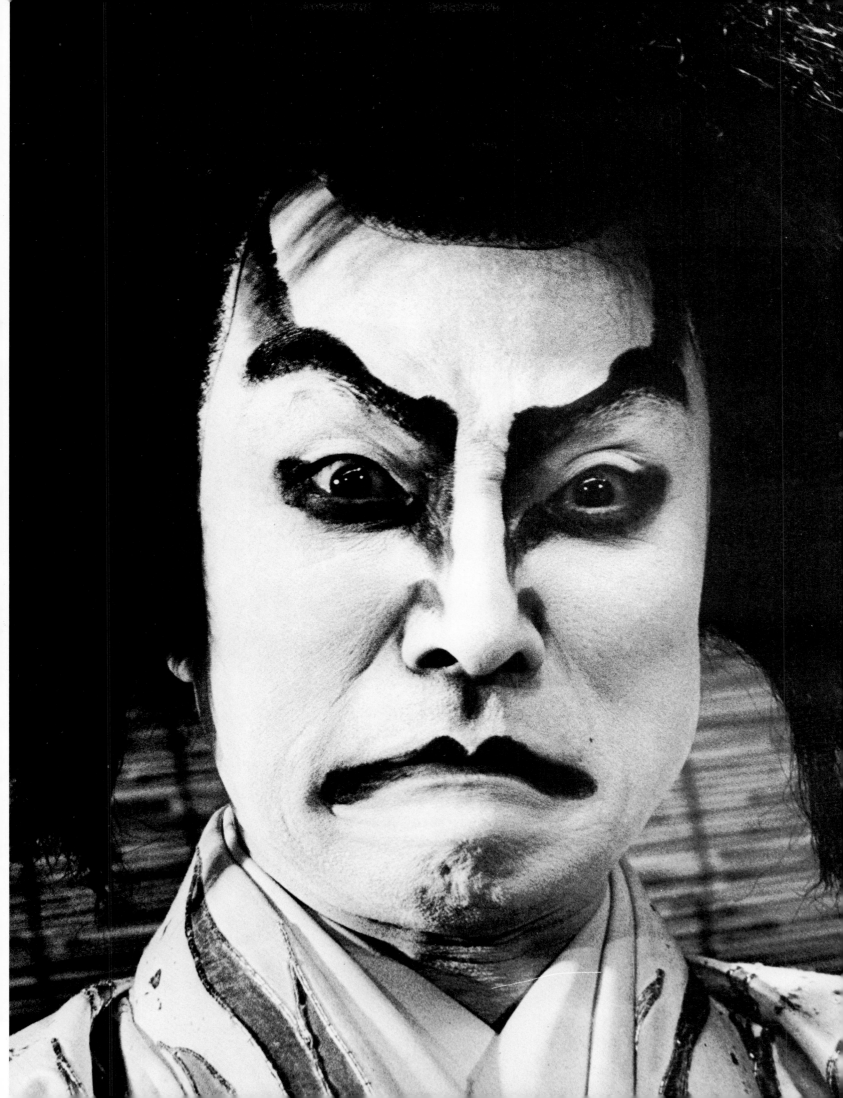

Mexico City: A new office
building. BELOW: Traffic on
the Paseo de la Reforma.

OVERLEAF: Ecuador—an Indian woman in a shrine in Guayaquil and a market scene in Quito. PAGES 288-89: Manhattan at sunset.

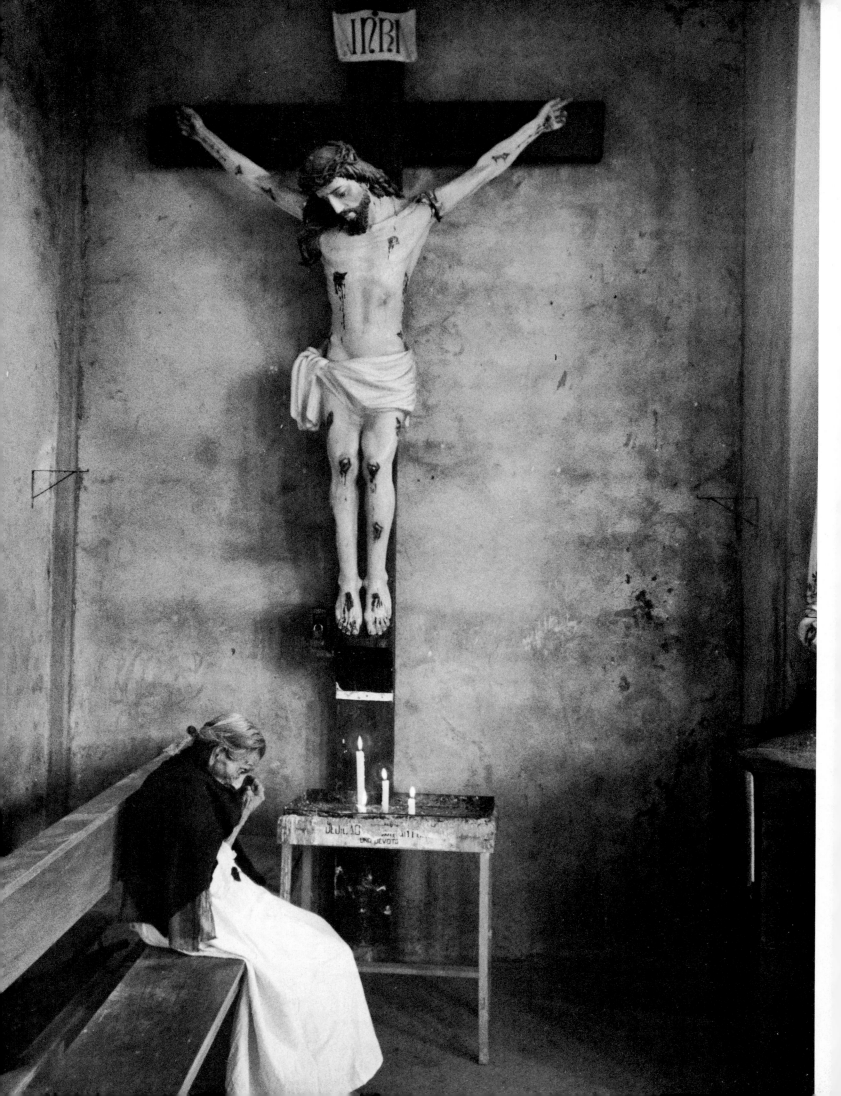

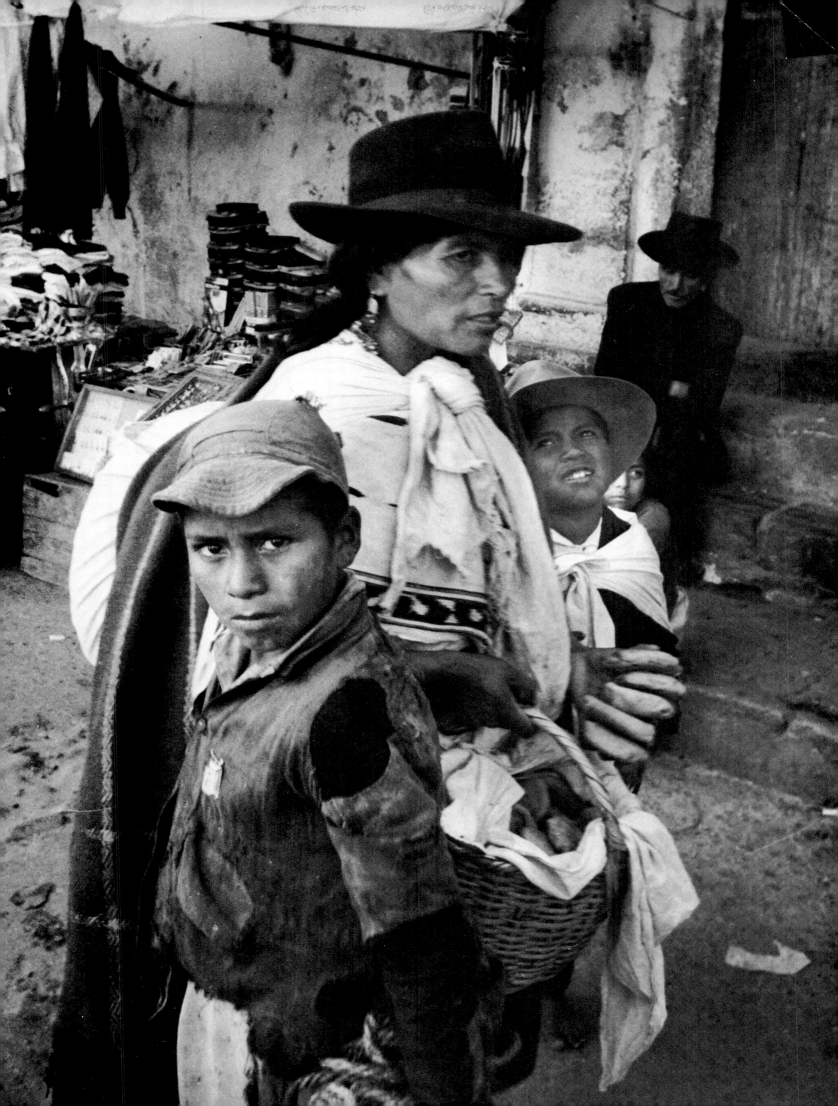

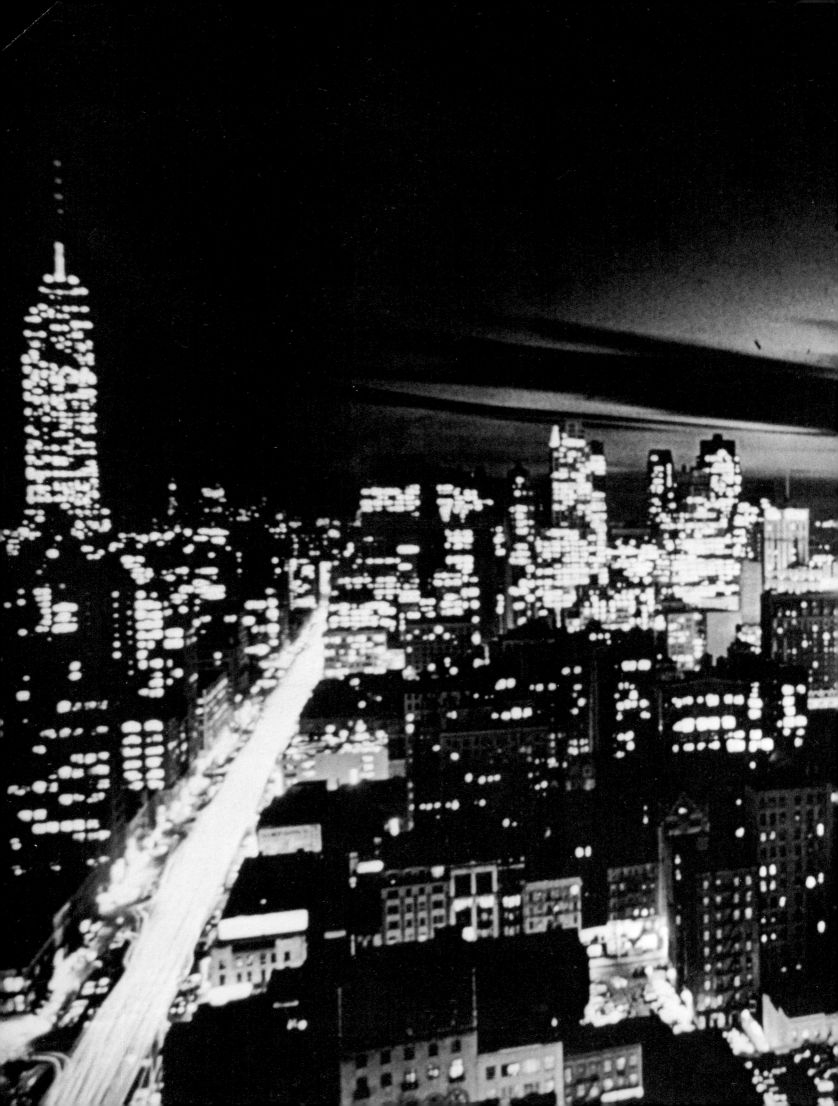

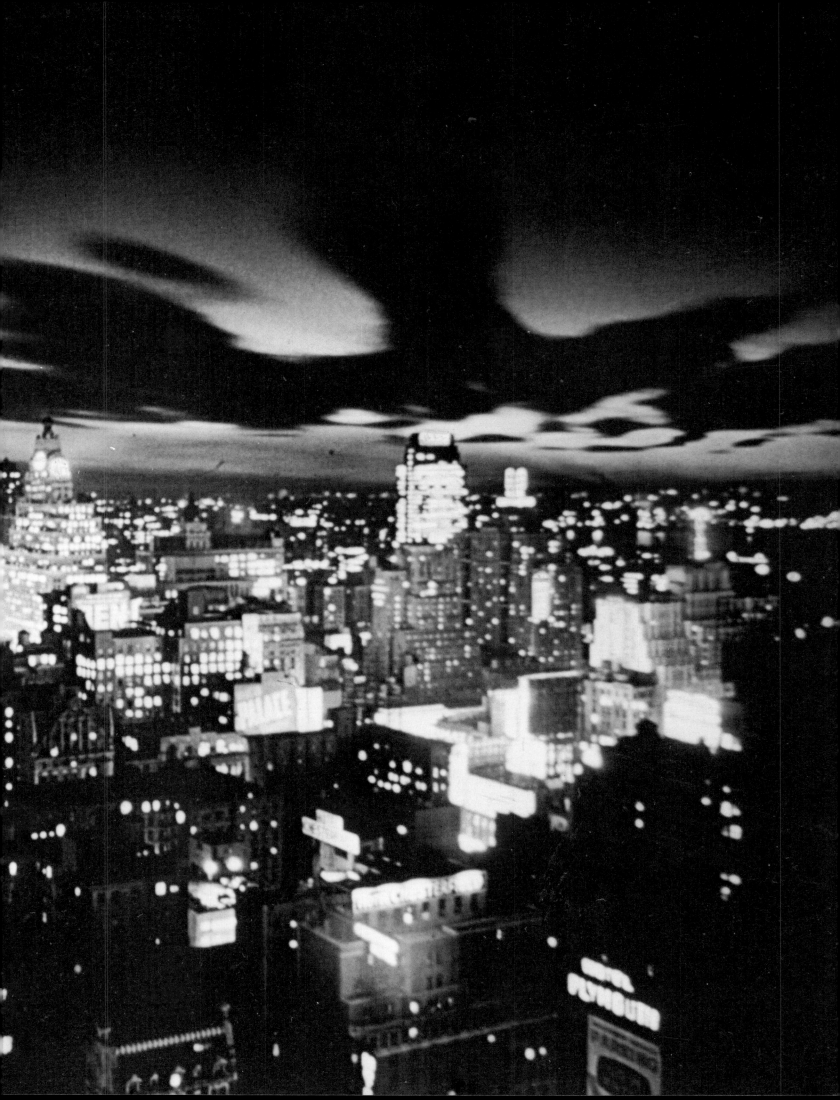

Dag Hammarskjöld, Secretary of the UN from 1953 until his death in a plane crash in Rhodesia in 1961.

The United Nations

The failure of the League of Nations dimmed, but did not destroy, man's dream of a world order backed by some kind of international organization. When the diplomats assembled in San Francisco in April 1945 for the founding convention of the United Nations, one newspaper called it "the most important human gathering since the Last Supper." South Africa's Jan Smuts, who had seen the birth and death of the League, also had high hopes for the new organization. He scribbled a rough draft of the UN Charter's preamble on a cigarette packet and told reporters: "This time we will pull it off. We have learned our lesson."

The hope of the men who framed the UN Charter was that peace would be maintained by the big powers—acting in concert. That dream died fast: each of the big powers had the right to veto any action in the Security Council and did so where its own interests were directly involved. The Russians used their veto with paralyzing regularity. But Sweden's Dag Hammarskjöld, a forceful personality who was Secretary General of the UN for almost a decade, thrust the organization, in the role of arbiter and policeman, even into areas where big-power interests collided—such as the Suez in 1956 and the Congo in 1960.

When the UN was founded, there were 51 nations in it, including four African countries. By the end of 1965 the General Assembly had 114 members, 36 of which were African nations. The host of new emotional, racial, tribal, and religious elements thus introduced considerably complicated the UN's search for an orderly world ruled by law and reason. But if it could no longer be policeman to the entire world, the UN remained, as Adlai Stevenson said of the Assembly, an "effective second line of defense for peace." One of Hammarskjöld's favorite quotations was from Shelley's *Prometheus Unbound*; one should, he said, ". . . hope till Hope creates From its own wreck the thing it contemplates."

OPPOSITE: Adlai E. Stevenson, United States Ambassador to the UN, in 1961.

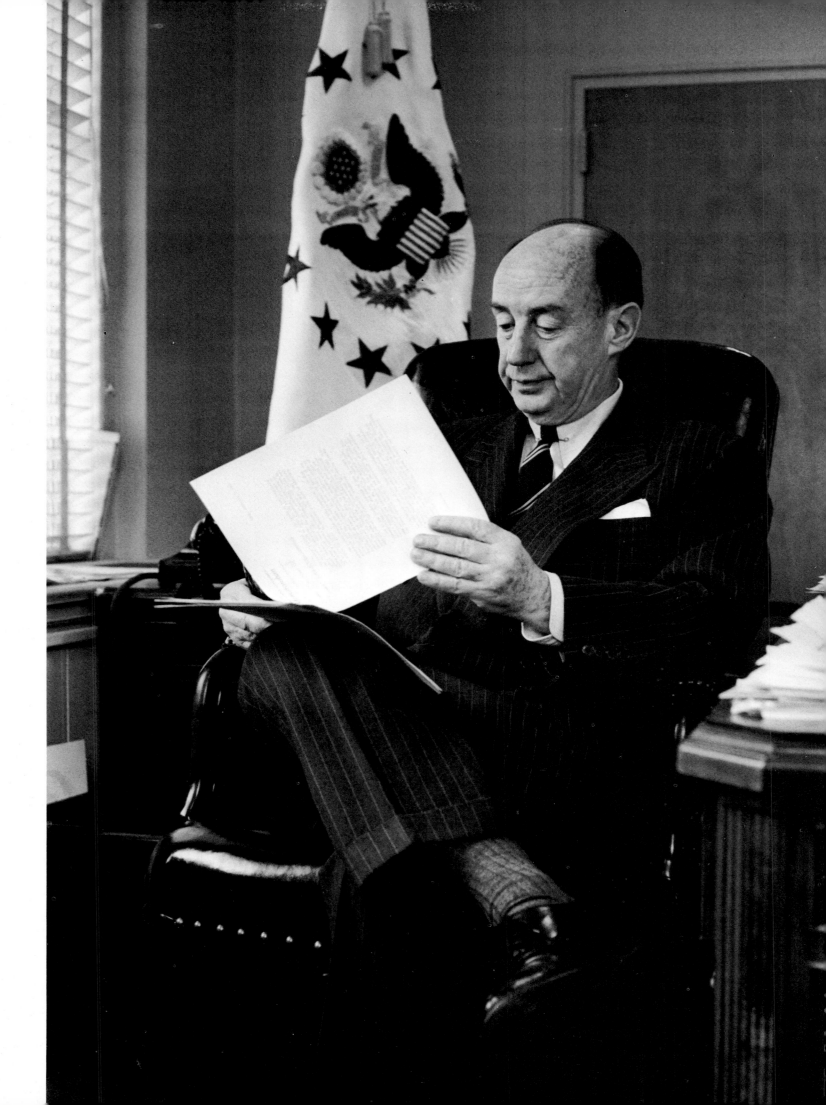

Never had the world seen a greater gathering of political potentates as delegates from ninety-six nations assembled in New York for the UN General Assembly in September 1960. Russia's Khrushchev was there with his Eastern satellites—Rumania's Gheorghe Gheorghiu-Dej, Hungary's Janos Kadar, Bulgaria's Todor Zhivkov, Albania's Mehmet Shehu, Czechoslovakia's Antonín Novotny, and Poland's Wladyslaw Gomulka. So were President Eisenhower and Cuba's Fidel Castro, and twelve new African nations took their seats for the first time. A key issue was the UN role in the Congo. Khrushchev delivered a 19,000-word, two and-a-half-hour speech that touched on the U-2 incident, United States "colonialism," the admission of Red China, and Berlin, and castigated Hammarskjöld's whole program in the Congo. It was a futile exercise: the UN had already voted 70-0 in favor of the UN operation there.

RIGHT: Indonesia's President Sukarno addressed the Assembly with an aide at his right. Behind them at the desk are Hammarskjöld and Canada's C. S. A. Ritchie, who was then president of the General Assembly. BELOW: England's Prime Minister Harold Macmillan in the corridors between sessions. BOTTOM CENTER: Hungary's Kadar (left) and his Foreign Minister Endre Sik. BOTTOM RIGHT: Israel's Foreign Minister Golda Meir

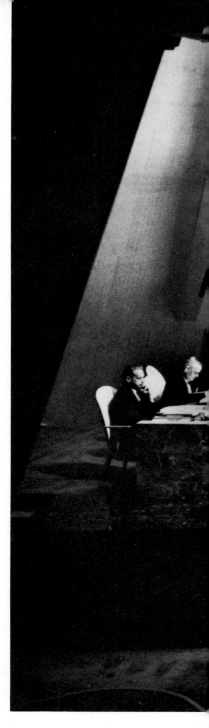

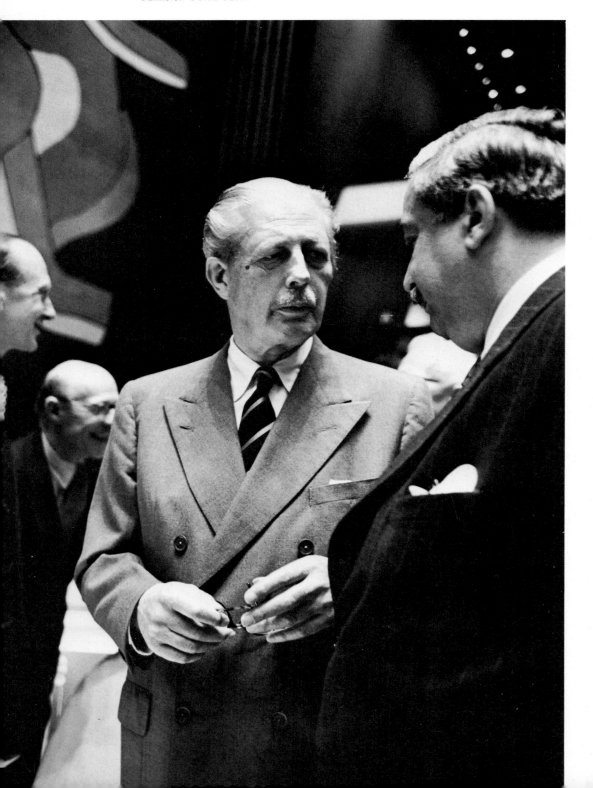

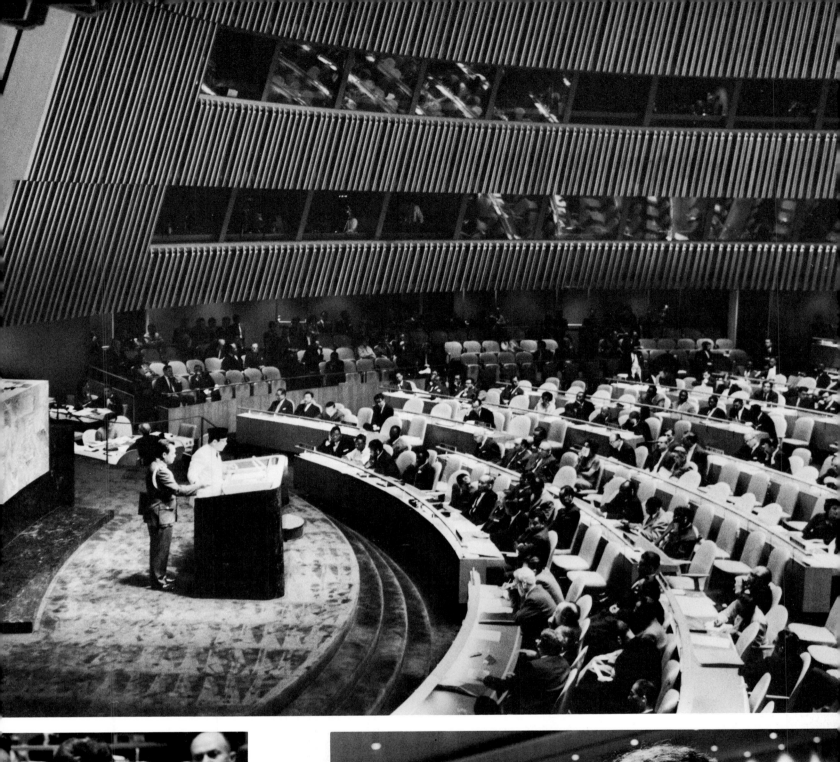
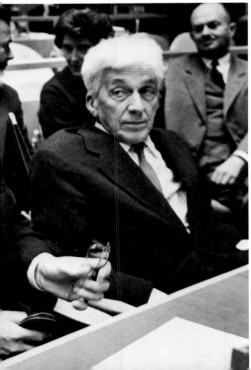

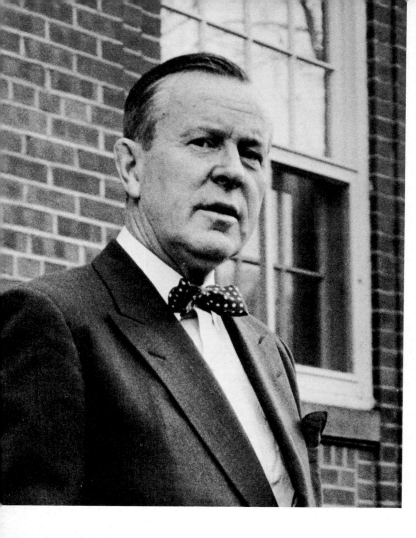

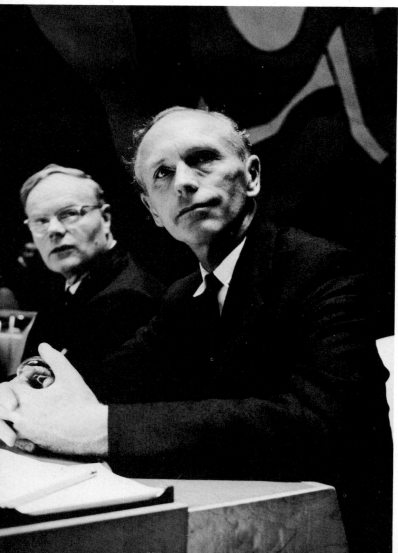

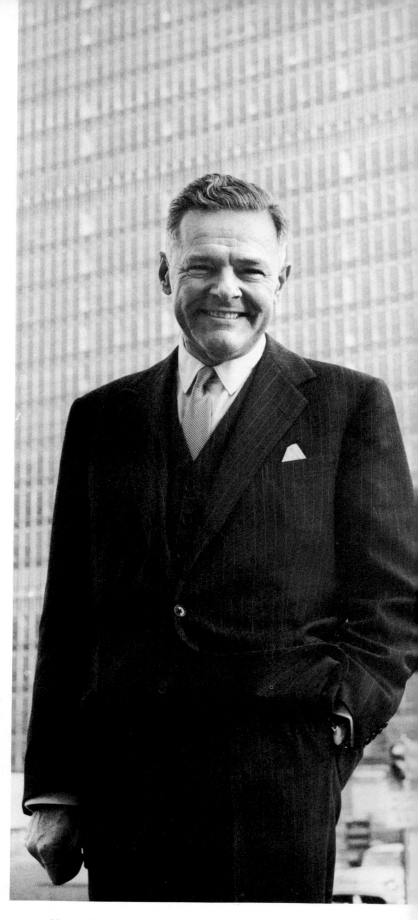

ABOVE: Henry Cabot Lodge, in front of the UN building. Lodge served from 1953 to 1960 as chief of the United States delegation. TOP LEFT: Canada's Lester Bowles Pearson, one of the senior advisers at the 1945 San Francisco conference that drew up the UN charter, was President of the General Assembly in 1952 and 1953, and won the Nobel Peace Prize in 1957. LEFT: Sir Patrick Henry Dean, United Kingdom's permanent representative to the UN, sits beside Sir Alec Douglas-Home, then the UK's Secretary of State for Foreign Affairs, who later became Prime Minister. RIGHT: India's Prime Minister Nehru.

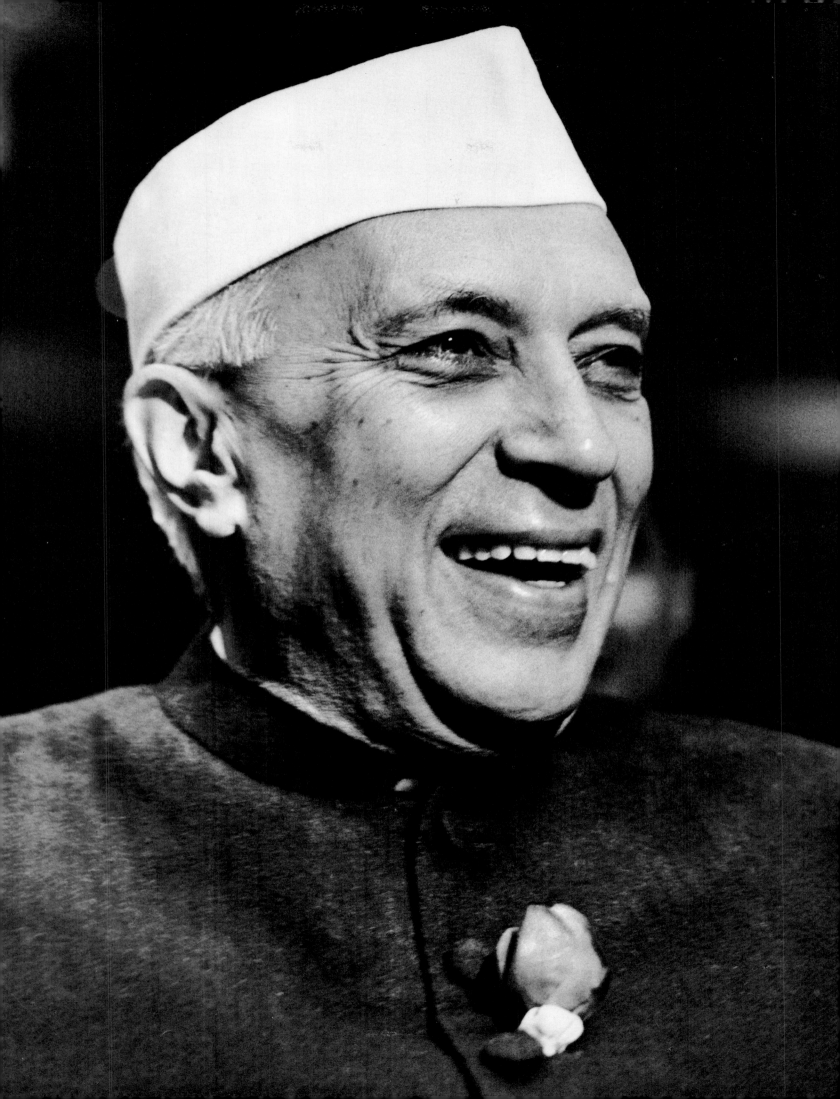

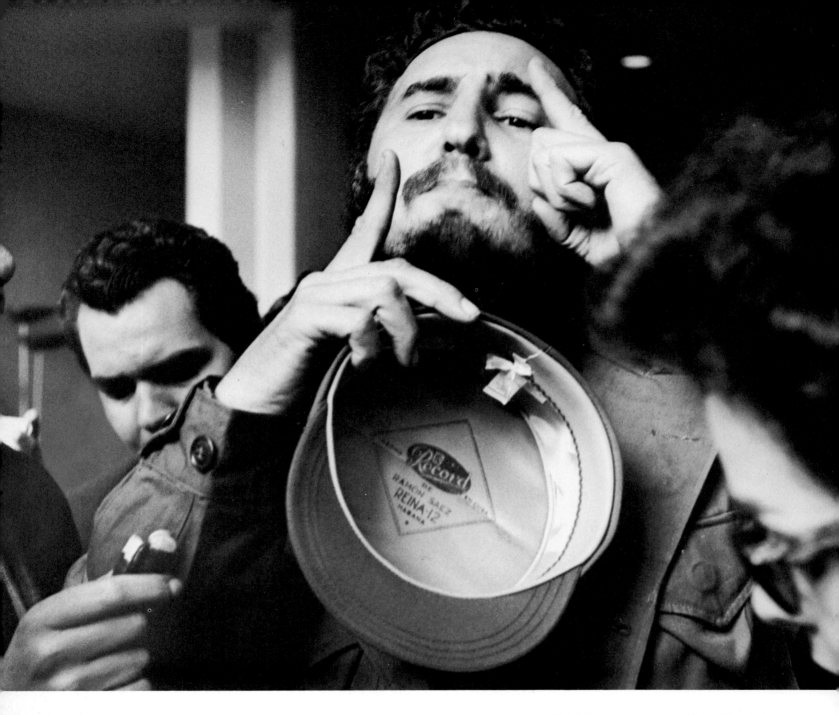

ABOVE: Fidel Castro. OPPOSITE: Nikita Khrushchev.

Off the Assembly floor Castro and Khrushchev stole the show. Castro, furious over his pint-sized suite in Manhattan's Shelburne Hotel on the genteel East Side, stormed with his eighty-five-man delegation to the Hotel Theresa, known as "The Waldorf-Astoria of Harlem." It was a propaganda ploy that worked: Cubans, Puerto Ricans, and even Negroes who lived in Harlem turned out in huge crowds to greet him. So, too, did Khrushchev, and the two leaders cracked jokes for twenty minutes.

OVERLEAF: A huddle of heads. Left to right: Yugoslavia's Marshal Tito, Rumania's Gheorghiu-Dej, and Khrushchev.

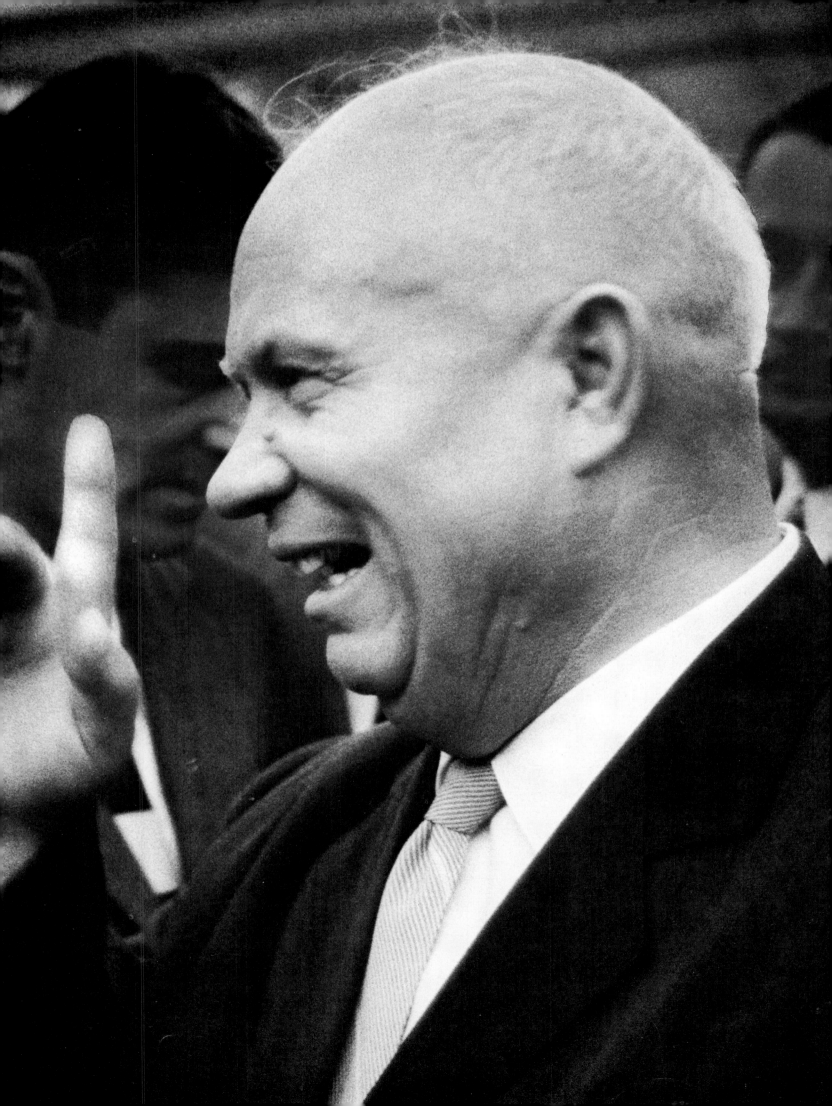

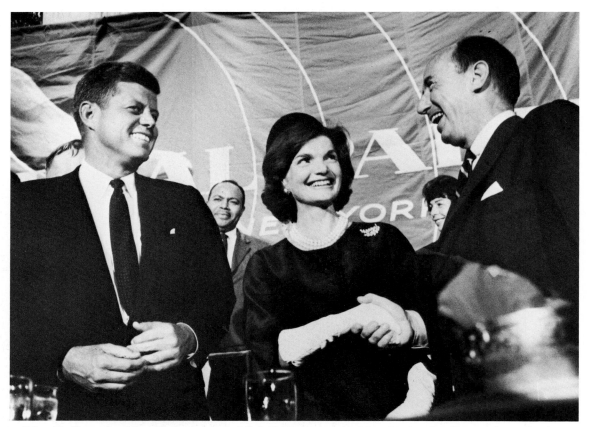

John F. Kennedy, Mrs. Kennedy, and Adlai E. Stevenson in New York after Kennedy's nomination.

John F. Kennedy

In a sense, it was a frog that gave me my first chance to meet President Kennedy. It was August 1960. Kennedy, having just won the Democratic nomination for President, was resting at his Hyannis Port summer home. I was looking for a frog and a pond in the area to do a color essay on Thoreau's *Walden*. As I was so close by anyway, *Life* asked me to take some pictures of the then Senator Kennedy.

Kennedy came into the dining room combing his hair. He shouted, "Catch!" and threw the comb and brush to the *Life* reporter with me; she did, and the atmosphere from then on was highly informal. Kennedy mentioned to me that one of his eyes was a little off-center, which tended to make him look stare-y if he looked straight into the camera. Then Caroline came in and crawled under the table to fumble with her father's well-pressed pants. He suspected she wanted to stick chewing gum on his trousers; she *had* hidden the gum somewhere, but Kennedy couldn't find it and he even looked into her mouth. Mrs. Kennedy came in, and I was stunned by her beauty. She reminded me of an exotic cat as she moved around the room. Even her voice was different from any other woman's: "Can I give you something to drink, Mr. E.?" The next time I saw her, five weeks later, she called me "Eisie," and it seemed only natural for me to call her "Jackie."

OPPOSITE: Vice-President Lyndon Johnson, Mrs. Kennedy, and the President, at Kennedy's Inauguration Ball in Washington, 1961. OVERLEAF: Mrs. Kennedy reads Caroline a bedtime story in Hyannis Port.

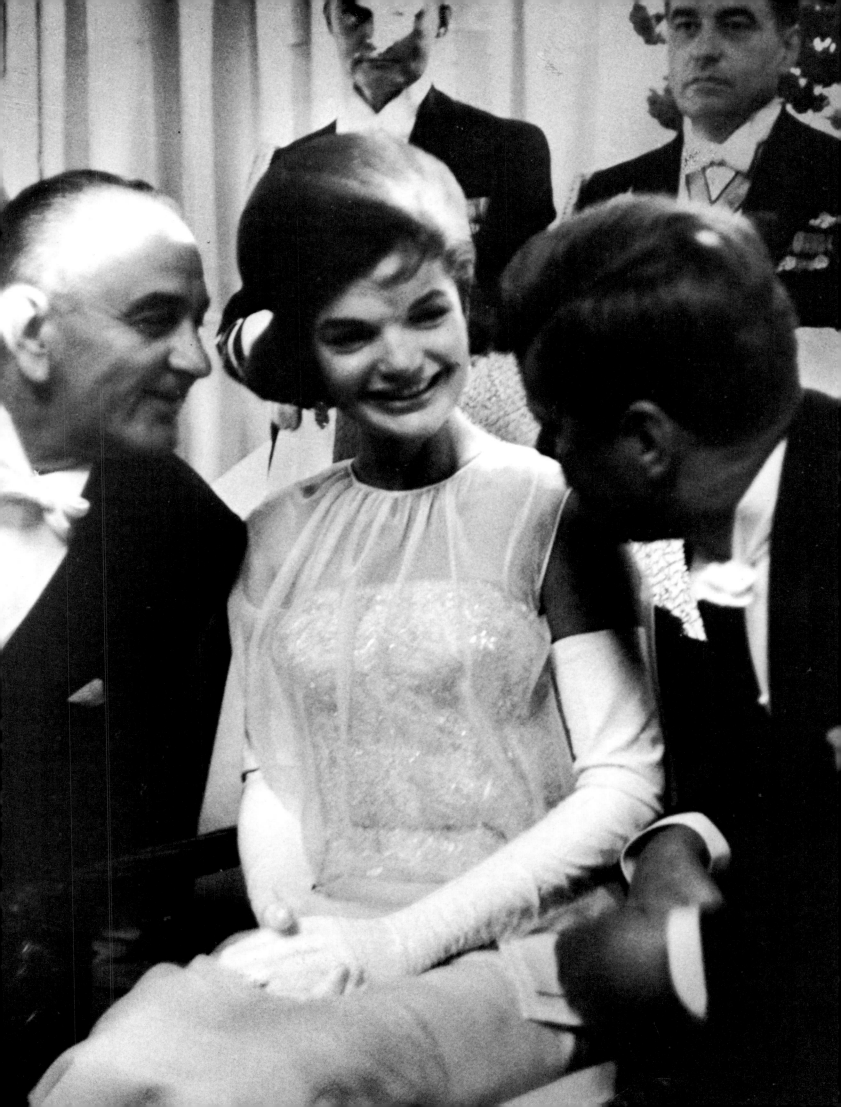

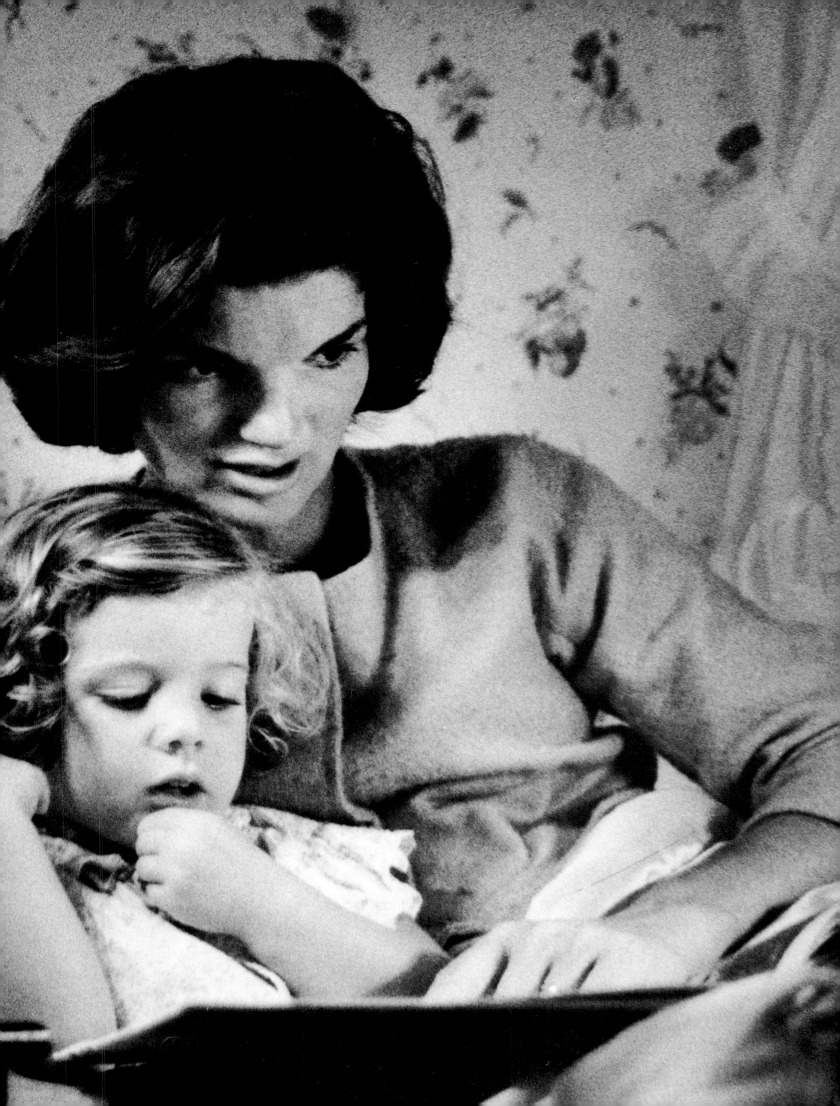

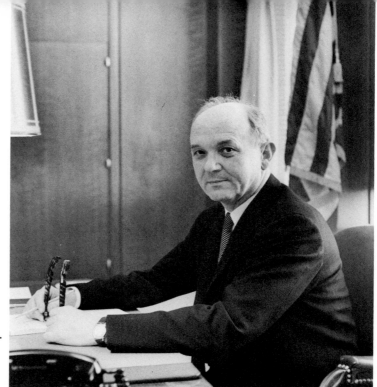

RIGHT: Secretary of State Dean Rusk.

BELOW: Secretary of Defense Robert S. McNamara.

ABOVE: Kennedy's White House staff was headed by these lieutenants, known as the "Irish Mafia." Left to right: Kenneth O'Donnell, appointments secretary; Ralph Dungan, staff secretary; Theodore Sorenson, speechwriter; and Lawrence O'Brien, liaison man for Congressional relations.

When President Kennedy took office in January 1961 he launched "the Great Talent Hunt" to find the right officials for his new administration. His one instruction: "I want the best men available for the job and I don't care whether they're Democrats, Republicans, or Igorots." The Cabinet he appointed included the president of the Ford Motor Company, a high official from the AFL–CIO, a vice-president of an insurance company, a Republican who had served under Eisenhower, and the President's own brother. They averaged 47.3 years in age, among the youngest Cabinets since George Washington's, and their IQs measured close to the so-called genius level.

RIGHT: Lyndon B. Johnson, then Vice-President of the United States.

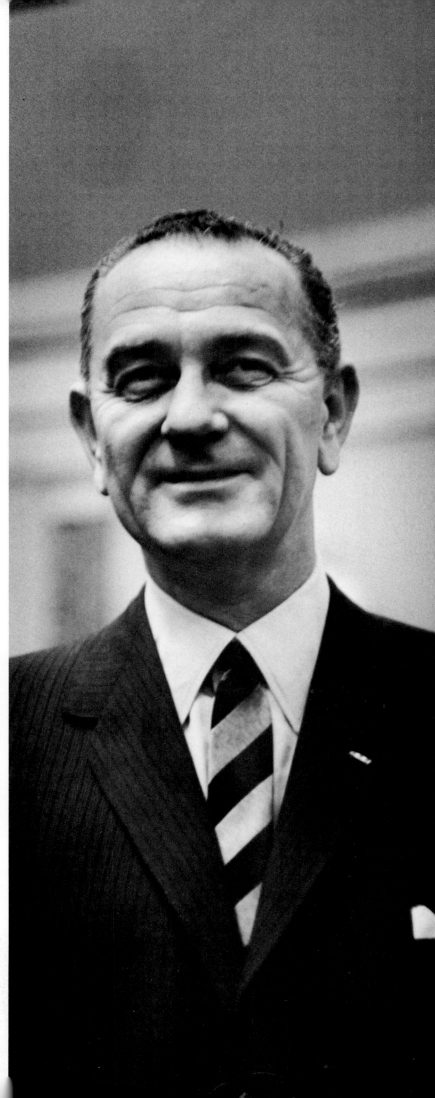

An omnivorous reader, President Kennedy scans the daily pile of newspapers in his White House office.

President Kennedy asked me in February 1961 to take his official photograph, which he would present to close friends and world leaders. I shot a roll of color and asked him if he minded posing further. "You are the boss," he said, "go right ahead." When I had finished, I showed him my autograph book, in which Robert Frost, who had written and read a poem for Kennedy's inauguration, had written a poem for me. The President was very interested and wanted to know if Frost's poem to me had ever been published. Then he wrote in my book: "For Alfred Eisenstaedt, who has caught us all at the edge of the New Frontier. What will the passage of the next four years show on his revealing plate?"

John Fitzgerald Kennedy—the official photograph.

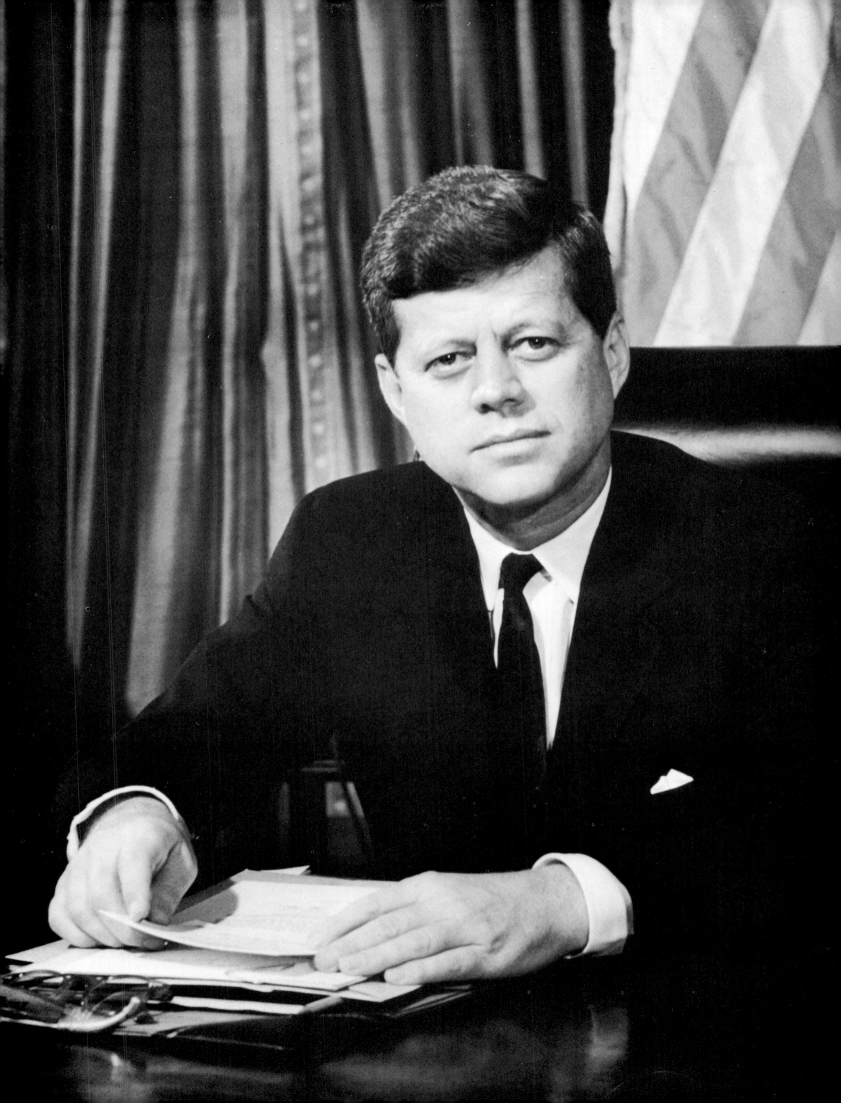

The author taking pictures at Lourdes, 1957.

The Eye of Eisenstaedt

"How strange that from staring through a glass of peculiar shape at dictators and kings, generals and statesmen, those who have sought one way or another to rule the world, you have come away so . . . willing still to search . . . for what further you may find. It is as if that miracle of glass, built to record without the faintest hint of a flaw those frightful images of terror on the sensitive and impersonal film, had endowed you with its grace of infinite purity, anastigmatic, clear as the sound of a silver bell. . . ."

Those words were written in my autograph book by poet William Carlos Williams in 1951. The dictators and kings, the generals and statesmen have passed away but "that miracle of glass" through the years has captured what are, for me, the enduring images that make up the remaining pages of my book.

Captions for the photographs that appear on pages 310-336 are given in order on page 337.

OPPOSITE: Procession at the Cathedral of Lourdes, France, 1958.

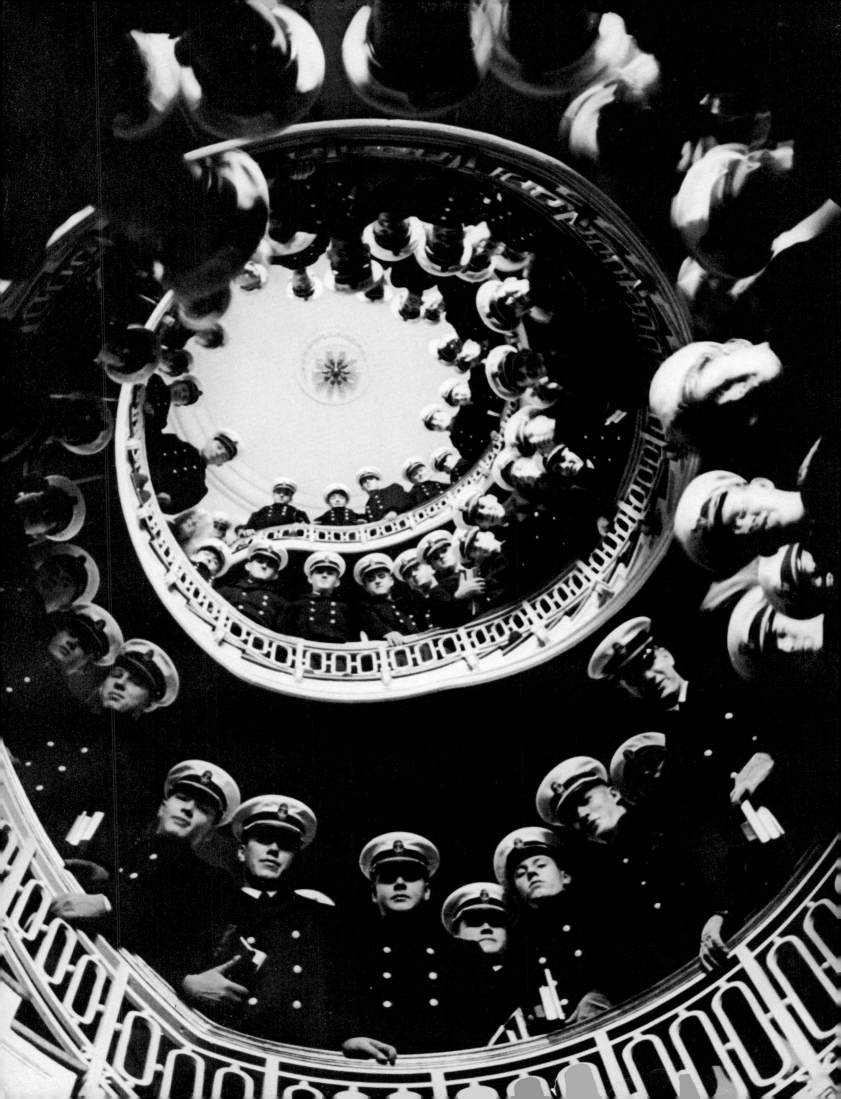

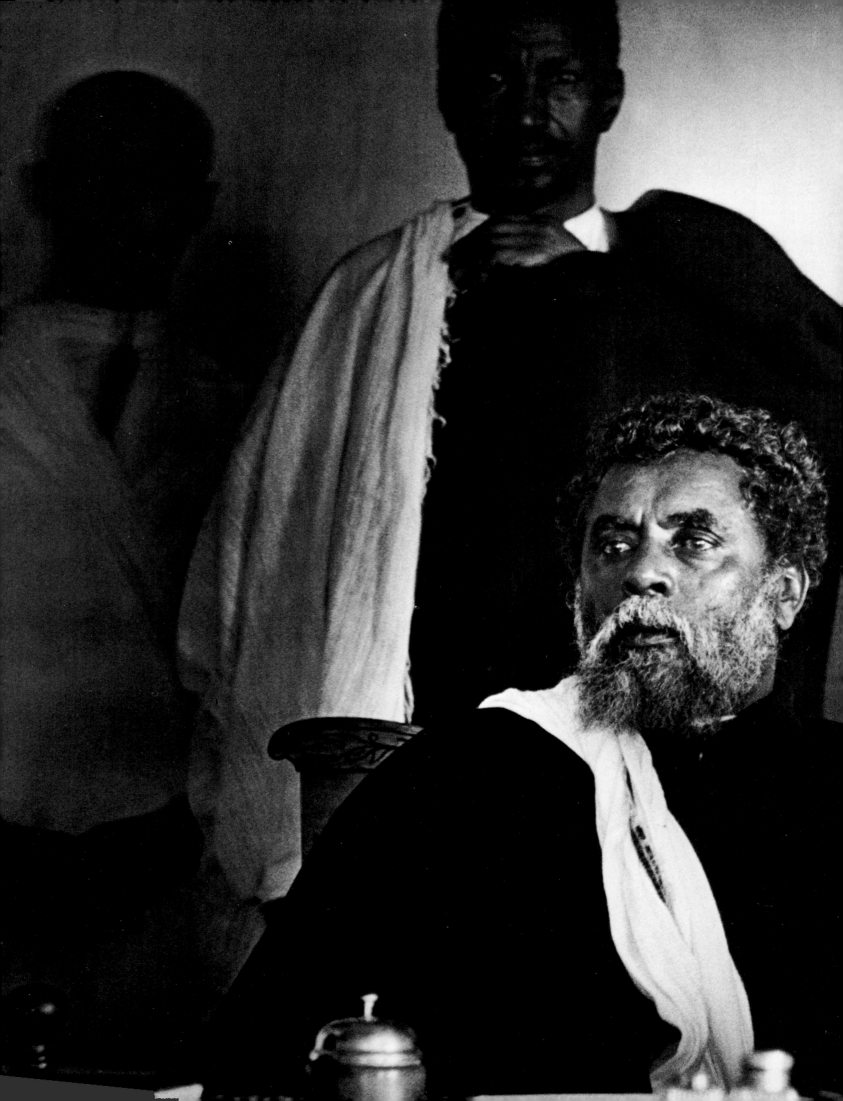

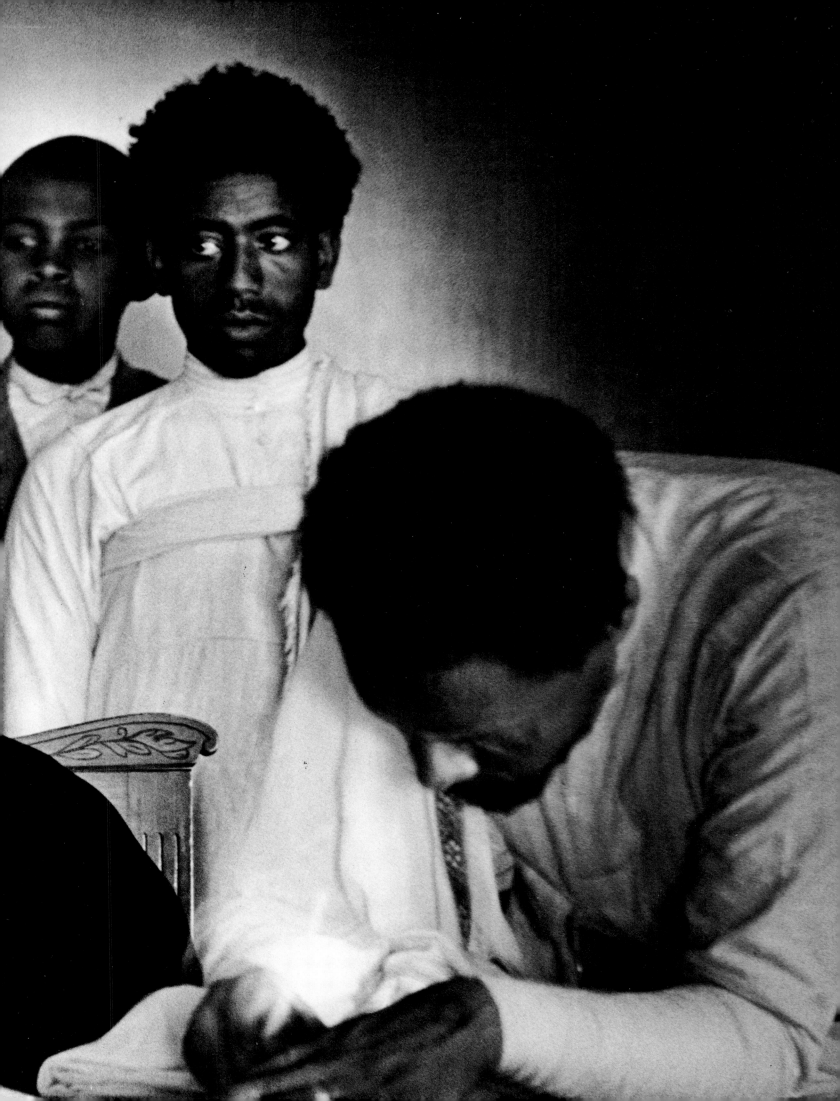

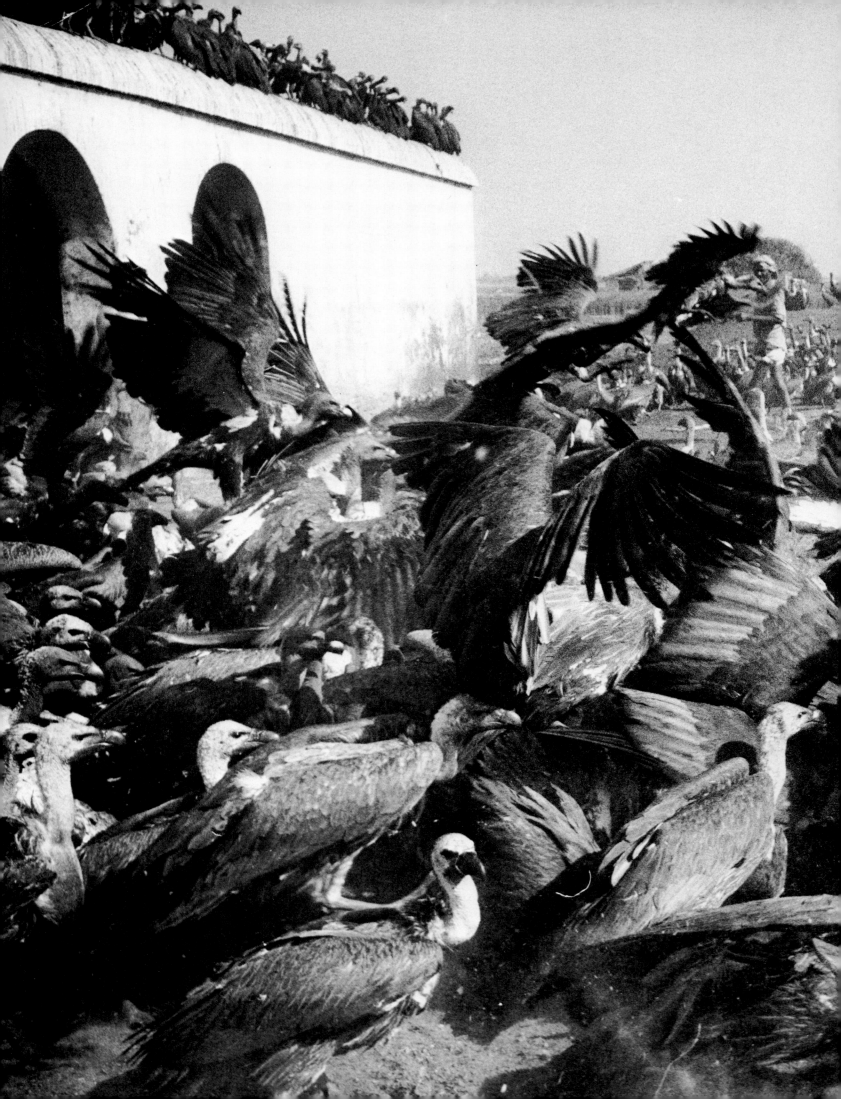

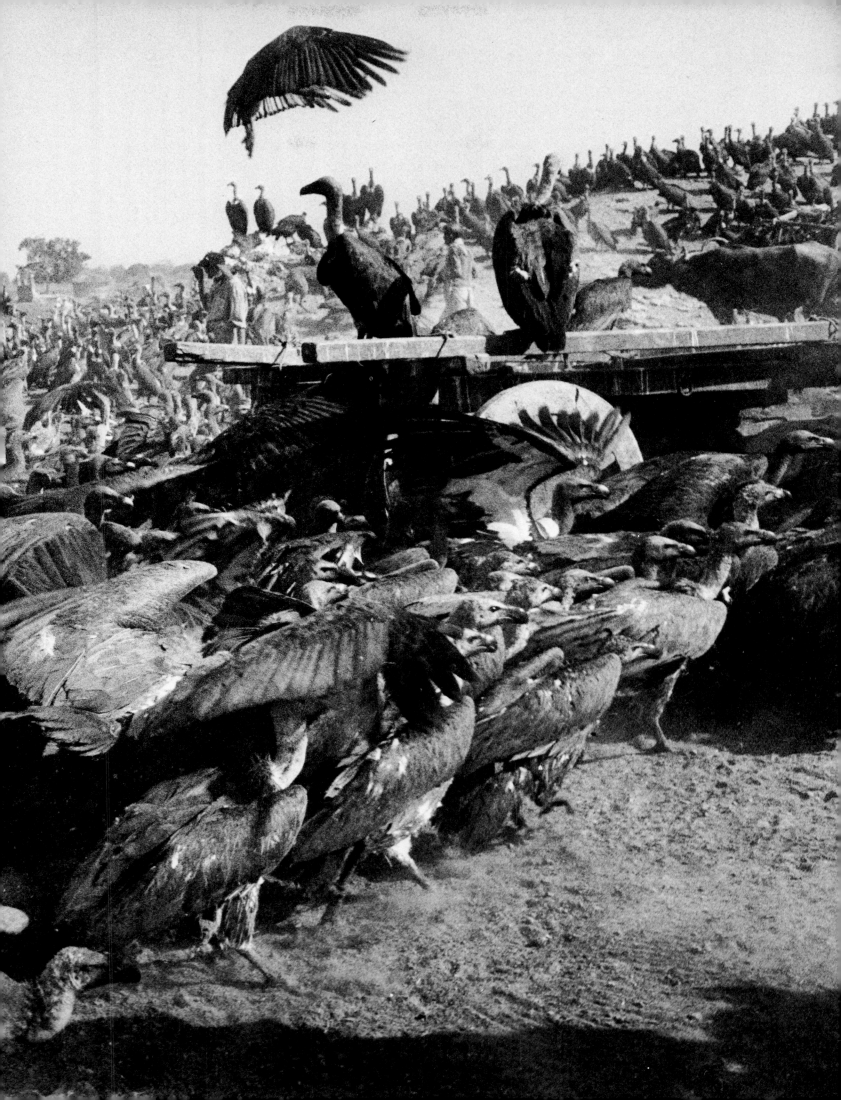

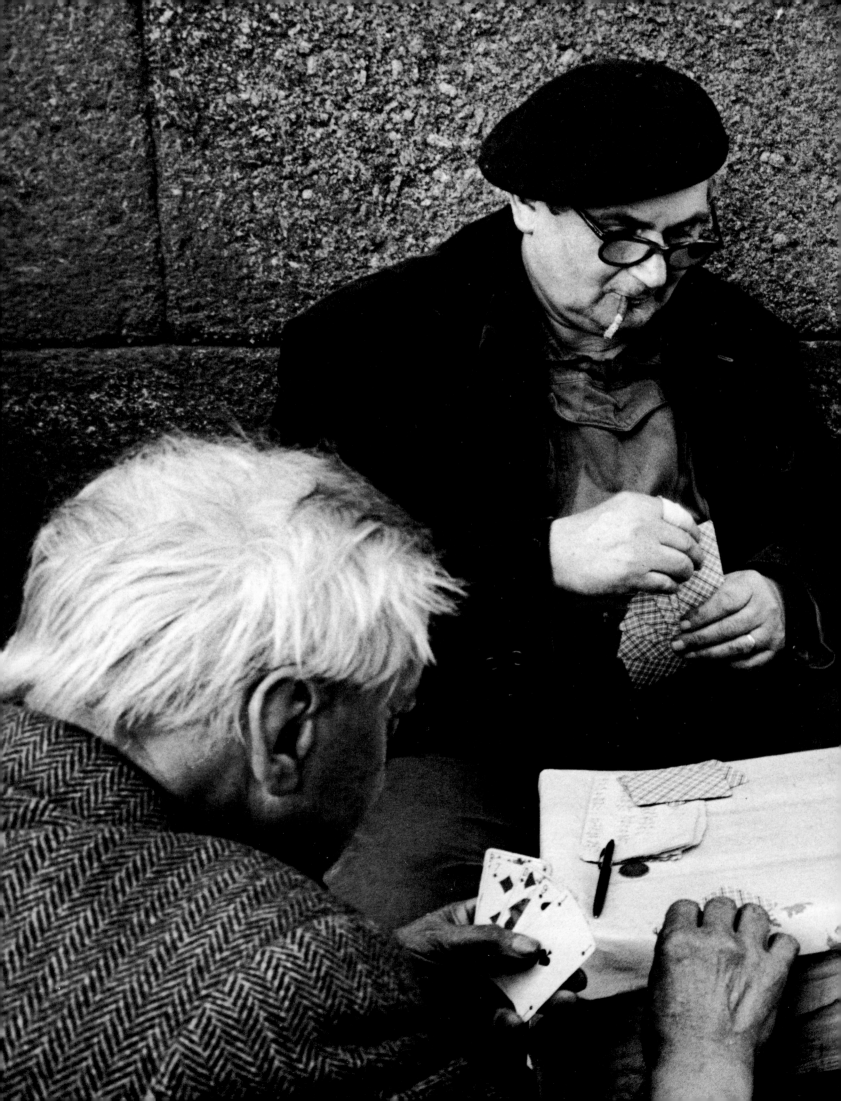

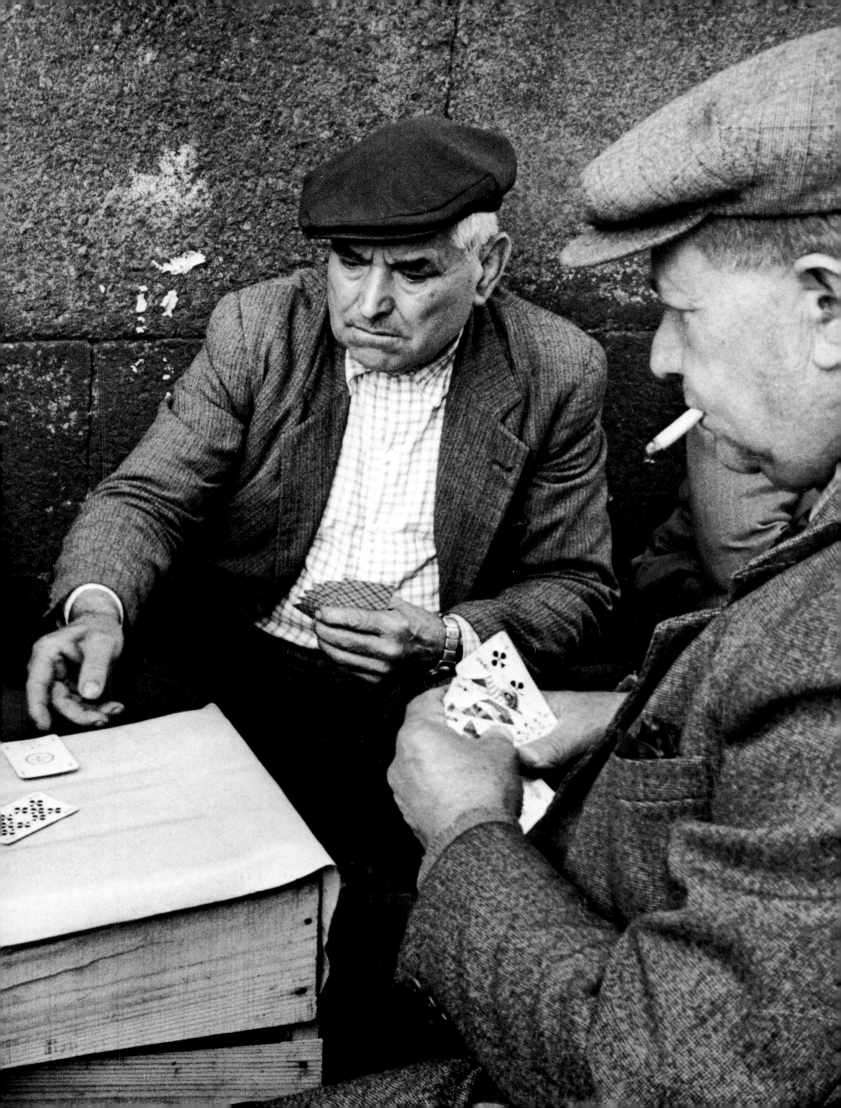

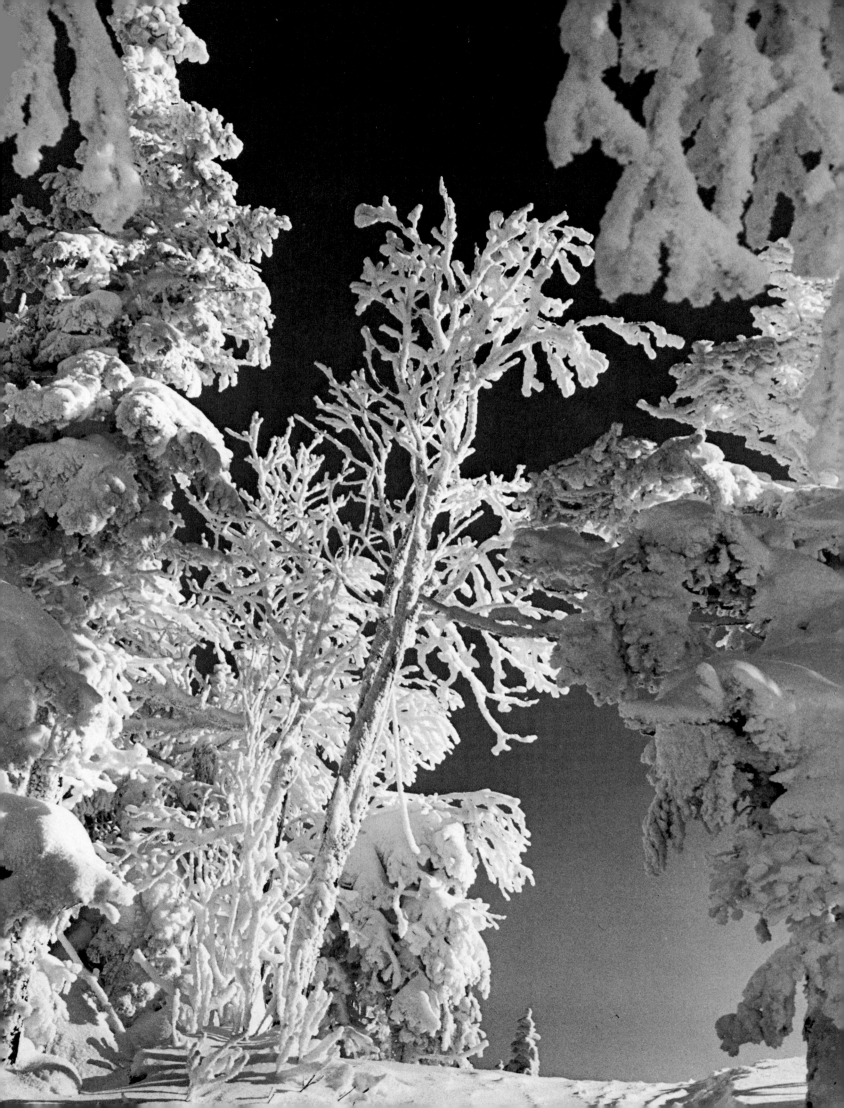

PHOTOGRAPHS ON PAGES 310-336.

Beethoven's birthplace in Bonn, Germany, 1934.

A dying monk in Varlaan Monastery in Thessaly, Greece, 1935.

A drum major and his protégés practicing in Ann Arbor, Michigan, 1950.

Nurses at Roosevelt Hospital, New York City, 1954.

Midshipmen at the United States Naval Academy, Annapolis, Maryland, 1936.

A nun at Lourdes, 1958.

Orthodox Rabbi Eleazar Brizel and his sixth-grade pupils in Jerusalem, 1955.

The U.S. Air Force Academy chapel in Colorado Springs, 1962.

A skyscraper of Rockefeller Center reflected in a window at Saks Fifth Avenue, New York City, 1959.

Martha's Vineyard, Massachusetts: Sailboats off South Beach. A dune called "Zak's Cliff."

Orchids: TOP LEFT: a Miltonia (Storm); BOTTOM LEFT: a Cycnoches (Swan's Neck); RIGHT: a Phalaenopsis (Clara Knight).

An American bullfrog.

A deer-hunting party on a South Carolina estate, 1937.

The Mayor of Addis Ababa, Ethiopia, in his City Hall, 1955.

Vultures outside a slaughterhouse in Khurja, India, 1964.

Card-players on the Ile de la Cité, Paris, 1963.

Mont Tremblant, Canada, at 51 below zero.

A pond near Mexico City, 1965.

A house on the island of Burano, near Venice, Italy, 1963.

An exhibition of the glass-blower's art in Venice, 1963.

Prismatic view of a San Francisco cable car, 1966.

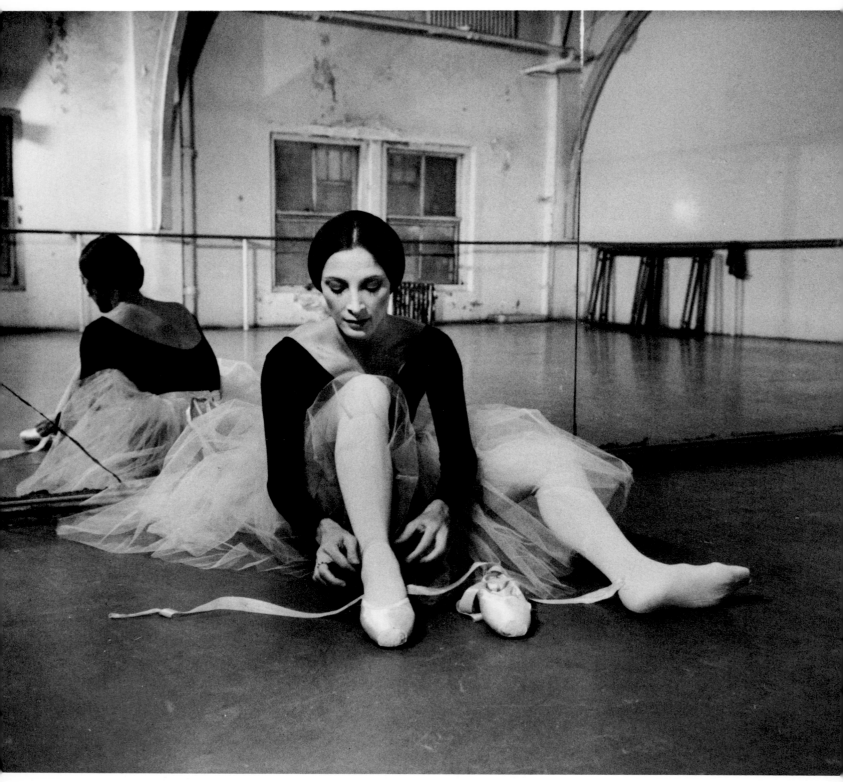

Cynthia Gregory, principal dancer of the American Ballet Theatre, 1978.

At the Minskoff Theatre in New York in 1979, I found Mikhail Baryshnikov rehearsing for a television special.

RIGHT: Alice Neel, one of America's great artists, posed in the company of several of her paintings, 1979.

BELOW: English sculptor Henry Moore with one of the massive figures that have made him famous, in Much Hadham, Hertfordshire, in 1979.

OPPOSITE PAGE, TOP: Karl Boehm, the world-famous conductor, studying a Schumann score in Salzburg in his native Austria, 1979.

BOTTOM: The versatile American architect-designer, geometer, and educator Buckminster Fuller viewing the author through a model of his ubiquitous geodesic dome, Philadelphia, 1979.

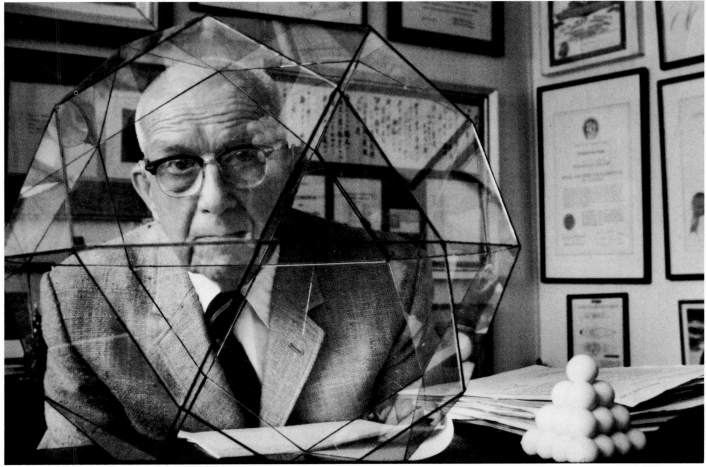

TOP: Arthur Miller, the distinguished playwright, at home in Roxbury, Connecticut, 1977.

BOTTOM: Anna Freud in London, 1978. Her writings and work in psychoanalysis rival the achievements of her father, Dr. Sigmund Freud.

OPPOSITE: Dame Rebecca West, whose novels and political and literary criticism have been winning honors for more than six decades, was at work on a new book and planning others when I took this picture in London in 1979.

LEFT: Peter F. Drucker, writer, teacher, management expert, consultant to governments and corporations, at Claremont College in California, 1980.

UPPER RIGHT: Professor Gunnar Myrdal, Swedish author and economist, in Stockholm in 1979.

LOWER RIGHT: W. Averell Harriman, former governor of New York and ambassador to the Soviet Union and the Court of St. James's, a negotiator of the 1963 Nuclear Test Ban Treaty, and ambassador to the 1968-1969 Paris peace talks, catching up on his reading in his Georgetown garden, 1980.

OPPOSITE: Dr. Kurt Waldheim, Secretary-General of the United Nations, at his desk in UN headquarters, New York, 1978.

ABOVE: George Cukor, director of an enviable succession of movie triumphs beginning with *Dinner at Eight* and *Little Women* in 1933, reading a script in Beverly Hills, 1979.

OPPOSITE: Actress Lillian Gish, seated at the window of her New York City apartment, takes a curtain call for the camera, 1979.

Producer-director Otto Preminger, in his Fifth Avenue office in 1978, preferred reading Graham Greene's *The Human Factor* to facing the lens.

Index

(Figures in italics refer to illustrations)